The Spell of Italy

The Spell of Italy

Vacation, Magic, and the Attraction of Goethe

RICHARD BLOCK

WAYNE STATE UNIVERSITY PRESS
DETROIT

KRITIK

German Literary Theory and Cultural Studies
Liliane Weissberg, Editor

*A complete listing of the books in this series
can be found online at http://wsupress.wayne.edu*

© 2006 BY WAYNE STATE UNIVERSITY PRESS,
DETROIT, MICHIGAN 48201. ALL RIGHTS ARE RESERVED.
NO PART OF THIS BOOK MAY BE REPRODUCED WITHOUT FORMAL PERMISSION.
MANUFACTURED IN THE UNITED STATES OF AMERICA.

10 09 08 07 06 5 4 3 2 1

LIBRARY OF CONGRESS CATALOGING-IN-PUBLICATION DATA

BLOCK, RICHARD A.
THE SPELL OF ITALY : VACATION, MAGIC, AND THE ATTRACTION OF GOETHE / RICHARD BLOCK.
P. CM. — (KRITIK, GERMAN LITERARY THEORY AND CULTURAL STUDIES)
INCLUDES BIBLIOGRAPHICAL REFERENCES AND INDEX.
ISBN 0-8143-3269-2 (CLOTH : ALK. PAPER)
1. GOETHE, JOHANN WOLFGANG VON, 1749–1832—INFLUENCE. 2. ITALY—IN LITERATURE.
3. GERMANY—CIVILIZATION—ITALIAN INFLUENCES. 4. GERMAN LITERATURE—ITALIAN INFLUENCES. 5. GOETHE, JOHANN WOLFGANG VON, 1749–1832. ITALIENISCHE REISE. I. TITLE.
II. KRITIK (DETROIT, MICH.)

PT2166.B56 2006
830.9'3243—DC22
2005024089

∞

PORTIONS OF CHAPTERS 4 AND 6 APPEARED IN *MLN* 119, NO. 3.
A PORTION OF CHAPTER 5 APPEARED IN *GERMAN QUARTERLY* 78, NO. 2

For Géza von Molnár, who insisted I continue,
and Leandro di Prinzio, who suggested I give up.

Contents

ACKNOWLEDGMENTS *ix* ABBREVIATIONS *xi*

Introduction *1*

1.
Opened Wounds:
Winckelmann and the Discovery
of the Art of the Ancients *17*

2.
Fathers and Sons in Italy:
The Ghosts of Goethe's Past *49*

3.
Taking the Words out of the Father's Mouth:
Goethe's Authorial Triumph *79*

4.
On Goethe's Other Trail:
Heinrich Heine's Grand De-Tour *111*

5.
The Return of the Repressed:
Nietzsche and Freud *141*

CONTENTS

6.
Goethe's Other Italy:
The Devil's Playground *185*

Epilogue:
Birthing Italy *223*

Notes *231* Works Cited *277* Index *295*

Acknowledgments

I WOULD LIKE TO acknowledge Liliane Weissberg for her support and the two anonymous readers of the manuscript for their exceptional insights. Others, with one exception, I will simply list since their contributions, whether it be in the form of comments, laughter, or patience, would only be diminished by any form of specification: Robert Block (for his musical phrasing), Kenneth Calhoon, Adrian DelCaro, Kathy Dougherty, Michael DuPlessis, Peter Fenves, Susannah Gottlieb, Thomas Hollweck, Mark Leiderman, Barbara von Molnár, Duane Perolio, Luciana Pignatelli, Karen Pinkus, Davide Stimili, Roy Vargason, and my parents.

I would also like to thank the Graduate Schools of the University of Colorado, Boulder, and the University of Washington, Seattle, for helping support research for this project.

Abbreviations

Eng.	English edition
HA	Goethe, Johann Wolfgang. *Hamburger Ausgabe in 14 Bänden.* Ed. Eric Trunz. 14 vols. Munich: C. H. Beck, 1982.
HK	Heine, Heinrich. *Historisch-Kritische Gesamtausgabe der Werke.* Ed. Manfred Windfuhr. 16 vols. Hamburg: Hoffman and Campe, 1973.
Briefe	Heine, Heinrich. *Briefe.* Vol. 1. Ed. F. Hirth. Munich: G. Muellen, 1914–20.
KSA	Nietzsche, Friedrich. *Kritische Gesamtausgabe.* Ed. Giorgio Colli and Mazzino Montinari. 15 vols. Berlin: de Gruyter, 1967.
SA	Freud, Sigmund. *Gesammelte Werke, Chronologisch geordnet.* Ed. Anna Freud. 17 vols. Frankfurt am Main: Fischer, 1940–52.
SE	Freud, Sigmund. *Standard Edition of the Complete Psychological Works.* Ed. and trans. James Strachey. 24 vols. London: Hogarth, 1953–72.
SW	Heinse, Wilhelm. *Sämlichte Werke.* Düsseldorfer Ausgabe. Ed. Manfred Windfuhr. Hamburg: Hoffman and Campe, 1986–94.
WA	Goethe, Johann Wolfgang. *Weimar Ausgabe.* 143 vols. Weimar: Böhlhaus, 1887–1919.

Introduction

In October 1973 the Austrian-born poet Ingeborg Bachmann died after suffering third-degree burns from a fire in her apartment in Rome. The fire apparently began when a cigarette dropped from her hand after she had fallen asleep. Her death ended what was certainly an intimate relationship with the land in which Goethe, some 195 years earlier, had experienced a creative rebirth. If Goethe's journey can be said to have established a tradition that became a constant preoccupation of subsequent German writers, Bachmann's life and death in Rome may be understood as a critical interruption of that tradition.[1]

In one of the better-known poems written during her stay in Italy, "Das erstgeborene Land" ("The First-Born Land" 1956), Bachmann describes Italy as *her* firstborn.[2] In the body of the poem, she repeatedly substitutes the possessive pronoun "my" for the definite article in the poem's title. Read in the context of the enduring German-Austrian fascination with Italy, the substitution is striking for two reasons: it both evokes and dismisses the tradition established by Goethe. While the poem affirms the (pro)creative potential of Italy, it also posits Bachmann as its mother; Italy is her firstborn. In the pivotal stanza that describes the land's transformation from sterility to fecundity, the nature of Bachmann's dual relationship to that tradition finds a telling expression:

INTRODUCTION

> Und als ich mich selber trank
> und mein erstgeborenes Land
> die Erdbeben wiegten,
> war ich zum Schauen erwacht (1:120)
>
> And as I drank myself
> and as earthquakes rocked
> my first-born land
> I awakened to seeing.

Drinking or internalization of the self is mirrored in the rocking of her firstborn land. The motion of swallowing is doubled in the image of the convulsing earth. At the same time, the violence of the earthquakes is softened by the use of the verb "wiegen," which suggests a mother rocking a cradle. The inseparability of the lyrical "I"'s self-absorption from the fate of the land is what allows her to see—or, since until now she has employed visual metaphors to describe the land as infertile and threatening, that relationship allows her to see anew. In the one-line stanza that follows, "Da fiel mir Leben zu" (life fell to or upon me), the coincidence (Zufall) of the two is not only affirmed, but also becomes a prerequisite for life. In this regard, Bachmann rehearses a fundamental gesture of Goethe's Italian journey: enlightening the eye serves as a prerequisite for creative rebirth.[3] But there is something not quite Goethean in Bachmann's formulation. The self that is rejuvenated is a procreative one; it gives birth to the land that was the site of Goethe's rebirth.

Inseparable from the notion of regeneration or rebirth is, of course, Goethe's apparent discovery in Sicily of the "Urpflanze" or primal plant. This discovery allows him to father not only a botanical discipline, morphology, but also countless progeny.[4] As he writes from Naples, "Nature herself will envy me" this discovery from which an infinite number of offspring or progenies will derive (21 May 1787).[5] His rewriting of nature is revisionist; it comes after the fact or after his return to Sicily, where he had a whiff of the primal plant's essence. If such revisionism contributes to the impossible allure of Goethe's journey, it also allows him to rewrite genealogy. By going to Sicily or some place his father had never been, Goethe, as I argue in chapters 2 and 3, comes to author his father. No longer following in his father's footsteps, Goethe lays claim to the origin in the form of the primal plant and can

INTRODUCTION

claim thereby to precede his father. Bachmann's poem thus poses a particularly vexing challenge for those who would follow Goethe to the origin or trace the origin back to Goethe. How does one antecede the mother?

If Bachmann's repetition of Goethe produces an ineluctable difference, it is not without precedent. As I argue, the journeys of Heine, Nietzsche, and Freud bear witness to the difficulty, if not the impossibility, of following Goethe in Italy. The self that Heine and Freud come to realize by imitating or even emulating Goethe eventually forces them into exile. Nietzsche goes mad. The difference that Bachmann affirms in the stanzas cited above anticipates a more radical break in the tradition. The one who gives birth to the land of Goethe's rebirth dies when her Italian rooms or *stanze* burn. As a woman and "mother" Bachmann gives birth by dispensing with the obligatory deference to Goethe or with adherence to the laws installed by his journey. She overturns his overturning of genealogy. Considered in this context, might her death not be something of an auto-da-fé, the punishment exacted from one who seeks to awaken from the spell of Goethe's Italy?

The purpose of this book is to pursue that possibility. It does so by attending to the seminal journeys of men who sought to produce and contribute to the tradition initiated by Goethe. But as Bachmann or the lyrical "I" that gives birth to Italy in "The First-Born Land" makes clear, the Italian journeys they hoped to imitate might have been something other than primary or original. From the beginning they might have been deceived.

Theoretical Questions

In the following six chapters and epilogue I undertake an investigation into the structure of Goethe's Italian journey—what I have just alluded to as its law—with a specific interest in determining the conditions of his journey that predispose, if not predetermine, that Italy will become, as it is so often in the works of Thomas Mann, a site to consort with the devil. The example of Bachmann is instructive insofar as it suggests that there is something about this law that cannot countenance the feminine, even if the feminine has only always been there.[6] The primary concern of this book, however, is men, most notably Heine, Nietzsche, Freud, and Mann, whose Italian journeys or preoccupation with Italy constitute what I provocatively call the poisoned legacy of Goethe's Italian journey. I am also interested in how Winckelmann's aesthetics, composed

INTRODUCTION

mostly during his life in Italy, seek to erase traces of the feminine and thereby prepare the terrain for Goethe and his followers. If we accept Madame de Staël's conceit in *Corinne, ou, L' Italie* and regard Italy as essentially a feminine land, then Italy as a real, a literal place can at any moment intervene and upset expectations of what these followers of Goethe sought.[7] The radical difference articulated by Bachmann is thus already evident in those journeys, such as Heine's and Freud's, in which the real Italy—its politics and its history—interrupt their itineraries.

While there is no shortage of works that consider the German-Austrian fascination with Italy,[8] what remains unexamined is the altered and demonic disposition the Italian landscape assumes in many writers, particularly twentieth-century ones, and the extent to which that alteration may be an inevitable consequence of the terms and conditions under which Goethe executed his own "reeducation." The "Baumskelett" or tree skeleton that hovers above the lyrical "I" in Bachmann's poem and that fails to inspire a single dream suggests that it is a land every bit as much in need of rebirth as those who have journeyed to it. The exclusion of the feminine infects the land as well. Stated in less provocative terms, the question pursued throughout this book is whether something about Goethe's Italian travels seduces future writers to seek in Italy a classical or artistic ideal that was in fact never there to be found and, as a result, sends legions of writers on a chase that can only end in disillusionment and turn up traces of deception.[9]

Bachmann already suggests that everything about Goethe's journey was derivative, including the classical ideal of ancient art. A central concern of this book is how the absence of an Italy (Bachmann has not yet been born) or the classical ideal supposedly discovered upon its soil gives rise to what I call a logic of substitution—the logic by which an absent ideal generates substitutes to sustain the appearance of its presence.[10] This is precisely the theoretical question I pursue: to what degree a literary history, understood as the history of German and Austrian writers in Italy, is a dialogue with absence and the ghosts that haunt that absence. I am thus obligated to consider how Goethe comes to author a tradition that has no origin—or could have none until Bachmann inserts herself into or before that tradition. Moreover, the journeys of Winckelmann and Goethe's father point to the impossibility of an origin that originates with Goethe. I am also interested in what traces of Goethe's misprision in positing presence in the place of absence and in installing himself as the author of that tradition surface in later nine-

INTRODUCTION

teenth- and twentieth-century works.[11] As we will see, the myths of race, nation, and even gender are the politically charged and haunted traces of that deception. Goethe's recognition that absence and the need to conceal it (or the means by which his journey[12] comes to conceal it) might account for what Gretchen Hochmeister has called "the anti-climatic and ambivalent tension" with which he departed Italy (57).

Summary of the Argument

The question taken up in chapter 1, by means of an examination of Johann Joachim Winckelmann's life and death in Italy, is why *Italy* should serve as the preferred site for a German reengagement with and resurrection of Greek antiquity. Already in Germany Winckelmann had begun to privilege the copies of Greek statuary over the originals. His writings in Italy extend that tendency to the point that Winckelmann eventually proclaims that modern man is in a better position to understand and construct the ideal in Greek art specifically because of the inferiority of the artworks and of the natural world surrounding him (*Geschichte* 430). *Die Geschichte der Kunst des Alterthums*, which Winckelmann writes and rewrites in Italy, is curiously constructed around an empty center; the ideal has nothing to show for itself save the statues that he dates after what he called the high point of Greek culture and civilization (Potts, *Flesh and the Ideal* 47–66). The copies Winckelmann so fondly and passionately describes are superior to the originals because the "original" Greek statues are themselves evidence of a coming after an ideal moment.[13] In other words, for Winckelmann the attraction of works of art is how they discredit themselves or, at the very least, disclose their own epigonic status—a condition, no doubt, not dissimilar from Winckelmann's own as an art critic nostalgically seeking to overcome the humble conditions of his own existence. Moreover, the artworks Winckelmann privileges, such as the Niobe or Laokoon, point to an erasure of the very expression they portray. In this fashion the male nudes in particular arouse desire and introduce the erotic component into Winckelmann's ekphrasis. Since the ideal does not exist, the ideal character of the Laokoon, for example, is to be found in how it signals its own lack. In fact, only that which signals its own lack or that which seeks to erase itself can stand in for the ideal. The peculiar erotica that ensue from constructing a lack reveal themselves in Winckelmann's fascination with the castrati (Richter, *Laocoön's Body* 50–54) and his insistence on ignoring the snakes as the source of the pain in his description

INTRODUCTION

of the Laokoon (*Gedancken* 20). Winckelmann's discomfort about his own origins and sexuality eventually renders it impossible to draw an abiding distinction between his aesthetics and his personal circumstances. Winckelmann's death—a consequence both of his refusal to travel to Greece and view, in many instances, the original statues of which he had so passionately written, and of his decision to turn back apparently at the final instance from a return to Germany and a confrontation with his own less than ideal beginnings—is a cogent reenactment on Italian soil of the operative principles of the aesthetics he espouses in his writings. If, as a result, Italy is to serve as the site in which self-discrediting copies or stand-ins lend credence or substance to the emptiness at the center of his ideal, his death at the hands of a felon, whom Winckelmann might well have enticed into murdering him, is the deposit or burden of proof required of an aesthetics that, insofar as those aesthetics are also personal, is self-abnegating.[14] Reading one's biography as a narrative or the performance of a personal aesthetics can only serve heuristic purposes. I do not contend that the link is something that can be proved; rather, I make the connection because it helps to reveal a dimension of Winckelmann's aesthetics that has often remained ignored. Moreover, his death scandalized and haunted the artistic community in Rome at the time and is thus not irrelevant to his legacy.

These forms of expression, however, never fully succeed in erasing themselves. As Winckelmann describes it, the castrati always have their "Gewächs" or "growth" (*Geschichte* 37). For instance, the Laokoon that he viewed had an extended arm, where a folded or bent one would have been truer to the original or the one now so configured and on view in the Vatican (Sichtermann 194–96). What in Italy stands in for the ideal is thus inseparable from Winckelmann's disfiguring erotica. That is Winckelmann's legacy. It may set Italy up as a site in which Goethe rediscovers his poetic genius and in which others seek to do the same on Goethe's trails, but it also casts Italy, as Freud will come to speak of it, as the land of "Genitalien" (*SE* 4:36). The unwanted growth of the castrati, the homoeroticism underlying Winckelmann's aesthetics, and the unmistakable shape of the Italian peninsula establish Italy as a locus of cutting off, something that must be cut off if Goethe, among others, is to return to Germany with only the spirit and not the disease of antiquity.[15] What I mean by disease will become clearer as the argument develops. The desire that issues from Winckelmann's aesthetics is a preliminary indication of the nature or etiology of that disease.

INTRODUCTION

The investigation of Goethe's Italian journeys from the perspective of Winckelmann's haunting legacy and personal erotica is as new as it is indicated by Goethe's own text. Chapters 2 and 3 attempt to explicate how Goethe, who spends much of his time in Rome reading an Italian translation of Winckelmann's *Geschichte* to a circle composed mainly of Winckelmann disciples, discovers the spirit of antiquity without succumbing to the fate that the aesthetic ushered in by Winckelmann seems inevitably to pronounce upon him. Goethe's essay on Winckelmann, originally entitled "Winckelmann und sein Jahrhundert," already indicates Goethe's effort to place some distance between his own era and Winckelmann's (*HA* 12:97–121). That distance is most apparently measured in the time Goethe took to rewrite, censure, and edit his letters to his friends at Weimar and his journal for Frau von Stein, and transform these materials into his *Italienische Reise,* which, with the exception of the "Roman Carnival" that appeared in 1791, were first published in 1816 and completed in 1829. The published work is thus a construction intended, on the one hand, as a literary comeback and, on the other, as a literal comeback or an effect of the process by which he manages to be "creatively" reborn in Italy without dying (Kiefer 375). The task of chapters 2 and 3 is to uncover what Goethe leaves behind in Italy to stand in for the classical ideal, which, by not betraying its secondary status, can call to other Germans in search of that same ideal. It is not an overstatement that this task implies that Goethe's real education in Italy is learning to become a master illusionist.

The issue is not merely a theoretical or speculative one; it is a philological one as well. Where does one order chronologically the document that serves as testimony of Goethe's rebirth? One might argue that what remains of his letters as well as of his *Tagebuch* to Frau von Stein should provide the most compelling or immediate evidence of his transformation in Italy.[16] At the same time, the heavily edited versions of those same materials decades later is Goethe's proof positive of his comeback or rebirth. If Italy comes to serve as a preferred site for Germans to undertake speculative vacations, the empty center or vacated space that Italy fulfills for Winckelmann to execute his aesthetics helps shift elsewhere and beyond definitive documentation the telling event of Goethe's rebirth and the birth of Weimar classicism. Like many of the letters Goethe burned in completing the "Second Roman Visit" of the *Italienische Reise* for publication in 1829, the actual event has only a secondary document to confirm its occurrence. The curious circumstances

or circumstantial nature of the evidence is replayed philologically. Critical editions such as the *Münchner Ausgabe* that attempt to proceed chronologically, can only leave the impression that the event of rebirth occurs twice or is already doubled by 1816 and again by 1829.[17] What issues from the site of speculative vacations is compelling seconds or, to reuse the terminology appropriate to Winckelmann, self-discrediting copies, save that Goethe's copies never own up to their secondary status. In seeking to preserve the original text, the philologist only abets the process. Other critical editions, such as the *Frankfurter*, that proceed according to genre, fare no better.[18] The event is a formal consideration whose content, like Winckelmann's originals, is evidenced by the works that issue from it or in reference to its occurrence. And as we know, Goethe became most occupied in Italy with primal forms, which, although they could never truly be found, give rise to countless variations as incontrovertible evidence of their existence.

The first of these two chapters concerned specifically with Goethe's *Italienische Reise* begins by noting his disappointment upon learning what Winckelmann had already discovered: Rome was anything but a site for discovering ideal entities. The recognition comes in the form of an expressed distaste for church "fathers"—clerics, or those whom the church asks be addressed as "fathers" (*HA* 11:1 November 1786). Insofar as psychoanalysis opens up that possibility, fathers, or their terror, stand behind the threat of castration and so are not unrelated to Winckelmann's legacy. Moreover, by virtue of his own journey to Italy in 1740 and in light of the Italian education he prepared for Goethe virtually beginning with his birth, Goethe's father adds to the impression that Goethe's journey is in search of an absent father. The insufferableness of the numerous fathers that greet him upon his arrival in Rome and sully what he thought were the ideal realizations of his childhood dreams simultaneously stirs up memories of Winckelmann and accounts of four murders shaking the artistic community (*HA* 11:23 November 1786).[19] The rest of the *Italienische Reise* is read as a document that devises a strategy for preserving Winckelmann's ideal without repeating Winckelmann's violent end. In other words, it describes how one lives to talk about nothing as if it were something ideal and, in turn, enshrine oneself as the poet whose work, by definition, would be of inestimable value.

Even if such a strategy of self-enshrinement is devised and executed sometime or somewhere between his two visits to Rome (upon his sec-

INTRODUCTION

ond entry into the eternal city Goethe declares himself "baptized a Roman citizen" (*HA* 12:8 November 1787, Rome), elements are already in place long before Goethe departs for points farther south.[20] These include the notions, journals, and directives for and about Italy prepared by his father as well as the incognito Goethe is already preparing for himself as he steals away to Italy in the middle of the night. A second identity or self offers the possibility of leaving that self behind in Italy as a stand-in for the ideal. The ghost of the father or his absent present serves the interest of an incognito seeking a phantom self to offer Italy in exchange for making off with the spirit of antiquity. If assuming an incognito is understood as a form of self-censorship, as keeping preserved or out of reach one's "real" or "true" self, it likewise preserves the impression of an ideal to be rediscovered. As we will see, two Goethes are traveling in Italy, but on distinctly different clocks. Even if one is essentially an empty form or the ghost that results from self-censorship, the always already given presence of Goethe's father in Italy sustains the illusion.[21]

Chapter 3 takes up the problems that issue from Goethe's Italian strategy to dodge the fate that visited Winckelmann. Of particular interest is the consequence of offering insubstantial substitutes. As noted above, the stand-ins have a two-fold significance: 1) as surrogate forms of self-erasure intended to fulfill the conditions for resurrecting the spirit of the Greeks along lines prepared by Winckelmann, and 2) as sacrifices of oneself, which, of course, is a prerequisite for rebirth. The peculiar conjunction of these stand-ins or ghosts (e.g., of his father or Werther) that attend Goethe during his Italian journey and that result in part from the lack of coincidence engineered between himself and his incognito remarkably serves to hook a Goethe readership insofar as these "absent presents" call to future Germans to seek out Goethe in Italy.[22] They establish Goethe as a de facto author, an author after the fact. It also means that future generations will be in attendance not to Goethe but rather to his ghosts.[23]

If Winckelmann's quest for the Greek ideal marked Italy as a site to act out the law or terror of the father, Goethe's authorial urge expresses itself most visibly in an overturning of genealogy. This overturning renders the illusion that one is the original author of what was prepared for one. As I indicated above, it is emblematized by the "Urpflanze," which Goethe claims, upon his return to Naples, to have discovered in Sicily (*HA* 11:17 May 1787, Naples).[24] On the one hand,

INTRODUCTION

the absolute absence, which the primal plant ultimately stands in for, is the ideal whose absence Winckelmann constructed. On the other, it is the illusion of an ideal generated by this reversal of precedence to a point apparently beyond all sexual difference. To be on Goethe's trails is thus to pursue an origin that exists only as illusion. Moreover, the peculiar convergence of his father's memory, mediated or even summoned by Werther, haunts the space of the noncoincidence of his self-projections and lends the impression that the ideal is within reach—or, as he says of the primal plant, that he is virtually upon it. In other words, something is always about him, but when Goethe leaves, that apparent something—which, like the primal plant, is the marker of his creative discovery in Italy—calls full of promise to others who would journey to Italy. But lacking the peculiar convergence of specters that accompanied Goethe, their relationship to that ideal will always only be sentimental. His followers will have lost that ideal before discovering or having it.

The desire generated by that loss promotes a formalism whose model is assumed but never questioned despite its absence. Yet it also gives rise to a restorative impulse whose political result, in part, is censorship. In nonpolitical terms, Goethe explored the mechanics of censorship in producing an apparent or illusory foundation to legitimate its truth. This permitted him to find what he considered the eternal, "das bestehende," in the eternal city, compared to the transient, "das vorübergehende," of the historically determined Rome (*HA* 11:29 December 1786, Rome).

The extension of this argument to the political ramifications of Goethe's journey is prompted most immediately by Heine and is the subject of chapter 4. This chapter further explores how Italy as a site of cutting off (Winckelmann) or as a site to be cut off (Goethe) orchestrates an exchange that determines in part the cultural landscape of Italy and Germany. This exchange is less the one between Italy and Germany and more the one between the functions prepared for Italy by Winckelmann and Goethe. Although Goethe intended via the logic of his own Italian journey to cut Italy off, the return of the repressed or of that which was cut off upsets the course Goethe prepared. Rather than being surmounted or internally overcome, the political besmears the landscape of the eternal, which Goethe thought to pass on to future generations of writers.

Heine is the irrepressible figure that results from the crossing currents of Winckelmann and Goethe despite attempts to censor him. He

INTRODUCTION

is the outgrowth or "Gewächs" of Winckelmann's cut—or, to use Adorno's words, the "wound that never ceases hurting" (1:81–85). Not the castrated one or "das Verschnittene," he is rather the circumcised one, "das Beschnittene," whose non-sublatable difference is ineradicably inscribed onto his body. Yet Heine's is the voice that issues from the stones Goethe thought had been rendered mute. As Jost Hermand has noted, his Italian travel sketches reawaken and put into motion the voice of Italy's repressed social and political classes (132–80). The Italy Goethe would not see, much less talk and write about, is the subject of Heine's chronicles. August von Platen, the most direct target of Heine's invective, represents the empty formalism that is the self-willed legacy of Goethe's eternal Rome. Platen's homosexuality, which Heine is accused of "cruelly" invoking, is the scandal that in effect ostracizes Heine from the German literary scene (Sammons 141–49). By refusing to censor what offended good taste, Heine provokes the political apparatus of the Restoration to effect and reveal its repressive mechanisms. Even if it is not fully successful, the gesture forces into relief the restorative politics and repressive aesthetics that issue from the Italian trail Goethe plotted in order to captivate and cultivate a literary progeny. Platen's sexuality conveniently emblematizes that trail's foundation for Heine, not so much because of its homoerotic sensibility but rather because of the denial of sensuality that configures itself in Platen's brand of sexuality. Like his ghasels, it imitates antiquated forms for purposes of voiding or vacating any content; it denies any materiality or progeny (Holub, "Heine's Sexual Assault" 415–28).

Italy must also be understood as marking the site of Heine the "baptized Jew." He is the physical embodiment of what the cultural traditions emanating from Winckelmann's and Goethe's Italy cannot abide. Heine reintroduces the body, politic and personal, in hopes of toppling the overarching formalism of what he terms the "Kunstperiode" of Goethe and what perpetuates his second-class status as Jew (Holub, "Heine's Sexual Assault" 415–28). The initial bliss of his Italian sojourn is interrupted when the much anticipated news of a university appointment in Munich never arrives. No news or acknowledgment is how one would prefer to deal with those who introduce disruption into the "eternal order" of things. Heine's decision to move to Paris, upon the uprising of 1831 and shortly after the fallout from his polemic against Platen in *Die Bäder von Lucca* (The Baths of Lucca), suggests that the writer-in-exile is also part of the legacy of Goethe's Italian trav-

INTRODUCTION

els. If Goethe the author or father of Weimar classicism is constituted de facto or under the terms described above, it is significant that Heine never went to Rome. Evidence suggests that he had no plans to go beyond Florence, the city for which Goethe, by contrast, on his frenzied approach to Rome allotted only three hours (Werner 1:172–73, 176). From the outset, Heine's intention might have been to interrupt or cut short Goethe. Paradoxically, that might also serve as the disquieting ritual of the German or "baptized" Jew.

In chapter 5, a reading of Nietzsche and Freud in Italy follows the examination of Heine's Italian fate. While it is difficult to isolate any particular text as emblematic of Italy's importance for Nietzsche's thought—his stays in Italy were frequent and extended—*Ecce Homo* is the central concern of this project. As Nietzsche's attempt to read his life as a struggle between the pagan and the Christian, the "Dionysus versus the Crucified," among the works apparently written in Italy, *Ecce Homo* is a particularly compelling example of the figuration the land assumes in his thought. It is important to note that Nietzsche also returned to Weimar after departing Italy, but, of course, he returned as anything but rejuvenated. As much as Nietzsche sought virtually from *The Birth of Tragedy* onward to sever the alliance of Greece and Germany, to unmask what he calls in *The Will to Power* the joke of the Greeks foisted on Germany by Winckelmann and Goethe, he never overcomes the insufferable tension that befalls a German in Italy who is the outspoken admirer of both Goethe and Heine. The non-negotiability of their divergent paths is a provocative but nonetheless not particularly convincing means to explain the madness that haunts Nietzsche. What Nietzsche's untenable position "between" Goethe and Heine points toward is an irresoluble doubling in his work, an incessant wavering, as Jean-Luc Nancy describes it, between a philological and a philosophical project that culminates in Nietzsche rehearsing endlessly the very traditions he sought to overcome (Nancy, "Nietzsche's Thesis" 49–68). Nietzsche's reading of his own work in *Ecce Homo* is assessed against this refractory impulse. The riddle at the beginning of the text, in which Nietzsche asserts that he is already dead as his father but alive as his mother and becoming old, is that he always retains the position of one who is before himself. The metaphysical remainder he would like to cut off reattaches itself, a procedure that recalls Winckelmann. Or rather, it always reappears as the one in strict observance of himself. "Why I am so wise" or "Why I am so clever" is because that "I" always stands be-

INTRODUCTION

fore Nietzsche in perpetual reevaluation. The mother is the family member recalled to escort Nietzsche in his final days back to the fatherland. This transferral ensures that his sister, whom he detested more than his mother (Podach 69–93), would become the protector of his works. The fate of Nietzsche's work at the hand of the Nazis is thus not so easily divorced from his fate in Italy. The eternal return of that which was cut off but never fully silenced or erased (Heine) finds its way or is carried back to Germany delirious. That delirium is the "Nachträglichkeit" of Nietzsche in Italy for Germany. The final seal on this exchange between Italy and Germany was evidenced when Mussolini was presented with the complete works of Nietzsche during his imprisonment in La Maddelana in 1943.[25]

The failure of Goethe's Italian project to refuse the imposition of history onto the eternal is written in the curious twists and detours that characterize Freud's Italian journeys. One of the most telling reminiscences about Italy comes midway through his essay on the uncanny. Italy, albeit provincial Italy and not Rome, is "unheimlich" for Freud; the return of the repressed—or, as he also describes it, the fear of castration and cutting off—is relived in Italy (*SE* 17:244). Like the baptized Jew, Freud's own person rehearses what the spirit sought to expunge.

The first question to pose is what in relation to Italy did Freud have to repress. In the *Interpretation of Dreams* he describes what Carl Schorske considers his "Hannibal" complex (Schorske 181–207). Five times between 1895 and 1898 Freud ventures to Italy and, like Heine, never arrives in Rome. In his waking life, Freud attributes his aversion to reaching the eternal city to an insult his father received in Vienna at the hands of a Christian nobleman of the Austrian Empire. In response to the father who is cut off from respectable society because he is a Jew, Freud takes Hannibal's pledge to be the son who carries out his father's vengeance on Rome, or the seat of Catholicism. In his dreams, however, Freud views Rome with romantic longing, as if its enforced displacement from him is evidence of the excluded one's desire for "equal access." Freud finally makes it to Rome, but only after his father has died and Freud has been admitted to the medical faculty in Vienna. The meaning of his dreams has been accepted. The political obstacles have been sublimated or surmounted psychoanalytically—something Freud suggests occurs in more advanced civilizations, of which fin-de-siècle Vienna evidently was one in relation to Hannibal and his time.

INTRODUCTION

The apparent success of this strategy is evidenced by his reading of W. Jensen's "Gradiva" in 1907 (*SE* 9:9–47). Freud's conscious reading of Gradiva's peculiar foot or gait, the most pronounced element in the story, is strictly from consideration of how that same peculiarity can only be associated with some form of degeneracy repressed in the author's unconscious (Gilman, *Case of Sigmund Freud* 145–50). In fact, Freud reads the story as the author's working out of his own incestuous desires for his sister, but since Jensen never had a sister, the reading is more indicative of Freud's unconscious than Jensen's. Moreover, Freud frequently refers to Gradiva's gait as unusual and even peculiar, when, as more than one critic has observed, it is entirely healthy. More importantly, Freud's gaze is fixed on her gait, not on the seductive manner in which she lifts her dress to reveal her perfect foot. As Sander Gilman has pointed out, flat-footedness was an accepted sign of a Jew's physical deformity and unfitness for military and thus political participation (Gilman, *Case of Sigmund Freud* 151). Freud's (mis)reading, one that rehabilitates along psychoanalytic terms the deformed foot and its underlying degeneracy, is thus a means to overcome that ostracism. For Jews, participation is a psychoanalytic faculty. It accommodates political ambition by restaging the gesture that cuts Jews off from the political.

Freud goes too far. He is the one who actually travels to Greece. The boundaries are eventually redrawn, and that which seems to be on the other side of consciousness begins to invade it anew. In his essay on the uncanny, Freud notes that, contrary to his initial observations, the boundaries between what was pyschoanalytically repressed and what was surmounted historically are in fact not so distinct. Not surprisingly, the site where this confusion most remarkably repeats itself is Rome. In the opening pages of *Civilization and Its Discontents* Freud attempts to configure the eternal city as the topos of the unconscious. Upon second thought, the irrepressibility of Rome's historic transformations renders the comparison untenable for Freud; however, this does not prevent him from undertaking further attempts to make Rome fit. Finally he confesses that the effort is idle and that the attempt demonstrates how "far psychoanalysis still has to travel" (*SE* 21:64–71). Its limit becomes apparent because of the inability to transform the city that was previously the locus of his political animus into a repressed site of the unconscious. It seems that Freud could only describe the event as uncanny. Writing in 1929, he was likely reexperiencing what Italy had rehearsed in various modalities for earlier generations of Germans and Austrians: a cutting

INTRODUCTION

off. Specifically for Freud, it was the repeated excision of the Jew from the body politic.

Since the spell of Goethe's Italy must be understood in terms of its effect on those who followed, chapter 6 takes up the question of the demonic character his journeys assume in crucial twentieth-century narratives. Of particular concern is the sort of payment that comes due as a result of the attempts by Goethe and his followers to render present an ideal that was by definition absent. At what cost do Germans preserve the illusion of Goethe's Italy? At what point and in what fashion do the secret or repressed material remains of these Italian journeys resurface? The chapter contrasts the Italy Goethe canonized with the politically oppressed one witnessed by several of his contemporaries. The issue is raised to what extent following and attending to Goethe in Italy promotes the questionable politics and even complicity of the so-called inner emigrants of the 1930s and 40s. In this respect, Goethe's Italy sponsors and harbors secrets of a questionable sort. The ideal Italy that Goethe substituted for the real one is never complete; the need to preserve the illusion never ends. More importantly, by its very attempts at preservation, it generates a history that in its most radical literary formulations is not unrelated to the political alliance between Mussolini's Italy and Hitler's Germany. The most startling shift in the German disposition to Italy occurs, however, not a century and a half following Goethe's celebrated sojourn and two soured alliances with Italy, but in Goethe's own work in the *Venetian Epigrams*.[26] In attempting to make off several years earlier with the classical spirit of Italy, Goethe left behind "material" remains that upon revisiting Italy assume a character unfit for the classical aesthetics he is in the process of installing in Weimar. The epigrams, as well as many of Goethe's letters, indicate Goethe wanted no part of those remains. If Italy serves as a repository for the repressed or censored remnants of German classicism, Goethe makes clear in these epigrams that he wanted to cut himself off from the real Italy. As demonstrated in earlier chapters, the *Italienische Reise* that Goethe reconstructs for publication in 1816 and again in 1829 is an attempt to cast those remains in a fashion that sends others searching for something else, for something ideal among those "ancient" ruins. But at the same time it cleverly or magically transforms those ruins into the incontrovertible evidence or remains of that something else.[27] The ultimate claim of chapter 6 is that the birth of Weimar classicism, insofar as it is tied to the imagining and positing of an Italy that was never there,

is something of a legerdemain, the substitution of one Italy for another. Furthermore, this "other" Italy, which is every much a product of the German literary imagination as the ideal one whose disfigured remains can never really be made to disappear by the prestidigitator, is destined to resurface. And it is the persistence of this "other" Italy which no doubt accounts for the demonic character Italy assumes in some works of the twentieth century, most notably those of Thomas Mann. As this vocabulary suggests, the chapter concludes with a reading of Mann's "Mario and the Magician" and the manner in which it proleptically sketches the shattering of the sleight-of-hand's illusion. Although written in 1929, the text illuminates what I will come to call the terms of a pact with the devil, the costly terms by which Germany's classical illusion was maintained.

In the epilogue I continue my discussion of the peculiar fate the Austrian poet Ingeborg Bachmann met in Rome. In chapter six, I describe how a literary tradition developed that linked the conceits of Italian journeys (e.g., creative rejuvenation and rebirth) with the darkest aspects of Germany's cultural tradition. It is the contention of this book that German-speaking Italian journeyers were obligated to Goethe. His was the fatherly impulse that inspired the journeys, and his debts were the ones these journeyers were lured to repay. Through a more complete reading of "Das erstgeborene Land" I demonstrate how Bachmann, as a woman, could give birth to a poetry that dispensed with deference to Goethe or adherence to the laws installed by his journey. But even if she can be said to have mothered the land that fathered the tradition of Italian journeys, her fate in Rome, her apparent auto-da-fé only serves to enshrine the haunting immortality of Goethe in Italy.

1

Opened Wounds

Winckelmann and the Discovery of the Art of the Ancients

If an element of swindle or forgery is a concern of later generations of German writers working their way south, it might be that a bit of hoodwinking is constitutive of the Germans' journeys to Italy from the outset. No doubt the primary, if not the initial, inspiration for undertaking such a journey was Johann Joachim Winckelmann, although he was not the first to valorize Rome as the "only place in the world for the artist"—to cite Goethe citing Winckelmann (*HA* 12:99). Already in Winckelmann's time there was an established community of expatriate writers and artists living in Rome. Among them were Mengs and Fuesil, Johann Tobias Sergel, the Dane Nicolai Abilgaard, and the Englishman William Blake. But Winckelmann was surely an influence of singular proportion. Goethe calls him the "reincarnation of ancient man—insofar as that may be said of anyone in our time" (*HA* 12:101). And in 1768, as a student of Oeser in Leipzig, Goethe gladly joined his mates in shunning Lessing for his attack on Winckelmann in *Laocoon* (Boyle, *Goethe* 69). As late as 1934 E. M. Butler summarized the affect of Winckelmann on German culture:

> That obscure German *abbé*, prowling around the streets of Rome, can hardly have foreseen the commotion he was to cause, let alone the works he was to inspire. Their fame is legion . . . : *Laocoon, Iphigenie, Helena, The Gods of Greece,*

CHAPTER 1

> Hölderlin's poems, *Empedocles, The Gods in Exile,* "The Gold of Troy," *The Birth of Tragedy, Olympian Springtime, The Seventh Ring;* directly or indirectly, we owe all these to Winckelmann, and we cannot imagine German literature or life without them. (Butler 333–34)

That Winckelmann's importance for Germany was for the ages was exuberantly expressed by Carl Justi in 1898:

> The figure of Winckelmann appears to Germans in the glow of the first morning light after prolonged darkness and an uncertain dawn. . . . His works and reception are one of the surest signs that finally Germany would be granted a leading role in the intellectual movement of the West.
>
> The inseparability of the plastic arts from the formation of our nationhood, the elevation of German literature to a world literature—these and many other things are evoked when Winckelmann's name is mentioned. (Justi 1:54–55)[1]

Winckelmann, of course, was an art critic or historian, not an artist. From the beginning he inspired an appreciation of works removed from view. What one is admiring is thus the effect of the works or, more accurately, the particular effect they arouse in one, who, insofar as anyone can be a reincarnation of ancient man, is a Greek. In other words, even before one considers the questionable status of the works that Winckelmann viewed and privileged, his influence is already an "affect" of the representation of something that the classicist Goethe acknowledges was possible only provisionally.

No doubt, aspects of such filtering are convenient. They establish a precedent for Winckelmann's reception. The shady circumstances surrounding his death, or the death of Winckelmann posing as Signor Giovanni, at the hands of a thirty-one-year-old unemployed Tuscan cook force Goethe into a defensive mode as he attempts to explain Winckelmann's "aesthetic love" of the male nude: "If the need for friendship and for beauty are satisfied by the same object, then man's happiness and gratitude seem to know no limit. He will gladly give all he owns as a token of his devotion and admiration. . . . Thus, we often find Winckelmann in the company of young men. He never seems more alive and

likable than in these moments, which are often so fleeting" (*HA* 12: 103–4).²

Goethe's apparent tolerance of Wincklemann's deviance qualifies him, at least partially, for experiencing the pleasures Winckelmann links with classical beauty. In fact, the only limit Winckelmann acknowledges to man's happiness is the limit one imposes on oneself in acknowledging the beauty of the male nude. In the "Essay on the Capacity for the Beautiful in Art" (1763) he remarks:

> Moreover, since human beauty, in order to be known, must be grasped in a universal concept, I have noticed that those who attend only to beauty in the female sex and are touched little or not at all by beauty in our own sex possess a sentiment for the beautiful but one that is not innate, universal, and alive. These same qualities will be lacking in these people with regard to the art of the Greeks, since the greatest beauty of their art is to be found more in our own sex than in the other. (*Kleine Schriften* 216)³

If the pretense of the statement is too extreme or the conditions of appreciation of Greek art endanger in some fashion the subjectivity of Goethe, the sexual "late-comer," Goethe can easily explain the uncomfortable position in which Winckelmann places him by pointing to this "Greek's" forced conversion to Catholicism. "For every one who changes religion remains in some fashion tainted (mit einer Art von Makel bespritzt) from which it seems impossible to be cleansed. It cannot be denied that Winckelmann's conversion heightened the romantic aspects of his life and character in our imagination" (*HA* 12:105). Goethe's explanation of Winckelmann's homoeroticsm is telling. Beyond playing into the antipapal sentiments of his audience, Goethe underscores a curious fraternity of men Catholicism fosters. If such fraternity among men arouses suspicion, its rites of community are nonetheless spiritual, not physical; yet they serve as a means to enliven our imagination. Goethe's acknowledgment of Winckelmann's penchant for the company of young men simultaneously arouses and displaces potential disapproval of Winckelmann the Greek. Winckelmann dances around a series of identifying characteristics. He changes his name, he changes his religion, and more than once he argues for a re-

CHAPTER 1

vival of allegorical representations in painting and self-presentation.[4] These dances make it difficult to identify him precisely, and they sully the reputation of a subject always changing positions (even Goethe cannot situate him historically). They also cleanse the space of his vacated subjectivity: a brotherhood of faith replaces a brotherhood of flesh.[5] The taint is faded, if not expunged. The Winckelmann effect, it could be said, forces displacement of the actual object of admiration, allowing the enthusiasm his ekphrasis arouses to settle and shape itself in a manner more cleansed or appropriate to social norms.

This chapter will evaluate not only how Winckelmann effects a voiding of the present but also how that voiding comes to constitute a law whose reenactments will leave its mark on the journeys of those who follow Winckelmann and Goethe to Italy. Winckelmann's mode of ekphrasis removes the actual object from sight; his enthusiastic descriptions are essential for a legitimate appreciation of the object.[6] He predisposes his audience to fashion an ideal in the space opened up by his displacements of the object and of himself. Whatever aspects of that ideal proved unflattering are left behind in Italy. What is to be transported home is not the object of adulation but—and perhaps the same could be said of Goethe's "Urpflanze"—the "living ray" stripped of all sexual markings or traces of the other and the repugnant.[7] Yet while Italy is being emptied, it is also being filled and marked by the gestures necessary to empty it. Albeit in different terms, Nicholas Boyle describes the manner in which Winckelmann's work facilitates an effacement of the object, leaving behind only the desire for the ideal, whose historical (and geographical) displacement will ensure that the ideal can always be cleansed of anything unseemly or not ideal:

> [Winckelmann's] removal to Rome in 1756, his conversion to a Catholicism of pure convenience, his notorious homosexuality, his devotion to . . . the sculpture of a distant age which he painted in seductive idealization, . . . everything in the life of the older Winckelmann was the clearest possible "No" to the land and circumstances of his upbringing, to the asphyxiating compromises of Felsenburg, Germany. One loyalty he retained, however, . . . his loyalty to the German language. In the prose poetry of his ekphrasis . . . Winckelmann made . . . perhaps the most influential contribution of all to the new aesthetic theory: the language of Pietist self-scrutiny

and religious transport . . . [that] he put in the service of a sensualist program, of a worship of heathen culture from which he was separated not by the metaphysical abyss that separated the Pietist from the godhead but by the misfortunes of history. (*Goethe* 1:28)

Of course it is particularly these misfortunes upon which followers of Winckelmann capitalize. The Pietist language of "religious transport" inspires Germans with the "living ray" of Winckelmann's experience of the ancients. But like the Pietists' effacement of the letter of the word in service of its spirit, only the transportable reaches Germany.[8] What Winckelmann inspires and bequeaths is twofold: a spirit of enthusiasm for Greek art as viewed in Dresden and in Rome, and a strategy for displacing oneself from oneself or from the object of idealization. What Winckelmann leaves behind or what he vacates through his language and shifts in his own subjectivity is a free space that enables other Germans heading south to construct the repressed dreams of their native culture. His homoeroticsm is only one aspect of that dream.

Finding an Opening

Georg Lukács's account of Goethe's need to flee to Italy to escape suffocating under the burden of administrative responsibilities points to the importance of Winckelmann's journey and its preparation of an empty space: "Again, we must stress the merit of Mehring who recognized that Goethe did not flee Italy out of disappointment in love, as a result of the crisis of his love for Charlotte von Stein, but because his attempt to reform the principality of Weimar socially . . . foundered in the face of the resistance of the court, the bureaucracy and Karl August" (*Goethe* 15).

Although one should not dismiss the impact of Charlotte von Stein on the construction of Goethe's wanderlust, his enduring fondness for Winckelmann cannot be separated any more easily from the latter's success in constructing a vacated space, a space for vacationing, in which any form of resistance to desire is removed.[9] Winckelmann himself expresses this in a letter to his friend Berendis: "[A]nd since freedom in other states and republics is only a shadow of that in Rome—something that might seem like a paradox to you—so there is also found here a different way to think. People of the latter sort mix freely with strangers who traverse Rome in secret" (29 January 1757).[10] That freedom is a result of an open or vacated space, attributable at least in part to Winckel-

mann's impermanent subjectivity. But it also has something to do with the place or the space of Italy. As Walter Benjamin notes in his essay "Naples," the place is porous, admitting of all possibility and freely changing character and disposition ("Reflections" 163–76). Winckelmann's description of freedom elsewhere as "only a shadow of that in Rome" can be understood to connote how that "elsewhere" is haunted by the empty presence of the eternal city. In this respect Winckelmann's word shall be read as a foreboding, since Italy's ghostlike presence is not yet embedded in the German imagination. Winckelmann himself has not yet prepared the terrain.

This also suggests how the space demarcated and voided by Winckelmann is not merely a result of a displacement of his own subjectivity. The paradox he refers to is that he is always seeking out the "elsewhere" in Rome; the ideal is present precisely where it is absent. His pseudonyms, his religious conversion, and his sexuality may be reenactments and telling evidence of the effects Italy or his aesthetics produced, but in shaping the German fascination with Italy Winckelmann creates an aesthetic ideal that is nonexistent. The works Winckelmann viewed as he proclaimed the classical ideal of "noble simplicity and quiet grandeur" cannot be ascertained (*Gedancken* 20). Winckelmann announced an unwillingness to examine anything but copies of the great works of the ancients. Alex Potts is not the first to point out that the more celebrated works in Winckelmann's studies, such as the Venus de Medici or the Apollo Belvedere, are Greco-Roman adaptations or copies (*Flesh* 18).[11] This is not an oversight on Winckelmann's part. Just as desire and a different way of thinking were to be pursued secretly among strangers lurking in the shadows of Rome, the desire for the beautiful in art would be fired by copies that offered only a dim outline of what desire sought. The freedom to pursue a new way of thinking was to pursue shadows and shadowy figures: "[We have] like the maiden only the shadowy outlines of our desires . . . , but we observe the copies of the originals more attentively than we would were we in full possession of the originals" (*Geschichte* 430).[12]

Substitutions, and recognition of how these substitutions are just that, are the preferred objects and aim of the art historian's study. Not only do these copies keep desire focused on what is missing and, paradoxically, authentic; they enable as well a depreciation of the present. The greater attention one brings to bear upon these substitutions permits a recognition of what they are not.[13] They allow for dismissing what

is before one or what is in one's presence in service of something that Winckelmann, at least, seems intent upon keeping impossibly removed or remote.[14] As E. M. Butler notes, Winckelmann was horrified at the possibility of traveling to Greece and coming face to face with the originals (*Tyranny* 37). While others could and some actually do go to Greece (Goethe is not among them), Winckelmann stubbornly constructs his classical ideals along lines that keep Greece far away and unknown. As already noted, no one can truly ascertain just what it is that Winckelmann is looking at. Dismissing the present or the object present for study as a copy helps him inauthenticate and simultaneously idealize the construction of his own desires. Authentic is only that which shows itself to be inauthentic, for the ideal is just as surely beyond reach as Greece is to Italy, presence is to subjectivity, or, most literally, the addressee is to Winckelmann's letter writing or the person who is always absent and socially out of reach:

> The most intensely dramatized relationships played out in his letters were with younger men who, in contrast to Winckelmann, came from upper-class or upper middle-class backgrounds.... Consciousness of class barriers played a significant role in Winckelmann's alterations between an apparently confident self projection as a "freely" desiring subject, and a retreat into masochistic self-denial, when the almost inevitable rebuff or coolness gave life to these fantasies. (Potts, *Flesh* 185–86)

Winckelmann's life and aesthetics can thus be understood as inextricably connected, something Goethe's essay underscores. To jump ahead of the argument, this may explain Winckelmann's attraction to his killer, a convicted felon. The shadowy figure preserves the possibility of something beyond its contour or apparent barrier. It preserves the *pursuit* of freedom through rebuffs.

In fact, the connection between life and art history is played out in one of the more curious episodes surrounding the assessment of Greek art in the *Geschichte*. The work contains enthusiastic descriptions of certain antique paintings, which, as it turned out, were clever forgeries. Among them, and the only work still in existence, is a depiction of an enthroned Jupiter tenderly embracing a nude Ganymede. The painting imitates the style of works that had been recently uncovered at Hercu-

CHAPTER 1

laneum and Pompeii. Winckelmann's unbounded enthusiasm for the painting is itself a bit awkward, given his expressed disappointment in Herculaneum paintings as "pale expressions" (*Geschichte* 281) of Greek painting in its prime: "it is the most beautiful painting which has yet appeared to the light of day, and surpass[es] anything to be seen at Portici [i.e., Herculaneum]" (*Briefe* 15 December 1760). The visual evidence should have tipped Winckelmann off. The "cosmetically rendered skin passages, the glucosic hues of raspberry and vanilla, or indeed the pastel-like prettiness of color and texture in general" all have "the distinctive flavor of the mid-eighteenth century" (Pelzel 306). Nonetheless, Winckelmann offered a pompous and laudatory explanation of the paintings in the first edition of the *Geschichte*.[15] Although soon after the publication of the first edition of the *Geschichte* he became aware that the paintings were forgeries and offered a public confession, he never recognized the Jupiter and Ganymede as anything but authentic.[16] Of the other paintings in the collection, Winckelmann had only seen drawings by Giovanni Casanova, and the difficulties he encountered in seeing the Jupiter and Ganymede may have served to arouse his curiosity (Pelzel 303–4). No doubt, the elaborate story of how the paintings were discovered, stealthily broken from a wall, restored, and sent off to England contributed to the appearance of their authenticity (Pelzel 304).

Since Winckelmann's reliance on copies always prompted an imagining of the ideal, it is not surprising that he found the drawings convincing.[17] The actual image was always removed from view. But his insistence on the legitimacy of the Jupiter and Ganymede is related as well to an erotic attachment to the nude Ganymede. In fact, he has little to say about the stylistic qualities of the work or its significance for the aesthetics of the ancients. In his letters as well as in the *Geschichte* his attention is focused entirely on the grace of Ganymede: "Jupiter's beloved is without doubt one of the most beautiful figures that remain from antiquity, and I find nothing to compare with his face; so much sensuality blossoms forth that his whole life appears to be nothing but a kiss" (262).[18] What was remarked above about his letter writing can also be said, at least in this instance, about his art history pronouncements: If desire is fostered or fired by rebuffs from the addressee, then desire is also sponsored by the painting that is only apparently what it is. A desire that is aroused and also frustrated serves to authenticate the painting. That desire is aroused, of course, by a forgery, which is to say that forged desire is a condition of authenticity. What is there, a forgery, gives

rise to a desire for what is not there, the authentic painting, which actually never existed. Authentic is that which rehearses the impossibility of desire.

Winckelmann's two major works, *Gedancken über die Nachahmung der griechischen Wercke in der Mahlerei und Bildhauer Kunst* (Reflections on the Imitation of the Greek Works in Painting and Sculpture) and *Die Geschichte der Kunst des Alterthums* (The History of the Art of Antiquity), repeatedly emphasize the roles of the copy and even the forgery. The *Gedancken*, published privately in 1755, is quite frank about the author's intention to praise the source and look elsewhere for evidence of the source's greatness: "The purest sources of art have been opened. . . . To search for these sources means going to Athens; and Dresden will from now on be an Athens for artists" (8).[19] Revealing the source renders it unnecessary to travel to the source; someplace else—in this case Dresden—can become what it is not and serve the same purpose. The work dismisses any need to view the original; the copies on display in Dresden suffice. That these works could only be viewed in dim light renders them shadowy and thus all the more desirable. This anticipates as well Winckelmann's assertion in the *Geschichte* that any concept of ideal beauty depends upon an idea of beauty that is extracted and compiled virtually piecemeal from one's inferior material world: "Since this [the highest beauty] is synonymous with perfection, of which humanity is not a fit vessel, our concept of universal beauty is still indefinite, and it is formed within us by single acquisitions of knowledge, which, when they are collected and joined, give us, if correct, the highest ideal of human beauty, which we exalt to the extent that we elevate ourselves above matter" (149).[20]

Obedience to what Goethe called, in "Über Laocöon," the physical laws of art—order, clarity, symmetry, positioning, and so forth (*HA* 12:58–59)—calls forth an idea of beauty's perfect harmony, of which humanity or modern man, as Winckelmann insisted, is incapable of being a vessel. Beauty is meted out to each creature appropriate to that creature's nature. The Greeks overcame this inherent limitation by bringing together the best from several sources: "The imitation of the beautiful in nature either directs itself toward a single object or it gathers observations of various individual objects and brings them together. The first method means making a similar copy, a portrait. . . . The second, however, is the way to universal beauty and to ideal images of it, and this was the way chosen by the Greeks" (*Gedancken* 17).[21] Writing

about knockoffs in Dresden is legitimated since it demands that the author undertake a process akin to the Greek one of selecting and discarding. In other words, successful imitation of the Greeks is premised on a methodological understanding of imitation. Winckelmann can become a Greek in Dresden or at least initiate himself into their ideal realm of beauty by forcing his eye to rise above the material world around him. Since his observations are often based on copies, there is little else he can do. And if, as Potts has argued, he sees his own era "locked in terminal decline," as "the endpoint of a long process of decline that had set in after the golden age of the Renaissance" (*Flesh* 25), what has to be counteracted is the spirit of the times, something that could best be accomplished by imitating the procedures and methods of another era.[22]

Greek antiquity is thus another term for the nonexistent original that sponsors so many forgeries. And one's relationship as a spectator or onlooker of copies or forgeries of "original" works of Greek art merely redescribes one's position in a world of terminal decline. Privileging the copy over the original precisely because it is a copy allows one to rise above or construct a horizon beyond the present. This surely accounts for Winckelmann's exhaustive account in the *Gedancken* of the procedures Michelangelo employed in preparing models for his actual works. The intrusion of procedural details into what is essentially a theoretical argument can only be explained as evidence of Winckelmann's insistence on a literal understanding of imitation, or rather as evidence of his insistence upon reading the genitive of the title as a declaration that imitation (Nachahmung) is constitutive of the original. Winckelmann admits that the actual procedures Michelangelo employed are unknown, save for the sparse notes left by Vasari. The method is thus a fiction, a means to lend the apparent copy the status of the original (*Gedancken* 29–31).[23]

This leads to the puzzling question of the archetype or "Urbild." For the Greeks nature seems to have provided privileged access to something worth copying. The exemplary status of their art is not so much the result of the original genius of their natures but rather of a nature that gave them something worthy of emulation. "The Greeks could arrive at these images [gathered from sundry observations], if not from more beautiful bodies, then from a daily opportunity to observe beauty in nature" (*Gedancken* 18). Implied, it seems, is the ability to discard the inessential by reference to an available archetype, which they could glean from the beauty fostered under what Winckelmann calls a "Greek sky."[24]

Moderns who do not live under such a sky must draw upon what Walter Benjamin described as Winckelmann's "will to symbolic totality" (*Tragic Drama* 186). According to Benjamin, Winckelmann subscribes in his *Versuch einer Allegorie* to a form that opposes the baroque tendency of "panthe or of bringing together as many concepts as possible to account for all the attributes of the god" (*Tragic Drama* 186). For Winckelmann, simplicity consists in a design that expresses the intended meaning in as few signs as possible or, as will be shown below, in an ability to discard defining characteristics. Were it available, the archetype would help streamline the design. Proper imitators of the imitation of Greek art (or of the imitation of the beautiful in Greek art) evidently have something in mind in their will for symbolic totality that allows for an extraction of the essential and a discarding of the extraneous.[25] The absence of the original, be it of the artwork or of the Greek sky that fostered such originals, renders such extraction and a proper imitation of the Greeks virtually impossible; it also explains Winckelmann's apparent awareness of the failure of the plastic arts to sustain an image of totality.[26] As Benjamin remarks, evident in Winckelmann's description of the Belvedere Torso of Hercules (1759) "is the unclassical way he goes over it, part by part and limb by limb." "And it is no accident," Benjamin continues, "that the subject is a torso . . . [I]ts beauty as a symbol evaporates when the light of divine learning falls upon it. The false appearance of totality is extinguished" (*Tragic Drama* 176). Winckelmann dismantles physical presence in order to prepare a vacated space that serves as testimony of the sublime power of the archetype. But the space does not remain vacated for long. Winckelmann projects a head and its thoughts onto the torso:

> If it seems incomprehensible to locate a thinking power in some part of the body besides the head, . . . the back, which appears bent by lofty considerations, forms for me a head occupied with a cheerful memory of its astonishing deeds; and by raising such a head full of majesty and wisdom before my eyes, the remaining missing limbs begin to form in my thoughts, flowing forth and together from what is present and effecting, as it were, a sudden restoration. (Bowman xvi)[27]

The ideal quality of the torso is that it is not what it was; through piece-

meal description or a going over of its parts it has paradoxically been completed. This is the "overthinking" or "Überdenkung" that Winckelmann attributes to his own act of reconstruction (*Werke* 1:273), and it is more a product of Winckelmann's narrative than it is of the torso. The archetype is thus a forged original and the great deed that occupies Winckelmann's own text as well. This movement, whereby dismemberment of the torso produces the torso's false totality or completion, is no doubt the "alternating motion" and "quick force" that Winckelmann attributes to the artwork (*Werke* 1:272). It is likewise its flowing out (Ausfliessung) from one form into another; that is to say, the thought that completes the torso destroys it (*Werke* 1:272): "As in a rising motion of the sea, the prevailing still surface wells into a lovely tumult . . . , where one [wave] is swallowed by the other and is again rolled out from the very same wave, here, just as softly swollen and drawn in suspension, one muscle flows into the other" (Bowman xv).[28]

The tension that arises is not so much in the descriptive power of Winckelmann's writing that forces one's readerly gaze to reconstruct an original image from the hints provided by the copy. Rather it is in the subtle dismemberment of the object as torso so that only a forged original or that which is the product of discourse remains, which explains why Winckelmann's writing in the example just cited performs what it describes. For Winckelmann, the most stirring characteristic of Greek art, or the wholeness of Greek art, is absence (Potts, *Flesh* 47). The only thing complete about Winckelmann's ideal is its withdrawal from the present, since the present is locked in a mode of terminal decline. "And a third motion . . . loses itself in the latter, and our glance, as it were, is likewise swallowed" (Bowman xv).[29] By virtue of the writing that now swallows the glance, the art historian uses words to attest to what his eyes saw.

For Openers

The aporia that structures Winckelmann's notion of Greek aesthetics is already apparent in the opening sentence of the *Gedancken*. "Good taste, which is becoming more and more prevalent throughout the world, began to do so first under a Greek sky" (3). On the face of it, the sentence seems merely to state the obvious: the sky, in its breadth or eternity, has extended across Europe to impart to some good taste. The Enlightenment, with its emphasis on good taste, is infused, insofar as its taste is good, with the spirit of the Greeks. Elsewhere, Winckelmann at-

tributes the accomplishment of the Greeks to a singular convergence of sky and climate, which in its singularity would hardly be transferable:

> It is easy to imagine what advantages the Greeks, subject to this sky and air, must have reaped from the felicitous situation of their country. The most temperate season reigned throughout the year, and the refreshing sea breezes fanned the voluptuous islands of the Ionic Sea and the shores of the continent. . . . Under a sky so temperate and a climate so balanced between hot and cold, the inhabitants could not have failed to have been influenced by both. (*Kleine Schriften* 100)[30]

So much does Winckelmann want to emphasize the geographical and historical components of the Greek spirit that he is led to conclude, for example, that Thebes lay under a thick (dick) sky, and as a result, its inhabitants were fat and strong (*Kleine Schriften* 103). However uneasily such observations reside next to Winckelmann's sensitive descriptions of Greek art, they underline the basic unresolvable problem of his aesthetic: "The incompatibility," as Peter Szondi emphasizes, "of his insight into the historical-geographical singularity and contingency of Greek culture with his demand for modern art to imitate that of the ancients" (*Geschichte* 1:28). The problem is particularly apparent in the opening pages of the fourth chapter of the *Geschichte* in which the influence of the skies is cited along with that of the government as the reason Greek art is superior to contemporary art: "The influence of the sky must vivify the seed from which art is to be produced. And for this seed Greece was the chosen soil. The talent for philosophy that Epicurus wanted to claim exclusively for the Greeks might be claimed more correctly for the arts" (128).[31] What Winckelmann considers imitable cannot be the specific confluence of factors that foster Greek art. He himself never stands under a Greek sky or upon Greek soil, but since Greek art is unthinkable without its historic or geographical specificity, it can only be, paradoxically, its absence that renders it imitable.

Not to be overlooked is Winckelmann's insistence that the fatherland of an artist can be detected without erudition from each figure drawn or sculpted by the artist. His mode of reading is by necessity backward. By reference to the absent whole of the Greeks, Winckelmann can assign the specific variations of later periods to a specific sky: "In painting his Venus, one would give it a French character, which, in

fact, a noted painter has already done; another would give her a hooked nose; . . . yet another would portray her with spindly fingers. . . . Indeed, from each figure even one lacking erudition could guess the fatherland of the author" (*Kleine Schriften* 112–13).[32] Likewise, it is with an equal eye toward what is missing that prompts the contemporary artist to assemble the fragments before him and construct, if not the wholeness of the Greeks, a more sensuous (sinnlicher) rendering of the fragmentation of his own era (*Kleine Schriften* 38).[33] This reading allows Winckelmann to erase what is written. He may bemoan the fragmentation of his own era, but that fragmentation issues in no small measure from his own methodology, which renders it impossible for the present to achieve wholeness once it is measured against the total absence of his ideal. This reading backward or assigning a work to a cultural or historic moment necessarily refers that work to what it does not possess and certainly to what is not present or available. The point of reference that permits such reading remains the absence of the wholeness of the Greeks or, in the instance of Greek art, the unavailable original. It is no wonder that Winckelmann describes Dutch painting as caricature; it can only appear as an overstatement, since what is ultimately desired is the wholeness of absence.[34] Anything else is simply too much.

What Winckelmann must thus come to argue for in the *Gedancken,* as far as painting is concerned, is allegory.[35] On the one hand, an allegorical turn away from representation of the present allows for the presentation of "invisible, past and future things" (43). The future is as invisible as the past. On the other, the only way to depict absence is otherwise, as allegory. In keeping with that thought, Winckelmann continues with the following observation: "[The painter] should leave our mind with more than he has shown our eyes, and he will attain this goal if he has learned to use allegory not to conceal his ideas but to clothe them (nicht zu verstecken, sondern einzukleiden)" (43–44). It is not a question of hiding thoughts or misplacing a signified. The thought or the signified has no place to occupy; it cannot be stuck anywhere. And since it is nowhere to be found, seeing, or what one presents to the eye, is only marginally required. What this "outfitting" of thought allows is the possibility of an uncovering. The seeing that follows is a form of presentation that discounts or invites a discounting of appearance. Clothing the invisible may tempt one to disrobe it and so direct one's gaze beyond what is presented to the eye, as many of the copies of Greek statues did for Winckelmann, but clothing just as read-

ily makes apparent that the absent ideal is uncovered or discovered through disguise. The ideal is thus only present insofar as it participates in its own cover-up. Moreover, this peculiar mechanics of cover-up resonates with Winckelmann's own life—as did the inclusion of the Jupiter and Ganymede in the *Geschichte,* and it suggests the difficulty of separating his work from his life, something I will take up later in this chapter.[36] It also offers particular insight into a passage from Casanova's diary, in which Winckelmann excuses his sexual relationship with a young man, although caught in the act, as having little to do with sexual proclivity and more to do with a professional imperative to stage a rehearsal of the Greeks (Casanova 4:262–64). Dressing up the act is wholly consistent with the notion of imitating the Greeks, and it is something that is possible only through reenacting the cover-up. What the Greeks were covering up, in Winckelmann's construction of their art and history, was nothing or an empty center.

Eyeing the Opening

In the *Geschichte* Winckelmann is far more instructive in demonstrating how one covers up an empty center. It is written in Italy, and its completion somehow requires that Winckelmann find excuses not to travel to Greece. Something about Italy, about the forgeries and copies of Greek art, make Italy rather than Greece the necessary destination for one seeking to imitate the Greeks. Winckelmann knows that the Greek sky is irretrievable, or, at the very least, the experience of its nature and the art produced by such a sky is connected to the impossibility of its realization in the present. Winckelmann thus valorizes allegory. Allegory or the allegorical mode is the only remnant, as Paul de Man writes, of the symbolic mode the Greeks might or might not have possessed (*Blindness* 188). That is to say, the Greek ideal can only be presented and preserved in its absence. In this instance, imitation becomes the effacement of the present, which is easily enacted by one who refuses to travel to the land of the "originals." The absence of the ideal is thereby preserved.

The point is presented more explicitly in Winckelmann's famous description of the most telling characteristic of Greek art, "noble simplicity and quiet grandeur." As noted earlier, the phrase is taken from the period when Winckelmann was still reduced to viewings in dark rooms in Dresden. Upon closer examination, the words might not have been intended solely for other artists; they seem to have an instructive

quality directed at both Winckelmann's own life and work. As Potts has argued, the stillness at the heart of the ideal is inseparable from a desire for a lifeless center. "*Stille Größe*" can only mean "an absence of signs of life. . . . The effect of beauty is produced through an entirely involuntary transfiguration: the bodily stillness that comes with the approach of death" (*Flesh* 1–2). This helps explain Winckelmann's insistence, a single page later, on the superiority of figures whose stance is one of repose: "The more tranquil the state of the body, the more capable it is of portraying the true character of [the soul]. Great and noble is the soul in a state of unity and calm" (*Gedancken* 21). At first glance, this might seem to stand in stark contrast to Winckelmann's apparent aesthetics of pain, what has been called "the violent juxtaposition of beauty and pain" (Richter, *Laocoon's Body* 4). According to Winckelmann, the statue of Niobe and her children, which he cites in the *Geschichte* as an example of one of the most important styles of classic Greek art, achieves its beautiful stillness through an excess of violence and fear so extreme and unbearable that all expression is erased from her face. Witnessing the slaughter of her children, Niobe is so stricken with grief that she is frozen into stone. That deathlike stillness, the transfixion of her unbearable suffering, is, for Winckelmann, emblematic of her absolute beauty.[37]

Winckelmann's interest, however, is always turned toward the beauty of the male body, and the self-obliteration of the Niobe statue thus fulfills another requirement for him. By assigning the female body to a sphere of obliteration, Winckelmann prepares a necessary clearing to allow for unobstructed and undistracted observation of the male body. It could also be argued that female beauty is the obliteration that the male body seeks. In the citation above, in which the Greek sky vivified the seeds of the land, the result was figures whose superior beauty lay in their feminization, which, as we will see, is the source of both their beauty and their suffering. If the feminine were not obliterated or preserved in any fashion, the feminization for which the work strives would be present in a form that was not ideal by virtue of the fact that it is present.[38]

It is therefore no coincidence that the earlier condition of beauty—noble simplicity and quiet grandeur—is inserted in the *Gedancken* into a reading of the "Laocoon." A framing device, which in the description of the Niobe allows for an erasure of pain by dismissing or ignoring its source, is already at work here. Winckelmann brackets out anything that inhibits attending to the commanding presence of the male figure. No

mention is made of the source of the pain, the snakes, which in this case is not even a hair's breadth removed from sight. If for Goethe, writing about the same work years later, the marvel of the statue lies in its perfect capturing of the transition from one condition to another—or, as he remarks, "a frozen lightning bolt, a wave petrified at the very instant it is about to break upon the shore" (*HA*, "Über Laokoon" 12:56–66)—Winckelmann transfers the entire contest onto the male body's struggle for expression.[39] Goethe focuses upon the snakes and the pain they inflict; Winckelmann excludes the intrusion of anything other into a gaze transfixed by the male nudes. What is striking about Winckelmann's description is its self-reflexive character.[40] It is thus worth citing at length his description of the work in the *Gedancken*:

> The universal and most distinctive characteristic of the Greek masterpieces is finally a noble simplicity and quiet grandeur. Just as the depths of the sea always remain calm, however much the surface may rage, so does the expression of the figures of the Greeks present a great and composed soul in the midst of passion.
>
> This soul is portrayed in the face of the Laokoon and not in the face alone, despite his violent suffering. The pain is revealed in all his muscles and sinews, and we almost feel it ourselves as we observe the painful contraction of the abdomen without regarding the face and the parts of the body. The pain, I say, expresses itself without rage. The pain of the body and the nobility of the soul are distributed with equal strength throughout the body and balance each other. Laokoon suffers, . . . his pain reaches the soul, but we wish that we could bear misery like this great man. (24)[41]

Somehow the obliteration Winckelmann cites in Niobe is unachievable by the Laokoon. Rather, what distinguishes this work is the struggle for unbridled self-expression, "parenthyrsis" as Winckelmann calls it. The unseemly pathos of the figure is tamed by the stillness that threatens all expression, but this pain is indistinguishable from the figure, since the pronoun "er" can stand for either the Laokoon or "der Schmerz" (Richter, *Laocoon's Body* 45). The pain of the figure is born out of the tension arising between the pathos of torture and the stillness of obliteration. This tension is anatomical, but the inability of the body or

sculpture of the male nude to arrive at full self-representation as it moves simultaneously toward self-obliteration is the source of its aesthetic greatness.

Relating the gesture toward obliteration to a series of framings that inform Winckelmann's work might help explain the genesis of the gesture. On a personal level, Winckelmann introduced a frame into his own sexuality by formulating his desires in terms of impulses mimetically tied to his Grecophilia. Moreover, he bracketed out the struggle with the snakes in his description of the Laokoon. Both gestures complicate and repeat his bracketing out of the real Greece, insofar as he refuses to ever journey there. But no matter how often it is repeated or imitated and no matter how stubbornly such bracketing out suggests the need for an unoccupied or vacated space to frame the ideal, it explains neither where nor how such a space emerges. A temporal or geographical displacement of ancient Greece can be achieved only through creation of a clearing. Greece is always almost upon Winckelmann; his dismissal of the present brings the past forward. Where then is the space for imitation, the self-reflexive impulse that not only frames his description of the Laokoon but also enables what I have called the imitation of imitation? A preliminary answer seems to be his erasure of the female. In other words, living in Dresden in inauspicious circumstances, Winckelmann might have doubted that self-expression was available to him. The Laokoon might not only serve to glorify the painful repression of his own desires but also lead him to seek expression of this something "other" in a place where inauthentic expression—insofar as the artworks he is to view are mostly copies and even forgeries—is the preferred mode. Even if full self-expression were somehow achieved, it would still be in the mode of the "other"—having been accomplished only by coming to occupy or stand in the place where the obliterated female once was. Given the description cited above of the Laokoon, the male nude can never achieve full self-expression. This might render it inimitable or wholly self-enclosed, thereby breaking the chain that summons one to Italy but no farther. In other words, there would be no history for Winckelmann to write, insofar as that history depends upon bringing forward but simultaneously holding at bay the Greek sky. Just as the self-reflexive character of the Laokoon depends upon its failure to achieve full self-expression, so too does the *Geschichte* depend on everything—and this includes expression of Winckelmann's desires—remaining at some remove from view. The *Geschichte* is a product of Winckelmann's stay in

Italy, and he revisits it several times to capture what he believes are his groundbreaking insights into the beautiful. The revisions demonstrate the open-ended nature of any history dependent upon copies or originals removed from view, but they also may be understood as attempts to negotiate a transference or deferral of desire. As he writes Baron von Stosch, "To speak among friends, I flatter myself, soon something perfect will appear (zum *Vor*schein kommen). I am so in love with this work" (18 September 1767; italics mine). What inspires his love is a completeness that only arrives at something short of appearance (Vorschein); its fullness is held in reserve. The deferral of erotic attachment that characterizes the *Gedancken* is consciously deferred in the later work. In fact, what organizes the treatment and assessment of the artworks in the *Geschichte* is the peculiar cathexis that distinguishes Winckelmann's notion both of the beautiful and of what is Greek. While Winckelmann purportedly celebrates the "Greek" rather than the erotic in the plastic arts, the term "Greek" is so generic as to elide any purposeful meaning (Potts, *Flesh* 18). Sculptures are Greek in Winckelmann's eyes if they are ideal representations of mythological figures, either nude or draped to reveal the forms of the nude. In other words, "Greek" allows for the peculiar dynamics of Winckelmann's eroticism to be played out. For example, Apollo represents the "highest concept of ideal masculine youth" in which the strength of maturity is united with the "beautiful spring of youth." Moreover, "upon this youth health blossoms, and his strength announces itself as the dawn does to a beautiful day" (*Geschichte* 158). Winckelmann insists, however, that not all statues of Apollo capture that quality. What Apollo represents is ascertained from particular representations of him that conform to aesthetic considerations founded upon the statue's ability to entertain or accommodate Winckelmann's erotic attachment. The essence of that attachment is deferral, since Apollo exists as a result of representations that in their ideal completeness (Vollkommenheit) bring him almost to appearance (zum Vorschein). What functions as a preexisting notion of Apollo or his Urbild is actually the result of the assessment of various representations of Apollo. The erotic attachment that informs Winckelmann's judgment sponsors a concept of ideal beauty whereby representations of Apollo are celebrated or discounted according to how they conform to something that is not in place previous to such assessments. The object of deferred desire is thus always deferred anew; it is refined or redefined with each representation. This explains the need for continued revisions of the his-

tory. It also clarifies why so many of the most celebrated statues in Winckelmann's work, such as the Venus de Medici or the Apollo Belvedere are Greco-Roman adaptations. Copies point toward the yet-to-be realized ideal or the ideal that is present only insofar as it is absent. This absence engenders a desire that is articulated in Winckelmann's erotically charged ekphrasis.

Similarly, the *Geschichte* may plot an organic transformation in the execution of the plastic arts of antiquity, charting their rise, flourish, and decline, and thereby offer historical coordinates for the presence of the ideal. But however real the events may be, the idealized and organic form of that history assures its withdrawal from Winckelmann's text. The ideal, as we will see, cannot conform to chronological coordinates. In fact, ideal beauty necessitates in its function as the ideal the "need to raise ourselves above the material world" and "to see into which we are in few things capable" (*Geschichte* 149). Certainly, a dematerialized world challenges the capabilities of vision; after all, what would it be to see nothing at all?

Winckelmann's history is, in fact, an exercise in preparing or rehearsing an encounter with an ideal that never occurs or appears.[42] The essential moment in the *Geschichte* is the period coinciding with the "Golden Age" of Greek culture—from the end of the Persian Wars of the early fifth century BC to the Macedonian invasion of Greece in the late fourth century BC. This period is characterized by continued progress from the stylized origins of the archaic period to a mastery of beauty and form, but it is also marked by a steady decline, evidenced by imitation and excess. Winckelmann thus shifts his principles of periodization from those based upon subject matter and iconography to ones based upon the period of origin—a process consistent with what I have called his reading backward. What distinguishes his work and assures its significance for future art scholars is assigning a temporal horizon to the ideal. More importantly, it underscores the fact that the idea and its eternal essence is necessarily at odds with its temporal appearance. Regardless of their subject matter, all works are no longer created equal or in equal times, and the times in which ideal works are created is accessible only through the plotting of an organically conceived history. Just how at odds Winckelmann's notion of beauty is with his temporal mapping of the history of antiquity is demonstrated by his refusal to assign more than a handful of works to the "High Period" of Greek art. In fact, Winckelmann locates the finest examples of Greek art in the so-called

period of decline (Potts, *Flesh* 48). The Apollo Belvedere, which Winckelmann cites as the highest ideal of art among the works of antiquity that escaped destruction, thus functions as a remnant of loss; its beauty is a result of how it marks the decline of an ideal whose only remnant is decay (*Geschichte* 64).

The emphasis on loss and the manufacturing of replacements in the form of copies finds its most ardent expression in the concluding pages of the *Geschichte*, a portion of which is cited above. Since the passage neatly summarizes and brings together many of the arguments offered above, I will quote it here at length:

> [J]ust as a maiden, standing on the shore of the ocean, follows with tearful eyes her departing lover with no hope of ever seeing him again, and fancies that in the distant sail she sees the image of her beloved . . . we, too, like that loving maiden have nothing but the shadowy outline of our desires, but that very indistinctness awakens only a more earnest longing for what we have lost, and we study the copies of the originals more attentively than we would were we in possession of the originals. We are like those people who would like to know and see ghosts, where nothing is: the name antiquity has become a prejudice, but this prejudice is not without advantage. One who always proposes to himself to find much will by seeking for much perceive something. . . . [W]e turn over every stone, and by inductions from many particulars we arrive at a measure of certainty that can be more instructive than the reports left to us by the ancients. (430–31)[43]

In this instance, the ghosts that called forth so many of those who followed Goethe to Italy are willfully called up long before Goethe arrives to welcome them. The real Italy is an empty space, allowing antiquity to assume the form of a prejudice (Vorurtheil) evidently consistent with the shadowy outlines of our desires. Winckelmann's *Geschichte* is effectively a conjuration, calling forth ghosts we would like to see in places where there is nothing to see. This conjuring—which generates both a longing to view the copies of Urbilder and greater attentiveness to those copies—depends upon a clearing away of the present, a dismissing of the particulars so that the outlines of our own prejudice can be filled in. The heightened longing produced by a deprivation of the original artworks,

however, renders art historians like Winckelmann superior to those, the Greeks, who supposedly had the prototype before them. In our impoverished state, we turn over every stone to arrive at conclusions that are possibly more instructive than those arrived at by the ancients. Our longing for what we cannot have renders us superior to those who lived under privileged skies.

What is the added ingredient that renders the observations gleaned from turning over every stone superior to those based on observing the real thing? This turning over, it seems, must be productive. More than a metaphor for Winckelmann's process of writing art history, it creates something where there was nothing, and this something is necessarily more than what was there before Winckelmann began writing about the art of antiquity. Moreover, this filling in where there was nothing is apparently the form given to the shadowy outlines of our desires (Schattenriß von dem Vorwurfe unserer Wünsche). The act of clearing away produces ghosts that conform to or fill in the shadows. In the process, the art historian's relationship to the missing artwork assumes the form of a love triangle, in which the historian is the female beloved looking hopelessly upon a departing ship to imagine in its sail the picture of the lover she will never see again. Imagining something never to be seen again describes the task of the art historian, but it serves as well to engender him as a beloved whose feminization is a result of filling in or projecting onto a blank sail or canvas that which can no longer be seen. The art historian's efforts thus produce a love object, a third party to this affair, who serves as the surrogate recipient for affections forever barred access to the real thing.[44] In addition, the idealized form of the male nude is an auto-formation of the art historian's effort, his turning over of every stone. What is brought to light, "outed" from beneath the stones, is a nothing that is nonetheless productive because it engenders a desire for the unrecoverable. If Greece is idealized because it is absent, that absence gives rise to a quest of which the feminine gaze or homoeroticism disguised or covered up as a feminine gaze is a product. This suggests that the obliteration of the female (perhaps a precondition of male homoeroticism) is linked to the occupation of that space by the art historian who, in that role, projects an idealized male for whom she (die Geliebte) hopelessly longs and whose condition of being is absolute departure. The idealized male nude is the turning over; homoeroticism is evidence that something has been overturned. It is an affect of art his-

tory or of writing the history of art. What has also been overturned is the relationship of copy to original.

Nowhere is the constitutive emptiness of Winckelmann's organic plotting of art history more apparent than in his placement of the high point of Greek art distinctly after the flourishing of the Greek polis. According to Winckelmann, the best Greek art was inspired by nostalgia for a previous spirit of political freedom:

> After the Greeks . . . had completely exhausted themselves through . . . persistent internal wars among themselves, Philip of Macedonia rose up over them, and Alexander and his immediate followers had themselves declared heads and leaders of the Greeks. In reality, however, they were the rulers of Greece. As now the system of government of the people took another form, so too did the circumstances of art change, and art, which until now had been grounded in freedom, took its subsequent nourishment from superfluity and munificence. It is to these factors . . . that Plutarch ascribes the flourishing of the arts under these monarchs. (*Geschichte* [Vienna] 69, 91–92, trans. Potts, *Flesh*)[45]

As Winckelmann's description of the Belvedere Torso emphasizes, Greek art flourished one remove from political freedom. Hercules, whose torso Winckelmann assumes he is viewing, is represented after his death; his body no long bears the marks of the struggles in which he proved himself the hero. Hercules' beauty is not an expression of strength but rather a representation of potential strength or even expended strength (*Geschichte* 368–69; Potts, *Flesh* 64–65).

This remove permits Winckelmann to posit an ideal as well as an organic flowering and waning of art. The absent and remote ideal exists only by virtue of the imitations that ostensibly point to its being. If so much Greek art was driven by a desire aroused by a displacement from the ideal moment, Winckelmann's own history can be nothing more than a narrative attempt to satisfy a mimetic desire that has only shadows, fragments, and copies to inspire it.[46] As he remarks in the concluding commentary to the *Geschichte* quoted above, his history is superior because of inferences drawn from countless individual instances that allow us to arrive at a hypothetical certainty. The accounts of the an-

cients are "merely historical" (431). Winckelmann's history is superior because it is not historical, because it is forced to turn over the stones of surviving fragments.[47] What it discovers is thus of its own making—an ideal whose only referent is the construction of that ideal's absence. If the high style of Greek art is "an idea conceived without the aid of the senses" that is "blown into being with a breath" (*Geschichte* 226), and if, by contrast, the beautiful is more appealing only by virtue of its remove from the ideal, the question that necessarily arises is whether the copied thing is perhaps superior to the thing copied.

Winckelmann asserts that we moderns, barred access to the actual art of the ancients save for what we project onto the space of absence, are in a position to understand and appreciate more fully what for the Greeks was too immediate and thus as invisible as the breath blown into it. What most certainly holds for the artworks, however, is that the invisible is unconditionally dependent on its material presentations. The high ideal, the stillness of grandeur, is achieved only in the representations that follow. In fact, one could and probably should begin to question the entire ordering of the art works, even if Winckelmann's own history were not so suspect in its ideal ordering (Potts, *Flesh* 64–66). The essence of the original has nothing to show for itself save for the more accommodating removes that purportedly follow it. That is to say, the essence of Greek art is a creation of Winckelmann's history. The instructive nature of that history lies, as emphasized above, in its ability to posit an ideal that exists by turning over or overturning the stones of the ruins with which the art historian is left. And such "overturning" extends as well to the issue of copy and original. This puzzling reversal of copy and original renders ancient Rome primary to ancient Greece, but it also upsets the chronology of the many who later would follow Goethe to Italy. Each journey undertaken in response to Winckelmann's and Goethe's would seem to repeat the very gestures of imitation that give rise to the notion of an original or an ideal. Just as Winckelmann's art history upsets the relation between original and copy, the "originality" of Winckelmann's and Goethe's journeys depends on the copies that follow. This explains more fully Benjamin's detailed description of Naples as porous. What for Winckelmann, Goethe, and those who followed is the site of an original ideal is a site full of holes, filled in only by a series of imitative gestures. The ideal is the displacement of the gesture, which, like Italy, is no more primary than the imitative gesture itself. The noble simplicity of art—or, to cite the German, its character as

"einfältig"—is the uniform simplicity of mistaking one's own echo or effect for an original that is irretrievably displaced beyond the fold. It is the posture of nobility assumed by one destined to interface only with stand-ins or surrogates.

Cut and Scarred

Given Winckelmann's libidinal investment in surrogates, it seems ingenuous to deny that such a form of aesthetic contemplation is divorced from his personal desires. Already in his formulations that privilege the perspective of one forced to seek an ideal in the remove that renders that same ideal inaccessible is a preliminary outline of what one might refer to as the desire of another's desire. That other, however, is curiously displaced or absent, since it finds its most obvious configuration in the female figure who stands in for Winckelmann, the art historian, as she pines hopelessly for a departing lover. The other whose desire Winckelmann desires is thus a figure or figuration of his art history, and the object of her desire—to recall the image of the sail above—can only be imagined. Winckelmann's desire, or the curious eroticism that shapes his descriptions of art, can only be expressed through an imaginary figure's imagined beloved. In this respect, the obliteration of the female in the description of the Niobe is required to make room for Winckelmann, the art historian. It allows him to assume an imaginary presence.

In more direct terms, Winckelmann's own lack—his inability to fulfill his sexual, aesthetic, and economic ambitions—reconfigures or doubles itself in an art history that seeks to execute an effacement of the present to ensure the absence of the ideal.[48] His own lack finds an equivalent in the art works he idealizes. His history is keenly fastened upon a notion of insurmountable temporal displacement. There must be no possibility of going back; the past must remain unrecoverable. That holds for Winckelmann as well, who finds it impossible to return to Germany (although he does make it to Austria) and turns back, at the last possible moment, to Trieste. His death in that city at the hands of a lowlife felon is a possible and curious result of his decision to turn back rather than to return. Something about the past, about all pasts, must be jettisoned so that one never returns to the original scene. At the very least, a return to Germany would threaten the ideal subjectivity Winckelmann constructed for himself in Italy and return him to his humble origins. Although the circumstances of his death remain shrouded in mystery, it is remarkable how Winckelmann may have promised his mur-

CHAPTER 1

derer a tour of Cardinal Albani's palace in Rome and claims as well to have transmitted a secret message to the Austrian empress.[49] In other words, something about a return to Germany is so threatening that Winckelmann takes to playing his act with rather puerile effects before what would seem to be the least consequential of audiences—except that it led to his death. Apparently it is far better to turn back upon a knife—or to place oneself in a position to have the knife turned in on oneself—than to return to German soil. Also noteworthy is that Winckelmann's thwarted trip to Dresden serves as a perfect excuse to refuse one that presumably would have posed an even greater threat to the preservation of distance or remoteness critical to his construction of an aesthetic ideal—namely, an all-expenses-paid trip to Greece offered by Baron Riedesel. Even if a trip to Greece was part of the trajectory of Winckelmann's aesthetics from his first writings in Dresden, such a trip would situate his ideal in historic circumstances too real to sustain its ideal and elusive character. As an effect of his own history, that ideal necessarily circulates outside history or just on the other side of a boundary that Winckelmann never dares cross.

One cannot, however, overlook the violence necessary to rip the object out of a temporal sphere for purposes of idealization. On a personal level, this allows one to conjecture about the serious bouts of dizziness that increasingly afflicted Winckelmann. The ahistoric nodal point of his history can be seen to dislodge the internal logic of his intuition. At the same time, these gestures help align his art history with his erotic pleasures. In response to the rebuffs of the upper-class recipients of his letters, Winckelmann sought the company of young men who were anything but ideal or of noble origins. As Dominque Fernandez writes about Winckelmann's tryst with his killer:

> To make love with a cook and a delinquent—what an unexpected miracle for a man who could thereby free himself from his inhibitions through debauchery and infamy. By sleeping with Arcangeli, he left intact and on their pedestals those boys whom he had venerated but had lacked the courage to approach. . . . He had so completely separated his intellectual ideal from his physical desires, that the spiritual wretchedness and moral baseness of his partner, rather than forcing him to renounce his place, facilitated his action. (44)

The suggestion—*and it must be understood only as a suggestion*—that Winckelmann sought his own death when faced with the prospect of returning to Germany, where freedom was only a shadow of what it was in Rome, emphasizes his radical need to find in debauchery, infamy, and self-sacrifice, the preservation of the distance necessary for the preservation of the ideal male.[50] The disfigurations of contemporary culture and the imprimatur of history could be interrupted only by arresting his journey back home to Germany and refusing to travel in the other direction, to Greece. *Italy is the place to cut things off.* Ending things there is the stroke of finality in his attempt to stave off time. Just as his *Geschichte* was interrupted at its organic core by a displacement of the ideal beyond any temporal coordinates, Winckelmann's own history writes a similar interruption into the alliance between the Germany of his time and the Greece of antiquity that is otherwise assuming a shape too definite and finite to remain ideal. In other words, German Grecophilia founds and sustains itself in absence. Substituting a pockmarked cook for a Greek lad ensures that the alliance will never be consummated; yet, paradoxically, it will be maintained.

If Winckelmann's legacy is to be found in the unwieldy patterns of his own journey, the undecidable question is whether cutting off in Italy frees German writers from the tyranny of Greece, allowing them to view their own efforts as "original." Are their works thereby freed from the tyranny of imitating an ideal whose very origin is premised on absence and is thus nothing more than an effect of imitating that absence? At the same time, Winckelmann's decision to arrest his journey back home may signal the impossibility of arriving anywhere save for a space in-between. Followers would thus be taunted by what always remains just beyond reach. Something irretrievable and unrecoverable would haunt and direct the moves of all who follow him to Italy. Trapped in that in-between land, they would be forced, like Winckelmann, to offer up a violent sacrifice—and here I link the circumstances of his death with his aesthetics—to install the ideal and effect its law of an internalized absence. The sacrifice itself can be considered critical to the construction of the ideal, helping cover up the unrecoverable by cutting off all potential access to it. Winckelmann's biography as well as the temporal logic of his history indicate the manner in which that cover-up is executed.

What can never be erased, however, is the mark of that sacrifice. Not only is the imitator essential to any form of ideal construction, but the legacy of the imitator is as well a mark of willful failure: it is a cut-

ting off to restore presence to an ideal that can only subsequently be called forth by imitation. Cutting off one's trip to Germany or Greece repeats the gesture of the art historian who privileges copies or, we might say, intermediaries so as to bar viewing what would then be revealed to be nothing or absence. Winckelmann is the intermediary, and his status as intermediary is the secret content of the message he claims to have delivered to the Austrian empress.

In this instance, Italy becomes a land of liberation only insofar as it inspires a "letting go" of letting go, a surrender to the order of law that his own giving in installs. The order of that law is visible first in Winckelmann's conversion to Catholicism, exchanging the vows of his first church for the ones of the father. He thereby secures his position in the eternal city through the most powerful protectors: bishops, cardinals, and finally the pope (il Papa). Even before Goethe's Italian journey rehearses his father's journey, escape from the fatherland to Italy becomes a return to a father who is not there, or is there only as a representation of something ghostly. A terror of returning to the fatherland leads to the need for an internalization of an idea whose authority is so complete, simultaneously enabling and barring the subject from its presence, that it very possibly lures Winckelmann to his death and forces him to cut himself and cut himself off from the land or ground of that ideal. Any acknowledgment of the real ground will prevent its appropriation or internalization; any internalization diminishes the necessary possibility of its real character. Greece represents the former possibility, Germany the latter. This predicament could be said to account for Winckelmann's penchant for allegorizing himself and assuming pseudonyms. He is only always a subject about to be born (e.g., as a feminized art historian). And the impossible possibility of maintaining the ideality of that history, be it a personal or an art history, is suggested by his curious death. It is a giving in to the law—an extensive law of the father who was never present or locatable—whose only sign of enforcement is the free sacrifice of the one who installs it.[51]

Self-Inflicted Wounds and Their Peculiar Growths

One does not need to rely on the peculiar details and twists of Winckelmann's biography to recognize the disfigurement characteristic of his life's work. As Simon Richter has pointed out, a favorite phrase of Winckelmann, one that appears with surprising frequency and regular-

ity, is "der Verschnittene" or the castrated one: "One stumbles across the word so often that it cannot be dismissed as an accident or insignificant quirk. Indeed, the word crops up in the most important places. The remarkable thing about Winckelmann's *Geschichte* is that every time he looks for the visual instance that best embodies the classical ideal, his eye strays past the Laocoon and the Apollo Belvedere and fixes on the eighteenth-century castrato" (Richter, "Winckelmann's Progeny" 50).[52]

Even in Dresden Winckelmann is drawn to the beauty and voice of the mutilated. He marvels at the voice of the soprano Giovanni Belli, a castrato who frequently performed there. In Italy, at the opera, he is transported back to Dresden by voices that recall Belli's: "In the evening I go to the opera. . . . I think I am in Dresden for the Pilaja sings. . . . The beautiful, no the most beautiful sings in Lucca" (20 Sept. 1761; Richter, *Laocoon's Body* 50). In a letter from 1764 he writes, "Tomorrow, I will go to Valla in order to see and hear the beautiful Venanzio, chi fa la parte di donna" (*Laocoon's Body* 50). Venanzio is also a castrato, and Italian is the language, operatic and discursive, to evoke the castrati. The dream of Dresden is not dissociable in this instance from the expressive nature of those who have been badly cut: they evoke its memory. The dream of the fatherland is thus a function of or coeval with cutting off. And the cutting off that produces the dream of the fatherland likewise produces the ideal in art.

Whatever Winckelmann's sexual intrigues in Italy may have been, they were apparently never divorced from the dream of an ideal beauty, whose embodiment or closest approximation is the castrato. The sexual ambiguity—or, more precisely, the asexuality that defines the castrato—is, in fact, a central theme of the *Geschichte:* "The attention of the Greek artist was not limited to male and feminine youths, but rather their observation was also directed to the conformation (Gewächs) of the castrati for whom boys of handsome shape were chosen. . . . Indeed, among the Greeks in Asia Minor, boys and youths of this sort were consecrated to the service of Cybele and Diana of Ephesus" (*Werke* 4:65).[53]

Ideal beauty is related to the disfiguration that results from an attempt to arrest time, and the ensuing mutilation is the curious expression of an ideal beauty linked to a notion of erasure. The ambiguous beauty of the castrato is thus itself twofold. There is the ambiguity of its gender. But there is also the simultaneous presence and absence of the markings of gender. Beauty is always ambiguous because its self-presentation is the mutilated expression of its attempted erasure or atemporal-

CHAPTER 1

ity. The same theme is evident in the theoretical section that opens the first version of the *Geschichte:* "The growth of the castrati is denoted in hitherto unobserved figures of the priests of Cybele through the breadth of the hips, and the breadth of the hips is indistinguishable even beneath the drapery of a figure of a boy of twelve years. . . . The many hermaphrodites, differing in size and position, show that artists also sought to express in the mixed nature of the two sexes an image of higher beauty, and this image was ideal" (37).[54]

Privileging the male nude is thus tied as much to a possibility of de-gendering the body as it is to Winckelmann's homoeroticism, to which he assigns a feminine gaze. This means that the body of the male nude is the product of the writings of one who would unmark what his writings or leering at the ideal male nude would produce. Just as beauty is stitched together from its piecemeal appearance in nature, art history is a form of hermaphroditism in which the genders are stitched together through a writing or ekphrasis that connects or even cathects the feminized observer of art with the body about to be castrated (Davis 115). The feminine gaze does not castrate. Nor does the castrato produce the feminine gaze. Rather, they are coeval, the forms of an expression that desires its own lack. And the ideal in art is an articulated performance in art history of this impossible union. The "Gewächs" of the castrato or the hermaphrodite, which is as over-gendered as it is de-gendered, is the product of this union, an ideal whose excess beckons the sculptor's knife and the historian's edit. Viewed from another perspective, the male body ready for castration best approximates the quiet grandeur that is the essence of Winckelmann's notion of beauty. The attempt to blur or exclude gender difference explains Winckelmann's exclusion of the source of the pain in his description of the Laokoon in the *Gedancken.* His attention is captured instead by the "muscles and sinews" of the suffering one as he struggles for expression: "He emits no terrible screams such as Virgil sings of his Laokoon. The opening of the mouth does not permit it; it is rather an anxious and oppressive cry . . . (ein ängstliches und beklemmtes Seufzen)" (*Gedancken* 24). The Laokoon sans snakes assumes in that loss a noble form of expression equaled only by the castrato, whose unbroken, heroic voice is inseparable from his loss. It is also the voice of the art historian as (s)he imagines on an empty canvas something (s)he imagines has been lost forever. But this impossible union, premised on irreparable loss on both sides, gives rise to a mark or scar—what we might also call a "Gewächs"—that renders the loss something

less than absolute, which, consistent with the paradoxical logic of Winckelmann's histories, preserves the union's impossibility. Something gets in the way.

In the *Gedancken* Winckelmann posits Greek youth as an ideal of beauty. Once he had dined with the castrati in Italy, the eunuch begins to fill out that image of youth; it is, to apply Winckelmann's words, the ideal "Gewächs." But the peculiar or unfortunate fate that produces this "Gewächs" ensures that the cut is not clean. Since the castrato still has something to mark what was cut, "Gewächs" could refer just as well to that which denotes absence as much as it does their broad hips or conformation. The excessiveness of the cut is also (re)productive, giving rise to Winckelmann's aesthetic notion of "Unbezeichnung." "According to this concept, beauty should be like the most perfect water drawn from the lap of the spring (das vollkommenste Wasser aus der Quelle geschöpft), which, the less taste it has, the healthier it is considered because it has been purified of all foreign parts" (*Werke* 4:40; Richter, *Laocoon's Body* 52). The beauty Winckelmann discovers in Italy has to be stripped of its foreign parts.[55] What lends definition to beauty is the mark of its "unmarking." "Unbezeichnung" unmarks the young male, yet it gives rise to the "Gewächs," an ineradicable foreign element without which there would be no visible sign of beauty and which, at the same time, renders beauty something less than absolute or ideal. After the fall into sexual difference, the male can reform or unmark itself, but only imperfectly so. Its recaptured beauty remains on the other side of expressivity; the scar or "Gewächs" of the act of unmarking ensures that the ideal remains beyond reach, just as it is in Winckelmann's organic casting of ancient Greek history.

Necessarily frustrating and simultaneously preserving this ideal state is not only the wound that stands in for the inexpressible ideal but also a spatial displacement of the thing to be erased. Substitutions define Winckelmann's aesthetics and self-identity. Just as the pope stands in for the father, a reattached and erect arm stands in for the elimination of the snakes in the Laokoon. The statue that now stands in the Vatican differs significantly from the copy Winckelmann described. The right arm of the father was not extended, as was the case with the Laokoon Winckelmann viewed, but was bent, withdrawing and closing in on itself (Sichtermann 194–96). What Winckelmann removes is reappended. It keeps showing up elsewhere, lending new meaning to the praise that Italians sang of the castrati: "Eviva il coltello" or "Long live the knife."

CHAPTER 1

In terms of Winckelmann's aesthetics, this is precisely what occurs; there is always a re-appendage or a displaced appendage to cut anew. Undoing time is itself a process whose remains find an equivalent in the castrati. Their heroic voices sound the impossibility of arresting time, and like all substitutions they are an imperfect fit. A mark or "Gewächs" suggests an irreparable wound, and the remains always re-attach themselves elsewhere. This perpetual displacement, however, keeps history and time adequately out of joint so as to preserve the misprision necessary for the construction and preservation of the ideal in art.[56]

Winckelmann's body also becomes, it seems, a site for displacement to leave its mark.[57] Whatever his attraction to his murderer Arcangeli might have been, it did not serve to cut Winckelmann out of the endless cycle of remarking that imprisoned him in Italy, making him unable or unwilling to journey beyond its borders. If, under these terms, Arcangeli's is to be the final cut, it fails, since Winckelmann's life and death have undergone constant revision and speculation (Grossman 213–19). Yet his death may be the result of the uncontrollable logic his aesthetics installs. Winckelmann hands himself or is handed over to the project he initiates. His life and his *Geschichte* are so intertwined that the beginning of one signals the end of the other, although, as we have seen, whose or which beginning and end are never finally discernible. If Winckelmann discovers or at least approaches more directly the erotic component of art in Italy, that component exists only insofar as a personal eroticism ("I am so in love with this work") arouses the interest necessary to reveal or uncover the heretofore unforeseen in Greek art. Winckelmann's eroticism passionately repeats and imitates the same denial of sexuality that preserves the future of all of his illusions—his own subjectivity and the subject of his *Geschichte*. The wound that results from that denial does not, however, cease hurting. The violent rupture of temporality or the cutting off that Winckelmann rehearses in Italy eternalizes a terror of the father, and that violence sets Italy up as the site for subsequent generations to act out that terror.

2

Fathers and Sons in Italy
The Ghosts of Goethe's Past

If the law of the father or of his terror is ultimately how one might phrase the legacy of Winckelmann's journey to but never out of Italy, the first father to have really mattered had already been there and done that by the time Winckelmann began his sojourn. Johann Caspar Goethe returned to Frankfurt in 1742 after a "cavalier's tour" through Italy had confirmed his manhood and charted a course for his son to confirm, with haunting similarity, his own manhood several decades later.[1] By coming in between father and son, Winckelmann instituted the law that was to stand in for the father. By the time the son repeated the father's journey, Italy had, via Winckelmann, become a site to honor and enshrine surrogates. Goethe was finally on his way to meeting a father who was never "there." By no means did Goethe have an absent father. On the contrary, his father was enthusiastically involved in his son's upbringing. Italy fulfilled the son's wish to confirm the father's absence by visiting or recalling his absent father in Italy.[2] This was also a trip that Goethe could not undertake until his father had passed away or until his death had posited an absence that the son could visit.

Since it is the law much more than the father that matters here, the father cannot be said to precede his son. His presence is only by virtue of the law that his son's journey executes. Winckelmann displaces the older Goethe so that a law can stand in for him. The writing of that law, however, can only occur if the journey of the younger Goethe imitates

CHAPTER 2

the father's—that is, if the moves of the son not only are predicted and accompanied by those of the father but also are destined to institute an order whereby the order of things is overturned. Despite every attempt by the Goethes to discover what the father called the "natural chain of being" (Johann Caspar Goethe, 18 March 1740) and what the son called the "Urpflanze" or "primal plant," that looking backward to creation means that everything is, in fact, backward: the son's trip gives rise to or resurrects the father's journey. This odd logic is perhaps better understood by remarking how the law that Winckelmann installs reverses the apparent order of that installment as developed by Freud in *Totem and Taboo*. If for Freud ingestion of the father and the consequent internalization of his presence accounts for the law of the father, for Winckelmann castration installs the father, who, like the ideal of the ancients, is absent. In other words, only through a valorization of castration does the father come to be or does his absence obtain. Without castration there would be no antiquity to imitate, no father or father figure for Goethe and those who follow him to emulate.

Even before one summarizes the effect of this law, it is apparent that the son's upbringing sustains the father's interest in Italy. For nineteen years—from 1752 to 1771, when the son was three until he was twenty-two, the father composed and rewrote an account of his own Italian journey. It seems the father could only begin to consider abandoning the project once the son moved on to Strasbourg and proclaimed "to Italy, Langer, to Italy" (Mandelkow, 29 April 1770). Other remarks in that same letter might well have convinced the father that the son would seek the father in Italy: "There is much that I still lack. Paris shall be my school. Rome my university. For it truly is a university, and once one has seen it, one has seen everything. Therefore I shall not enter it in a hurry." The son recognizes a lack that renders Rome irresistible. The land of "il Papa" is the university that sponsors the son's rebirth, and it is a rebirth that calls into question the need for any father save an absent one. The nature of the secrets housed in the archives of that university, which permitted the son to proclaim he would have seen "everything," are suggested in the previous chapter. Everything Winckelmann saw was no longer there. The concern of this chapter is how everything depends upon a deceased or absent father returning to or from ancient ruins. Goethe's Italian journey demonstrates the ideal possibilities that ensue from an absent father.

FATHERS AND SONS IN ITALY

FATHERLY FIGURATIONS

From the start the son seems to have been at home in Italy. As he reports in *Dichtung und Wahrheit,* Italian was the first language in which he and his sister were given instruction. The hallway (Vorsaal) of the father's house was ornately decorated with Roman scenes; all rooms led to and from Rome. That too seems to have been the belief of the son, who spent only three hours in Florence as the desire to reach Rome increased with every blink of the eye: "Across the mountains of the Tirol I fled rather than traveled. . . . My desire to reach Rome was so great, grew so with every moment, that no more stops were possible, and so I spent only three hours in Florence" (Rome, 1 November 1789).[3] His flight to Rome was nothing short of a homecoming, a return to his childhood: "I now see all the dreams of my youth come to life (Alle Träume meiner Jugend sehe ich nun lebendig)," he writes in that same entry, which in fact is the second entry of his first day in Rome, November 1 or All Saints Day. And the blessedness of that day lay in its revivification of dreams inspired by a deceased father: "For it is the beginning . . . of a new life, when one sees with one's eyes what one partially knew inside and out. Everything is as I imagined it, and yet everything is new. I can say the same of my observations, of my ideas. I have not had a totally new idea, not one that I found completely strange; rather my old ideas are so definite, so vital and coherent that they could be considered new" (Rome, 1 November 1786).[4]

Goethe is quite explicit in describing how he came to know these things inside and out. In that same entry he underscores what was commented upon above: "(My father hung views [Prospekte] of Rome in the hall)." Like the law, the son's "prospects" were always hung or placed before him—something Goethe mentions parenthetically as if to stress that his journey is both a continuation and an interruption of his childhood. In other words, the past is an aside, an accompaniment to what otherwise might be the absolute foreignness of things heretofore unseen.

If his arrival in the first city of the world is initially marked by a joyous encounter with an immediate past, the realization overtakes him rather quickly that Rome is at best a home away from home, a site where one's personal past circulates with others'. Its prospects are suddenly sundry and threatening. To his dismay, more than one father's ghost traverses the ancient city. Just two days later he writes: "One of the main

reasons that I gave myself as a pretense for hurrying to Rome, namely, that All Saints Day was on November 1, turned out to be a delusion. If, I had thought to myself, they pay such high honors to a single saint, what a spectacle it must be when they honor them all at once. How terribly I deceived myself" (Rome, 3 November 1786).[5] Celebrations of the saints occur on each one's name day; they do not all come together and join as one on November 1 as Goethe had hoped. To recall the ecstatic language of his earlier entry, the all-encompassing breadth of his dreams and ideas is fragmented by diversity, and his dream of self-sameness denied by the realization that all holy figures are not uniformly honored. If Rome is the first city of the world, it is not because Rome is the original destination of his dreams, but because Rome is where he will come face-to-face with an original loss of those dreams and the place to which he will return to enact or rehearse the imitation necessary to stand in for that loss. On All Saints Day his disappointment in finding emptiness where he had hoped to see a dead saint "appear in all his glory" is momentarily assuaged by the appearance of the pope (or the "Vicar of Christ," as Goethe calls him) on the Feast of All Souls Day, November 2. But that father is not the real father, and guilt quickly overtakes him: "When I saw him moving from one side of the altar to the other . . . , the original sin of the Protestant stirred in me, and I had no desire to enjoy the well-known and traditional sacrifice of the mass here" (Rome, 3 November 1786).[6] Whatever Goethe's assessment of his father may have been, his Protestant upbringing will not countenance a Catholic stand-in. Rome is to be the site of absent fathers. "What would He say, I thought, were He to enter and see His representative on earth droning and tottering about? (summend und hin und wider wankend anträfe)" (Rome, 3 November 1786). His dismissal of the pope is accompanied by the curious observation, "The words *Venio iterum crucifigi* came to mind." The dreams of his childhood summon a father in unacceptable garb, whose presence arouses not only guilt but fears of Goethe's own sacrifice as well. With so many fathers and representatives of the fatherland roaming about, Goethe senses that he will never overcome the guilt inspired by these stand-ins. There will be no possibility for rebirth—it is important to stress that Goethe's Italian journey is significant because it sponsors his creative rebirth—so long as all the dreams of his childhood are accompanied by his father's ghosts.[7]

A key tactical element in trying to escape this fate is to become unidentifiable, to take leave of oneself. In this regard, Goethe, traveling

under the name of Möller, is pleased to discover that his real identity can remain a secret.[8] The entry of 5 November concludes with a description of an "adventure" he offers as an antidote to the ponderous earnestness of his previous remarks about art. The adventure focuses on his supposed presence and absence in Rome. Tischbein informs Goethe of a "fabulous prank" based upon the widespread rumor of Goethe's appearance in Rome. The failure, however, of anyone to recognize him, even those to whom he had been presented, is, Goethe asserts, grounds for relief (Rome, 3 November 1786).[9] Even a German who has insisted that he has been living with Goethe in "friendly circumstances" denies Goethe to his face. Thus in Rome Goethe is free to explore the possibility of existing outside or only alongside his presence. He is a rumor, detached from its origin. Goethes of haunting familiarity exist on friendly terms with other Germans, and already he is the ghost that constitutes or legitimates their coterie. According to Tischbein, people compete for bragging rights to Goethe or his rumored presence in Rome. Therefore, what is most soothing about this particular anecdote is that his incognito is still safe or covered (gedeckt). He cannot be held accountable for what the other half does; his legacy is not his own or is not yet something he wishes to claim. Being only elsewhere, Goethe remarks that he can now mingle more easily among the artists: "I now moved around more freely among the crowds of artists (Ich mischte mich nun freimütiger unter Künstlerschar)" (Rome, 3 November 1786). Of course, which Goethe—the one sighted or the one living under cover—is to leave the traces that will captivate his followers is not so easily determined. It is obviously not in the interest of Goethe the chronicler to tell the reader. What his "soothing" account does tell us is that in Rome, rehearsing absence not only preserves an artistic ideal, as it did for Winckelmann, but it also preserves an ideal Goethe who exists before, if not beyond, the reach of terrorizing, illegitimate fathers.

The Executive Process

In arranging for look-alikes to fulfill functions, albeit primarily social ones, Goethe marks Italy as a site for emissaries long before he will unwillingly escort Anna Amalia from Venice back to Weimar, or before he sends Eckermann to deposit his son August in Rome.[10] To be sure, with its pope and celebrants of the saints, Rome was an apt place for receiving emissaries, but Goethe's own moves were defining Italy as a specifically German colony. As I will argue in subsequent chapters, his ghostly

presence charts an itinerary for future Germans. The Italy that Goethe chronicles establishes the terms under which Italy is to be processed by future Germans seeking admittance to the higher circles of culture. Goethe also seems to be keenly aware that he too is only always subjected to the same terms. He does not so much arrange for look-alikes to secure his incognito as it is prearranged for him. Perhaps that explains the need to switch names and careers yet again upon his arrival in Rome. Until that time Goethe had traveled under the name Jean Phillipe Möller, a merchant from Leipzig. In Rome he becomes the painter Johann Phillip Möller. He is, as noted above, fulfilling the function his father marked for him. And he is there in Italy, as the Tischbein anecdote suggests, long before he has arrived, not only "sighted" by some of his contemporaries but also summoned to Rome by himself or his father. His subterranean journey to Italy is haunted. His friends at Weimar may be unaware of his whereabouts until he reaches Rome, but Rome was waiting for him.[11] So driven was he to make his way to Rome that the man who occupies himself so fully with drawing, visiting museums, and lodging with artists could find only three hours to devote to Florence. Evidently Florence did not call to him as Rome did. The pleasures he sought were offered only by Tischbein and his circle.[12] "It is a great stroke of luck to live with Tischbein in a true society of artists (Ein großes Glück ist es mir mit Tischbein zu leben und bei ihm zu wohnen in treuer Künstlergesellschaft)" (Mandelkow, 7 November 1786). In other words, a place at the table alongside Tischbein had been prepared for him; he has a function to fulfill.

Winckelmann himself perhaps unwittingly reserved Goethe's place. That the deceased historian and his ghosts are not far removed from this society is evidenced by his many students and companions who comprise the circle of the nearly eighty German artists living in Rome at that time.[13] Perhaps in exchange for the lessons these artists provide him in drawing and perspective, Goethe often reads to Tischbein's circle of friends in Rome from Winckelmann's *History of the Art of Antiquity* (Rome, 3 December 1786). Yet the darker side of Winckelmann's presence seems likewise to haunt these artists. During the month of November, the month of Goethe's arrival in Rome, four successive murders shake the artistic community. The first, as Goethe evidently learns from Karl Philipp Moritz, befell a pretty youth who had served the German artists as model. Since, according to the calculations of the artists, the culprit was acting in self-defense, the German artists helped disguise him

as a shepherd and thus abetted his escape. In part because of their own knowledge of perspective and camouflage, German artists enabled the accused to be passed off as someone else. In other words, self-defense is the excuse and eventual mode of existence for fugitives from Italy, and disguise is a defense against oneself. That Rome is particularly suited for staging or providing lessons in staging executions is apparent from Moritz's description of the execution of one of the murderers, who was also a model for German artists:

> On the morning of the execution the entire place was filled with spectators. The offender was brought forward and immediately led into the gateway that had been lined in black. As he received the sacrament, he ascended the ladder, and the executioner cried out to him, "Do you believe in Jesus Christ?" Once he had affirmed his belief, the executioner threw him below from the ladder and stepped upon his shoulders to hasten his death. Then he placed himself on the dead body . . . , which he embraced and kissed, in order to demonstrate that he did not harbor any hatred for the condemned. The Romans continued to admire the beautiful form of the body and repeatedly cried out: "O che bel morto!" (Moritz 2:473)[14]

In his sensuous description of the Laokoon, Winckelmann demonstrated the importance of staging a beautiful death: that was the function of art in Italy. The transformation of the criminal into artistic model had a long history in Italy (e.g., Caravaggio), but the mechanics of the transformation from criminal to model is important for Winckelmann for the manner in which it elevates the forgery or copy to a model of artistic achievement. Winckelmann's death does not fulfill that promise; his pockmarked murderer/executioner frustrates the transformative abilities of the most accomplished artists or historians. What remains is only the scandal. There is also something about Winckelmann having the knife turned in on himself—or rather, the knife having been turned in on him. His death may be tragic because it threatens to reveal the passionate excesses of his aesthetics, but it is also beautiful in the manner of the execution described above by Moritz. Goethe's notion of execution differs from that of Winckelmann's—or at least from the manner in which Winckelmann's execution can be read.[15] Goethe's appraisal of Ab-

bate Monete's *Aristedemo* emphasizes that the art of execution does not include the execution or suicide of the artist. While he applauds many aspects of the play and finds parallels with *Werther*, the suicide at the end is wrong: "Moreover, it seemed to me that, to Italians, suicide was something utterly outside the range of their comprehension. One killed other people. Yes, that one heard almost every day. But to take one's own precious life, or even consider it possible, that I had never heard of" (Rome, 23 November 1786).[16] This is the art that Goethe will come to learn in Italy. The reacquisition of his creative genius will be nothing other than discovering possibilities of his own rebirth there that result from the performances of the forms of execution necessitated by Winckelmann's aesthetics but contraindicated by his death.

Giving up art for poetry is one result of that discovery. As Goethe tells Eckermann many years later, art requires a handing over of oneself to the object. He had, however, a certain fear of letting objects make their impact on him. If his drawings, as he claimed, are insubstantial, it is the lack of artistic talent that provides him with a means to make off with the spirit of Italy, as Stefan George writes of Goethe, without handing himself over to its objects (10 April 1829). The purpose of Goethe's art was to learn perspective; in turn, this allows him to dispense with the material or sensuous aspects of things (sinnlichen; Rome, 20 June 1787). As Goethe remarks during his second Roman visit, "I am in the land of the artists, let us study them thoroughly, so that we may find peace and joy for the rest of our lives and then move on to something else" (Rome, 20 July 1787).[17] The conditions for leaving Italy and that enabled Goethe to go on to something else are clear: art must be learned and overcome. These conditions are evidently so clear that only a few days later he remarks, "I am thoroughly ashamed of all the babbling about art (Kunstgeschwätze) in which I used to join" (Rome, 29 July 1787).

Goethe's falling out with Tischbein several months later is instructive in this regard. "You cannot imagine how profitable, but also how difficult, it has been for me to live for a whole year among absolute strangers, especially because Tischbein—this is between us—has not turned out to be the person that I thought he was" (Frascati, 2 October 1787).[18] At a time when Goethe is seeking the primal plant and laws by which nature and being are organized, Tischbein introduces a certain lawlessness and instability. His unexpected arrivals and departures interrupt Goethe's perspective, generating impermanence while Goethe is

searching for accountability in nature and the eternal in Italy. "I want to see Rome, the everlasting one (das bestehende) and not the one that is passed over every decade (das vorübergehende)" (Rome, 29 December 1786). But this lawlessness is something Goethe must experience and then overcome. As he explains, he must first lose himself in Rome's deep waters before he can regain perspective and discover that which endures: "Now, it is becoming more and more difficult to give a proper account of my stay in Rome. The more I see of the city, the more I find myself getting into deep waters" (Rome, 25 January 1787).[19] Tischbein and painting in general upset those plans. However necessary painting may be to winning a perspective on things, the requisite surrendering of oneself to the object produces something that Goethe prefers to leave behind or silence.

The threat that Tischbein poses in respect to betraying that secret is evident years later upon the renewal of their acquaintance after Tischbein returned to Hamburg. In 1821 Goethe wrote a cycle of poems to accompany a set of Tischbein's Italian landscapes, "Wilhelm Tischbeins Idyllen." Goethe rearranged the images to fit his own poetic one (*HA* 1:696). The final lines of what Eric Trunz (*HA* 1:376) presents as the seventh poem suggest that Goethe's dismissal of the painterly, or at least his need to distance himself from Tischbein and rework his art, stems from a fear that the painterly renders audible how nature reveals itself in Italy: "Seltsam, wie es unsrer Seel / Schauderhafte Laute spricht. / So erweist sich wohl Natur, / Künstlerblick vernimmt es nur (Strange how our soul / speaks such ghastly sounds. / Thus nature proves itself to be, / Only the artist's eye perceives it)." Evidently Goethe felt that the manner in which one's soul interacted with nature in Italy was better maintained within, secured from a public airing. Consider only the lines in the Trunz edition (*HA* 1:376) that conclude the sixth poem: "Lasset Lied und Bild verhallen, / Doch im Innern ist's getan (Let song and image sound unheard, / indeed it is done within)." As Trunz points out, Goethe began the cycle thirty-five years earlier while living in Italy with Tischbein. This was something the two had borne ever since: "One can assert that Tischbein carried many of his pictures inside of himself much as Goethe did many of his poems" (*HA* 1:696). Tischbein makes known something that Goethe prefers be preserved internally. Given that the Trunz edition presents only a fraction of the poems, perhaps Goethe prefers that much of what occurs during immersion in Italy's waters be discarded or censored.

CHAPTER 2

There is no reference to what it is that might be aired. Indeed, the need to censor or repress *something* is more urgent than any possible object of censorship. The process produces an object to be executed, and as the following entry makes clear, that object is Goethe. He immerses himself in that which is to be observed so as to observe himself, but the self he observes should not be rendered audible—least of all by Tischbein's paintings ("Let song and image sound unheard"):

> But how can we, petty as we are and accustomed to pettiness, ever become equal to that which is so noble and immense and cultivated. Even when one has adjusted oneself to some degree, a tremendous mass crowds in on one from all sides, facing one at every step, each demanding the tribute of one's attention. How is one to find one's way? . . .
>
> The new edition of Winckelmann's *History of Art*, translated by Fea, is a work that I immediately bought. Read on the spot where it was written and with an able and learned company to consult, I find it is very useful. (Rome, 3 December 1786)[20]

He is drawn, overdrawn in fact, by that which envelops him from all sides. To survive he needs to be drawn in such a manner as to be able to retrieve something of himself, lest he go the way of self-erasure prescribed by Winckelmann. But like any overdraft, this one encumbers him with a debt; not everything or every part of himself is retrievable.

As he notes, Winckelmann proves to be quite helpful in negotiating this debt—or, at least, Winckelmann as translated by Fea. A German version of Winckelmann's *History* might not be readily available in Rome, but that does not diminish the significance of translating Winckelmann into Italian. For Goethe, Winckelmann is Italian fare. He does not map a course for withdrawing from Rome to Germany, but he does serve to educate Goethe in the art of execution. In the same entry of 3 December 1786 in which Goethe praises Winckelmann's utility, he announces the beginning of a second life, a "rebirth" that began the day he entered Rome. Thirteen months later, he prefers to consider himself reeducated. "When I arrived in Rome, I felt reborn (neu geboren); now, I feel reeducated (neu erzogen)" (Rome, 21 December 1787). Winckelmann is out of the picture, displaced by one who has learned to survive the executions that recall Winckelmann's presence, by one who,

through self-education, will, unlike Winckelmann, return to Germany. The following passage demonstrates just how closely linked Winckelmann and murder are in the mind of Goethe: "What strikes every foreigner . . . are the murders which happen almost every day. In our quarter alone there have been four in the last three weeks. Today, an honest artist called Schwendemann, a Swiss, was assaulted exactly like Winckelmann" (Rome, 24 November 1786).[21]

However grisly recollections of Winckelmann might be, Goethe recognizes that engagement with his absent presence is essential to the execution of his own affairs in Rome. Winckelmann is the teacher, but like all good teachers he must eventually give way to the pupil. "Today, many of Winckelmann's letters, which he wrote from Italy, fell into my hands. With much emotion I began to read them" (Rome, 13 December, 1787). Since letters presume the distance of the author, it is Winckelmann's necessary absence that touches Goethe. That comes as no surprise, since Winckelmann is the historian who idealized absence. But his frequent appearance in Goethe's journal suggests that Winckelmann may have also been the conjuration that called Goethe so urgently to Rome under an incognito and amid a circle comprised mainly of Winckelmann disciples. In fact, Goethe summons Winckelmann repeatedly by reading his *Geschichte* to this circle of artists, who also serve as Goethe's teachers. But just as he eventually abandons drawing or what Winckelmann's disciples teach him, he invokes Winckelmann so as to be drawn by him for the purposes of withdrawing from Rome and the relationships (e.g., with Tischbein) he cultivated there. Something in that process or in the intervening year causes him to rethink his rebirth as a reeducation. But it also allows him to draw up favorable terms for repayment of the overdraft.[22] He learns via Winckelmann to execute his art differently from Winckelmann. By coming between father and son, Winckelmann usurps the presence of the father(s). If Goethe is to reclaim his name and return to Weimar his fate must differ from Winckelmann's.

Goethe is not unaware of that. For him, Winckelmann's work is unfinished: "In spite of all he did, Winckelmann left much undone, and his work leaves much to be desired. With the materials he had collected, he built quickly so as to get a roof on his house. If only he were still alive" (Rome, 13 January 1787).[23] According to Goethe, Winckelmann's inability to survive Italy accounts for the unfinished character of his work. He is unable "to make use of what others, following in his footsteps, have done" (Rome, 13 January 1787). He cannot follow

those who follow him; he cannot be in two places at once: both before and after his disciples. Moreover, his untimely death prevented him from outliving his benefactor, Cardinal Albani, whose eventual death, Goethe observes, would have allowed Winckelmann to say much of what he left unsaid. Winckelmann's genius remained stunted so long as the father figure, Cardinal Albani, remained alive; something of himself always remained unexpressed. Going beyond Winckelmann (and this includes surviving to return to Germany) is what is meant by the reborn Goethe when he speaks of his reeducation. Via Winckelmann Rome had been prepared as a site to meet absent fathers. If the death of Goethe's father prompts the son to race to Rome, it is clear that the fathers Goethe finds there are false and offensive.[24] It is also apparent from Winckelmann that the emptiness at the center of his artistic ideal demands the self-sacrifice or execution of all its stand-ins or substitutions. Copies must be marked as imitations, and a sign of their lack of originality is—whether it be the Laokoon, Winckelmann, or the figure described by Moritz—the excessive staging of their execution. Goethe emerges from Italy reborn by virtue of his reeducation. In seeking the laws of nature and of drawing, Goethe discovers how to displace himself from the execution of the laws his presence enables. As we will see, the absence of the father vacates a space that allows Goethe to complete his business in Italy, something not permitted Winckelmann, which accounts as well for his work remaining unfinished.

More than incognitos are needed. Two Goethes, an Italian and a German one, are being fashioned here, as he makes clear in his first entries in the diary he is preparing for Frau von Stein.[25] Leaving part of himself to be sacrificed as something other than himself requires more than transporting an absent father for deposit in Rome. That would hardly be remarkable and would bear no witness to the son's deed. Or perhaps that is precisely the point. No one should bear witness to the son's deeds, as Goethe's falling out with Tischbein suggests. Unlike Winckelmann's Italy, his will not be a site of cutting off; it will be cut off. Most notably through his journals and recollected letters, Goethe determines what one sees and does not see of Italy. This also explains why he destroyed the original letters that formed the basis for his second Roman visit, what he calls his reeducation. Goethe himself will become the ideal substitute or copy privileged in Winckelmann's aesthetics.

FATHERS AND SONS IN ITALY

Executive Deal Making

If the classicist works produced at Weimar are the fruits of Goethe's Italian journey or of his study of imitation (Nachahmung), as he once referred to his work in Rome, the artistic ideal that becomes the object of such imitation cannot be exposed as empty (Rome, 6 June 1787). Successful imitation of the ancients must have something more to show for itself than self-erasure; there must be something to sustain the presence of the artist. Winckelmann bemoaned the modern tendency to counter "quiet grandeur" with baroque ornamentation, to clad the empty or still center with excessive decoration. Curiously, thoughts of baroque imitation and self-sacrifice are joined in Goethe's mind as he prepares to enter Rome:

> The favor of the muses, like that of the demons, does not always visit us at the right time. Today, I was driven to develop a most untimely idea. As I approached the center of Catholicism, surrounded by Catholics . . . the thought arose unbidden in my soul that all traces of early Christianity had been obliterated. Indeed, when I visualized it in its purity, as recorded in the *Acts* of the Apostles, I had to shudder at the distorted, Baroque paganism that has imposed itself upon those simple and innocent beginnings. (Terni, 27 October 1786, evening)[26]

Goethe's concern is twofold. His Protestant or (Pietist) sensibilities are offended by the self-indulgent excesses announcing one's entry into the seat of Catholicism, and the muse that favors him, at least under these conditions, exercises bad timing. It is not merely a matter of Catholicism interrupting or obscuring antiquity, of its distorted baroque overlay preventing direct access to the land of his childhood dreams. Rather, his timing is all off, something which must improve if he is to miss his own execution. He must interrupt or elide the rhythms that placed Winckelmann at the mercy of "il Papa" and the knife. What has upset his rhythm is being "locked up in a 'sedia' with a priest (mit einem Priester in eine Sedie eingesperrt)." Even before arriving at the seat of that other religion, the presence of what will upset him on All Saints and All Souls days begins to overtake him. The priest's presence makes it impossible to recall the father's absence. The occupation of a space that must be vacated

CHAPTER 2

recalls the son's fear of a second crucifixion:[27] "Once again, the legend of the Wandering Jew came to mind, who witnessed all these strange developments and lived to take part in that extraordinary scene when Christ returns to look for the fruits of his teaching and is in danger of being crucified a second time. The words *Venio iterum crucifigi* must serve me as an epigraph for this catastrophe" (Terni, 27 October 1786, evening).[28]

Self-erasure, so central to Winckelmann's aesthetics, eventually led to the knife being turned in on him. Moreover, according to Goethe, Winckelmann's failure to outlive Cardinal Albani accounts for the unfinished, sometimes inaccurate character of his work. Winckelmann was cut off from saying what he needed to say. Being locked up with a priest renders Goethe untimely, but it also summons thoughts of a second sacrifice of the son. It seems the only way out of this catastrophe is to time things so that the son can usurp the place of the father. That also means correcting Winckelmann's errant course. Censorship must be redefined or overcome.

Fortunately, fixing identities in Italy is not easy, as is evident from the joy Goethe and others took in hiding them or the difficulty Winckelmann had in distinguishing the original from a copy. Goethe's task is further eased by his father, J. C., whose constant mingling in his son's affairs had already suggested a willingness to take the son's place. It seems that while in Italy, the son is prepared to both recall and mourn the father. "I can forgive anyone for going off his head about Naples (von Sinnen kommen) and remember with great affection my father who received such lasting impressions from the very same objects that I saw today" (Naples, 27 February 1787). The loss of one's senses opens up the possibility of a reorientation or even of a sleight of hand; the position and order of things can be changed. On the other hand, the son keeps his senses about him and goes on in his eternal after-life to become Germany's national poet. However, his resurrection in Weimar challenges the conditions under which Winckelmann resurrected antiquity. Goethe is reborn without dying and avoids the fate of the Wandering Jew or the one who denies the resurrection. This is the magic of his Italian journey: he assumes the ideal character of absence only to turn up later without having truly disappeared. Even if we do not know the exact nature of this transaction, we do know that it has something to do with what he prefers to call upon a second visit to Rome his reeducation. His reentry is a baptism: "I arrived here safely two days ago, and yesterday,

the Feast of Corpus Christi re-baptized me as a Roman citizen" (Rome, 8 June 1787). His timing has improved; the holiday that marks his second arrival celebrates transubstantiation, not false fathers. Fears of a second crucifixion are replaced by the proclamation of a second baptism. Whatever his relationship to the transubstantiation of J. C., Goethe has exorcised the demons that compromised his first visit, and the rumors of executions and murders have ceased.

Two months later Goethe writes of the need to continue his studies and of his intention to remain in Italy until the following Easter. He needs to witness or experience resurrection in Italy once more. He also makes clear that his studies have everything to do with the play of appearances: "You should receive letters from me regularly . . . so that you will have a notion of me as absent but alive (als eines abwesend Lebenden), whom you so often used to mourn as dead" (Rome, 11 August 1787). Vivifying his absence will be the arrival of *Tasso* in January; his presence will be announced by *Faust:* "Faust in his courier's cloak will announce my visit" (Rome, 11 August 1787). Faust is in Goethe's employ, raising the specter of Mephistopheles and the role of the devil in enabling Goethe to cheat death—something that will become more apparent in the discussion of his visit to Vesuvius between Roman visits. Goethe's eventual canonization or idealization as Germany's classical author depends upon a resurrection of antiquity according to terms prescribed by Winckelmann, whom Goethe reads while in Italy. Moreover, through his reeducation he manages to be reborn without dying; he does not meet Winckelmann's condition of self-erasure, either of the ideal or of himself.

While we do not yet know what it is that stands in for absence or how that stand-in denies its secondary status, such transactions are only apparently so. That which appears as what it is not does not for Goethe—as it does for Winckelmann—announce its "as-such" character; rather it orchestrates its absence so as to assert its presence. As the entry cited above from 11 August 1787 explains, letters and works will keep his absence alive. In other words, Goethe learns to hide the conditions of appearance; he travels incognito. This playing with appearance, making the absent present without revealing its conditions, is what I call the work of the devil. More precisely, it requires the enlistment of the devil's services.[29] Goethe's mention of Faust signals the connection, but a more telling reference comes later: "If the progression of my work is to proceed under the same lucky constellations . . . , [I] must give my

CHAPTER 2

soul to the devil (muß mich dem Teufel ergeben) so that I can write *Faust*" (Rome, 10 January 1788).

The remark anticipates Thomas Mann's *Faustus* and the necessity of enlisting the devil to engineer a creative breakthrough. Although there will be more to say of Mann in chapter 6, the allusion emphasizes the need to offer the devil something in return for genius. In the case of Mann, Leverkühn sacrifices the ability to love; he is a willing syphilitic. Goethe's debt (Schuld) remains unpaid for at least forty years, if one considers how long it took him to complete his *Faust*. According to Benjamin, it was something that Goethe never made good on: "The fear of responsibility is the spiritual fear above all others that encumbered Goethe's entire essence" ("Goethes Wahl" 87). That unmet responsibility haunted Goethe to the extent that he became immensely superstitious and idiosyncratic, even expecting a knock at the door at any time from the one who had come to collect his due (ibid.). Indeed, the halcyon ending of *Faust* might be seen as an attempt to rewrite the terms of his *own* agreement with the devil, suggesting his possible difficulty in meeting its initial terms. Whatever the exact terms, the following are certain: 1) In the gardens of the Villa Borghese in Rome Goethe sketched the Witch's Kitchen scene (N. Miller 433). Faust is given a potion to rejuvenate himself and thus render what appearances would otherwise have made impossible. The aged scholar is now youthful enough to seduce Gretchen. 2) Goethe was unable to deliver Faust, but the fragment that finally appeared in 1790 included allusions to secret negotiations with Mephistopheles (*HA* 3:536–37). The full extent of those negotiations are not known until they appear in the later version as a bet, but the three dashes (or the ellipsis) that precede the inclusion of that allusion attests to the need to censor something about the terms of a newly reached agreement—one apparently negotiated between the above citation from 1788 and the 1790 text. It can be ventured that the terms had something to do with the ability, learned in the gardens at the Villa Borghese, to play with appearances. Of course, the bet is the crucial revision Goethe makes to the traditional material, which represents the agreement as a pact. The bet allows Faust to have it both ways: he can enjoy all of Mephistopheles' gifts, and so long as he never volunteers the magic words (i.e., "If I should ever say to the moment: stay awhile! you are so lovely!" [*HA* 3:57]), he gets off scot-free or free of any assessment. He must certainly play with words as Goethe does with appearances.[30] What must also be assumed is the need to post or leave behind

some form of collateral to cover the debt incurred for recovering his creative powers, something, as stated above, tied to his encounter with classical antiquity and the artistic ideal of the ancients. Thus arises the need to usurp the place of the father or have something stand in for Goethe, given the conditions Winckelmann placed on the appearance of the classical ideal.

The figure most suitable for sacrificing in the Goethe oeuvre is Werther. For most of his journey Goethe seeks to escape recognition as the figure's author, which makes hiding behind an incognito all the more inviting. But Goethe presents himself as Goethe to the Prince of Liechtenstein, signaling the introduction of a calculation into his Italian journey: "As useful as I find my incognito, I must not forget the fate of the ostrich who believed that he could not be seen when he buried his head in the sand. While sticking to it on principle, there are occasions when I myself relax my role" (Rome, 23 November 1786).[31]

Goethe is conscious of being two, and the one who is the author of Werther preserves himself for nobility. As with painting in general, the painter Möller is eventually given up. However, the author of Werther only reclaims his creation in order to dismiss him. As we know, upon viewing *Aristodemo* with the prince, he criticizes the "Wertheresque" ending as something incompatible with the Italian spirit. Italy is where alternatives to Werther are played out. But if the author is to preserve himself for the nobility, he still has a need for the work. Recollections of Werther are never far behind, and his untimely reappearances will become part of the calculation: "It would be miraculous (wunderbar) indeed, I cried out, if a fate like Werther's should pursue you in Rome and ruin the life you have so carefully maintained up till now" (Rome, October Report, 1787).[32]

The remark, whose full significance will be taken up in chapter 3, is occasioned by the unfortunate fate of a Milanese woman whom Goethe had previously tutored. However, the recollection of Werther is as wondrous or miraculous as it is unwelcome. As Reinhart Mayer-Kalkus has argued, the search for an absent father gives rise to Werther's suicidal urges or "sickness unto death." In the emerging family triangles of the second half of the eighteenth century or of "Empfindsamkeit," the father's absence haunts the nearness of the ideal: "Werther's desperate cry for the absent father corresponds to the relentless progression of his delusion in the vicinity of the beloved object" (Mayer-Kalkus 130). The beloved or ideal summons Werther, but the passion enflamed by

CHAPTER 2

that object is intended for the absent one, whose ideal character is defined by what one is willing to sacrifice for him. Werther's pleas at the end of his letters assert the persistence of the father as well as the nearness of the two: "Father, whom I do not know, who once filled my whole soul, . . . call me to you! stay silent no longer! Your silence will not sustain this thirsting soul—And would a man, a father, be able to show anger if his son, returning unexpectedly, should fall upon his neck and cry: 'I am here again, my father!'" (*HA* 6:90–91).[33]

It is no wonder that Werther seems to shadow Goethe. These words can almost be read as a paraphrase of Goethe's expressions of joy upon his arrival in Rome. Despite the bald discrepancy in tone, Werther's plaint underscores how Goethe's own arrival in Rome, the "irresistible drive" to reach the "hub of the world," has long been prepared by a father whom he would gladly embrace and let know that he has finally gotten there after "an almost subterranean journey" (Rome, 1 November 1786). Although he initially declares that the dreams of his childhood had come to life, that exuberance is soon muted by the "delusion" of All Saints Day; too many fathers render it impossible for Goethe to find his own father (Rome, 3 November 1786).[34] The "subterranean" awareness that in these parts he is known foremost as the author of Werther serves to keep alive the father's absence.

Goethe's reeducation, however, also signals his ability to distance himself from absence, to reappear in Weimar as the ideal or idealized poet after disappearing in Italy. Until Rome his journey was marked by absolute secrecy ("I hardly dared to tell even myself where I was going"; Rome, 1 November 1786), but this homecoming of sorts gives rise to a homesickness. He resolves to return to Weimar, even if he does not yet know "what it is I will bring home with me," how it is he will reclaim the classical spirit for Germany without succumbing to Winckelmann's fate. "Now that [the desire to see this country] has been satisfied, my friends and my fatherland have once again become very dear to my heart, and my desire to return keen, even all the keener (wünschenswerter)" (Rome, 1 November 1786). The miraculous "reappearance" of Werther and that figure's convergence with the father present the possibility of leaving something behind in Italy to cover up the absence at the center of the artistic ideal and likewise keep the father's ghosts buried in the south. The trick is to merge father and Werther into a single presence or form that can stand in for what is missing—a task that can descend only upon the son of J. C. Goethe and the author of

Werther. Goethe must distance himself from himself; something of himself must be left for dead in Italy.

The manner in which the ideal father (in contrast to the many knock-offs that appear on All Saints Day) is called forth by the self-sacrifice of the son recalls the manner in which castration called forth a father or his law in Winckelmann. This replay of Winckelmann is hardly precise; there is even a wild substitution of object and figures. The mechanics, however, are the same. As Goethe's repeated references to Winckelmann suggest, this replay is in the spirit of things and allows one, as well, to understand what George meant when he wrote of Goethe making off with the "spirit" of Italy. But if in the spirit of things a person or a ghost or a thing can substitute for something else, all things are not equal. A debt is incurred. While such substitutions obscure the difference between one's life and the narrative of one's life by subjecting real-life figures to aesthetic principles and a certain narrative logic, the move is justified by the genre, the travel journal, in which one's life is the subject of narrative.[35]

With respect to substitution and its debts, the German envoys who follow to Italy on Goethe's trail perform an important function. They lend an ideal character to his afterlife. This is required if, in the spirit of things, he is to fulfill Winckelmann's notion of self-erasure but return nonetheless to Weimar to become Germany's most celebrated classical author. For in the moment he returns and reclaims his name, he is no longer there. He is missing in action. Those who follow are seeking a ghost, whose presence is affirmed by those seeking what by definition is his absence. Like Goethe's son August, some may not return and will be left there for dead. They would thus serve as a form of repayment on the debt that accrues through substitution.

EXECUTIVE SCANDALS

The need to repay the unrepayable, the desire to make absence present in Rome makes that lack into something which in itself is nothing but for itself becomes something. As we will see, its paradoxical character is due to the manner in which Rome gives rise to or promotes forms of self-censorship that sustain the illusion that something was there to censure. The example of Faustina is telling. Hers is the name of the beloved in Goethe's *Roman Elegies* and the one to whom Goethe is so often said to have lost his virginity—despite the lack of even scanty evidence to suggest her actual existence. In somewhat different terms, Matthew Bell

explains the phenomenon as follows: "The idea of Italy as a 'rebirth' or 'new life' did not have the same connotations for Goethe and his Weimar friends in the 1780s as it would have later for the author of *Italienische Reise*. In the *Italienische Reise* the old life is simply a gap—it was, after all, the period which Goethe omitted from his autobiography—so that the Italian journey comes to represent a rupture in Goethe's development, which, in fact, never happened" (178). Although Bell points to the "old life" as the period censored, he emphasizes the need to construct a nonexistent rupture, which in his scheme grants the Italian journey an excessive significance. The positing of a rupture, or in the language of my argument a cutting off, is a prerequisite for meaning. For both Bell and me, Italy is where Goethe learns just how meaningful cutting off can be.

The magic of this act should also be considered in terms of the spell it casts upon later generations. Those who follow Goethe search for something that can only lead nowhere; the search is endless. His readership in the afterlife is as guaranteed as it is with those he left behind in Weimar and who anxiously waited for news of his whereabouts. But this sorcery—in which the illusion acquires a material character—is not without its traces or witnesses. The act by which something is made to disappear has a history.[36] Here is where multiple identities or stand-ins are so helpful. Substitutions, such as artists' models—who sometimes murder or end up murdered—or Faustina suggest there is something to hide or censor. The stand-in invites others to seek what was there in the degraded form of a surrogate, thereby lending absence a history which will give that absence the appearance of presence. Unable to present (or, in the case of the primal plant, to find) what Winckelmann had discovered, Goethe subscribes to the mechanics of censorship and lends what also might be called the unpresentable, such as the terms by which an agreement is struck with the devil, a productive capacity. In this mode Goethe is the master of misdirection, setting his followers in search of trails that only ghosts had prepared or trekked.[37] They will never find Goethe, but they contribute, nonetheless, to his allure and idealized legacy.[38]

Once again, learning to see—or what Bell calls "pure seeing"—is essential to this aspect of Goethe's Italian education: "Each day brings some new remarkable object, every day new strange pictures and a wholeness, which one imagines and dreams but never achieves with the powers of the imagination" (Rome, 10 November 1786).[39] Pure seeing is articulated as a fragment, while totality is an ideal most remarkably in-

dicated by remaining beyond the reach of the imagination. Distance—more specifically, a distance from Werther—is how, according to Bell, Goethe acquires this ideal perspective. "In Italy the hunger of the Wertheresque imagination is staved off by pure seeing" (Bell 179–80). A splitting of the self produces an unimaginable purity that can only be preserved in terms of what it staves off. The specter of Werther needs both to be recalled and dismissed. By delimiting the imagination, that specter sponsors the possibility of pure seeing or a seeing of seeing in which objects give way to an unspeakable, unimaginable totality.[40]

Such misdirection is also a matter of timing. The father's and/or Werther's ghost must always be an "eternal" step behind if distance is to be maintained, if the possibility of both recalling and dismissing that ghost is to be preserved. Hartmut Böhme, for example, has focused on Goethe's experience of time in Italy and linked Goethe's scientific accomplishments to an aesthetic born of the clash of human time with nature's time. "In this dialectical tension the configuration of history and nature, of temporality and the ground of being, of the subjective and the objective mirrors itself in Goethe" (211). "The *Italian Journey* can be understood in the aesthetic sense of a 'restoration' (Wiederherstellung) in which the reciprocal effects of historical memory and an immersion in nature come into view" (220). Böhme's vocabulary may not be consistent with the one used here, but the dynamic he describes is. Measured as an experience of time, Goethe's perspective is divided. The split is itself reproductive since it gives rise to the beholding of an interaction between experiences of time. But if we understand the experience of nature's time in the same manner as pure seeing, the objective and the ground of being are products of the subjective and the temporal. The interaction that Goethe beholds is only possible by virtue of the illusion that the objective exists apart from or even prior to historical memory. The father's ghost contributes to that illusion. It grounds the illusion but, given the atemporal or prehistorical character of that illusion, the ground itself is illusory.

The idylls of Wilhelm Tischbein, alluded to above, exemplify this principle, particularly the following excerpt:

Würdige Prachtgebäude stürzen,
Mauer fällt, Gewölbe bleiben,
Daß nach tausendjähr'gem Treiben
Tor und Pfeiler sich verkürzen.

> Dann beginnt das Leben wieder,
> Boden mischt sich neue Saaten,
> Rank' auf Ranken senkt sich nieder;
> Der Natur ist's wohl geraten. (*HA* 1:374)

> Dignified, splendid buildings crumble,
> The wall falls,
> Vaults remain,
> That after millennia of bustle
> Gate and pillar are shortened.
> Then life begins anew,
> The ground is newly germinated,
> Shoot upon shoot descends;
> It comes out well for nature.

The excerpt is an ekphrasis of sorts, recalling the manner in which Winckelmann's descriptions of art allowed for the positing of something or an ideal that by definition was absent. The descriptive ability of language asserts a process which, through use of the present tense, acquires an eternal or ahistorical character. Goethe presumes to witness the deterioration that produces ruins; the productivity or rebirth that is assumed to follow such decay is merely a reiteration of language's own productive or performative capacities.[41] Language asserts a totality he cannot presume to have witnessed or experienced. The final line is nothing less than an expression of serendipity. Nature is made good by what it allows Goethe to experience; presumed objectivity serves a subjective end. The experience of a second kind of time, nature's time, is an aesthetic phantom—in the language of German classicism a "Schein"—that allows Goethe to be somewhere else, to appear to be in two places at once.[42]

By asserting that the production of the aesthetic is Goethe's scientific accomplishment in Italy, Böhme confirms that the Italian journey is law bound. Its benefits are calculated. However, this "Schein" is not easily defined; it is as elusive as it is illusive. In part, "Schein" is Goethe's paternal past glorified as the perduring past of antiquity, awaiting reawakening out of the ruins: "The wanderer's landscape of ruins is fantasy, a montage of elements, something from the father's descriptions that the son remembers or that made an impression upon him" (Böhme 219). As Goethe notes, everything he knew only in fragments through "paintings, drawings, etchings, woodcuts, plaster casts and cork mod-

els" he now sees as "whole," and "a new life begins" (Rome, 1 November 1786). This "whole" is, however, mere appearance. To be sure, the images become real objects in Rome, but nothing is restored to its original state. Moreover, until Sicily the ruins he studied and saw were mostly Roman or Roman copies. The whole is thus better understood in terms of a new or second life whereby the self is linked to a fictionalized present that self-destructs as it resurrects itself. As we know from the Tischbein idyll cited above, the process is also related to the dual nature of a temporality that simultaneously fosters, according to Böhme, forgetting and self-reproduction (220). Goethe's Italian science teaches him to experience himself two times or in two seemingly distinct times.[43] His handiwork consists of a forgetting that allows him sufficient time to escape from himself even as it preserves or realizes the possibility of reproducing himself. The Goethe who returns to Weimar metamorphosed via science as a classicist is himself only "Schein" or reproduction. The original is preserved for another time, interred in the ruins for safekeeping. That is to say, the science of "Schein" allows the process by which one seeks out the essence of something to stand in for what cannot be recovered. Goethe substitutes the process for the thing itself.[44] Rebirth is a reiteration whose auto-formation is the appearance of a second Goethe in the land of copies and knock-offs. And as we know from Winckelmann, there is something ideal about the secondary.

Thimblerigging

Dividing time between an eternal past and an apparent present is no easy task. The evocation of an eternal past from out of the ruins of antiquity requires some form of appearance (Schein) to suggest its accessibility. That past is thus always almost upon Goethe and poised to overtake him. This is particularly true because Goethe tends to identify the ghosts that haunt him in Italy with his father, and of course there is no shortage of stand-in fathers in Italy. Naples is evidently a particularly irresistible haunt of the father, so it presents Goethe with the possibility of depositing his ghost there: "They say that someone who has seen a ghost will never be happy again; vice versa, one might say of [my father] that he could never really be unhappy because his thoughts could always return to Naples" (Naples, 27 February 1787).[45] The ghost may unnerve those who witness it, but one who can ghost himself, particularly in Naples, wins eternal bliss. Goethe undoes that reversal by having it both ways. "In my own way I am completely calm; only when every-

thing becomes too crazy do my eyes pop out of my head (mache große Augen)" (Naples, 27 February 1787). Something about Naples, about discovering the permanent haunt of his father's ghost, restores his calm. Goethe may be wide-eyed and very possibly mesmerized, but the ghost he beholds is also liberating. Its form, as something that can be beheld and thus stand over and against one, is the surest sign that its paralyzing presence in Rome can be overcome: "It is truly irresponsible that one finds these treasures so near to Rome and doesn't visit them more often. One's excuse is only the discomfort of any excursion into these parts and the binding spell of the Roman magic circle" (Velletri, 22 February 1787).[46] On the way to Naples Goethe already notices that something has been lifted from him. Magic excuses the debt (ent-schuldigen), but the treasure that such magic enables is only apparent in parts south of Rome. Overcoming the magical power of Rome involves the transformation of the fathers' spirits in Rome into a single apparition from which some distance can be gained. But once one escapes Rome's enchantment, the find south of Rome suggests the incurring of another debt, necessarily of a different kind.

This debt, however, has little to do with acquisitions and everything to do with participating in trickery. An incident from 22 February 1787 is helpful. Toward the end of the day, some women near Goethe's inn in Velletri encourage the interest of Goethe's entourage in purchasing antiques. Once that interest is expressed, the women, bursting with laughter, bring out a heap of junk: old kettles, fire tongs, and other worthless items. This incenses Goethe and his companions. "[The travel guide] assured us that this trick was tradition here and that all foreigners needed to pay tribute to it." Goethe and his circle succumb to the trick, pay tribute to it, and also dispense with payment. What the experience teaches Goethe are the forms of payment expected of one in these parts. He has already paid (tribute) in advance, and the junk the women offer, as well as their belittling laughter, legitimate refusal of any additional installments. Likewise, any debt owed his father's ghost—which is as counterfeit as the women's treasures—is relieved. On the other hand, so long as he attends to his father's ghost, Goethe is paying him (tribute); but once dismissed, the ghost may demand some form of payment, the actual terms of which will be taken up in the following chapter. Since recollection of the classical ideal cannot be summoned solely by a heap of junk or a pile of ruins, the debt (Schuld) increases by virtue of the services rendered to salvage an ideal. The logistics of substitution permits

the transformation of ruins into monuments, junk into something ideal, but it is only a game of thimblerigging. What one is led to believe is there is only there apparently. And as with any game of thimblerigging, someone eventually gets swindled. All that is brought forth (hergebracht) are old fire kettles, which, however, may be of use to one who upon his return to Rome will write about a witch's kitchen and a youth-restoring potion as part of his magnum opus, *Faust*.

The need to educate himself in the logistics of substitutions, or the mechanics of its transactions as well as its benefits, is best understood if we revisit Goethe's frenzied approach to Rome. It is no exaggeration to characterize that approach as haunted. As he writes from Terni, "Similar dreams hover before me. In my impatience to move on, I sleep in my clothes and can think of nothing lovelier than . . . to allow these first and best fantasy images to do what they like with me" (27 October 1786).[47] As noted above, the sorts of dreams to which he refers are of the Wandering Jew and a second crucifixion. The problem is not so much the fathers that haunt such dreams, but timing. "The favor of the muses like those of the demons do not visit us at the right time" (Terni, 27 October 1786). Goethe grants these ghosts the freedom to wander at will, something their untimely appearances suggest that they already possess. A second crucifixion is a reiteration, as is the wandering of the Jew; but Goethe's own pronouncement that grants caprice to the muses and demons is iterative as well. The immediate effect of this repetition is a reiteration of absence. Although Goethe indicates on the 28th that he will arrive in Rome the next day, he delays his arrival to coincide with All Saints Day. The absence indicated by the break in the text between 29 October and 1 November is staged to reenact his resurfacing in Rome, since during the actual visit his circle at Weimar was unaware of his whereabouts.[48] Reiteration places him elsewhere but, as a second crucifixion suggests, recalling the father also places him in danger. Thus his remark from the 28th, just before his announced arrival in Rome, is all the more curious: "I will not miss the last evening (Den letzten Abend will ich nicht fehlen)." But the last evening is missing, as is he. The *Italienische Reise* offers no account of those days. The text manipulates absence—an attempt perhaps to time the appearance of muses and demons. The manipulation of his own doubling, of a taking leave of himself, is evident here, but it is something that will be learned only later, or at least not until his second entry into Rome when he is baptized "a Roman citizen." The text emphasizes a distinction between two

CHAPTER 2

Goethes: the one who stages and manipulates absence and the one who fears it. His disappointment on All Saints Day demonstrates that he has not yet learned what the later text of the *Italienische Reise* affirms. His final wish before he enters Rome carries a dual significance: "[W]hat shall I wish for next? I know of nothing better than safely landing at home in my pheasant boat to find my friends healthy, cheerful, and happy to see me" (Catellana, 28 October 1786).[49] His wish and his whereabouts are unknown to his friends, but their whereabouts are known to him by the time he recomposes this text for publication in 1816. The musing about his life after Rome before he has even been "reborn" in Rome signals the projection of an absent self or of a self to be absented. He, who is not yet who he is, is already somewhere else or imagining himself to be somewhere else.

This form of self-erasure certainly differs from the one prescribed by Winckelmann. As his renewed contact with Weimar indicates, Goethe's desire to turn up elsewhere requires a stand-in to be where he will have been. Since his father has already been there, he can stand in for the space that Goethe will absent. As Böhme remarks in discussing Goethe's experience of a dual temporality in Italy, forgetting is an important element of the equation. One must forget that the ideal was nothing or that the self that erased itself to preserve the ideal was a stand-in or substitution.[50]

In this game of bait-and-switch it is not solely the father who serves as a placeholder for nothing. Once the mechanics of substitution are mastered, the forgetting or cutting off that grants the substitution its persuasive power opens up possibilities for more than just the father to stand on the other side of the cut. The poem "Zueignung" (*HA* 1:149–52) demonstrates how those possibilities are realized. Goethe began the poem before he left for Italy, and in its fragmented state it was intended to serve as an introduction to the epic *Geheimnisse*. Only after his Italian reeducation enabled him to grasp the mysteries of the classical world could the completed poem appear in an edition of his works (in the same volume with *Werther*), which he had already begun preparing in 1787 (*HA* 1:539). According to the text of the poem, the lyrical "I" receives (is gifted) from a feminine hand the poetic veil of truth (Der Dichtung Schleier aus der Hand der Wahrheit). The poem is the veil that protects him from the blinding radiance of the feminine presence. Writing the poem is thus the weave or veil (aus Morgenduft gewebt) that protects him from naked truth; the text is a commentary upon its

own event. It offers an allegory or emblem of truth in the form of the feminine. Her veiled presence, her only possible means of presentation, depends upon the poem. The gift of poetry is in actuality an aptitude (Eignung) for writing a dedication (Zueignung), for constructing the appearance of the feminine behind its own cover. In effect, this particular idiom of poem posits a figure whose absence sponsors the poem.

The last line of the first stanza offers an indication of what this aptitude entails. "Und alles war erquickt, mich zu erquicken (And everything was refreshed to refresh me)." That which is refreshed or revived does the same; in the narrative of the poem, it revives the lyrical "I" from a refreshing sleep. Reiteration is thematized; the text is doubled.[51] Such ghosting is evident in the next stanza, in which fog and clouds obstruct the vision of the lyrical "I." The narrator cannot see through the cover of his own words. "[Z]og . . . Ein Nebel sich in Streifen sacht hervor, / Er wich und wechselte, mich zu umfließen (A fog stretched gently forth in bands. It came and went to surround me)." The fog produced by reiteration creates bands or, according to this reading, the lines of the poem. And these lines envelop the lyrical "I," serving as a pretext for something to shine through. The movement through which the fog reshapes or reforms itself generates, or is reformulated, as the feminine figure of truth. In effect, she is an auto-formation of the poem, which no doubt accounts for her first words: "Kennst du mich nicht? (Don't you know me?)." As if to render unmistakable the condition of her appearance, the stanza repeats two times the observation implicit in the question: "Erkennst du mich? (Don't you recognize me?)" and "Du kennst mich wohl (You know me well)." In this instance, recognizing is synonymous with knowing; to make out the figure is to know her. This asserts eternal bonds between them, bonds that extend back to his childhood. And these bonds are realized through the figuration of the poem that posits her presence. That presence serves as well for the lyrical "I" to stand over and against himself and realize the grandiose possibilities of self-figuration: "So glaubst du dich schon Übermensch genug (So you think yourself superman enough)." But other possibilities must be realized if, as she insists, his "duties as a man are to be fulfilled." It is not enough to double as more than one. Goethe's study of transgendering in the Italian theater is of use here (Tobin, *Warm Brothers* 120–22). The fog or haze that becomes the veil of poetry ("Schleier" can mean both haze and veil) is something that carries, as the origin of the word "Schleier" suggests (etwas Schleppendes). As long as it schlepps, it can

reweave or refigure the form it both veils and posits. The form of his inflated self or the figure that serves as an emblem of a truth, which can be articulated only through poetic repetition, can redress itself and thereby meet its obligations. The masculine veil (der Schleier) of poetry engenders itself otherwise. In this instance the textual ghost of such reiteration is not the father but a feminine figure of truth. That would hardly have satisfied Winckelmann.

If the Italian journey ushers Goethe into manhood (Eisler), albeit belatedly, "Zueignung" attests in some fashion to his fulfillment of the attendant obligations. Through the substitutions enabled by reiteration he forges and realizes bonds with the eternal feminine. But that apparent triumph comes with a warning implicit to the feminine figure's remark, "Kaum bist du sicher vor dem gröbsten Trug (Of crude delusions you are hardly free)." Her idealized presence behind the veil might be the crude delusion against which she herself warns. Without the veil to refract his vision there may be no vision to behold. The veil of the poem is all that attests to her being. The same, of course, can be said of Faustina, whose only evidence of being is the sixth Roman elegy, in which her spine serves as the backdrop for Goethe to tap out hexameters. Faustina can no longer be understood as the real-life figure with whom Goethe had his first sexual experience; rather she is the emblem of Goethe's failure to deliver, for example, the completed *Faust*. She veils the absence of a relationship and stands in for the original or ideal figure that substitution can never manufacture. But as we know from the end of the poem, mourning by others for the poet (and his friends) due to what can be described as the poet's loss of "her" (truth or Faustina) is itself a form of recovery. For that mourning projects future generations born out of and addicted to this mysterious form of love: "Und dann auch soll, wenn Enkel um uns trauern, / Zu ihrer Lust noch unsre Liebe dauern (And when for us our children's children sorrow / For their delight still must our love endure)." Such mourning requires future generations to read Goethe's poetry. Moreover, implied in such a projection is a future preterit. A subsequent generation will have been, and that generation is burdened with standing in for its own projected absence, thereby lending a future to the crude delusion of the ideal. Such substitutions might also explain the regret "Vezeih mir, . . . ich meint es gut (Excuse me, I meant it well)" that results when these substitutions have no original object. But excusing himself is less an admission of regret than it is a continuation of projecting doubles; it places

the "lyrical I" in a relation to himself or somewhere outside himself. The words of the unnamed feminine interlocutor just before she speaks of the crude delusion now assume fuller significance: "Du siehst, wie klug, / Wie nötig war's, euch wenig zu enthüllen! (You see, how clever, / how necessary it was to unveil so little to you!)." Might not the use of the second-person plural be understood just as easily to refer to the multiple selves produced by reiteration and substitution of which she herself is a product?[52] The unveiling is necessarily restricted, since it is also related to its opposite, "verhüllen," the veiling that is the writing of the poem. Revealing is concealing. It is also necessary in the sense of how much of nothing can one reveal. And it is clever (klug) since it creates an unsolvable mystery, refusing to reveal the delusory and crude nature of a love that takes the place of nothing. That cleverness also signals the triumph of his Italian journey, the recovery of his poetic genius. Through smoke and mirrors, haze and self-citation, Goethe has learned to time the appearance of the muses, whose untimely appearance disturbed his first arrival in Rome, to the rhythm of the poem.[53] For what else is the feminine hand from which the veil of poetry is received than the hand of writing?[54]

3
Taking the Words out of the Father's Mouth
Goethe's Authorial Triumph

A critical difference begins to emerge between the classical aesthetics of Winckelmann and Goethe. In its most concise formulation it might read as something similar to the following: the former imitates the imitation of the ancients; the latter imitates that imitation. The consequences of such differences are telling. While imitation in Winckelmann requires a cutting off that extends to a narrativization of his life, Goethe's narrative of his life in Italy offers a reading of imitation that extends to the very cutting off so critical to the preservation of the ideal in Winckelmann. By originating another order of imitation or substitution, Goethe further conceals the absence of the ideal and survives the conditions otherwise indicated for the survival of that ideal. As Michel Serres points out in *Rome: Book of Foundations,* Goethe may even be the better reader of Rome, the true inheritor of its traditions. According to Serres, Rome is founded upon an infinite regress of violent acts. Romulus murders Remus and Rome is founded. But this act is only one in a series of repetitive and violent acts of foundation:

> Today we are familiar with numerous examples of originating processes that can develop only by sawing off the branch from which they were able to grow. They only develop by erasing the condition of their development; they only have successors by destroying their predecessors. The more origi-

> nating they are, the more they are turned toward what follows them, the more they turn their back on the ensemble that presupposes them, the sequences that condition them. A particular element appears that multiplies only by destroying the world that made it appear. Alba must be destroyed for Rome to be founded. (28)[1]

The originary genius that draws its inspiration from Rome does not reveal the conditions of its (re)birth as it does in Winckelmann's aesthetics. Rather, it conceals those conditions. In fact, this concealing is the originary act, although in the case of Goethe the violence at the origin is not wholly clear. As suggested in the previous chapter, the unusual frequency with which murder greets his arrival into the land of his childhood dreams may serve as a predictor or indicator of what the apparent rediscovery of his poetic talents required.

I have also used the term sorcery to describe the manner in which Goethe's creative rebirth was effected without prescribing to the terms such a rebirth in Rome presupposes. One sure sign of this sorcery is that his rebirth acquires a form of origination it never possessed. In other words, the truly original character of his Italian journey and its supposed rebirth is to be found in a staging rather than an actual reenactment of the conditions for new beginnings in Rome that Winckelmann and Serres presume. The rupture with his past, the sexual breakthrough with Faustina, the resolution of what Eisler has called an enduring Oedipal repression might all be names for a concealment or veil placed over nothing (Eisler 2:927–30). It is important not to assign intention here; a spectacular confluence of factors allows Goethe's journey to acquire the unique status that it achieves.

I have already indicated that somewhere or sometime between his first and second visits to Rome Goethe masters the logic of substitution or the imitation of imitation. The events or passages of his Italian journey that demonstrate such mastery is the subject of this chapter. Goethe's "rebaptism" in Rome will now come to be understood as an indication of Goethe's understanding of what it means to be a true Roman citizen: a staging or reiteration of the rites of rebirth. In this regard, he is a reader, not a follower, of Winckelmann. And since that reading is also Goethe's reading of his own travels in Italy, it always situates him elsewhere. His presence is concealed: "It is history, above all, that one reads quite differently here from anywhere else in the world.

Elsewhere, one starts from the outside and works inward; here, one thinks to read from the inside out. Everything is encamped about and sets forth again from us" (Rome, 29 December 1786).[2]

In Rome, reading moves in the opposite direction; history's course is reversed. This allows Goethe to author his father and opens up all the possibilities for misdirection discussed in chapter 2.[3] In this respect, Goethe's reading is true to Serres's. On the day of his arrival, we recall, Goethe articulates his intent to discover in Rome that which persists (das bestehende). That which persists, we can anticipate from what has been remarked about Serres, is concealment and misdirection.

Missed Calculations

In 1792 Goethe included the "Roman Carnival" in the Göschen edition of his collected works. Along with *Der Groß Cophta*, the text was intended to describe and privilege metamorphosis and law-bound development or evolution over the vulcanite eruptions of the French Revolution (Kiefer 7). In his account of the carnival Goethe insists that chaotic and even spontaneous outbursts are in fact regular and law-bound. Writing on Ash Wednesday, the day after the festivities, Goethe submits that the carnival will disappear "like a dream or fairy tale." The more lasting impact will be on the readers of his own account rather on those who actually participated in the festivities: "And so the exuberant festival has passed like a dream or fairy tale, leaving fewer traces on the soul of the author, perhaps, who took part in it, than on the souls of our readers to whose imagination we have brought the coherent whole" ("Roman Carnival," Ash Wednesday).[4] Any imprint on the soul arises from reading with Goethe, who is already elsewhere by the time he reports on the carnival. His written restaging of the carnival's theatrics confers a sense of coherence and totality that places Goethe, in remove from the carnival, at its center. Goethe the author persists and multiplies (unser, wir), while Goethe the participant disappears. The "we" who is Goethe survives the madness of the carnival. In this mode of detachment that which is a product of his writing is idealized and made whole, but its ideal character depends upon missing the Goethe who actually participated. Immediacy, however, is not without its rewards: "[S]o we remark, . . . that freedom and equality can be enjoyed only in the intoxication of madness and that desire reaches its highest pitch of excitement only in the presence of danger and the voluptuous, half-sweet, half-uneasy sensations which it arouses" ("Roman Carnival," Ash Wednesday).[5]

CHAPTER 3

As Kiefer reminds us, freedom and equality invoke the ideals of the French Revolution (Kiefer 7) and allow Goethe to assert in the same passage that life, taken as a whole, is like the carnival: "The narrow, long, crowded Corso reminds us even more so of the road of our earthly life (Noch mehr erinnert uns die schmale, lange, gedrängte volle Straße an die Wege des Weltlebens)." But if that simile likens life to the carnival, which, in turn, is likened to the French Revolution, then Goethe the author has somehow stepped outside of life, and his presence in the carnival of life is only a likeness. In other words, freedom and equality exist only in a frenzied madness or in the experience of voluptuously sweet and anxious moments whereby danger and pleasure are equated. But the carnival that gives rise to such emotions—the immediacy of which is denoted by an admixture of contradictory sensations—is as staged as Goethe's account of the festival. Immediacy is troped, and the ideal character of Goethe's account substitutes for the ideals of freedom and equality, which, insofar as they are aspects of the carnival, never truly exist. Cutting the reader off from the actual event, which itself is cut off from its conscious political referent (Keifer 7), describes the manner in which totality is achieved. What is striking about this totality is that it is the product of an author who himself is cut off from that carnival. Absence is thus a condition of totality, but that from which one takes leave is merely a simile or trope. If Winckelmann privileged the copy so as to dismiss it, Goethe, as a reader of Winckelmann's reading of antiquity, introduces a second order of substitutions—or, as indicated by the signifying chain of the "Roman Carnival," a simile of simile.

While there will be more to say shortly about Goethe's portrayal of the Roman carnival, his reading of Winckelmann relates to the construction of authorship or what is commonly termed the recovery of his poetic talents. He himself is implicated in his reading of Winckelmann insofar as that which is cut off is a reading or substitute of himself. In the previous chapter I attributed that self of reading to the ghost of reiteration. But if the Roman carnival offers a preliminary glimpse of what we might call the Goethean Italian ideal, it is the area south of Rome where his authorial talents are reacquired, where his true authorial feat occurs.

The first indication of such talents occurs during his ascent of Mount Vesuvius, and it is the result of a missed calculation. In preparation for the ascent, Goethe employs a newly discovered law to "calculate exactly" the interval between eruptions. But at a sharp edge of the

monstrous abyss Goethe forgets or delays his calculation: "Our slow count was missed (versäumt)" (Naples, 6 March 1787). As a result, he and Tischbein are subjected to "a shower of stones" that "with a terrific charge flies past them." In other words, his missed calculation allows him both to experience and to escape the eruption. Had he observed that strict law, he would have been denied the "great delight" that also accompanied his apparent participation in the Roman carnival.

In subsequent chapters I will explore the significance of stones, particularly how such stones lure others to Italy and how they serve as an interlocutor for Heine, who knows no Italian. But in this context the stones that call to Goethe are the ones he ducks and leaves behind. His trail or legacy is marked by what he avoids. That is the bounty of his calculation, save that a missed calculation accounts for the trail that marks his escape. In this instance, the calculation, or "Abmessen" as Goethe calls it, is the locus of his cutting off. Unlike Winckelmann's cut, the interval between eruptions of the volcano does not lead to self-erasure. Instead, a missed calculation or "Versäumen" gives rise to the interval. The root of "(ver)säumen" is "sumun," which Müller-Sievers has described as the "summen" or melodic humming of Goethe's classical poetry. But there is more to this connection than etymological proximity. In his analysis of Goethe's *Roman Elegies,* or what he calls the delayed bounty of Goethe's Italian journey, Müller-Sievers demonstrates that the shift in Goethe's classical poetics is from experience and immediacy to a mean time in which the rules of an already extinguished language are mastered, "while all the time keeping up the illusion of daring immediacy" (439): "It was not naked love that Goethe had finally discovered in Rome as the veiled secret of human and poetical happiness.... If it was the temporal and spatial supplementarity of *Erlebnisdichtung* that had driven Goethe to Italy, it was the derealization of experience—of sexual experience in particular—that allowed him to leave Rome and redefine his position in Rome" (442). Goethe's so-called classical science, in which there exists a reciprocity with poetry (Kiefer 221), depends upon a missed calculation. That "summen" renders the objects of de-realization, such as the stones and lava of Vesuvius, the stuff of poetry, which, in turn, is a marker of his escape.

The dead language of stones, which is the occasional subject of his science (e.g., "On Granite") and the matter of his classical poetry, is related to the language games Goethe plays with Moritz. The game itself is a form of calculation or "Abmessen." The apparent intention is to

CHAPTER 3

ground all language in a universal human nature on the basis of an "intellectual-emotional" alphabet. The game is entirely rule-bound insofar as the two "try out hundreds of combinations" by altering, taking apart, and rejoining parts of words from various languages (Rome, December 1787, "Moritz als Etymolog"). The notion of an essence or a universal human nature is sustained purely by anagrammatic variations.[6] Despite a decontextualization of all words, Goethe remarks how the game enlivens one's "feeling for language." Language is deadened only to be revivified through mechanical means. Talent and feeling play no small part in Goethe's relationship to his father in Italy. Johann Caspar's journal contains nearly a thousand pages of transcriptions of Latin inscriptions. It is appropriate to observe here that Goethe's poetic talents lie in putting into play the mute language of the dead father. The law-bound character of Latin inscriptions and anagrams conveys feelings of a very personal sort, if not a universal human nature.

The ascent to Vesuvius was a rehearsal of one undertaken earlier. Goethe also undertakes a third trip, which is prompted by news after the fact or after news of yet another lava flow reached him. Since the flow is not visible from Naples, he must travel to Ottaino or to the other side of the volcano (Naples, 20 March 1787). This journey to the other side signals a forgetting. Hereafter, all attempts to approach the center of a volcano will be abandoned. For example, his description of Mount Etna focuses solely on lava and rock formations. Of primary interest to Goethe are the petrified remains of that which he is unable to reach. Forgotten is any attempt to experience or record the violence that his father, who also ascended Vesuvius, had described as sublime, given the volcano's ability to turn anything "that fell under its spell" "to ashes or dust instantly" (Johann Caspar Goethe, 10 April 1740). Vesuvius makes explicit what Winckelmann's recalled presence suggested, and the particular spell of Goethe's Italy will lure others to that which he learned to avoid or miss.

The impossible allure of Vesuvius is anticipated by Goethe virtually upon his arrival in Naples: "Vesuvius remained on our left, emitting copious clouds, and I still took pleasure (ich war still für mich erfreut)" (Naples, 25 February 1787). By the end of that sentence a form of petrification overtakes Goethe as he describes the volcano as a noteworthy object: "I still took pleasure at seeing this remarkable object (diesen merkwürdigen Gegenstand) with my own eyes at last." The objectification of the spewing mouth of the volcano is a form of shorthand for

what occurs later in the missed calculation: the object of primary interest is the petrification of a process that is forgotten amid such powerful vapors. The forgetting that leads to his attention being turned elsewhere is suggested by Goethe a few days before his second ascent of Vesuvius. "If one is glad to study in Rome, here one only wants to live; one forgets oneself and the world (Wenn man in Rom gern studieren mag, so will man hier nur leben; man vergißt sich und die Welt)" (Caserta, 16 March 1787). Forgetting to study or count is how one lives south of Rome. But such forgetting is also self-reflexive and suggests a form of self-severing in service of preserving oneself. In fact, in the Italian "Notizen zur Botanik," what Serres describes as a "sawing off" that simultaneously obscures the conditions or materiality of its origins Goethe describes as birth. "[Birth] would be the act whereby the same body separates from itself. The severed body, in the first moment in which we become aware of its having been severed, we call birth" (*WA* 2:274).[7] Once again, in the mean time of the cutting off the calculation of the actual act is missed; the body becomes the locus of birth. Moreover, self-consciousness of the process of forgetting also means that one is shifted to the other side of the process, just as Goethe shifted to Ottaino without traversing the impossible center of Vesuvius. The mean time or the interval is thus ideally infinite or empty, since in the mean time one necessarily has shifted elsewhere. Goethe names that petrified elsewhere "birth." For self-consciousness—and this includes Goethe's—it is a rebirth, one that is premeditated but only insofar as it is miscalculated.[8]

Filial Paybacks

The translocation of the original or founding act of violence from Rome to Naples has something to do with what I have called a miscalculation. The shift is geographical as well as temporal, and the result, which in this instance is the study of stones, is geological. One can also speak of a certain premeditation to this shift, although there is always something dangerous in assigning premeditation to any author, especially Goethe. On the one hand, it results from a calculation, even if that calculation is missed. On the other, it seems always to have been a possibility anticipated by the recollection of a dead father during a trip the father had planned for the son since the son's infancy. In fact, Naples is where the father is closest to the son, where the son "pardons anyone for going off his head" (von Sinnen kommen) as the father had (Naples, 27 February 1787). The father and Naples are inextricably connected for the son,

who asserts that the father was never unhappy so long as he could go off his head about Naples. Soon Goethe travels beyond his father to Sicily, leaving the latter behind. Since Goethe took possession of his father's Italian diaries upon his death and had them with him in Weimar, he might well have anticipated that Naples would be a suitable dropping-off point for his father, or, at least, a point at which he might dislodge from his pedestal a father who had "gone off his head."

There is no way to confirm this last form of premeditation, but the lack of urgency that surrounds the son's visit to Mount Etna is an early indication that a burden has been removed. The path to this volcano was not prepared by his father and thus is not haunted by him. As a result, Goethe must not hand himself over to the abyss and its "powerful vapors." There is no need to surpass risks undertaken by the father. Goethe and his traveling companion Christoph Heinrich Kneip may set off for Monte Rosso, and he may be tempted by the cliffs of Jaci with its beautiful zeolite. "But the Englishman's [Brydone's] ghostly warning (warnende Geist) triumphed. We gave up the zeolites" (Catania, 5 May 1787). Brydone had been unable to reach the peak and instead offered sensational descriptions of the volcano.[9] Unlike the one of J. C. Goethe, Brydone's ghost or that of the scientist allows compulsion to give way to renunciation and self-control. By backing away, Goethe is soon able to grasp himself. "Therefore I sat down in order to take control of myself (um mich zu fassen) and survey the landscape" (Catania, 5 May 1787). Such backing away was anticipated by Goethe's choice of his companion and sketch artist Kneip. By assigning the artist's responsibilities to Kneip, Goethe transfers the losing of oneself in the object, which he had remarked was required of the artist, to another. According to their agreement, Kneip's sole purpose is to draw, and those drawings belong to Goethe (Naples, 23 March 1787). The one who draws allows Goethe to withdraw or back away. As a result, his attentions can be turned elsewhere to the artifact, to Kneip's drawings or to the volcanic remains. In other words, the over-looking, a form of grasping oneself, discovers in the excess of its vision (and Kneip is certainly another set of eyes for Goethe) the ruby stones and ashes of Mount Rossi or similar subjects of Kneip's drawing. Something of itself is deposited. For Goethe that is his father's ghost.

The persistent proximity of Goethe's father to his son in Italy is not difficult to determine, although his ghost cannot be said, at least at this point, to have taken up permanent residence in Italy. Several aspects of

the father's influence on the son's journey have already been mentioned: the extended preparations the father made for the son's Italian education, the acquisition of the father's Italian diaries by the son, the invocations of the father by the son throughout the latter's journey, and the search by each for a chain of being or an "Urpflanze." So profound are the similarities of their journals that upon the 100th anniversary of the father's death, O. Volger remarked in reference to the father's diaries: "Indeed, the more we look into the matter, the more we find repeated and extended in the essence of the son the essence of the father. We are convinced that the son brought the father's life to a more glorious completion—without, for the most part, knowing it himself" (Volger 145).[10]

An example of the manner in which the journeys mirror each other is evidenced by the father's entry into Venice, after a significant quarantine, and his joy in participating in the carnival. Particularly appealing to a man frustrated in his social climbing (Boyle, *Goethe: The Poet* 48–51) is the mixing of all classes. If the father delighted in reporting about the carnival amid the masses and from under a mask (sotto una bella maschera), the son's account of the Roman carnival, the first account of anything about his journey that he will publish, assumes the posture of the unmoved onlooker, far removed from the intoxication that ushers in equality and the "temporary abolition" of the "differences between the social orders" ("Roman Carnival" introduction). This perspective allows him to capture and transport "the reveling and tumult of the carnival . . . elsewhere." As we know, Goethe is not so much the participant but rather the one who takes the carnival apart, organizing and arranging the event according to a series of discrete categories (e.g., "The Corso," "Driving in the Corso," "Climate and Clerical Dress") (Oehlenschläger 221–27). Goethe retreats to a quarantine outside the carnival, a quarantine reminiscent of the unpleasant one that marked the beginning of his father's journey. Such a point of retreat to what for his father had occurred before any real beginning of his Italian journey mirrors in some respects the son's search for the primal plant in Sicily. Journeying beyond the father takes him to a position prior to the father insofar as the primal plant points to a pretemporal (and nongendered) sphere. His self-imposed quarantine from the carnival after immersion in it, his apparent return to the beginning of his father's journey, usurps the father's position just as the apparent discovery of the primal plant is accorded an ideal character beyond the reach of fathers and sons. If the author of the primal plant cannot be found, he is to be envied. As

CHAPTER 3

Goethe remarks in Naples upon his return from Sicily, "nature itself will envy him" his apparent discovery of the primal plant (Naples, 17 May 1787). Since his father never reached the island to discover his "own chain of being" (Ancona, 18 March 1740), he can be said to belong to that same nature. By stepping outside nature so as to be envied by nature, Goethe stands beyond the chain of being. The primal plant is the emblem of his idealized absence.

In fact, the son pursues or engineers several of the father's interests in new ways. In Bolgona the father was enamored with the production of silk, taking a particularly keen interest in the production of veils. (Glaser has noted how the father even tormented his children with his interest in the process [68].) Johann Caspar also reports with pride about the measures taken to keep the process secret. As noted in chapter 2, the son learns in Italy to produce a veil of poetry that helps preserve the secret of the absence behind the veil. Production of the veil thus also serves to conjure the father, who, standing in for the absence behind the veil, suggests there was a secret worthy of being kept tightly. The originary figure, in this case the father, is now a product of the son's veil-making.

While it is a considerable authorial feat on Goethe's part, the reversal of fatherly order might have been inaugurated, or at least suggested, by the father himself. In Italy Johann Caspar reflects long and hard about the starfish, which he had previously considered a plant. Such reflection leads him to reassess the relationship among the animals, minerals, and plants: "That reminds me that coral transforms itself backward into rock, which, nevertheless, must be considered without doubt a plant" (14 March 1740). If the father cannot ascertain a natural order of being, the son is necessarily more interested in assigning an order to things. The father's recognition of a movement backward (and what else is the son's desire for antiquity?) enables that movement whereby in the process of going back something else is constituted to stand in at the beginning. When Goethe goes back to Weimar, for example, he is eventually installed as the father of German classicism, the father of a movement whose roots have been transplanted from ancient Greece via Italy to Germany. And the reworking of his Italian journey for publication in 1816 and 1829 reinstalls him in that position (Kiefer 325). As we also know, his interest in the order of things has something to do with conjuring his father so as to execute forms of self-erasure in service of the classical ideal. Frankfurt society's rebuff of the father's attempted advances points

to the father's understandable confusion between a movement forward and backward. By contrast, the son is adamant about the direction of that movement, insisting on the primacy of the primal plant. But like the weaving of the veil, the planting of evidence is the primal act.

Once again, the father may have been the one who supplied the evidence to be planted. Whereas his maniacal transcriptions of Latin inscriptions were a means to enliven the past, Goethe was merely responding to the father's cue (Glaser 105–7; Johann Caspar Goethe, *Viaggio*, Farinelli intro., cvii). If the father could progress no further than moving from Latin to the labored and awkward Italian of his diaries, the son seems to have been able to appropriate in the meantime, as Müller-Sievers insists, classical or Latin meter.[11] Insofar as the son learns in Italy to forgo immediacy, it is the father's Italian diaries that prompt the son to do so. "The father's choice to write in Italian means in fact a renunciation of immediacy and vivacity of expression" (Johann Caspar Goethe, *Reise*, Meier intro., 19). The son's publication of his own Italian journals in German—or rather of his highly edited and censored journals—is the calculated marker of a progression that retreats from immediacy. At the same time, the father, the interlocutor or intermediary, is destined to be lost in the translation, ghosted or rendered immaterial once the son overshadows and displaces him. The father's absence, which shadows Goethe throughout most of his journey as a very real presence, is what eventually hooks a Goethe readership, necessarily seeking the presence of the absent classical ideal. Those who seek that absent present can find it only by missing it. Goethe had the same advice for those seeking to experience the Roman carnival. The readers of Goethe's account, which he compares to a "dream" or "fairy tale," are left with more than the one who participated in it. This neither prevents nor discourages them from journeying to Italy and Rome, but it sets them off in search of a coherence or "Zusammenhang" (the hanging together of the father and the son) that was achieved only through conjuration, missed calculation, and translation. The best way to miss the carnival is to read Goethe, which ironically will foster an additional need for Goethe's authorial guidance so as to approach the elusive crux of what is missing.

Missed and Magnified Lines of Communication

If the *Italian Journey* displaces the father or upsets and reverses the order of things, it may also account for the haunting frequency of Werther in Italy. Goethe was already known throughout Europe as the

author of *Werther*, yet, as we have seen, it was an honor he only occasionally claimed. "The much lamented shadow," as the poet Goethe later dubbed him in the "Trilogy of Passion," never quite cut himself off from his maker. He remained a problem. The psychoanalytic model offered by Eisler suggests that the demons of Goethe's youth are exorcised in Italy once he overcomes an extended conflict with the father (2:930–1006).

In a line of argument that approaches Eisler's, I have suggested that Goethe's traveling beyond his father to Sicily is a key indication of that liberation. One cannot ignore, however, that these demons, among them most notably Werther, continue to persist and appear. A few additional lines from the first part of the poetic trilogy, the section entitled "An Werther," support the impression that this particular demon was hardly any less forward in its advances as late as 1823–34, the period of the poem's composition or the one virtually halfway between the publications of the first and second parts of the *Italian Journey*. "Noch einmal wagst du, vielbeweinter Schatten, / Hervor dich an das Tageslicht (So, once again, you much lamented shadow / venture into daylight)" (1:30). As the logic of substitution suggests, it is not just Werther who revisits Goethe, it is also Tasso, "ein gesteigerter Werther" (Wilkinson 186–87). Not only is *Torquato Tasso* the work that Goethe carries around with him throughout Italy; Tasso is also the father's favorite poet.[12] In fact, the proximity of the father to Tasso in Italy is often in evidence in his journals. For example, upon his arrival in Ferrara the father rejoices that he can now follow closely upon the trail of Tasso, which leaves little doubt why the son "continuously grappl[ed] with the moods of Tasso" while in Italy (Rome, 26 February 1787). If, as he told his circle of friends in Weimar, the completed play anticipated his return to Germany, the uncompleted play points at best to a triumph mediated via his father of the demons of his youth. It is the father's poet that the son becomes or appropriates, and the repeated appearances of Werther indicate that the substitution of one Werther for another does not dispense with the demon; instead it establishes an economy whereby all transactions leave something behind or unaccounted for. The same can be said of Faustina, so important in the psychoanalytic model as a sign of Goethe's advance beyond paternal conflicts. Once we read her as the self-generation of a poetic act that surrenders all claims on immediacy, she becomes another figure in an endless chain of substitutions.

TAKING THE WORDS OUT OF THE FATHER'S MOUTH

At this point, a deficiency in the psychoanalytic model, or at least Eisler's—which points to a presencing of the self and thus an end to its surrogate forms—is apparent (2:950–1005). I propose that one read the journey literally, as a mapping out that seeks to deposit the demons among the ruins and extract from those ruins an alternate essence or identity. The journey is a moving away from or a traveling to the other side of the abyss of Vesuvius or the emptiness at the center of Winckelmann's classical aesthetics. The father is merely a deposit on the forms of self-erasure demanded for expression of the classical ideal. As stand-in or surrogate, he not only gives rise to other surrogates, but he is also pure ruse, insofar as he is the result of the son's moving away or journeying to the other side. He is the auto-formation of the son's journey but one that was always only predicted by the events since childhood that led to the son's going to Italy. Since this journeying recalls and *virtually* instantiates the father, it should not be read as the son's overcoming of a psychological conflict but rather as something that allows Goethe to assume that the essence of German high culture is a holy father. And the author of that father, since no one else would ever be in a position to find or recall him, can only be Goethe: "So my life is happy because I am about my father's business (So lebe ich denn glücklich, weil ich in dem bin, was meines Vaters ist)" (Rome, 28 September 1787).

It is now evident in what sense Goethe's fame, especially in Italy, is owed to Werther. He recalls the debt to his father's ghost, which can never be paid in full since that ghost is a marker, not an issuer of that debt. Werther issues from the father. As remarked in the previous chapter, Werther's "sickness unto death" results from the longing for an absent father (Mayer-Kalkus). But the triangle of the father, Werther, and Goethe must also be understood in terms of the father's construction of a doomed passion that he summons and celebrates in Milan. Goethe's replay of what he calls a "Wertheresque" passion for a Milanese woman underscores the significance of the father in his absence, who in that absence, serves as an intermediary to rescue the son from a Wertheresque fate (Rome, October Report 1787).

At the end of the father's diaries is a letter exchange between a Milanese woman and a foreign suitor, who pleads for an opportunity to regard up close the object of his affection and to bow before her. The identity of the foreigner is hardly veiled. If the content and place of ori-

gin of the letters did not reveal the author to be Johann Caspar, the idiosyncratic character of the Italian would (*Viaggio*, Farinelli intro., cvii). Despite the foreigner's persistence, a close encounter between the two never occurs. Protocol and personal inhibition prevent her from granting the suitor his request. The impossibility of fulfillment inflames his passion, thereby preserving and extending the medium of that passion, the exchange of letters, which he ultimately severs from Strasbourg. If the father functions as an intermediary, the manner in which his own letter exchange with the Milanese woman is initiated is instructive. The writer held her/his letter up to a magnifying glass so the recipient could read it with the aid of opera glasses. Magnification of a medium, of emotion—particularly letters—is certainly characteristic of Werther, but judging from what I have said about Werther previously, it is clear that in Italy the son comes to understand that the sacrificial object need not be the author. So long as the lines of communication are open, the trajectory of that desire can be directed or misdirected elsewhere. The lines can cross so that the father and Werther become reconnected, and the father becomes a marker of the son's sacrifice of immediacy.

The son's own encounter with a Milanese woman, occurring as it does in Rome, suggests the displacement of the potential love object from its original setting.[13] In fact, Goethe selects her over a Roman woman who sits on the other side of him during a game of lotto. Their meeting during a game of chance indicates that the concern is less in being the original author of one's fortunes and more in playing out and manipulating a game with prescribed rules. During his second encounter with the woman it becomes apparent how fortunes have changed. She professes to Goethe her partial illiteracy. "We aren't taught to write ... because it is feared we will use the pen to write love letters (Man lehrt uns nicht schreiben, ... weil man fürchtet, wir würden die Feder zu Liebesbriefen benutzen)" (Rome, October Report 1787). Goethe proceeds to give her preliminary instruction in English (and writing), thereby transferring the hand (and language) of writing as well as the fate that accompanies it onto another. Tellingly, the instruction concerns an article from a periodical about an Englishwoman who fell into some water and was saved by either her rejected or her favored lover. It is also uncertain whether the woman intended to drown herself. While the instruction summons and fans feelings for the Milanese woman, it is through a manipulation of grammar and the "placement of key words" that accounts for a transfer of potential fates. After explain-

ing to her the mechanics of English, Goethe is satisfied that she is "catechized." However, the more immediate beneficiary of her lesson is Goethe. Although he learns that the Milanese woman, "who had become so dear to him shortly before," is engaged; the miscalculation of her marital status recalls Werther only to dismiss or overcome him: "'It would be miraculous indeed,' I cried out, 'if a fate similar to Werther's should pursue you to Rome in order to ruin the meaningful way of life that you have so carefully maintained until now.' . . . I returned without delay to Nature and the study of landscape, which I had been neglecting, and tried to copy it as faithfully as possible, but I was more successful at seeing than doing" (Rome, October Report 1787).[14] A reiteration of Werther turns him into an observer of nature and of himself. If such a position above or beyond himself and his entanglements offers a safe harbor, it is related as well to an experience of himself as belated and conveniently untimely, something he already had begun to sense a year earlier: "[I] now see the objects in nature . . . of which I so often heard my father speak. To be sure, I see all of these things a bit late" (Mandelkow, *Goethe's Briefe*, 4 November 1786).[15] Recollection of his father precludes immediacy and enables perspective, which in this instance lends Goethe the insight necessary to escape Werther.

In this exchange, unlike the epistolary novel, it is the pursued who suffers. For unknown reasons the fiancé of the Milanese woman breaks off the engagement. The transmission of the father's Italy to the son allows the latter to remove or excuse himself from a result that otherwise might prove to be tragic. "I immediately sought to avoid the English lessons" (Rome, October Report 1787). Since the son's reiteration of the father's own advances to a Milanese woman signal a surrendering on the son's part of all claims to originality, the object constructed in the exchange is what is potentially handed over to a Werther-like fate. The jilted fiancé is the petrified result of this exchange or translation, and her subsequent bout with a life-threatening fever recalls the dangers of immediacy apparent in Goethe's earlier accounts of Vesuvius. Similarly, her recovery points to the rewards of mediation and translation: "I [Angelika] am only acting as an interpreter because my young friend cannot find words to express what she has wished for so long . . . and has repeatedly said to me, how obligated she felt to you for the interest you took in her illness and her fate" (Rome, February Report 1788).[16] Goethe's withdrawal is a form of participation, which allows for the recovery of the victim. The farewell gesture between the two points to the

CHAPTER 3

importance of a new relationship, in which the translator comes between them: "'That is all true,' said [the Milanese woman], leaning across her friend to extend her hand, which I could touch but not with my lips" (Rome, February Report 1788).[17] The hands of writing touch, and the position of the translator assures that all possibilities of immediacy are averted. The lips of the one cannot inspire the hand of the other.

The convergence of events between the father's and the son's accounts of their Italian journeys, particularly in the cases of the Milanese women, allows us to think of the son's account as a translation of the father's or of the son's German as a translation of the father's Italian. Goethe will admit later that he spoke mostly German in Italy. But if such a translation permits a transference of fate, most remarkably of a Wertheresque one, it also refigures the translator or the task of the translator. In the episode just cited it is the female friend who occupies and fulfills that role. And since all translations presume an original text, Goethe is now in a position to assume the role of the author of that which is translated. To begin, he is the author of *Werther*, which he gladly claims upon his second Roman visit: "Here, they pester me with translations of *Werther*, asking me which is the best one and if the story is really true (Hier sekkieren sie mich mit den Übersetzungen meines 'Werthers' und zeigen mir sie und fragen, welche die beste sei und ob auch alles wahr sei)" (Rome, 1 February 1788). He is the author who authorizes translations of his work, and he longs to have the last word: "Almost without exception, I found German travelers very tiresome; they speak about what they should have forgotten (In der mittleren Zeit war mir aus Deutschland kommende Reisende immerfort höchst beschwerlich; sie suchten das auf, was sie vergessen sollten)" (Rome, October Report 1787). Evidently it is for Goethe to decide what German visitors should remember. Perhaps it is reasonable to assume that what should be forgotten are the terms of the transactions that installed Goethe as author, not just translator.

The reason for insisting on such forgetting is clearer if we attend to an episode that Goethe relates before dismissing his German visitors. While he is still wrestling with his emotions surrounding the Milanese affair, he is a dinner guest at the home of the Englishman Jenkins and brings as a gift for the table a basketful of mushrooms. He later learns that the host was dismayed to have been surprised by a dish he neither ordered nor chose. Upon reflection Goethe surmises that the host was concerned that a dubious dish such as mushrooms was served without

his inspection. Goethe then muses: "Thinking over this culinary adventure, I realized that I, who had been infected with a very special poison should, through another act of imprudence, have come under the suspicion of trying to poison a whole household" (Rome, October Report 1787).[18] His own special poison refers to his affections for the Milanese woman. Keeping her at a distance rescues him from a Wertheresque fate and also requires that he mingle with countless visitors "to avoid her without affection." But in pursuing others to come between them, he passes the poison onto the interlopers. In other words, the gifts of authorship that he bestows upon Italian readers of translations of *Werther*—or, for that matter, even upon his German visitors—requires a set of transactions or transferals whereby these others are poisoned (vergiftet).[19]

Double Shifts

In his analysis of the Oedipus myth, Jean-Joseph Goux argues that Oedipus's major flaw lies in his incomplete confrontation with the maternal monster. Instead, an "anthropological" perspective, which Goux equates with instrumental reason, allows him to avoid or circumvent "a bloody ordeal" with the Sphinx or "Thing" (36–38); patricide and incest are the consequences of this incomplete initiation (72–73). Unlike Oedipus, it cannot be said of Goethe that a patricide completed in public view precedes his solution of a Sphinx's riddle. Goethe's own "anthropological solution" requires as well a coming to terms with paternal ghosts (Eisler 2:927–41). The Italian brand of science or (instrumental) reason that places him in two places at once or permits an experience of two forms of time is a double avoidance. Just as a second order of substitution enshrines Goethe as a modern subject and the author of that subject, a second order of avoidance accounts for the success of his Italian journey. He merely shadowboxes with his father's ghost or recalls that ghost to lend presence to a self he would like to avoid or overcome. If, for Goux, avoidance as a rite of initiation creates the original rift that founds the Freudian unconscious, Goethe's crossing of the Brenner Pass into Italy initiates an extensive site for the unconscious that results from a doubling of its own condition of being.[20] Italy is the destination or geography of an unconscious that seeks to escape the violence that accounts for the coming into being of the unconscious. The debt (Schuld) accrued by Oedipus through a first order of avoidance is doubled—in the figures of the father Johann Caspar and the son August, who will die

in Rome during his own Italian journey. A potentially tragic destiny or confrontation is circumvented, but the debt passed on to others is itself eternally deferred.

The joy that marks Goethe's return to Rome is an indication of the triumph of that gesture: "The great feast of St. Peter and St. Paul has come at last" (Rome, 30 June 1787). There are two figures to celebrate, and the pageantry that lends expression and form to this double celebration can only be described as a "fairy tale" that at first leads "one to distrust one's eyes." The magic of that spectacle, and no doubt the reason it challenges the confidence of Goethe's vision, lies in the manner in which a double avoidance can be staged as the celebration of two holy fathers or saints. Moreover, seeing double is evidently what it means to see what is really there. "Now that I had learned to see objects just as they are and not, as formerly, to supply with imagination what is not there, a spectacle has to be really good before I can enjoy it" (Rome, 30 June 1787).[21] The only festivals Goethe takes joy in observing are those that, through doubling, lend actual contour to what was previously only imagined or was simply not there. To recall Goux's terminology, Goethe's circumvention of a bloody ordeal with the "Thing" allows him to see only things (Sachen).

Goethe's missed calculation at Vesuvius is itself a double avoidance: of the volcano's eruptions and of the calculation to escape those eruptions. The most noticeable results are the displacements that have in part been discussed above. Some are geographical—the Milanese woman to Rome—others temporal: the "mean time" of his verse or the double delay in the publication of the *Italian Journey*, first in 1816 and then in 1829. There is also a genealogical displacement between the father Johann Caspar and the son (the death of Goethe's son August in Goethe's lifetime is an equal measure of this displacement), and a philological one between translator and author or between the father and Werther. Finally, these forms of displacement suggest a taking leave of oneself: in the form of an incognito, in the recalling and burning of letters addressed from Rome to his circle of friends in Weimar, and in the retrospective sections that comment years later upon a remembered second visit to Rome.

Predictably, Sicily, the island his father never reached, marks a turning point. It is also the point where Goethe turned around to revisit Naples and Rome. His reevaluation of Paestum during his return voyage indicates a change in perspective. Initially he dismissed its "stubby

and conical columns" as "offensive and even terrifying." Upon a second viewing, Paestum is the "most glorious idea with which he will return North." "Even the central temple, in my opinion, is better than anything that Sicily has to show" (Naples, 23 March 1787 and 17 May 1787). The "tasteless vulgarity" of the estate of Prince Pallogonia contributes in considerable measure to his dismissal of most of what he saw in Sicily. So offensive are the "misbegotten horrors" of the estate that Goethe cannot attribute them to the tastelessness of one man. The prince's ancestors share an equal burden, as evidenced by the most peculiar "absurdity," the family's coat of arms: "a satyr holds a mirror in front of a woman with a horse's head" (Palermo, 9 April 1787). What families bequeath is under the sign of a phylogenetic anomaly. At the same time, the mirror the satyr holds signals the possibility of a reversal or self-reflection. In the case of Goethe such a reversal is an overturning of the genealogical order of things enabled by journeying to Sicily and beyond the horizon of his father.

Goethe thought long and hard about traveling to Sicily; his decision was haunted by ghosts, as was his trip up to that point: "In the next fourteen days I must make up my mind whether to go to Sicily. Never before have I been so strangely torn by conflicting feelings. Today, something happens which makes me favor the trip, the next, some circumstance turns me against it. Two spirits are fighting over me" (Caserta, 16 March 1787).[22] The seasickness he endured during the trip (hin und her gebogen) was a reenactment of the spiritual teetering produced by journeying beyond the father. By contrast, the fortuitous breeze that rescues Goethe from certain shipwreck upon his return is a sign of the journey's success (Naples, en route from Sicily, 14 May 1787). The primal plant, whose existence he avers in the entry that directly follows his account of a miraculous escape at sea, signals the introduction of a new order into the chain of being. The plant, he insists, will allow him "to go on inventing new plants forever (Pflanzen ins Unendliche erfinden)" (Naples, 17 May 1787). It is the "hidden germ" or legacy of his Italian journey, and Sicily its displaced site.

Goethe expected to discover the primal plant in Sicily. But as the enactment of his own cutting off, it disavows any possibility of presenting itself. It can only defer its presentation, to Naples. The plant is on the other side of gender and phlyogenetic anomaly. As perfect creation, it serves in its imaginary presence to mark the spot where the father (or mother with "horse's head") was erased; but it also lends Goethe's work

CHAPTER 3

"an inner truth and necessity," which distinguishes it from "painterly or poetic shadows and appearances" (Naples, 17 May 1787). Goethe now prefers to be the scientist who, "by dividing himself" and excluding "none of the human faculties," moves beyond the dim outlines of art.[23] That self-division is a division from the father or from his imaginary presence. The primal plant is the illusory wholeness necessary to sponsor division. It marks nothing save for what issues from it.[24]

MISSING IN ACTION

The coincidence of fraud and genealogy occupies a central chapter in Goethe's account of Sicily. As he approaches the end of his stay in Palermo, he is "gifted" a particular adventure, which, rather than relate in its essentials, he prefers to report in a roundabout manner ("umständlich"): "A singular adventure was gifted to me (beschert) shortly before I left, which I will now report in detail" (Palermo, 13 and 14 April 1787). The adventure, described in a manner suggestive of Christmas or the celebration of a "fatherless child," results from Goethe's decision to employ deception in order to meet the relatives of Europe's most celebrated charlatan, Cagliostro.[25] Goethe's effort to fib his way to an appointment with Cagliostro's presumed and impoverished relatives stems from the talk of the town that one of its outcast sons, Joseph Balsamo, was Cagliostro. "Opinion was divided whether this person and the Count Cagliostro were one and the same (ob aber diese Person mit dem Grafen Cagliostro nur eine Person sei)" (Palermo, 13 and 14 April 1787). Uncharacteristically, Goethe takes an interest in the peasants as opposed to the nobility, or in people in general as opposed to artworks. Certainly, his interest is not unrelated to one that seeks to explore the limits of disguise and deception. The case of Cagliostro is instructive in determining the limits of cutting off, leaving one identity behind and taking off with another. Goethe's pronounced and extended occupation with copying and confirming the accuracy of Joseph Balsamo's family tree is another indication of this interest.[26] Most striking about this passage is the manner in which Goethe condemns "the deceived, the half-deceived and the deceivers who worshipped this man" and "felt elevated by their association with him," yet takes astonishing pride in posing as an English acquaintance of Cagliostro so as to gain access to the latter's relatives in Palermo. Similarly, Goethe draws upon Cagliostro's antics in *Der Groß Cophta* to condemn the excesses of the French Revolution, but in Sicily Cagliostro serves as a prompt to mislead the innocent and

foster false hope.[27] During his stay in Italy Goethe has cause to forge ties with the presumed family of a forger.

To receive an invitation to visit the family Goethe falsifies his identity and pretends to bring news of Cagliostro's safe arrival in England. Once again an interlocutor, here the clerk of the lawyer (der Schreiber), enables Goethe's passage. He arranges the meeting and translates the Sicilian dialect for Goethe. When Goethe arrives by himself the day after the initial visit, he picks up a letter from the family to their relative in England. Clearly, Goethe never intends to deliver this letter. He is in a position or positions himself to post and deliver only those letters that he authors, like the ones to friends in Weimar that form the basis for this report. Since authors or the originators of letters may not lead back to only one person ("whether this person and the Count Cagliostro were one and the same"), control of the discourse network is crucial, something Goethe maintains via deception.

Control is not Goethe's only consideration; the limits of sacrificing one's identity are in question here as well. How does one control or continue to author what one has forfeited, especially through deception? Reassuming control depends, it seems, upon relieving others of the burden of authorship: "The particular delicateness of the Italian language favors the choice and noble placement of its words, which beyond this are always accompanied by exuberant gestures by which that nation is accustomed to lending its expression an unbelievable charm" (Palermo, 13 and 14 April 1787).[28] Goethe offers his explanation after the grandmother offered her own tender outpouring of good wishes for Cagliostro. If Goethe had not fabricated his own story the eloquence of the Italian language in enhancing the choice and placement of words would not have been brought into relief. Of course, reports of such eloquence are strictly in German; the placement and choice of words are all Goethe's. The liveliest gesture or the one that casts an "unbelievable charm" is the one that transfers authorship to Goethe. It is very possibly the one that elevates the place setter of language or "Schriftsteller" to "Dichter." And this gesture, like the ones Goethe calls attention to but does not describe, is never seen. It is not only authorship that does not lead back to just one person; the original deception has no author as well. In order to collect information for Cagliostro's genealogy and investigate his relatives, the clerk or "Schreiber" manufactures his own tale about the possibility of a secret trust due the family. The family's trust is subsequently repaid by Goethe with a second deception; its pos-

CHAPTER 3

sibility is realized only by Goethe and the "Schreiber." Since Goethe departs the next day, he cannot be held accountable. The family's trust can hardly be said to have been reciprocated.

Or, at least, Goethe does not consider himself accountable. The family had mentioned to Goethe that before departing, Cagliostro borrowed fourteen ounces from them. Bemoaning the abject poverty of the family, the sister asks Goethe to remind Cagliostro in a kindly manner of his debt and request some support. The plea comes during the same visit that the request for delivering the letter does. The family does not so much speak with different voices as it does through different media. Controlling the manner in which these media intersect or around whom they intersect is essential to the installation of Goethe as author. Crucial to such control are calculations or miscalculations, which play a role in Goethe's parting promises to the family. Before departing, he mentions that his first intention (erster Vorsatz) was to make the family a gift of those fourteen ounces, with the assertion that Cagliostro would reimburse him. Starting with the conditions under which Goethe initiated his Italian journey, his calculations never stood in direct relation to his intentions. Thus the final sentence he passes on the family is at odds with the first: "[W]hen I made my calculations alone at home . . . I could well see that in a land where a lack of communications extended distances into infinity, I might place myself in an embarrassing predicament were I to take it upon myself to remedy through my own good intentions the miscalculations of a rogue" (Palermo, 13 and 14 April 1787).[29] Goethe reckons that assuming accountability for a debt that only came to light due to a fabrication of his identity would be a miscalculation. A lack of communication threatens not just his finances but also the discourse network as a whole. Escaping with one's incognito secured (from Weimar or from Palermo) depends upon reckoning what calculations are to be missed, and in this instance the fourteen ounces must be counted among the ones to be missed. They are the responsibility of the rogue, whose untidy calculations (Ungerechtigkeit) allow his origins to be traced and injustices to be addressed.

Among Goethe's miscalculations must also be counted his efforts as an artist. Toward the end of his second Roman visit Goethe confesses that he is a failed artist: "For the visual arts I am too old; it is one and the same whether I bungle (pfusche) a little more or a little less" (Rome, 6 February 1788). Such misappropriation of time is not without its rewards. Soon thereafter the recognition of this bungling produces the

recognition of his true calling as a poet: "Daily, it becomes clearer to me that I was really born to be a poet (zur Dichtkunst geboren bin)" (Rome, 22 February 1788). The genuine advantage of his extended stay in the Eternal City is that it renders future dabbling in the visual arts unnecessary. Now that his sentence as a sketch artist in Italy has been served, Goethe can attend to the more important business of being a poet. Creating an interval in which the more direct or immediate inspiration could be delayed or misdirected was the important task of what he calls his "extended stay" (Rome, 22 February 1788). In fact, February is not the first instance in which Goethe recognizes the relationship between art and poetry. Throughout the second Roman visit Goethe underlines the importance for writing of passing time unproductively. It is helpful to recall his remarks noted in the previous chapter: "I am in the land of the arts, and let us study them thoroughly so that we may find peace and joy for the rest of our lives and be able to move on to something else" (Rome, 20 July 1787). "I find that drawing and studying art is a help, not a hindrance, to my poetic faculty. In Rome, one must write very little and draw a great deal" (Rome, 21 December 1787).[30]

The result of this apparent misdirection or misappropriation of time and resources is one of the very few poems or works that Goethe writes in Italy, "Amor as Landscape Painter" (*HA* 1:235–37). The roles of the elder and the son are reversed in the poem so that "the boy acts the master." The boy, the young painter, brings to life his romantic creation by allowing wind to lend form and substance to her veil or robe: "a zephyr . . . fills the veil of the completed maiden." The source of the sorcery is the boy painter, a role that no longer recalls a Goethe who abandons painting and asserts via Faustina his passage into manhood. But it is the poet or lyrical "I" who makes off with the spoils of such sorcery, just as Goethe took possession of Kneip's drawings. As the boy's index finger breathes light into the landscape, the lyrical "I" takes leave of the scene, perhaps to follow or feint following the maiden. "Do you think I sat so calm and steadfast / Rocklike on my rock? (auf meinem Felsen / Wie ein Felsen)." By now we have come to recognize that reiteration, particularly as it concerns a description of the self, signals departure. The one who magically employs his finger is ultimately usurped by the one who employs the hand of writing. The remains of his creative act are in the poet's hands. The one who describes what the painter performs is moved and leaves the scene of magical appearances. As Marcel

CHAPTER 3

Mauss notes, a doubling of the self for the purpose of leaving a stand-in of himself is characteristic of the magician. "In fact, it would not be far-fetched to imagine the magician splitting himself in two . . . , leaving his double on the spot and taking his real self off somewhere else" (35). The magic attributed to the boy is one more in a series of feints. The real act of magic is the one that allows the lyrical "I" to leave the scene while a stand-in remains to be caught in the act. Since, as was noted in the previous chapter, painting means for Goethe handing oneself over to the object, the reversal of roles allows for the other, the boy, to be sacrificed to immediacy. The magical appearance of the maiden behind the veil is once again the veil of poetry that summons something to be veiled. In this instance, the poem rehearses what it describes. Like the maiden, authorship belongs to the one who can veil appearances, who makes off with immediacy's remainders. In fact, the production of spiritual effects is what Goethe calls the lesson to be learned from art. "When one knows these little tricks (Kunstgriffe), much that looked like a miracle is merely a game" (Rome, 8 December 1787). Art is the mastery of tricks, poetry its effects. Left behind is a ghost or spirit, a spiritual effect and a sure sign, as Mauss reminds us, of the work of a magician.

Indeed, Goethe's uncertain whereabouts become a potential police matter in Messina, shortly after he departs Palermo. The despotic governor feels more than a bit rebuffed when Goethe is tardy for a dinner he did not know he was expected to attend. The governor sends people "all over the city to hunt" for Goethe. Since he had previously asked Goethe to attend his table, Goethe's second failure to appear is particularly irksome. Moreover, the governor let it be known, in Goethe's presence, that he distrusts as spies anyone "who moves from place to place" (Messina, 13 May 1787).[31] While the governor's suspicions issue in no small measure from his imperious temperament, they may not be misplaced. "Amor as Landscape Painter" certainly allows for consideration of the poet as a spy, who observes from the rock what he would like to make off with and then leaves another as the fall guy.

Were one to return to Palermo, it is unlikely that any trace would remain of Goethe.[32] Following his final visit to the Balsamos or Cagliostros, Goethe remarks that the festival of Santa Rosalia, planned for the following day, would with the slightest sweep of wind conceal "God and man in a dense cloud of smoke" (Palermo, 14 April 1787). Rosalia is the protector of Palermo, attributed—upon the discovery of her bones in a cave and their subsequent transport to Palermo—with

freeing the city, via her skeletal presence, from the plague. The festival, whose excesses are, according to Goethe, in stark contrast to the humble shrine in her honor, is the event that signals Goethe's departure from "this paradise" (Palermo, 16 April 1787). The festival, however, only comes to pass due to the occurrence of a miracle upon which the people of Palermo were content to depend. As in years past, a downpour miraculously clears a path for the procession, settling and washing away the dust and debris that was stirred up in days past and would come to obscure the path of the procession soon thereafter. Accompanying Goethe's escape from the consequences of his fabrication of an identity to the Cagliostros is a miraculous washing-away that allows for celebrating the sending-away of the plague. For Goethe Sicily commemorates exile. This is evidenced by the circumstances surrounding his departure from Messina or by the festival, which by standing in for all that has been concealed can only be described by Goethe as "excessive." The reconstituted trail, of the festival or of Goethe's escape, will never lead back to the source and certainly not to Goethe. The storm has washed everything away. (A storm also greets Goethe on his departure from Messina.) This is the source of its miraculous nature. On the basis of information Goethe gives Cagliostro's family, they believe that Goethe has already left Palermo by the time of the festival. They had insisted, therefore, that Goethe return another year to celebrate the festival with them. The festival is a telling event of Goethe's displacement from himself. In the one year he might be found, he will not be looked for, but he will be expected in those years in when there is no hope of finding him. Or, it can be said, he will always turn up in the same capacity: that is, missing in action.

As we know, Sicily is the site of Goethe's discovery of the primal plant. He marks Sicily as the site of cutting off or the site where one displaces oneself from oneself. To be sure, Sicily itself is a displaced site.[33] Long before Goethe decided to venture to the island his father never reached, miscalculations began to characterize his Italian journey. Moreover, Naples is the site from which he announces his discovery of the primal plant in Sicily. Sicily is where substitutions end; it is where the chain of substitutions ends. As it was for the Festival of Santa Rosalia, the trail no longer leads anywhere or is any longer readable. It marks the spot from which Goethe will return to Naples and Rome, and it is also the spot of no return. There is no second set of entries from Sicily, nor will there be a report on those second entries, as there is from Rome. At the

same time, it is the site from which doubles issue (two reports from Naples and Rome, two appraisals of Paestum). It would thus appear to be the site of the origin, referring us to the primal plant. But in light of Goethe's disdain for the estate of Pallagonia, Sicily is only a land of knock-offs and bad imitations. And Sicily is itself a displaced site, standing in for the lack of an original in the chain of substitutions.

As the site of cutting off, Sicily is as likely a place as any for Goethe to encounter ghosts. To be sure, they have often haunted his travels before Palermo, but on this occasion the ghosts tend toward a singular form.

> It is truly a misfortune to be haunted and tempted by so many spirits. Early this morning, I went alone to the public gardens with the firm intention of continuing my poetic dreams, but before I knew it, another ghost seized me, one that had already been haunting me during the last days. . . .
>
> Seeing such a variety of new forms, an old whim (Grille) came back to me: among this multitude might I not discover the primal plant? . . .
>
> I tried to discover how all these divergent forms differed from one another, and I always found that they were more alike than unalike. . . . Why are we moderns so distracted, why do we let ourselves be challenged by problems that we can neither face nor solve! (Palermo, 17 April 1787)[34]

All the spirits (Geister) that have pursued him to Italy can now be named as something other or as ghost (Gespenst). The descendant figures point to a common origin that cannot be reached; their promise is unfulfilled. Instead, Goethe is left with an old whim. But "Grille" can also mean cricket, which is to say that Goethe loses the plant but finds the chirping insect. That his calling is to be a poet—a proclamation he will make upon his return to Rome—might have begun to assert itself at the moment when the cricket began chirping. The visitation of this ghost is rather upsetting, since it frustrates Goethe's intention (Vorsatz) to develop his poetic dreams. In the past, interruptions of this sort have permitted Goethe to discover in the meantime a means of escape. In this instance, the interruption leads to a form of ghostwriting, whose abandoned or thwarted intentions deposit its ghost in Sicily. If Goethe's Ital-

ian journey is remarkable for the paucity of writing he completes or needs to complete there, it is because the form of writing his "reeducation" teaches him is ghostwriting. This is not to say that Goethe does not claim to be the author. On the contrary, he will always have the afterword, either as critic, commentator, or, in particular, editor and censor of the letters and diaries that make up the *Italian Journey*. In this fashion, his intention or previous sentence (Vorsatz) is cut off and suspended. Like the publication of the first part of the *Italian Journey* in 1816, authorship is planned as a comeback. It is always only an afterward, an afterword to the most persistent of these ghosts, the father.

Bad Relations Making Good

If Winckelmann necessitates a chain of substitutions as each copy discredits itself, Goethe's talent lies in summoning and depositing a ghost of himself, most notably in the form of his father, to stand in for the absence of an ideal at the origin. His tactic of substitution presents his readers with a stand-in of the copy. It is a substitution of substitution that, through reiteration of its tactic, calls forth a ghost that allows for the illusion of an origin to persist. The poetry or ghostwriting that issues from such a tactic foregoes immediacy, but it gives rise to a double that is forever on the other side of "iterability" and thus appears to precede all iteration, not unlike the ghost of the dead father. This reversal allows Goethe to be where he is not, to precede his father and claim discovery of the origin, the primal plant, in the space never visited by his father or in Sicily. The abandonment of painting, as if Goethe had ever really been a painter, is the production of a poetry that is very much an ekphrasis that gives rise to the notion that someone had been given over to the object of the painting. Such a surrendering of the self, we might recall, was Goethe's description of painting. "Amor as Landscape Painter" is an example of such ekphrasis.

The magic of Goethe's act, and I refer to Mauss's definition cited above, incurs a debt; in relationship to the father, we might call that debt guilt. If the illusion is to persist, it will always require, like the primal plant, descendant figures, to say nothing of the debt owed to the "one left on the spot." Goethe seems to anticipate the long-standing debt his Italian journey will pass on to others. Since absent fathers will never be enough, he is prepared, as we know, to send his son August years later with Eckermann. It appears at times that he is preparing the weaker and sicklier Moritz for the role. As noted in the previous chapter, Moritz

knows how to write about the staging of executions and the importance of a beautiful death. He is Goethe's favorite companion (Rome, 20 October 1787) and functions at times as Goethe's ghostwriter. Not only does he teach Goethe about anagrams, his prosody is also the beacon (Leitstern) that allows Goethe to complete *Iphigenia* (Rome, 10 January 1787). Goethe makes frequent mention of Moritz's condition and the need for him to find someone capable of explaining it to him.[35] At the same time, Moritz's tendency "to withdraw into his favorite hiding holes" makes him the best sort of candidate for one seeking a ghostwriter (Rome, 19 February 1787). He is, however, the broken arm of that writing duo, the result of a riding accident that brands him as both burden and sacrifice in Goethe's Roman circle: "[Moritz's accident] has destroyed all of our joy and brought calamity into our circle" (Rome, 8 December 1786). This handicap allows Goethe to take control of the hand of writing. Moritz may serve as a sounding board and interlocutor for Goethe's botanical studies, but, as Goethe makes clear, the ideas and words are his: "I spent very pleasant hours with Moritz and have begun to explain my botanical system to him. As we talk, I write down everything we say, so I can see how far we have come. This is the only way in which I could get some of my ideas down on paper" (Frascati, 28 September 1787).[36] At least on paper, Moritz will always be missed and missing, and his absence is what in this instance enables Goethe's authorship. When he finally emerges from isolation, it is to instruct Goethe in the language games he has invented. He teaches Goethe how to arrange letters on a page. Goethe insists that he cannot communicate the particular charm of the game (December, Rome Report 1787). It is not in his interest to do so. Goethe's elation over Moritz's newfound "preoccupation" does signal, however, that by the time of the second Roman visit Goethe has realized a proper role for Moritz. Immediately after specifying Moritz's role in Frascati, Goethe remarks that he is "very happy to be about his father's business." What business Goethe has with his father, he apparently also has with Moritz. But Moritz's arm is only broken, not cut off. Some time after Goethe, Moritz makes it back to Germany and even Weimar. His return suggests the need for others to go in his place. Goethe's debt is no longer covered (gedeckt); no one is there to cover for him or his double.

If there is any doubt that Goethe was aware of such a debt, his actions in Weimar confirm an eventual awareness of it. He passes the un-

delivered letter from the Cagilostros around his circles at Weimar and Gotha. After collecting a generous sum from them, he sends it to Palermo in time for Christmas. In response, he receives a kind letter from the Sicilian family, thanking the intended recipient or Cagliostro in what is now a second letter (*WA* 1, 31:301). Goethe is therewith the author of an economy in which words and money are exchanged.[37] He is the "lodestar in a network" that pays for the letters he intercepts and translates for it.[38] Others have now been enlisted to settle the debt. Goethe's authorship thus depends on followers, readers, and critics to succumb to the pleas of his letters. This is the form of authorship ghostwriting, afterthought, and missed calculations produce. It is always planned as a comeback.

The same can be said of the primal plant, of which Goethe claims to have found its chief feature after he had left the island of its supposed origin. Goethe asserts he has discovered the law from which all variation and offspring issue. "I have clearly and without doubt found the main point where the germ (Keim) is hidden" (Naples, 17 May 1787). But Goethe has not discovered the seed; it will always be in hiding. Rather, he has discovered what is required of an absent present if it is to be viewed upon looking back as a hiding place for something. His answer, we might recall, is "an inner truth and necessity." The multitude of plants must give rise to an inner truth, which of necessity they veil. Since the "same law will be applicable to all living things," his readers and all those he enlists in paying off his debt similarly give rise to his authorship (ibid.). The two—debt and payment, author and reader—are constituted simultaneously. Inner truth and necessity produce a retrospective—as evidenced by the account of his second Roman visit—that posits a primary author in the space otherwise occupied by the middleman or translator.[39]

It is possible now to consider briefly the play whose plans Goethe carried around with him throughout Italy but only completed upon his return, *Torquato Tasso*. Since the play considers the tragic end of his father's favorite poet, the disposing of the father's ghost in Italy might suggest that the play signals a shift in Goethe's approach to a figure that recalls Werther and Werther's final pleas to an absolute father. While this is not the place to undertake a renewed reading, the play might be understood as the document of an author who sacrifices claims of immediacy or the forms and promises of authorship based on such claims. In

the staging of a poet rendered mad and mute by the tortures of playing to an absolute reader, Goethe makes a claim for the reader playing to the author. In fact, the conditions of *Tasso*'s authorship are obsolete. They belong to a different era, before Goethe travels to Italy. A laurel wreath is placed on Tasso's head before he delivers his work; he finds the debt so incurred unrepayable. Goethe's work or authorship shifts that debt onto others. Unlike the Italian journeyer and author of "Amor as Landscape Painter," Tasso cannot move from the rock: "Ich fasse dich mit beiden Armen an! / So klammert sich der Schiffer endlich noch / Am Felsen fest, an dem er scheitern sollte (I throw both my arms around you. Thus / The helmsman at the very last clings to / The rock on which he was about to falter)" (*HA* 5, lines 3451–53). Since he cannot remove himself from the rock, he is not the sort of author who will be missing in action in Italy.

In 1823, while completing the second part or the elegy of "Triologie der Leidenschaft," Goethe altered Tasso's plea to the absolute father in a manner that helps explain his different notion of authorship in the time after *Tasso*. In the play Tasso cries, "Und wenn der Mensch in seiner Qual verstummt, / Gab mir ein Gott zu sagen, wie ich leide (And while man is rendered mute by his torture, / God gave it to me to say, how I suffer)" *(HA 5,* lines 3432–33). In recycling that phrase for the elegy's epigraph, Goethe changes the "wie" to a "was" (the "how" to a "what"). What the poet now seeks is an artifact or aftereffect of that suffering.[40] As artifact, the "what" marks a shift in the transference of Tasso's or the poet's debt. It is the shadow or indelible remainder of what that shift cuts off, and its untimely appearance is beguiling enough to set legions in search of its author, who like Goethe's father was never "there" or will come to have been never there. The artifact, which should be understood to be the poem, will always appear as something other than what it is, since the ineffable can only leave a marker of its unutterability. What one of Hofmannsthal's characters in "A Conversation about Goethe's *Tasso*" says of the play is particularly relevant here: "Something is unveiled (Es entschleiert sich etwas)" (*Prosa* 1:701–3). "Something" will always come to stand in for the subject of a sentence ("es") about self-disclosure. In Italy, Goethe learns to author such sentences, and such sentences always provide a need for others. *Dichtung und Wahrheit* (Truth and Poetry) leads to the *Italienische Reise*, which leads to *Gespräche mit Eckermann* (Conversations with Eckermann),

TAKING THE WORDS OUT OF THE FATHER'S MOUTH

and so on. Additionally, one should factor in the readers who followed Goethe's lead and delivered volumes of his letters and diaries. The sentence was passed on to them. Once again Sicily marks the apparent site of that transfer: "Italy without Sicily makes no impression (Bild) on the soul; Sicily is the key to everything" (Palermo, 13 April 1787). What Goethe discovers on terrain cut off from the mainland is legend.

4
On Goethe's Other Trail
Heinrich Heine's Grand De-Tour

If the Goethe effect is an attempt to divide or split subjects so that the specter of one's posited self might link up and lose itself with other castoffs amid the ancient ruins, three of the more curious excavations subsequently undertaken by German or Austrian writers were those by Heine, Nietzsche, and Freud. Their findings are the subject of the next two chapters. After an examination of the conditions that surround Heine's Italian journey of 1828 and lead to its aberrant course, this chapter considers the consequences of that journey as reflected in *Florentine Nights*. The second portion of the chapter returns to the earlier Italian travel sketches to examine how Heine's journey leads to a virtual ban of his presence in Germany. The reason for considering the later text first is simple. Heine retraces Goethe's trail until he finds that his reading or going backward sends him veering in another direction, away from Germany and into exile. My strategy is in response to Heine's own cue, and it is this strategy that differentiates this project from previous ones. Certainly, there is no shortage of literature concerned with Heine's travel sketches as well as his relationship to Goethe. But to my knowledge, none to date has considered how his relationship to Goethe is mediated through Italy and how attending to Italy as a very real space subverts the logic of substitution mastered by Winckelmann and Goethe. I am concerned here with how the Italy of Winckelmann and Goethe constructs and reifies ethnic difference in order to exclude

CHAPTER 4

Heine from the circles into which the rite of an Italian journey might otherwise initiate him.[1]

Heine's journey, begun in joyous anticipation of an appointment to the recently founded University of Munich and abruptly concluded three months later upon no news of an appointment and the grave news of his father's illness, is an attempt to reverse or overthrow the Goethe effect. If a dead father and the lurking question of what to do with him is the occasion for Goethe's Italian journey, the impending death of Heine's father signals an end to what Heine considered, at least for a portion of his stay, some of the happiest moments of his life (Butler, *Heine*, 70–71). Writing to his uncle Salomon from Lucca, Heine extols the recuperative effects of Italy: "Here, nature is beautiful and man lovable. In the high mountain air that you breathe in here, you forget instantly your troubles and the soul expands (erweitert sich)" (*Briefe*, 15 September 1828). But the land that Goethe canonized as a site for the rejuvenation of one's creative powers has a different effect on Heine. Two months later he writes to his publisher Cotta, "I, poor rogue, am in the throes of a catarrh, which makes it inadvisable to travel across the Alps" (*Briefe*, 11 November 1828). Nevertheless, a month later Heine recrosses the Alps to attend to his dying father, who, by the time Heine arrives, has been dead for a month. In contradistinction to Goethe's journey, Heine's is a measure of bad timing. His missed calculation is not productive. He is virtually paralyzed, the immediate result of which is a creative block and a cessation in all correspondence (Werner 1:172–76; Sammons 139) finally overcome by three Italian travel sketches, including the notorious "Die Bäder von Lucca" (The Baths of Lucca). Lucca may have been the city from which Heine boasted to his uncle about a halcyon expanse of the soul, but the work that issues from his stay there does little to ensure his standing in Germany as a successor to Goethe. By virtue of his ribald attack against August von Platen, Heine's work, as is commonly known, is branded by friend and foe alike as unseemly and unfit for publication.[2] Having made off with the "spirit" of Italy, Goethe returned to Weimar rejuvenated; Heine's spirit, by contrast, was depleted. "I would be once again drawn to Italy. I have squandered all my amorous energy in vain.... My heart is empty; my head dumb and only my nose is full of the scent of oranges" (*Briefe*, 6 September 1829).[3]

If smelling rather than seeing was the sense Heine developed in Italy, what he sniffed was what Goethe's sight would not abide.

Goethe's eye was turned to the past; Heine's nose fixed to the present:[4] "Germany is impossible. . . . But where should I go? Once again, to the South? To the land where the lemon trees bloom, the land of the golden oranges? Alas, in front of every lemon tree is an Austrian sentry who thunderously screams at you, 'Who goes there?' Like the lemons, so too have the golden oranges become sour" (*Briefe*, 1 July 1830).[5] Heine picks up on that which restoration, of one's poetic talents or of a state's political might, would censor or shield. Heine is the object censored, the auto-formation of a process, initiated by Goethe, that needs something to stand in where nothing seems to have been. His Italian journey is thus the partial and belated return of what Goethe's and Winckelmann's tactics of erasure displaced. His detour—Heine never makes it to Rome—is the growth or "Gewächs" of those earlier journeys, whereby something is not entirely cut off but merely reattached elsewhere. This is not to say that the mechanics of censorship fail. As witness to a process that ought itself to have been censored, Heine endures the pain of a reattachment elsewhere. Soon he is forced to live in exile. And the texts that issue from sniffing along the tracks that Goethe sought to cover up lead to an eventual ban of his works in Germany.[6]

It is important to understand—even at the risk of getting ahead of the argument—that the political commentary Heine introduces into the archives of Germany's journeys to Italy is a configuration or even an evolution of the materials that Goethe and his followers sought to cast off or leave behind as unfit for German soil. Ironically, these materials may be the only real content of what has been described in the previous two chapters as a creative rebirth of pure form. This lack of content is emblematized by the primal plant. By setting followers on a search for what was never really there, Goethe induced generations of Germanists to regard the gesture of covering up the emptiness of that content as evidence of that emptiness's unrecoverable greatness. Being of such singular character, as they say, Goethe is the only one able to recover that which was always only missing. Viewed in this light, restoration has a dual function: 1) to restore appearances to an absence that at any moment could be revealed as such, and 2) to restore the purity of that absence, which Heine threatens by merely reenacting and chronicling the mechanics of the cover-up.[7] Goethe, the tradition that ensues from adulating him, Restoration politics, and the dead, untimely poetic forms of Platen are all linked for Heine.[8] What Heine traverses is an Italy that cannot be entirely erased or censored. His travel sketches collect or attract

the discarded. As a result, the Jew who, like the Italian is a "Knoblauchfresser" (garlic guzzler), is sent into exile in hopes of ensuring that what was jettisoned or cut off in Italy will never return to contaminate and haunt Germany's "classistic" revivals.[9]

Reversing the Mechanics of Censorship

Heine's Italian journey breeds a poison pen, and the works that issue from that pen are necessarily suppressed by a circle still infected with Goethe's classical spirit.[10] "What good is it to write, if it is not to be printed" (*Briefe,* 1 September 1836). The plaint from 1836 underscores Heine's lasting predicament in Germany, out of which he hoped to emerge with another work set in Italy: *Florentine Nights,* the "harmless novel" written for Salon III and which, "not accidentally," has often been regarded as the weakest of his major works (Sammons 215).[11] The strategy for such a victory was self-censorship: "Everything that spilled over into the area of politics and state religion has definitely been expunged." This is one of at least seven references Heine makes to his attempts to ensure that his own pen, not a Prussian official's, would do the cutting (*Säkularausgabe,* 2 September 19–24[12]). Heine employs censorship to expose the indecencies of the "high-minded" offended by the ribaldry of his earlier Italian sketches.

Not the least of those indecencies is the means by which self-censorship auto-generates the appearance of an ideal to cover up absence. That was done in the spirit of a classicism revived by Winckelmann and Goethe. Heine forces the reading to go the other way. Looking backward, as the conservative times demand he must, he reverses the mechanisms of censorship to restore substance to semblance or "Schein." He does so by writing a boustrophedon, which, since the annals of Livy has been descriptive of the deception at the foundation of Rome and the classical world (Serres 1–28).[13] Cacus, we might recall, leads the oxen he has stolen from Hercules backward into his cave. Any reading of the tracks leads in the wrong direction. Heine's reading of Goethe eventually takes him to Paris, not to Weimar, but it is a reading that Goethe's writing invites, as law-bound as Goethe's own journey was. Initially, boustrophedon was applied to Greek law to describe writing that alternated from left to right and right to left. Heine's reading is true to the spirit of antiquity, but its moving to the left is precisely what a very right-leaning empire cannot abide. In other words, Heine's reading of Goethe's Italy provokes the very censorship that necessitates such a

reading (after all, it is the law). But unlike the forms of censorship practiced and perfected by Goethe, the repeat has a political content. And the manner in which censorship restores that content is the subject of *Florentine Nights*.

The opening pages of the story suggest what sort of audience delights in tales expunged of politics. Maximillan, the narrator of the story within the story, is instructed by the doctor that his patient, Signora Maria, is gravely ill and therefore should only be told tales that console the dying: "Please, tell her all manner of ridiculous stories, so that she will be obliged to listen quietly (Bitte, erzählen Sie ihr wieder allerley närrische Geschichten, so daß sie ruhig zuhören muß)" (*HK* 5:199). The signora represents a dying order, but the artist who would escape the censor's condemnation—as Heine would have his narrator—must attend to this dying order with foolish tales from the salons of Europe. Like Heine's German readers, the dying patient is not to be aroused. Eager to fill the doctor's prescriptions, Maximillan proclaims his suitability for the task: "I have taken pains to become an accomplished babbler. I will give her no opportunity to speak. I will tell her plenty of fantastic stuff ([I]ch will ihr schon genug phantastisches Zeug erzählen)" (*HK* 5:199). Germany, supposedly so revived by the find of its classical roots in Italy, is a drugged patient attending to fantastic tales to increase the half-life of the Italian narcotic and its numbing of political life.

The setting of Maximillan's first tale is his "mother's chateau," what his father referred to as "the castle." In reality, the castle is a one-story dwelling that, upon Maximillan's first visit as a child, was already a "pitiful picture of the past" (*HK* 5:201). To restore the grandeur of what Maximillan had imagined was an idyllic retreat, he steals away onto the grounds where he discovers a "marble goddess with exquisitely pure features and with a finely chiseled noble breast" (*HK* 5:201). Forced to sleep on a makeshift bed of carriage cushions, the narrator sneaks back into the garden to kiss the marble goddess with "a passion, a tenderness, and a desperation" such as he never felt in his life "from any kiss" (*HK* 5:202). The dying Maria's pose on a green sofa prompts the narrator's memory of that kiss and awakens as well an irresistible desire to kiss the patient. Censored forms of storytelling are thus designed to arouse, via their fantastical restorations of a past in ruins, a necrophilia. In fact, the actual kiss inspires in Maximillan a strange passion for marble statues that sends him that same day to the Lorenzo or the Medici library in search of a pleasure that only marble statues, such as those of Michel-

angelo, can impart. Exiting the library, he finds himself in a chapel built by an Italian family. In the chapel's center a female statue comforts the slumber of its occupants: "The whole realm of dreams, with its calm felicity, is wrought into this statue; a tender rest dwells in the beautiful limbs. . . . O, how gladly I would sleep the eternal sleep in the arms of this night" (*HK* 5:203).[14]

For Heine, statuary is always associated with Winckelmann (Hohendahl, *Occident* 9–15). Indeed, the description of marble statuary offered by Maximillan explicitly recalls Winckelmann's love of "quiet grandeur." Whatever their gender, these marble objects of desire are symptomatic of an unnatural impulse. Like Winckelmann's love of the castrati, they are tied to a drive to resist the inevitable passage and transformations of time, and they are likely to be no more procreative. The contra-creative climate of censorship is the legacy of Italophiles invested in going on and on about the passions aroused by copies of Greek art.[15] Such passions rehearse those of Winckelmann and lend new meaning to his confession, "I am so in love with this work." Practiced in an art of storytelling that does not stir the body, Maximillan describes unequivocally the trajectory of passions stirred by Winckelmann's love of statuary: "'And you have always loved only sculptured or painted women?' Maria asked with a smile. 'No, I have also loved dead women'" (*HK* 5:204).

The distinction between chiseled and painted women is also instructive. Maximillan recalls that only once did he find himself in love with a painting: "a wonderfully beautiful Madonna whom I came to know at Cologne on the Rhine" (*HK* 5:203). He muses that he dreamed of fighting in the Crusades to defend "Maria's immaculate reception (immakulierte Rezeption)" (*HK* 5:204), but soon thereafter he forsook God's mother for the Greek nymphs of the galleries of antiquity. Catholic denial of the flesh prepares one for a return to the insentient forms of antiquity, especially if one reads backward from late Romantic Germany to Goethe and Winckelmann. This progression, which is also a regression, is a noble one, if Maximillan's acquaintances—including those who are the talk of all the salons—are any indication of his station. By contrast, Heine's late Romantic contemporaries have not yet matured from the two-dimensional love of their newfound Catholicism to the three-dimensional fullness of Greek statuary.[16] These are the two critical stages of necrophilia. The boustrophedon that Heine writes is an inscription of the law of his time. The backward reading that

comes to be the law of the time always leads back to Goethe—but also to petrification. Thus Maximillan, who is the product of a self-censorship that Heine was certain would not arouse the official censor's ire, arrives at a station above his Romantic contemporaries by virtue of his love of stone. It is precisely that love which qualifies him as Winckelmann's disciple.

The tales produced by this narrative law can only be described as fancies of a moribund imagination. These include the narrator's insistence that he witnessed Bellini in a moment of unsurpassed enchantment shortly before his untimely death. "In this moment he appeared to me as if touched with a magician's wand, as if changed into a thoroughly well known apparition, and I immediately became fond of him. . . . It was perhaps the brightest moment of his life" (*HK* 5:213).[17] True to the spirit of Winckelmann, the moment before death is privileged and enshrined. It forms the bond between Maximillan and Bellini, but the charm of this Bellini lies in the impending obliteration of all expression, much as the tortured expression of a dying Laokoon inspired in Winckelmann a love of his work on art history. Moreover, magical and fanciful appearances are all that remain to enliven the world of the necrophiliac. They are what can be summoned of the dead. The emphasis is not on that which is given but rather on that which one imagines in its place. This explains Maximillan's so-called musical second sight, which brings "visible forms and facts" before his eyes during one of Bellini's concerts (*HK* 5:217).

It is not remarkable that the only man who ever succeeded in putting the true physiognomy of Paginini on paper was a deaf painter "who in his inspired lunacy (in seiner geistreichen Tollheit) hit off with a few pencil strokes the head of Paginini so well that one is both amused and frightened by its truth" (*HK* 5:214). The frightening truth of the matter is how the essence or the defining characteristic of Paganini's talent is insignificant for those like Goethe and Winckelmann who prefer to learn to see. Much to any censor's delight, such seeing has little do with anything actual or current. Similarly, Maximillan's attendance at the opera is solely a means to view from afar the faces of the Italian women and the manner in which those faces recall statues under torchlight. Dismissal of the present, becoming deaf to the actual, is how one is admitted to the in-dwelling spirit and silent mysteries of the marble monuments of the past. The censor's knife is the necrophiliac's delight.

CHAPTER 4

What in the first Florentine night was a parody of classical aesthetics or desire aroused by classical statuary becomes in the second night an indulgence in the desire for the irreal. The descriptions of Mademoiselle Laurence and her entourage that occupy the second part of the text chart the trajectory of castrated desire. The passion that issues from Winckelmann's love of the castrati breeds a necrophilia by virtue of its capability of arresting time. And the cut that arouses such desire is also the censor's cut, the results of which are the freak shows and frivolous fantasies of the second Florentine night. At the same time, the text restores a political character to the censored text by exposing the material lack that results from that cut. In this regard, the dying Maria's question at the beginning of the second part is revealing: "But tell me, was Mademoiselle Laurence a marble statue or a painting, a corpse or a dream?" (*HK* 5:207). As we shall see, the answer turns out to be all of the above. The dream of a lifeless corpse inspires both Winckelmann and the oppressive regime of the Restoration, and Mademoiselle Laurence, the "child of death," is the eventual content of that dream.

At the end of the second night, Maximillan reveals the source of the mademoiselle's charm. Her haunting dance, which so captivated Maximillan and apparently made her an item throughout the Continent, had something "of drunken abandon, something gloomily inevitable, something fatalistic." She danced, he concludes, "like destiny" (*HK* 5:231). What such destiny promises, however, is not the simple death awaiting Maria or any mortal but rather a premature burial, a life lived under the sign of an early death. The dancer's moniker, "child of death," and the spasmodic movements characteristic of her performance derive from the peculiar circumstances of her birth. She was the child of a count who repeatedly abused his wife but had her buried with great ceremony. At the time of her death, the mother was far advanced in pregnancy; when churchyard thieves opened her grave, they found the countess still breathing and undergoing labor. Upon the child's birth, the countess died and was returned to her grave. The countess's case proves that grave robbing is productive and that a dying order can always be restored or recalled through, among other things, Mademoiselle Laurence's dance of death.

The subject of the self-censored text is the living dead and an articulation of what it means to be buried alive. Grave robbers share certain practices with the politicians of the Restoration. But it is also important to point out that Heine's text participates in those practices; it is the

voice of the buried alive. In fact, Mademoiselle Laurence fascinates precisely because she allows the dead to be ventriloquized, although she remains cursed by that voice. Of course, it is not her mother's voice that curses her but rather that of her adoptive father, the famed ventriloquist, whose talents lie in an ability to disguise the source and make his voice resemble that of the dead mother as if it were coming from the earth. "Cursed grave child (Todtenkind), I wish I had never brought you out of the grave" is a favorite refrain of the ventriloquist (*HK* 5:246). In the previous two chapters, we saw how concealing the source was a condition of classical beauty. In this instance, concealment curses its progeny, which does nothing to diminish its appeal. It merely announces the destiny of those bewitched by its spell.

The censored text may issue from the grave, but its fate is a political one. The cut is not complete. As with Winckelmann, the text, subject to a discourse network of its own, necessarily comes to elaborate the conditions of censorship, and since censorship is an expressed politic of the time, the text accrues a political content. The politics that emerge from this incomplete cut, however, is virtually unreadable. Maximillan's comments about the English are instructive in this regard. The frivolity of his remarks about their pitiful cuisine, endless toasts, and truncated noses contrasts in subject matter but not in tone with his observations about how indiscriminately the death penalty is administered in England. He decries the hypocrisy of inundating the world with Bibles but executing sheep thieves and forgers. Nonetheless, the real source of his ill humor, he insists, is the machine-like character of the people. "Yes, wood and iron and brass seem to have usurped the spirit of man . . . while soulless man, like a ghost, attends machine-like to his everyday business" (*HK* 5:227).[18] Concern for the soul of man and disdain for his ghost is odd, coming as it does from one inclined to love the dead. The potential sincerity of his concern is further diminished when he articulates the images summoned by a profound melancholy as he stands upon Waterloo Bridge. The mood, inspired perhaps by thoughts of Napoleon's defeat, evokes images "of the most powerful sorrows": a rose wet with vinegar and thus withered before its time, a stray butterfly between walls of ice, and a domesticated ape serving its young (*HK* 5:227). Sincerity is a posture one strikes, and political sincerity is no less postured. Mourning the loss of a genuine politic or of Napoleon is no less impossible than imagining a rose dipped in vinegar or a frozen butterfly.

CHAPTER 4

The other performers in Mademoiselle Laurence's troupe, particularly the dwarf and the poodle, frame all political references in the context of the absurd. At first glance the dwarf seems to be the easiest figure to read. When he is not crowing like a cock, he spews the names of emperors, kings, and princes whom he celebrates as patrons and friends. He insists that as a child of eight, he held a lengthy interview with Louis XVI, who in later years often consulted with him on matters of state. Even Pius VII virtually "idolized" him. Only Napoleon shunned the dwarf. His most dazzling feat is with the sword; with a long rapier he transfixes the air in all directions and challenges anyone in the audience to a duel. Obviously, he has no challengers, just as no one challenges the bald absurdity of his claims. Displays of what the narrator dubs "old French grace" are consigned to street alleys and circus booths (*HK* 5:228). In fact, just before his death, Maximillan sees him between two very tall lubbers dressed as clowns, leading the narrator to observe how odd it was that "a dwarf who dies among giants would compare himself with a giant who dies among dwarfs" (*HK* 5:243). Aristocratic airs are the product of a dwarf whose measure of things is inverted. But is such commentary even readable? The apparent critique of anti-Napoleonic sentiment by the messenger, by a narrator seeking to flatter and flirt with the dying, and by the absurd trappings of the tale reduce the critique to idle fancy.

The same can be said of the so-called fourth person in the troupe, the trained and "very hopeful French poodle," who composes the name Lord Wellington out of wooden letters and adds the epithet "Hero," to the delight of his English audience (*HK* 5:228). As the editor of the text points out, Heine held Lord Wellington in low regard because he defeated Napoleon at Waterloo. The narrator's first encounter with the troupe on a bridge named for the battle accentuates the reference (*HK* 5:987). Praise for Napoleon's conquerors is reserved for a person who is really a dog—and that would include the Prussians as well. The gesture may be consistent with Heine's own sentiments but not with Maximillan's—and even less so, one can presume, with the censor's. In each of these instances the text turns back upon itself.[19] Like the boustrophedon, the text reads in both ways. The censored script stutters. It needs to say something and nothing, which is precisely how one could describe the fantastic tale of Mademoiselle Laurence and Heine's predicament. The structure of the story, in which Heine cedes his voice to the narrator who in turn cedes his to Maximillan, signals a strategy to splin-

ter or disrupt "univocity." Such "equivocity," if we might call it that, does not undo what was said but marks the text as Jewish. That was confirmed by Heine's contemporaries, who charged that Heine missed the times with a piece more suited for France than Germany, and, more to the point, that Heine's intellect and wit were misapplied and totally "ungerman" and "unnatural" (*HK* 5:879–80).

The censored or halting voice never ceases hurting, just as Winckelmann's cut never did. And the traces of that incomplete cut, which never ceases hurting, always show up elsewhere, as was also the case with Winckelmann. In this instance, that elsewhere is the intended preface to *Florentine Nights*, which, due to its aggressive tone, was removed and published separately in "Über den Denuzianten." Heine's target was Wolfgang Menzel, the so-called pope of literature, whose shift from a progressive politic to a conservative, anti-Semitic one was already predicted by his moniker (Sammons 196). Heine attempts to turn the tactics of anti-Semites back on themselves, to reverse the trajectory of that assault and draw out from hiding the excessive and violent zeal that characterized the conservative tradition emanating from Goethe and Winckelmann. Heine's billingsgate is thus relentless. Menzel is a man of dishonor and inferior literary talent, of Mongoloid rather than German origin (*HK* 11:154–68). Menzel did not respond. As Sammons writes, "Far from driving Menzel into a corner, [Heine's attack] allowed him to climb on a high horse of superior dignity and disdain the challenge as well as its author" (215). What Adorno calls Heine's wound is self-inflicted. The "excessive mimetic zeal of the outsider" exposes what is on the other side of the cut, its material remains (Adorno 1:80–85). If Winckelmann was fascinated by the castrato or "der Verschnittene," Heine is the circumcised one or "der Beschnittene," the ineradicable scar of that cut.[20] *Florentine Nights* traces the cut that is the signature of German classical aesthetics. At the same time, Heine's Italian travel sketches, to which I will now turn, reinscribe what Winckelmann and Goethe sought to erase by that cut.

BACK TO ITALY

For Heine, whose father's death is not a pretext for an Italian journey but rather a shadow gathering on the home front, all roads will not lead to Rome. Goethe's trails will be interrupted. Unlike Goethe, the "baptized Jew" does not arrive a first, let alone a second time in the Eternal City to find himself "rebaptized a Roman citizen on the Feast of Cor-

CHAPTER 4

pus Christi."[21] The Italy that addresses Heine does not reconstitute its body or bodily remains in ideal and everlasting terms. He "submits more willingly to the flow of things" (Butler, *Heine* 78) and has no official appointment to sustain a speculative vacation. What speaks to Heine is what has been cut off or excised from the tutelage of fatherly patrons.[22] The discredited copy—and in this context one must consider that Heine is both the baptized Jew whose German is zealously mimetic (Adorno 1:8) and the one whose trip to Italy is financed by swindling his patron Uncle Salomon—is what Heine installs in the space of the speculative.[23] What was necessarily vacated so as to enable the appearance of the ideal is recalled in Heine's Italian sketches, and it testifies to the mute disfigurement that founds and sustains the classical illusion. The plaint of the castrato or the Laokoon or the Apollo Belvedere, the censored or burned journals of the Goethes and Faustinas who were declared missing in action—everything that was cut out because it did not fit or was deemed unfit for Germany is what Heine picks up on. He turns the stones over once too often: "I see Italy, but I don't hear it. Nonetheless, I do not often lack for conversation. Here, the stones speak, and I understand their mute language" (*Briefe*, 27 August 1828, Livorno).[24] Heine does not speak Italian, so he must negotiate additional obstacles, making it impossible for him to perform the translations that allowed Goethe to make off with the spirit of antiquity. Heine is left with the material remains. That same letter continues: "Even the stones seem to feel deeply what I am thinking. A broken pillar from Roman times, a crumbling Lombard tower, or a weather-beaten Gothic arch understands me. I myself am a ruin, who wanders among ruins."[25] What has been rendered mute (and in the discourse that Goethe conducts from and after Italy, Frau von Stein should be included) finds an interlocutor in Heine, who at night wanders the streets to discern the secrets of a "monumental" past. "Indeed, evenings I understand Italian completely," he writes in the same letter. To be privy to such secrets, however, is not without its risks. "In Genoa a scoundrel swore in front of the madonna that he was going to stab me. The police warned me that such people definitely keep their word and advised me to depart immediately" (*Briefe*, 6 September 1828, *The Baths of Lucca*).[26] Although Heine insists that he is not unnerved by the threat, *The Journey from Munich to Genoa* often portrays Italians as sly, treacherous, greedy, and bloodthirsty. Goethe developed a strategy whereby surrogates would be offered up to this Italy. Heine, who long ago declared himself to be at war with Goethe, might

well have considered himself handed over or offered up to this Italy.[27]

The first of his Italian travel sketches, *The Journey from Munich to Genoa,* is designed to set Goethe's record straight. If Goethe labored for decades over the text of his Italian journey, Heine privileges the immediate. He is not driven to arrive anywhere and does not seek to glorify the dreams and prospects of his youth. The Italy mediated by Goethe via his father via Winckelmann is lost on the impulsive Heine. His journey is a grand de-tour through the sidestreets and alleyways that shadow the "via" that led Goethe—if we recall his account of the Roman carnival—to a purchase above or removed from Rome's grand "corso." As Jost Hermand writes: "In contrast to Goethe, [*The Journey*] is not merely travel letters but rather a thoroughgoing report. . . . Heine is not driven from the beginning to make it to Rome, to the 'eternal city,' to 'the capital of the world.' He therefore gives in freely to his momentary impulse instead of holding onto the illusion in Italy—at all costs, to rediscover the magnificence of antiquity" (138).

The itinerary featured in Heine's text repeats the early part of Goethe's, including stops in Munich, Innsbruck, Brixen, Trieste, Ala, and Verona. As we know, Goethe was interested in learning to see with an artistic/scientific eye, in arriving at a form of "noble perfection" through appreciation for all the "objects that were so worth seeing" (Rome, 3, 5 December 1786). That meant fixing his eye on the works of Michelangelo and Raphael to the point that even nature became "distasteful" to him (3 December 1786). To love Rome was to love rocks, which in turn led to a love of "history, inscriptions, [and] coins" (Rome, 19 June 1787 and 3 December 1787). But it is the first leg of Goethe's journey that Heine retraces and that throws him off course. These are the sections in which Goethe's encounter with Palladio leads him to imagine for the first time perfection in the place of a fragment. It is a task, he argues, to which one should devote years, which in fact he does (Venice, 2 October 1786). It is also a task that requires removing one's person from the scene of observation, which, as the mysterious traveler with an assumed name, he also does. Heine's attention is turned toward the everyday, which never presents the opportunity for years-long observation: "Even the small harpist, in which Goethe saw a symbol of pure innocence, is for Heine a rosebud that has wilted too soon" (Hermand 140).

More to the point, Heine collects anecdotes, not rocks. In fact, the sketch begins with a seemingly frivolous discussion between the narra-

CHAPTER 4

tor and a Berliner about the virtues and shortcomings of Munich, the city referred to as the "modern Athens." Gradually, Grecophilia assumes a ridiculous character as it is exposed as a fashionable sentiment, the topic of the day:

> I however came to the defense of the modern Athens. . . . Berlin is not a real town, but simply a place where many men, and among them men of intelligence, assemble—who don't care about the place; and these persons comprise the intelligent world of Berlin. The stranger who passes through sees only the far-stretching, uniform looking houses . . . which afford no clue to the manner of thinking of the masses. Only Sunday children can ever guess at the private state of mind of the people who live there. . . . Here it is hard to see ghosts. The town contains so few antiquities, and is so new, and yet all this newness is already so old, so withered and dead. (*HK* 7, 1:16–17)[28]

The narrator's stance on the matter is circumstantial, dictated by a need to defend the honor of Munich and the dreams of Grecophiliacs, both of which require ghosts to enliven what would otherwise be considered dead. At the same time, his perspective allows him to comment on the character of Berlin in regard to the living. Its dismal and deathlike character is a consequence of the time in which the many "sickly, stupid countenances" that peep from "so many stupid, superstitious houses have settled down among the old, skeptical, philosophical dwellings" (*HK* 7, 1:18). If the narrator's account betrays parochialism, it is the result of the narrator's preoccupation with the living, the visible, and the present (Pabel 200). Even the dreams of antiquity are reduced to a caprice. Those like Goethe, who prefer to encounter the spiritual mysteries of a place that survives its circumstantial fate, must hurry instead to places where antiquity and ruins abound. Only there does one engage ghosts, which is the true pastime of Sunday children. It is also a preoccupation of Goethe, the self-dubbed subterranean traveler to Rome, who is greeted by so many dead fathers upon his arrival (Rome, 1 November 1786).

That Heine's text is only an engagement with the present is indicated as well by the mechanics of the passage cited above. The need to defend Munich as the "modern Athens" is not an enduring passion or

conviction. (Indeed, the narrator admits his ambivalence moments later.) Instead it is an itinerant thought, only as stable as the narrator's station. The narrator himself could be said to be in different places at once, insofar as he is addressing several audiences at once. The standard text is an edited version of one that initially appeared in Cotta's *Morgenblatt*. The earlier version is the milder one, eliminating or vitiating in many instances religious and political critique as well as erotic detail.[29] In fact, the text itself is mindful of its various audiences. As in this passage, the narrator frequently addresses the reader in a manner inconsistent with the position he stakes out with his textual interlocutor. His observations tend therefore to be so affected by the immediate circumstances surrounding each utterance that they are in need of a vocabulary to anchor or stabilize the discourse. Grecophilia serves that purpose. References to antiquity become a means to say about the present—which, in the climate of the Restoration is in denial of itself as a means to privilege antiquity—what the present is unable to utter about itself. For instance, while confessing that "we" are yet "raw hands at modern Athens-making," the narrator offers comparisons that say more about the present than the enduring importance of antiquity:

> Everything is just beginning and far from completion. Only the lower lines of business have been taken up, and it cannot have escaped your notice that we have plenty of owls [professors], sycophants, and Phyrnes. . . .
> We have only one great orator, but I believe that Demosthenes could not bellow so loudly over a malt tax in Attica. And if we have never poisoned a Socrates, it was not because we lacked the poison." (*HK* 7, 1:20–21; Eng. 16–17)[30]

The present is always inflected by a conscious posturing of the narrator in response to competing or coeval concerns. He responds to the place, the speaker, the censor, the taste or fashion of the time, and the language that frames his comments. If antiquity is a point of reference, it is necessarily filtered through these other competing concerns. One cannot simply arrive in Rome and, as it happened for Goethe, be upon it. Heine's Italian journey, sensitive to the shifting perspectives of the traveler, the author, the critic, the Jew, and so on, is so circuitous that he never even arrives in Rome. If self-citation or reiteration helped Goethe find his way to and from Rome, the narrator's self-citation that inter-

rupts the first line of the passage above suggests a seamless movement between selves where nothing is left behind and everything is brought forward.

Mimicry, or some form of parody or irony to disrupt the argument, is Heine's preferred mode to engage the present. Examples of such mimicry abound: the mention of a poison in need of a Socrates, or, a few pages later, the disruption of a debate about irony by a waitress who interjects that "irony" is a beer not offered by the inn (*HK 7*, 1:19). The cultural vocabulary of the moment is evoked only to be disrupted or mocked by its collision with the everyday. The two contexts are inseparable. This form of mimicry reiterates as literally as possible the defining spirit of the so-called "Kunstperiode." By engaging the cultural issues of the day by reciting them, their foundations, which supposedly have endured since antiquity, begin to shift. The passions and positions of Heine's narrators are as transient as the traveler's abode. For Heine no road leads to Rome; his journey is riddled by detours, not the least of which is a political one.

The persistence of the political—even in instances where one might expect the conversation to drift, as it had for Goethe, to considerations of aesthetics—is most apparent in the narrator's response to the opera. Goethe had commented on the success of his entourage in silencing "the chattering audience"—a gesture the performers rewarded by addressing the "most important parts of their performance directly" to Goethe and his friends (Rome, September in Retrospect, 1787). The attentions of Heine's narrator are directed elsewhere. Rather than bracket out the Italian audience, he summons its presence as an irreplaceable component of the performance: "To be sure, to love contemporary Italian music . . . you have to have the people before your eyes, . . . their entire history, from Romulus, who founded the Holy Roman Empire, to more recent times when under Romulus Augustus II it was destroyed" (*HK 7*, 1:49).[31] Art is not the detached expression of one who, like Goethe, learns on his vacation in Italy to transcend the occasional. More likely, it is the ineluctable expression of what has been repressed so as to enable that transcendence: "Even the use of speech is forbidden the indentured Italy, and it can only express the feelings of its heart through music. All its resentment against foreign dominion, its enthusiasm for freedom, its madness over feelings of its weakness, its melancholy over memories of past greatness, . . . all is masked in those melodies" (*HK 7*, 1:49).[32]

Art cannot be understood by assuming a position above or apart from the masses. Such a purchase, we might recall, permitted Goethe to convey what he called the essence of the carnival, allowing him throughout his journey to issue judgments based on claims of special access to an ideal that was absent. For Heine, art is much more a manner and means, particularly for one unable to speak Italian, by which to engage the passions and lifeblood of the land. What Goethe filtered out so as to create an absence to preserve the appearance of an ideal, Heine readmits. Museums, operas, and churches do not inspire in Heine appreciation of noble simplicity or quiet grandeur; rather they provide occasion to comment on the long history of oppression and impoverishment inflicted upon the masses. In Italy, Goethe is tone deaf, a consequence of too much seeing. The real preoccupation of art is foreign occupation, something one knows only by listening to rather than silencing the masses.

For Heine the education of the Italian journeyer is a political one that looks to the conditions of the people for its lessons. For example, interaction with a fruit vendor in Trient prompts the narrator to consider the overall political climate of his day. Likewise, at Marengo his German-Russian traveling companion inspires him to take up the cause of the Russians against the Turks. Goethe saw the Italians as "children of nature, who for all the pomp and circumstance of their religion and art are not a whit different from what they would be were they still living in forests and caves" (Rome, 24 November 1786). What he learns to see removes him from any experience of the oppression resulting from foreign occupation: "Everything points to the fact that this is a happy country which amply satisfies all the basic needs and produces a people who are happy by nature, people who can wait for tomorrow without concern to bring them what they had today, and who for that reason lead a happy-go-lucky existence" (Naples, 12 March 1786).[33]

If Winckelmann considered the skies above ancient Greece to have blessed its citizens with a sense of noble simplicity, Goethe's gaze is fixed to the ground, where cave-dwelling Italians live in harmony with the land. The move from Greece to Italy does not mean the observer is any more occupied with the present. On the contrary, the substitution of one place for another is the mechanical means of production necessary to preserve a timeless ideality. The Italy that Heine's narrator tracks by way of trafficking with peasants, beggars, and bandits could not be more opposed to the one offered by Goethe: "Inwardly, the entire Italian peo-

127

CHAPTER 4

ple is sick. . . . The suffering expression of the Italians is most visible when one speaks to them of the misfortunes of their fatherland, and in Milan there is ample opportunity. That is the sharpest pain in the breast of the Italians, and it quivers even when it is touched only lightly" (*HK* 7, 1:65).[34]

In fact, Milan marks the divergence of Heine's path from Goethe's. After Verona Goethe traveled to Venice; Heine made off in the opposite direction toward Milan, the city in which Goethe's father discovered love via letters and mirrors. Goethe may have had good reason to eschew the Milanese so early in his trip. His encounter with a Milanese woman in distress would come much later in Rome, once he had learned to estrange himself from the ghosts of the past and the Italy of the present. Heine, however, pursues the trails unreported by Goethe.

That he was destined to move in another direction is evidenced by his experience at the amphitheater in Verona, the spot where Goethe marveled at the first great monument of antiquity he had seen. Moreover, Goethe joins quite explicitly the notions of perfection, nothingness, and preservation in his remarks: "The amphitheater is the first significant monument of antiquity that I have seen, and so well preserved! As I entered, . . . I had the odd impression that as grand as it was it was nothing" (Verona, 16 September 1786). Goethe discovers in Verona what will become the grand gesture of his entire journey: the positing of an ideal in the space of overwhelming absence. By contrast, Heine is unable to furnish that nothing (eigentlich nichts) with the accouterments of the ideal. To be sure, his visit is attended by visions of the "grandeur of Rome" and "spirits wandering far below like shadows in the darkened circus" (*HK* 7, 1:59). As he makes his way along the benches of the amphitheater, he, like Goethe, is captivated by the spirits of the ancients. But what calls to Heine is not the need to preserve ancient monuments to offer an ideal frame for the present. Goethe noted that a "public spectacle" or match he stumbled upon about a thousand paces from the arena should have been played in the amphitheater, which offered "proper provision for spectators" (Verona, 16 September 1786). Heine, who has no desire to be an onlooker, is visited instead by political visions. The formal position of the spectator is unimportant. He does not marvel, as Goethe did, at the manner in which the theater would allow for the masses to become a singular and noble form. Rather, Heine ponders the "harshest, bloodiest earnestness" with which the Romans conducted their sports (*HK* 7, 1:58).

These sentiments summon a different antiquity. Caesar and Marcus Brutus appear, wandering arm in arm, followed by Tiberius Nero. Their political might, according to Heine, was an expression of an "eternal Rome" or, in Goethe's jargon, what we might call the enduring (das bestehende). The persistence of visions from the past should not suggest any continuity between the present and the heroic age of the past. Musings on ancient Rome do not transform or ennoble the spectacles of the everyday, rendering the land idyllic. They merely call attention to the feeble spirit of the present: "Barely had I heard [Agrippina's] plaint—when the dull tones of a vesper-bell and the fatal drumming of taps rang out. The proud Roman spirits disappeared and once again, I was immersed in the Christian Austrian present" (*HK 7*, 1:59–60).[35]

The dash highlights the incompatibility of the two epochs or the impossibility of arriving in Arcadia, as Goethe did.[36] The sight of his first antique monument takes Goethe to Venice, where the gondolas stir fond memories of a childhood toy: a model of a boat his father brought back from Venice and with which, on occasion, he would allow the young Goethe to play (28 September 1786). Heine travels in the opposite direction, where the "wounded cries of the fatherland" are irrepressible. Their divergent itineraries add another dimension to the observation that Goethe's father was comfortably buried by the time the son took off for Italy while Heine's was ailing and approaching death. Heine travels under the sign of genealogical ailment. He cannot appropriate, make disappear, or deposit in points south the inhibiting remnants or shadows of the past.[37]

In the later chapters of Heine's text, Goethe becomes an explicit reference. He is the mirror of nature, which lends an element of irony to his reflection on the Italians as cave dwellers. "Nature wanted to know how she looked, so she created Goethe" (*HK 7*, 1:61). In fact, so perfect are Goethe's recreations that Eckermann, as Heine recalls, notes that "Goethe might even have improved on some of God's creations."[38] But no matter how masterfully it appears to substitute for God's own work, Goethe's lacks "a manliness of thought," which is to be found instead in Lady Morgan's *Italy* and Madame de Staël's *Corinne* (*HK 7*, 1:62).[39] Manliness of thought demands that the poet not sentimentalize the plaint of the Italians.

The eighteenth chapter begins with a citation from Mignon's lyrical expression of homesickness for Italy, "Kennst du das Land wo die Zitronen blühen (Do you know the land where the lemon trees

bloom)," but the picture of Milan that emerges from such sentiment differs quite dramatically from the one that Mignon's nostalgia summons. In Heine's world the lemon trees, myrtle, and laurel give way to unbearable heat by day and flesh-devouring fleas by night. Moreover, Mignon's song, which serves in Goethe's text as a prelude for her servitude to Wilhelm Meister, is replaced by the arias sung at La Scala, in which "soft, wailing tones" evolve in "wild active pain" (*HK* 7, 1:64). "The ancient melodies and feelings—which Italy has ever borne in her heart" and which come alive in her music—do not situate the trauma that occasions such longing in an irretrievable past, as they do in Mignon's song; rather they resituate that trauma as the ongoing experience of Italy's political servitude. They are signs that Italians are anything but "politically indifferent" and that the sentiments aroused by antiquity will pour over into the political arena (*HK* 7, 1:64–65). In a word, they are contextualized. Heine's Italian narrative seeks to articulate what might otherwise be considered only a musical sentiment. The one who does not speak Italian is in attendance to other voices, typically silenced and censored. As at least one critic has noted, Heine prefers to be history's narrator: "[He] would . . . rather say, 'History would like to know how she looks, and so she created Heine'" (Hermand 144).

Nature has for its spokesperson Goethe; history, Heine. But striking out against Goethe is less Heine's endgame and more the only means to liberate censored or oppressed voices. Heine reiterates Goethe's journey, but as the citations and comments about Goethe substantiate, Heine notes what this repetition marks. Not only does he pick up on what Goethe left behind, his awareness that something else is being picked up on gives Heine's journey a different trajectory as well. In this regard, Heine's short, disappointing, and interrupted vacation in Italy offers a promise of liberation. In fact, that is what the narrator of the text defines as the "great question of the age," which is also to say that it is not a natural question or a question for nature. Rather, it is a historical one:

> But what is the great task of our age?
> Emancipation. Not just the emancipation of the Irish, the Greeks, the Frankfurt Jews, West Indian blacks . . . but rather the emancipation of all peoples. . .
> Don't smile, late reader. Every age believes that its battle is

the most important, . . . even though our descendants might look down on our battle with disdain. (*HK 7*, 1:69–70)[40]

No citation could be more convincing in differentiating Heine's Italian experience from Goethe's. We should recall that the latter's "Roman Carnival" was published as a literary, even political, antidote to the French Revolution. Goethe sought to reduce the apparent spontaneity of the massive celebration to a predictable demonstration of basic organizing principles. Heine seeks to hand himself over to the mass to break away from the authorial figure. The dynamics of his text are critical components of that project. On the one hand, his relentless critique serves to endanger his status as author and invite the ban of the censors. On the other, the manner in which the figures in the travel sketch are set in play with each other relativizes the questions of any age. Goethe is also only of relative value.

Italy's Rear Guard

The inevitable smile that overcomes the later reader also infects the present one. In *The Baths of Lucca* the critique is directed at the self. Cristophoro Gumpelino, a baptized Jew, is the target of Heine's parody, which extends to Heine as well. Like all forms of identity, Jewish identity must be loosened from the historical circumstances that anchor it. Both *The Baths of Lucca* and *The City of Lucca* demonstrate Heine's attempt to situate himself and thus betray the local character and circumstance of identity. The conservative Heine, what many have termed the apolitical and lyrical one, results from this self-divisive tactic.[41] In this instance Italy as a site of cutting off produces a very different result. Whereas Winckelmann and Goethe sought to excise imperfection in hopes of giving rise to an ideal apparition, Heine's cut exposes the impotence of those apparitions, one of which is his own.

The concluding chapters of *The Baths of Lucca* and their lurid attack against Platen are the ineradicable growth or "Gewächs" of Heine's cut. His apparent Jewish self-hatred, which he directs toward Gumpelino, is what arises on the other side of the cut; it is the result or even destination of a path that follows Goethe's to a point of departure.[42] The baptized Jew can follow Goethe only so far until difference constitutes an unbridgeable distance that takes him in another direction from Goethe and from himself. But that from which he is distanced has

a form of expression, and it is an inevitable outgrowth of what Goethe sought to cut off and leave behind in Italy. No wonder Goethe told Eckermann that Heine's squabble with Platen was "unsuitable for literary life" (*Gespräche*, 14 March 1830). It is no more an attack against Platen than an exposure of what Goethe the Italian journeyer bequeathed.[43]

Heine could not have failed to see himself as part of that heritage. Attempting to secure a position at the University of Munich, he instructs his publisher Cotta to let the king know that he is "much milder, better, and perhaps quite different" from the Heine of his early works. Heine also asks Cotta to emphasize how the sharpness of his sword should not be measured by the cause for which it is employed (*Briefe*, 18 June 1828). Heine is willing to sell his pen to resuscitate a moribund tradition. During the same period, he also acts as "press agent" for the Duke of Braunschweig. In this capacity, he offers the most despotic of German princes placement of his work in the *Politische Annalen*, of which Heine is the editor. He begins writing a letter in defense of the prince, which he later abandons once the prince is expelled from Munich (Sammons 136). After Italy, or at least the publications of his Italian travel sketches, such obsequiousness could hardly succeed in currying favor. His travels south instill his poisoned pen with new vigor; the pen is already poisoned because it has been dipped in inks swimming with impure motives. But such double dipping also serves to remove the veil of sanctity from Germany's conservative elite. Heine's body of work is no exception, since it marks the site of that impurity.[44]

Under these conditions it is no wonder that Heine complained of being "surrounded by enemies and clerics full of intrigue" (*Briefe*, 15 January 1828). The most "insidious of those enemies," Heine insists in the same letter, is "[my] poor health," which serves as reason to journey to Italy. As we know from letters cited earlier, these enemies are not vanquished in Italy. Heine is convinced that murderers were on his trail in Milan. There is simply no escaping the ailments of his age; they afflict his mind and body.

Unlike Goethe, who could lay to rest in Italy the demons of the past, Heine is the unlikely successor who discovers that all is not well there. The disease of what was laid to rest in Italy or the manner in which it was laid to rest that caused it to become diseased is so much a part of Heine that he can never establish enough distance between those demons and himself to return to Germany reborn. The predicament is summarized by the narrator in the closing pages of *The City of Lucca*:

"Alas, I will not, like Ham, lift the blanket from the private and shameful parts of my fatherland, but it is appalling how slavery has become mere chatter and how German philosophers and historians wrack their brains . . . to justify all forms of despotism" (*HK 7*, 1:201–2).[45]

Ham, we might recall, lifted the veil against his father's wishes to witness a naked Noah in a drunken stupor. Noah cursed Ham and his son Canaan, declaring that the latter and his offspring would be slaves to the descendants of Noah's brothers. Heine, who never completely relinquishes the hope of becoming Germany's next Goethe, does in fact lift the veil. As a result the curse falls on him:

> [I] must engage in continual duels, . . . and I never win a single victory that doesn't cost my heart's blood. Night and day I am in need, for these enemies are so malicious that many whom I sent to their deaths still put on airs as if they were alive. . . . How much pain I have suffered on account of these ghosts! . . . Everywhere, and where I least expect it, I discover their silver, slimy trail. (*HK 7*, 1:202–3)[46]

The ghosts that haunted Goethe return to plague Heine, whose Jewishness bars him from following in the tradition of Goethe. But insofar as his movements, or at least those of the narrator, are choreographed to those of the ghosts, he is every much a part of that past as he is its combatant.[47] Heine is his own enemy, and he can emerge victorious only if, like lizards who introduce the narrator of the sketch to the secrets of nature, he can molt—only if he can get out of his own skin. Such a feat would match Goethe's, who, as we know, was versed in the secrets of nature. In this instance, such dreams are impossible ones, as the concluding section from *The City of Lucca* emphasizes: "You might want to smile and dismiss such concerns as mere vain imaginings like those of Don Quixote" (*HK 7*, 1:203).

Heine's ever-present engagement with the affliction of the fatherland suggests that his attacks on Platen, to which I will now turn in some detail, are an extension of an effort to engage that aspect of his own body or person that is mired in currying favor from despots. Of course, the apparent provocation for Heine's attack against Platen was the latter's *Der romantische Oedipus*. While the play was intended as a parody of Romantic irony in the tradition of Aristophanes, it also contains a series of jabs at Heine and his friend Immerman. The end of Heine's

CHAPTER 4

Nordsee includes a number of satirical epigrams by Immerman directed against what the two of them regarded as the absurd literary tastes of the day, most notably the flood of Persian ghasels inspired by Goethe's *West-Östlicher Divan*.[48] Typical of the epigrams is the following: "Von Früchten, die sie aus dem Gartenhain von Schiras stehlen, / Essen sie zu viel, die Armen, und vomiren dann Ghaselen (Of the fruits that they have stolen from the garden grove / They eat too much, the poor ones, and vomit thereafter ghasels)" (*HK* 4:166). Apparently stung by the attack, Platen branded Heine "the baptized Heine," "swollen with synagogue pride," "the Pindar of the little tribe of Benjamin," "the Petrarch of the Feast of the Tabernacles," and "Nimmerman's bosom friend." Nimmerman, Platen continued, was not Heine's lover, since even he could not stand the stink of garlic (*Werke* 1:170–79). The irony of the description lies in calling Heine "baptized," an apt description yet one that refers to an event of which Platen could have had no knowledge. Even Heine's patron, his Uncle Salomon, noted that "without flattery Platen has hit you off to a T" (Butler, *Heine* 78).

In the tenth and eleventh chapters of *The Baths of Lucca* Heine returns the favor. The protagonist Gumpelino has been foiled in his attempt to rendezvous with Lady Julia Maxfield by swallowing an enormous dose of salts provided him by his servant Hirsch-Hyazinth. To relieve his disappointment he spends a restless night reading Platen's poems, only to discover the following morning that he has been cured of his passion for Julia. The implication is clear: Platen's poems are bathroom reading that vanquish healthy desire due to their "lack of natural sounds" (*HK* 7, 1:142). His homosexuality is linked with a desire to revive antiquity and give life to dead forms, such as the ghasel. Platen anticipates Maximillan's necromancy in *Florentine Nights*. Moreover, such perverse sexuality is merely "a contrived attempt to capture for the present what properly belongs to a past age" (Holub, "Sexual Assaults" 420). "[I]n his illustrious hobby (Liebhaberei) I detect something untimely, namely the timid and coy parody of the high spirit of the ancients. . . . In antiquity such romantic spirits were in keeping with the practices of the time and were displayed with heroic openness. But the count frequently masks himself in pious feelings and so avoids any mention of gender; only the initiated get his meaning" (*HK* 7, 1:140–41).[49]

The second half of the excerpt could read just as easily as a description of Winckelmann, whose art history sought to clothe in pious ekphrasis a love of the castrati. Such were the effects of a self-censored

sexuality that in some measure was an expression of Winckelmann's deference to his Catholic patron. Platen demonstrates how that kind of sexuality is wedded to obeisance: "This troubadour of misery, enfeebled of body and soul, tries to imitate the most powerful, most imaginative and wittiest poets of the youthful world of the Greeks. Nothing is more disgusting than this sickly impotent who wants to inflate himself with effrontery" (*HK 7*, 1:148).[50]

While imitation of the Greeks was intended to restore a vigorous ideal to the cultural longings of his countrymen, Heine exposes that impulse as fey, self-abnegating, and unnatural. Platen's love of the ghasel and similar outdated forms is linked to an unhealthy and debilitating restorative impulse that hopes to revive what should have been relegated to an already surpassed moment in history. In *The Journey from Munich to Genoa* Heine emphasizes that the greatness of an age founded on a notion of its eternal character, such as ancient Rome, is itself a historical moment that inevitably passes. Seeking to maintain its character beyond its historical moment is unnatural. Platen attempts to extend the age of Goethe beyond its time. He is the weak link in a chain of substitutions that began with Winckelmann's aesthetics.

Not surprisingly, Platen makes it to Rome for an extended stay. Rather than trying to decipher and bring to expression the songs of the oppressed in Milan, he writes a cycle of sonnets about Venice (published in 1825). If we recall Goethe's entry in the *Italian Journey,* Venice is the city in which one remembers playing with the toys of the father. By virtue of such recollections, one is greeted like "an old friend" by the "steel-sheeted prows of the gondolas" (*Italian Journey,* Venice, 28 September 1786). What Winckelmann's logic of substitution and love of the castrati cuts off continues to show up elsewhere. And the chain of substitutions that form around Platen's brand of poetry—or the one who dreams of being Goethe's successor (Butler, *Heine* 79–81)—includes a psychosexual devotion to the father, to Catholicism, to the circle of Munich literati who would not give Heine an appointment, to the feminized male, and to pederasty (Sammons 143). With the exception of the Munich literati, such devotions typify the Italian journeys examined in previous chapters. Heine's text is peppered with sexual innuendoes to confirm the associations, at least in respect to Platen. These include the butchered citation from one of Platen's ghasels that begins the text, "I am like woman to man" (*HK 7*, 1:82); the description of Platen's poetry as "Sitzfleisch"; and his characterization of Platen's in-

sults as "a posteriori" (*HK* 7, 1:139).⁵¹ These pale in comparison with the following: "In fact, he is a man more of the rump than of the head. The name 'man' does not fit him at all; his love has a passive, Pythagorian character. He is a Pathetikos in his poems, he is a woman, who at once deifies the feminine and is also a male tribade" (*HK* 7, 1:141).⁵² In Heine's judgment, Platen's "feminization" is so extreme that he regards him as a male lesbian. He parodies the logic of substitution by equating a feminized male with a tribade and fulfills Winckelmann's desire as well to erase any marker of gender. Insofar as he is a disciple of Winckelmann and Goethe or a student of their classical aesthetics, Platen is the incarnation of a rear guard, whose self-abnegating obeisance to the past frustrates all efforts at emancipation—those of the Jew and the homosexual included.

As we know, Heine cannot declare himself to be entirely outside the circle he attacks. His own body is a site of what I have repeatedly described as the most characteristic gesture of previous Italian journeys: cutting off. Heine is cut off from the very circles with which he sought to curry favor, but he is still wedded to them, and, as noted above, he offers his pen in their service. Sammons suggests that Heine could have found an ally in Platen: "[Platen] was not a reactionary; he was a dissident political poet of considerable force, who shared, although in a different key, many of Heine's fundamental positions. . . . In fact, there was much in Platen that made him a potential ally of Heine; their democratic instincts coupled with an aristocratic view of the poetic calling. . . . But Heine did not see it, or did not want to" (145).

The self divided against itself cannot help but attack its allies.⁵³ But if Heine is attached to that from which he would like to become unattached, so-called self-hatred is a means of turning the knife on himself or on his own. The tactic in *The Baths of Lucca* extends to Heine's merciless parody of the Jewish parvenu Gumpelino.⁵⁴ Wealth allowed Gumpelino to buy culture, which in this instance means either counting the feet of Platen's ghasels while sketching their scansions on the floor (*HK* 7, 1:138) or paying tribute to an Italian woman of faded charm "in the name of all Germany" (*HK* 7, 1:97). Equating culture as it was worshiped by Germans in Italy with almost lifeless forms of tribute anticipates the necrophilia of *Florentine Nights*. This is evidenced by the tulip that Gumpelino presents Lady Maxfield. In Persian culture, or in the world of Platen's ghasels, the delicate but non-fragrant flower signifies non-carnal or homoerotic love (Sammons 145). It is no wonder that the

intended recipient runs off in horror. Her illicit tryst with Gumpelino is unsuccessful, since he swallows salts and Platen's poetry, which render him "unavailable and no longer interested." Particularly significant about the salts is that Gumpelino's assistant Hyazinth mistakenly calls them "Glaubensalz" instead of "Glaubersalz," implying that the salts are the stuff of religious belief. He had received them from his "fat lady love" Gudel, who lives on the "Dreckwall." The reference to the Jewish quarter of Hamburg and his status as an outsider are contrasted with the gesture of swallowing the believer's salts that renders everyone the same: "On my word of honor it will work. . . . Why shouldn't it work? It worked with me! And am I not as alive as you? Believer's salts makes all men equal (Glaubensalz macht alle Menschen gleich)" (*HK* 7, 1:121). Leveling all difference produces impotent desire. This surfaces in the poetry of Platen, a potential ally of Heine. It also produces dead desire in the baptized Jew, whose necrophilia also infects Heine.

In contrast to *Florentine Nights*, *The Baths of Lucca* is concerned not only with the debilitating and self-abnegating effects of Christian high culture, which for Heine are equivalent to the manner in which one adores and idolizes antiquity. Gumpelino emphasizes that only a Catholic can understand the works of the great masters (*HK* 7, 1:115). *The Baths of Lucca* is also concerned with the displacement and self-divisive attempts that assimilation fosters.

If Gumpelino is in part a parody of Heine's efforts to assimilate, that self-divide is most visible in Gumpelino's servant Hyazinth, formerly known as Hirsch before his master forced him to change his name. As many have noted, Hirsch-Hyazinth and Harry or Heinrich Heine have much in common.[55] Not the least of these similarities are discomfort with the dominant culture and an inability to assimilate fully. The first words Hyazinth speaks suggest that discomfort: "I have high hopes (guter Hoffnung; am pregnant) . . . that you still know me" (*HK* 7, 1:92). The effects of assimilation are extensive or uncertain enough that he is not sure whether the narrator will recognize him, an uncertainty that results in no small measure from the vague position occupied by the narrator. The assimilating Jew knows neither who he is or exactly to whom he should present himself. This awkwardness is expressed by his use of the idiom, "Ich bin guter Hoffnung," that describes a pregnant woman. Jews had long been accused of speaking "mauscheln" (Gilman, *Jewish Self-Hatred* 260–64), and Heine's language was often criticized for its inauthentic character. But just as the mimetic zeal of

CHAPTER 4

Heine's language reveals something otherwise hidden about its model, Hyazinth's expresses more than it lets on. In this instance, his description of himself as a pregnant woman conveys the feelings of unnaturalness that result from service to a parvenu who takes "pleasure in trying to perfect him" (*HK* 7, 1:94). His status as absolute outsider, a condition that is exacerbated and not overcome in Italy, is expressed by his desire to leave Italy and return to the stepfatherland (Stiefvaterland) where he might view the parrots (Papagoyim) in the zoo. The outsider prefers to exist in a condition of exile rather than be exiled from his state of exile. His stepfathers, his gentile fathers, are like parrots, whose imitative mien makes it impossible to know what model is to be emulated. He cannot follow Gumpelino into Catholicism, whose devotions include—as only Hyazinth can express—kneeling before the "Prima Donna mit dem Jesuskind." Converting to Catholicism, journeying to Italy in homage to Germany's own "prima donna," or swooning at the opera are all alike. But if Hyazinth would like to hold on somehow to his own Jewish identity, this strategy is as impotent as the fellow he serves. As another of his malapropisms makes clear, the new or reformed Judaism is a mosaic of services or "Mosaik-Gottesdienst" (instead of "Mosaic services") full of German orthographic songs and sermons. The traditional form, however, was only a source of pain (*HK* 7, 1:116). The wounds from the past do not cease hurting just because traditional practices have been abandoned. The Jew seeking assimilation continues to bleed.[56]

Heine is thus the absolute journeyer, lacking any means to ground his identity, lacking any ground to speak from. Perhaps this explains the vertigo that ensues from attempts to locate Heine or his position in any of these texts. Gumpelino, Hirsch Hyazinth, the narrator, or even the Italian masses, for example, all bear traits of Heine or the Jew divided and cut off from himself. In fact, the figure that Heine in these guises most resembles is the target of his most biting and persistent critique, the necrophiliac. In her analysis of Proust, Hannah Arendt describes the Jew as a figure of "necromancy," in which nothing is expressed other than his own "illegitimate extremity" (*Jew as Pariah* 82).[57] In other words, the seemingly assimilated Jew, who wants at all costs to be considered a legitimate exception, takes up positions that guarantee his exclusion from society. He lives in exile—in this case, Italy—and his positions behind the masks of narrators are indeterminable or fantastic. Where Heine is in relationship to his narrators and their interlocutors is unknowable. He is at the margins or the extremes, delegitimated by the

Prussian censors. With specific reference to Heine, Arendt speaks of the "exception Jew" or "exceptional specimens of humanity," whose otherworldliness serves obversely to affirm the fundamental unity of humanity. The Jew was called upon to reveal his ineradicable difference and his apparent admittance to society confirmed Jewish difference but at the same time precluded actual inclusion (*Jew as Pariah* 58–61). Something about the Jew could not be erased or cut. At the end of *The Baths of Lucca*, Heine satirically affirms this difference by making it anatomical. The part of the Jewish body that affirms Jewish difference, however, is not the circumcised penis but rather the nose:[58] "Mathilde's warning, that I should not bump into [Gumpelino's] nose, was well founded, and were it not lacking just a bit, it would have poked out one of my eyes. . . . [A]ren't these long noses a kind of uniform, whereby the Lord God Jehovah can recognize his own body guards even if they have deserted?" (*HK* 7, 1:88–89).[59]

What was previously referred to as sniffing along Goethe's trails acquires added meaning. Following Goethe's trails highlights Jewish difference and threatens the eye trained by such attention to Goethe's script. Cutting himself off from himself, Heine invites censorship, but what is cut off always shows up elsewhere. Winckelmann's cut produces a body—in this instance, the Jewish body, which is also a textual or contextual one. In the context of Heine journeying to Italy, that body is fantastical insofar as it is always already elsewhere and everywhere.

Heine is always about to take leave of himself. He holds no position or ground for very long. This accounts for his ability (or the narrator's) to befriend lizards in *The City of Lucca*. He is as mutable as the chameleon, and the figurations of such stubborn mercurialness become the textual body of censorship, the nose that sniffs out what needs to be excised. But if we attend the lizards, mutability as a by-product of censorship promises progress: "'Nothing in the world wants to go backward,' an old lizard (Eydeychs) said to me. 'Everything strives to move forward, and in the end a great natural advancement will take place'" (*HK* 7, 1:160). In the age of Restoration all positions must be given a temporal character to expose the historical rather than the apparent eternal character of the order of things or of nature. Heine's "advancement" eventually takes him to Paris. To get there, which means to live in exile, he must say the unsayable and betray secrets (Eid-bruch), Platen's among them. Winckelmann's and Goethe's secret was that there was no secret, only an absence. Platen's was an absence of desire.[60] Absenting

CHAPTER 4

himself from himself, Heine ventriloquizes what censorship stills. Stones and lizards often do the talking. The cut that allowed Winckelmann to rip the castrati out of the temporal realm and project them onto an ideal one, the cut that allowed Goethe to veil the absence of the ideal or of the primal plant he claimed to have found in Italy—that cut may mark Heine's exclusion, but it simultaneously reproduces in the manifold voices of Heine's Italian travel sketches what it sought to suppress. The temporal or historical is thereby regained. In a word, censorship is productive: "How can one, who has always been subjected to a censor, write without one. All style will cease, all grammar, all manners"[61] (as cited, L. Marcuse 181). The remark from 1848 is not without irony, but one should also recall the opening line of Heine's first Italian travel sketch, *The Journey from Munich to Genoa*, which is repeated a page later: "I am the most polite man in the world" (*HK 7*, 1:15–16). Without censorship or manners Heine would have no voice. In Italy he learns the importance of being cut.

5
The Return of the Repressed
Nietzsche and Freud

Heine's Italian journey articulates the long shadow cast upon Italy by Winckelmann and Goethe as well as the consequences for one who is unable to trace the contours of that shadow. More specifically, Heine's journey exposes the need to censor or cut off one who cannot help but report what others sought to erase. Heine's Italian sketches were destined to offend; in effect, he was exiled from Germany. The sickness and eventual death of his father while he was still in Italy were perhaps augurs of his future relationship with the fatherland. Winckelmann in Italy is perhaps best characterized by his adoption of the eternal father or "il Papa." In Italy he sought to recover the ideal by observing copies of ancient Greek statuary of the de-gendered male nude. Not surprisingly, the pope's patronage provided him with sufficient means to access the ideal male who was nonetheless absent.

Shortly after the death of *his* father, Goethe was able to journey to Italy to report, review, and reclaim much of what his father had prepared for him. This left him with the impression, or the need to leave the impression, that he had stumbled upon and appropriated an original ground of being in the form of the primal plant. He would make that discovery his own. In the eyes of many, he returned to Weimar to father German classicism as a result of his apparent find in Italy. His willingness to confuse his own origins with those of civilization is perhaps one source of his naiveté: "Yes, I have finally arrived in the capital of the

CHAPTER 5

world! . . . I now see all the dreams of my youth come to life. . . . My father hung views (Prospekte) of Rome in the hall" (Rome, 1 November 1786). The childhood dreams inspired by his father are inseparable from the recovery of the classical ideal in Italy.

Heine's Jewishness disables any claims to ideal origins. His attempts to participate in the culture reinforce the conditions of his exclusion. His journey to Italy in the hope of renewing his health is one such act, but the works that ensue are considered, at least in his time, pornographic rather than canonical. Winckelmann and Goethe reclaim ideal origins but through untellable means. Winckelmann's sexuality is a possible example of this, and Heine's pornographic text responds to what was repressed. Winckelmann's *History of the Art of Antiquity* is a more certain example, since the ideal work or moment is always just beyond view or reach. Goethe's ability to conjure the appearance of an original ground of being is akin to a magician's trick—what I have called thimblerigging. The pattern of substitutions and reiterations assumes a figuration that persists despite the lack of any real ground. Traveling, after all, is a ceding of that ground. At the very least, the text that attests to such a find requires a lot of editing, rewriting, and erasing—more than forty years in some cases—to keep up appearances. The proximity of Goethe's discovery of the primal plant to the episode in which he deceives and thereby ingratiates himself with Cagliostro's family suggests the skills required to complete his Italian education. Heine reports what is necessary to repress if such illusions are to be maintained. In Italy he comes to embody what Goethe had to leave behind or must bury in Italy if he was to return—as Stefan George insisted—with only the spirit of Italy.

Since Germany would not accept the body of its legacy or its progeny, this unwanted offspring necessarily continues to haunt and even poison the culture. The demonic disposition that Italy comes to assume in subsequent chapters of German and Austrian literary culture is evidence of the persistence of that progeny. The Italian experiences of Friedrich Nietzsche and Sigmund Freud illuminate this transformation. While the repressed, either in terms of Nietzschean resentment or the Freudian unconscious, suggests as much, I do not attempt here a renewed engagement with the works of Nietzsche and Freud; rather I want to resituate key concepts of each in the tradition of Italian journeys detailed thus far. That is to say, fundamental aspects of their texts respond to the tradition canonized by Winckelmann and, above all,

Goethe. The specter of their Italian journeys ghosts the works of both Nietzsche and Freud but, by virtue of its repressed character, that specter is anything but ideal.[1]

Fatherly Pursuits

Nietzsche's eventual collapse after years of living in Italy is an alluring premise for such research.[2] More telling are his own descriptions, written there, of a troubled paternity and his success in blurring all origins. The oft-cited opening sentence of *Ecce Homo* offers perhaps the most provocative attempt to revisit his origins: "The good fortune of my existence, its uniqueness perhaps, lies in its curse. I am, to express it in the form of a riddle, already dead as my father, as my mother I am living and becoming old" (*KSA* 6:264).[3] The remark invites a Freudian reading, anticipating as it does Freud's discussion of the family romance. According to Freud, children develop fantasies to compensate for the weaknesses they recognize in their own parents. Once the fundamentals of biology have been grasped and maternity can no longer be contested, the child's fantasies turn to the father (*SA* 9:98). Nietzsche's attempt to assign himself aristocratic origins and lay claim to Polish nobility are consistent with Freud's analysis and further necessitate considering the two figures together.[4] More important, a dead father rather than a dying one is a prerequisite for returning to Weimar, which Nietzsche eventually does. In *Fatherland: Novalis, Freud and the Discipline of Romance*, Kenneth Calhoon links the notions of philosophical inquiry and travel via the family romance: "Romance is a topographical overlay that transforms inquiry into travel, but one that superimposes a regressive geography on the Romantic concern for origins" (7–8). Heine's attempt to reverse or refuse that geography by restoring its historic character ensures that his origins are unacceptable to the Germany of his time. Nietzsche returns to the fatherland mad, exposing the temporal disjuncture that is the signature of the German attempt in Italy to recover its classical roots. Nietzsche's necessarily enigmatic reimagining of his origins is his "undoing" (Verhängniss); it somehow undoes what Goethe had done.

If the death of the father allows Nietzsche to author the father and reiterate Goethe's triumphant gesture, the persistence and continued growth of the mother's roots doom his Italian journey. As we know, much of Nietzsche's work was obliterated by his mother and/or sister for the sake of canonizing what would come to be known as *The Will to*

CHAPTER 5

Power.⁵ To read with Calhoon, the inquiry into origins that the family romance transforms into travel eventually takes him back to the fatherland, which is paradoxically maternal. As we will see, the change of masculine pronouns to feminine ones in rewriting the "Magician's Song" from *Zarathustra* as "Ariadne's Lament" (Turin, 1888–89) in the *Dionysian Dithyrambs* is evidence of that reversal. But it also signals the impossibility of following on Goethe's trail and duplicating the latter's rebirth and revitalization. Moreover, Goethe's singular nature is thereby barred Nietzsche: "What is disagreeable and offends my modesty is that at bottom I am every name in history" (Letter to Jacob Burckhardt, 6 January 1889).⁶ To be every name is to bear the patronym of every father. If we recall Goethe's arrival in Rome and his disappointment in being greeted by so many fathers, Nietzsche's reiteration recalls Goethe, but he is unable to replicate the latter's rebirth. Among the many names that is also Nietzsche's must be Heine's: "Heinrich Heine has provided the highest notion of the poet. I seek in vain in all the empires throughout the millennia for a music that is equally as sweet and passionate. He possessed that divine malice without which it would be unable for me to think of completeness" (*KSA* 6:286).⁷ By coming in between Goethe and Nietzsche, Heine is the interloper whose deviant course upsets Nietzsche's. Signals get crossed, as they did for Goethe, but the result is madness. That completeness (das Vollkommene) is too much—too many names of the father—a predicament that hands him over to the care of his mother and sister. What has been called the destruction of his work in the latters' hands is the surest sign that the interruption introduced by Heine precluded a healthy return to Weimar.⁸

Freud went to great extremes to establish a consanguinity with Goethe and was throughout his career, as one critic has noted, indebted to Goethe as the secret father of psychoanalysis (Ronell, *Dictations* 11). More telling is his confession to Giovanni Papini in 1934: "I am a scientist by necessity, and not vocation. I am really by nature an artist. Ever since childhood my secret hero has been Goethe" (Papini 101–3). Throughout his work, Freud frequently draws on psychoanalysis to read Goethe; Goethe thus needs Freud to be understood. Moreover, Freud suggests that Goethe "intuited the systemized theory underlying *Totem and Taboo* in which fathers are ingested and thus appropriated by their sons" (Ronell, *Dictations* 27). According to this logic, the frequent appearance of Goethe in Freud's dreams points to Freud's own attempt to romanticize his origins and replace his own paternal line with that of the

father of German classicism. Ingesting Goethe is the crucial moment in Freud's family romance.[9]

Later in this chapter I will turn to how Freud's family romance is played out in Italy. For now, it is important to note how psychoanalysis makes a science of what Goethe's Italian journey accomplished; that gesture attempts to duplicate the scientific character Goethe sought to lend his Italian experience. While such reiteration repeats the lessons Goethe learned in Italy, the question is whether the results are as distinguished as they are for Goethe. If Goethe needs psychoanalysis, then that science allows Freud as well to overturn genealogy and become the founder of a science that also seeks to conceal its debt (Schuld) to a forefather. His admittance to the medical faculty in Vienna requires an acceptance of that science. But the nature of Freud's unconscious makes it impossible to erase the traces of that debt. The quote from Goethe's *Faust* that appears on the frontispiece of *The Psychopathology of Everyday Life: Forgetting, Slips of the Tongue, Bungled Actions, Superstitions and Error* reveals the dual nature of the relationship: "Now, the air is so full of that ghost that no one knows how to avoid him" (*SE* 5:vii). Not coincidentally, the first chapter of the work is "The Forgetting of Proper Names" (Ronell, *Dictations* 29).

Overcoming the scar of his Jewishness—and the Vienna of his time was becoming increasingly anti-Semitic—is tied not only to such forgetting but also to Freud's peculiar relationship to Italy, and to Rome in particular. As more than one critic has demonstrated, "Italy is also the archaeological site of Freud's Christian wish-fulfillment. He fantasizes his triumphant arrival in Rome—a sign that the Jewish science of psychoanalysis has become universally acceptable" (Stone 105). Moreover, Freud's overcoming of his aversion to Rome and his frequent returns there suggest that he had been successfully "re-baptized a Roman citizen" to apply Goethe's words. He apparently accomplished through psychoanalysis what Heine's Italian travails could not.

Freud's reprise of Goethe, however, is riddled with contradiction. The most obvious of these is the need to succumb to the temptations of the family romance but at the same time telegraph the gesture essential to the very success of the romance. As Calhoon observes, "much of Freud's theory, in particular the theory of the superego, is concerned with describing the processes . . . that ensure the son's ultimate identification with paternal authority" (17). Without the visibility or omnipresence of the father, psychoanalysis has no subject, yet the persis-

CHAPTER 5

tence of the father renders a repetition of Goethe's Italian rebirth impossible—particularly if that father is Jewish. Moreover, psychoanalysis betrays the dynamics of the family romance. Thimblerigging, substituting one father for another, can no longer conceal what has been covered up or is missing.

Instructive in this regard is Freud's dream of the yellow-bearded uncle analyzed in *The Interpretation of Dreams* in the section "Dream Distortion." In the dream, Freud feels great affection for his friend "R," a medical colleague who had visited Freud the previous evening and who was nominated to a professorship long before Freud. "R" learned that his promotion was turned down because of "confessional considerations." Freud's dream conflates the image of "R" with his uncle Josef, who had served time in prison and whom his father had called a fool (*SE* 5:155). While Freud is baffled by the association, since "R" was neither a fool nor a criminal, he recalls an earlier encounter with "N," also a Jew, who was refused a promotion on the basis of a trumped-up charge of extortion. Freud ultimately decides that the dream conflated the two figures to suggest that "R"'s denial of a promotion had nothing to do with his Jewish origins but rather with the bald fact that he was a fool. Freud's fear that his own promotion would be imperiled by his origins is thus overcome. As Calhoon writes, "This dream can be read as an attempt to invalidate birth by creating a rational structure in which the circumstances of birth are no longer relevant. The dream is further significant because it supplies a framework for the discussion of . . . the process of distortion in dreams, which he likens to the work of the political censor" (14).

Freud wants to have it both ways. The father matters yet he doesn't matter.[10] Without him, no science. With him, no promotion—unless he can be conflated with the fool. Freud's confessional science reveals what Goethe's Italian science does not; it succeeds precisely because it distorts. But the political censor reasserts his authority. Perhaps that explains the persistent references to Italy throughout Freud's work. His Christian wish-fulfillment is never complete. As I will show below, the archaeological site of the fulfillment, Italy, will not conceal the traces, as it did for Goethe, of what is certainly a game of "fort" and "da" or of "now I am a Jew and now I'm not." In other words, transforming censorship into a science recalls what was cut. Goethe can never substitute for Freud's father, no matter how much the latter romances the former.

THE RETURN OF THE REPRESSED

Additionally, Freud's description of Italy as "Genitalien" in *The Interpretation of Dreams* points to the uncanny ability of psychoanalysis to turn up those traces of the Jewish body that mark it as absolutely different (*SE* 5:56). Like Heine, his body and text mark the site of a cut or wound, and the culture into which Freud seeks admittance demands a repetition of that cut. In the last portion of this chapter, I will explore how Italy marks the stunning failure rather than triumph of his Christian wish-fulfillment.

Nietzsche's Homecoming

In 1942 Benito Mussolini illegally removed from the Museo Nazionale delle Terme a six-foot-high sculpture of a clothed and bearded Dionysus. Since it is bearded, for some time the work confounded its allusions, belying the more traditional feminized representations of Dionysus.[11] A Roman copy of a Greek original, the statue was part of a number of antiquities found in 1926 near the Castello Gandolfo and dates from 340 to 330 BC. Moreover, so "re-masculated," the work hardly fulfills Winckelmann's concept of beauty. If nothing else, the so-called Bearded Dionysus points to the failure of a copy to furnish an image of the ideal. Perhaps that explains the odd history surrounding the Bearded Dionysus. Originally, Mussolini intended the statue to commemorate Italy's fascist alliance with the Third Reich. As *Art News* reports, "[H]e probably thought the six-foot-high sculpture . . . would never return to its native land. After all, Adolf Hitler had proclaimed the Nazi empire would last 1,000 years and Mussolini envisaged the statue spending the millennium on display at the memorial archive of German philosopher Friedrich Nietzsche, whom he greatly admired, in the city of Weimar" (90). The German Army transported the "gift" to Weimar, where for a time it stood in the train station. During the Allied bombing of Weimar, the statue was kept at the Nietzsche Memorial Hall; it remained in the storeroom of the archive until 1954, when it was put on display in the Athena Room of the Pergamon Museum. In 1988 the Italian Ministry of Culture asked for its return, but it was not until the unification of Germany in 1990, when the Pergamon came under the control of the Foundation for Prussian Cultural Holdings, that arrangements were made to have the work returned to Italy. What Mussolini delivered to Germany had to be returned to sender. The manner in which the spirit of antiquity, once again in the guise of a copy, had made its way to

147

CHAPTER 5

Weimar—drunken, bearded, and corrupted by Fascist power and alliances—was no longer acceptable.

The Italian idiom "fare la barba a qualcuno," or in this case "a Dionysus," is helpful here. Typically, the phrase means to shave someone, but it can also mean to cheat or deceive someone, to set up a person—or in this instance a nation—for fraud. This relic of antiquity that is finally refused threatens to betray the unholy and nearly fraudulent conditions that allowed Germany to honor the spirit of antiquity, in this case Dionysus. The central figure in this exchange or failed exchange, whose own return to Weimar and the seat of German classicism recalls the violence and madness necessary for a restoration or fabrication of origins, is Nietzsche. What his own archives would not admit, Nietzsche's return to Weimar under the care of his mother and sister had already brought back some forty years earlier. As E. F. Podach has written in his study of Nietzsche's collapse, he succumbs to his family (95). This submission means not only that his works are destined to fall into the wrong hands but also that he is handed over to a woman who proudly proclaimed that her roots in Weimar went back to the days of Goethe (Podach 29). The curious history of the Bearded Dionysus reiterates the messy, even untoward character of these transactions; they too fell into the wrong hands.[12] It is also worth noting that these transactions continued to generate a history. As part of a broader exchange concluded at the same time, or in an attempt to make up for keeping what it had no right to keep, Berlin sent on unlimited loan a sarcophagus that portrayed the action of Achilles during the siege of Troy (the Museo Nazionale already possessed fragments of the same sarcophagus). In turn, the Italian museum sent two large wall paintings from the second century AD to fill a gap in the Pergamon's collection (*Art News* 90).

Questions arise whether Nietzsche's homecoming was one too many and how a reiteration of Goethe's return to Weimar after Italy acquired something that did not belong. Nietzsche's continuing to live and age as his mother introduces a genealogical trace that for Winckelmann was only present insofar as it marked erasure. The feminine was a sign of "Abzeichnung," of de-gendering the male nude. Outfitting Dionysus with a beard is nothing less than unbecoming. That gesture hardly captures the spirit of the philosopher of becoming (Werden), but the real source of its scandal is that it ridicules the logic of substitution. The male authorial figure that stands in for absence is an ill-conceived

construction that no amount of suturing can conceal. Like the history of the statue, Nietzsche in Italy comes to articulate the incompatibility of the actual character of the substitution and what the substitution stood in for.

The problem could be understood just as readily as an attempt to understand how the history of Germans in Italy disables any pure reiteration of Goethe's journey. Although there is no shortage of scholarship that speaks to the topic of "Nietzsche in Italy," virtually no attention has been directed toward the role Italy plays as a site of specific interest to German writers of particular interest to Nietzsche.[13] If Goethe and Heine were two of the few German writers whom Nietzsche could suffer, Nietzsche's Italian journey is attendant to ghosts that move in opposite directions. Any return to Weimar thus returns what was sent into exile. The following remark taken from "The Birth of the Tragic Thought" can surely be read to indicate that Nietzsche's Dionysus is as overdetermined and even excessive as the unwanted statue of the same: "Only the ecstatic tone of Dionysian celebration, in which the entire excess of nature is revealed in pleasure and sorrow and recognition, penetrates a world so constructed and protected by art. Everything that until now serves as a boundary, as human destiny, is shown to be artistic semblance! 'Excess' reveals itself as truth" (*KSA* 1:593–94).[14]

Nietzsche's reintroduction of Dionysus onto the Greek stage certainly reverses Winckelmann's aesthetics, in which any image of pain and suffering points to its own erasure and repose. There are nonetheless points of convergence in this apparent reversal—most notably, the gaze of both is directed toward the inexpressible beyond the frame (Übermass). Nietzsche's movement beyond "artistic appearances" neither dismisses nor gets beyond the violence that enabled Winckelmann to arrive at the stillness of his ideal. For Nietzsche aesthetic images are threatened and haunted by something just on the other side of that image. The untoward history of the Bearded Dionysus lends expression to what that "other" might be. Nietzsche's penchant for Heine might even be explained by the unwillingness of both to sublate the "excess" or remains of previous Italian journeys. Nietzsche picks up on the violence that enables the transporting of the classical spirit back to Italy. Heine speaks to the dispossessed victims of Austrian/Catholic oppression. Nietzsche is attendant to ghosts of a different order, and Goethe in Italy is certainly one of them.

CHAPTER 5

SYPHILIS: OR I HAVE GOETHE ON MY MIND

That Goethe was on Nietzsche's mind, or what remained of it, in later years can be documented.[15] In states of madness or delirium (Umnachtung), Nietzsche could often be heard uttering, quite audibly, "More Light. More Light."[16] Repeating Goethe's last words is a small but telling clue of the demons that visited Nietzsche and contributed to his breakdown. While speculations about madness can be only that, they emphasize that Nietzsche's thought was always shadowed by some aspect he was unable to overcome, erase, or—to use Deleuze's term—"doubly affirm" (Nietzsche 188–89). In fact, the process by which Nietzsche seems to affirm difference is the shadow that forever visits the margins of his text. In the jargon of Nietzsche scholarship, there is an irreducible doubling that weaves its way through each of his texts. As Gary Shapiro has pointed out, in *Ecce Homo,* an autobiographical text inseparable from Nietzsche's stay in Italy, a partial list of paired concepts might be the following: affirmative/negative; health/illness; live as mother/dead as father; Dionysus/the crucified; good food/German food; Polish ancestry/German ancestry; being a beginning/being a decadent (160). One voice always supplements the other; the pose of one being is always dislodged by the appearance of a counterpart. The doublings are not stable. The lists grow or the pairs multiply, and the terms themselves, such as Dionysus/Apollo, are subject to slippage and redefinition. An unaccountable shadow always revisits the interlocutor.[17] Throughout this book reference has been made to the countless spirits roaming the Italian terrain, so much so that one is tempted to associate those spirits with the ones haunting Nietzsche's texts. In fact, Nietzsche, shadowed by what Goethe and others left behind and buried in Italy, might account for the most haunting narrative to have visited Nietzsche's work: the fate of his teachings in the hands of the Nazis.[18] A selective reading of certain passages from his work bolsters the association. The following remark, taken from the first lecture in "On the Future of Our Educational Institutions," fuels such readings: "For that was the curse of our students who are so full of misgivings: they did not find the 'Führer' that they needed. For I repeat it, my friends!—all education begins with the opposite of that which is prized today as academic freedom, with obedience, subordination, discipline, and servitude" (*KSA* 1:750).[19]

THE RETURN OF THE REPRESSED

It is necessary to consider the manner in which Nietzsche's work is always haunted by another. This clearly situates his work in the tradition of Italian narratives. As we will see, the difference is that Nietzsche names that figure as himself; it is stripped of its ideal character. Education (Bildung) begins with submission and servitude, and the curse that visits students is a lack of what is most necessary, guides or "Führer." In Italy, particularly for one who is an admirer of both Goethe and Heine, there is no shortage of spiritual guides. In fact they are doubled. The dutiful student vivifies such spirits merely by attending to them. But when such guides move in opposite directions or become incompatible, the genuflections necessary for their perduring presence no longer suffice to sustain the illusion of their presence. Movement is halted. Goethe and Heine cross or meet once again in Italy in the figure of Nietzsche, but the infelicity of that convergence denies the Italian journeyer the attribute that defines him as such, namely movement. Jean-Luc Nancy has described this phenomenon: "With Nietzsche and in Turin, there occurs that moment in history where death precedes itself to show what it 'is.' Until that moment 'God' has always signified as long as there had been a 'god' that death is not. . . . That is why, once this significance is abolished . . . a moment arrives in Turin, where it is death which overtakes itself and which shows itself for what it is: paralysis and death" ("Dei Paralysis" 203).

Goethe learned to precede his father in Italy and so came to author German classicism in Weimar. But when the distance essential to maintaining the illusion of an ideal in Italy can no longer be sustained, when cutting off overtakes itself and shows itself for what it is, all that remains is the figuration of the act. The ideal can no longer conceal that it "is not." The cursed fate (Verhängnis) of Nietzsche's work in the hands of the Nazis is a reminder that the figuration of cutting off comes to precede the ideal that concealed the violent gesture that enabled it. The ghost of the "other" Goethe is upon him, transfigured by subsequent journeyers such as Heine who followed on Goethe's trails. Nietzsche's Nazi fate likewise demonstrates that deceit and deception in Italy could return to Germany in the form of high crimes.

Nietzsche's work is, in fact, always haunted by another, who often enough he tends to name as himself. Late in his life he writes to Georg Brandes from Turin, "After you had discovered me, it was no feat to find me; the difficulty now is to lose me (Nachdem Du mich entdeckt hast, war es kein Stück mich zu finden; die Schwierigkeit ist jetzt die, mich zu

CHAPTER 5

verlieren)" (*Briefe* 8, 20 November 1888). Goethe's stay in Italy had the opposite effect; finding him or what of himself he had left behind in Italy became the real challenge. For Nietzsche, the doubling of terms noted above is perhaps a response to his own persistent reappearance in the form of what he initially declared to be other. What appear to be dichotomies or distinctions within Nietzsche's work are illusory. As Beda Alleman notes, the element of the other in any of Nietzsche's binary distinctions, the element which always appears to be standing over and against him, is merely a different stage in a labyrinthine progression of discoveries that there is no other" (45–64). There seems no possibility of cutting oneself off from oneself. The problem is most apparent in *Ecce Homo*, or certainly in its tone. On the one hand there is the aggressive and self-assured tone of an author who can declare himself to be a fate. On the other are those elements that stamp the work as a swan song, a testimony of Nietzsche's inability to complete his reevaluation of all values.[20] Likewise, there is the lyrical tone of the poem "Venedig," which I will turn to shortly, and the parodic tone of the section just mentioned. The statement on the title page, "How one becomes what one is," needs to be read not so much as a genealogy of selfhood but rather as indicative of how being is always shadowed by becoming. The self is in two places at once—or is two selves in one.

This is perhaps best understood if we return to Alleman's argument. The notions of the Apollonian and the Dionysian in *The Birth of Tragedy* may undergo a metamorphosis in his later writings, but the essential characteristic of that description, namely its apparent dualism, is repeated throughout Nietzsche's entire work (Alleman 57). Being and appearance are identical in the early work since everything else has been stripped away. This relationship, whereby the Apollonian is a projection of an underlying will, determines Nietzsche's position to the end: "Existence is aesthetically justified only after all other grounds that could offer some consolation have been denied. . . . His poetic reflection always returns to this position. One is almost tempted to say that this reflection has obstructed his poetics. . . . He seeks aesthetic semblance and sees through it at the same time" (Alleman 58).

The separation of selves or the self of reiteration is dismissed the moment it appears. There can be no question of preserving an incognito. Since the metaphysical stance of *The Birth of Tragedy* leads unfailingly to a dismissal of all being as mere appearance, that which is undone or deconstructed can only be replaced by more images, which, like par-

ody, become images of their own undoing. "Semblance can only be sustained paradoxically, and in order to remain all the more beautiful, it cannot admit this to itself; rather it must cling to the myth of its Dionysian origin" (Alleman 58). Failure to see through the veneer of the beautiful or refusal to admit the insufficiency of all being is either ruse or deceit. Italy is the site where that ruse can no longer be maintained. When the legacies of Goethe and Heine cross, ruse becomes itself—just as death does, to recall Nancy's observation.

In this light, the descriptions of the "overman" in *Thus Spoke Zarathustra* have a somewhat tragic character to complement the parodist. The overman is a figure born less of triumph than of tragic necessity, seeking to identify himself with something beyond the progressive unmasking of all being as mere appearance. Man is just one more of those appearances. "The opposite of the overman is the last man; I created him at the same time (Der Gegensatz des Übermenschen ist der letzte Mensch; ich schuf ihn zugleich mit jenem)" (*KSA* 10:162). The inseparability of the last man from his superhuman ideal means there is always one figure too many (e.g., Goethe *and* Heine). This inseparability forecloses the possibility of unloading one figure to stand in for the ideal or for that ideal self to withstand the unraveling of appearance as mere being. Zarathustra also describes man as a rope stretched across an abyss. At one end of the abyss is the beast, at the other is the overman: "A dangerous crossing over, a dangerous wayfaring, a dangerous staying behind, a dangerous shudder and staying put (Ein gefährliches Hinüber, ein gefährliches Auf-dem-Wege sein, ein gefährliches Zurückbleiben, ein gefährliches Schaudern und Stehenbleiben)" (*KSA* 4:16). Movement to the other side is always halted; the figure that man would become is unmasked as appearance. The journeyer is paralyzed. In the context of Italy or Nietzsche in Italy a tradition of Germans in Italy lends contour to the shape of that figure. It is shaped by the deceptive moves that permitted the figure to assume or move toward a ground of being. After Heine, keeping up appearances in Italy is impossible.

What I am arguing is that the ghosting of all being as appearance is nothing new in Italy. What is new in Nietzsche's case is that the ghost of Italian journeyers past has revealed the conditions that enable appearance or the appearance of something ideal at the other side of the bridge or at the end of the journey. Moreover, what was required to maintain appearances has acquired a different character, given Heine's fate in Italy. The figuration of moves necessary to preserve the illusion that the

ideal is something other than self-projection or reiteration has also altered its character. Nietzsche's collapse in Italy is an indication that he hears those voices ("Mehr Licht! Mehr Licht!") or that the self that was to be other is merely talking to itself.

The journey to Italy has always held out the possibility that what apparently presents itself as something original might reveal itself as only a placeholder for absence. From the beginning Nietzsche seeks in vain, to paraphrase Allemann, for some ultimate ground; his thought is shadowed by its own impossibility. And the space vacated by the unmasking of all being as appearance invites or summons the ghosts that have been lying in wait in Italy. Jean-Luc Nancy has demonstrated how Nietzsche's entire work, intended as an attack on metaphysics and teleology, comes in the end to reiterate the very voices he sought to silence or dismiss. According to Nancy, his early philological work into the authenticity and sources of a body of work (i.e., his project on Democritus) gives rise to a "philosophical impulse" that must concede the forgery of philology's primordial ground ("Nietzsche's Thesis" 50). At the same time, the philosophical project miscarries. Like the philological project, it seeks a "ground zero," "that place where it would no longer need to offer up a philosophical thesis" (53). Instead, it brings to prominence "the motif it inscribes at once inside itself and outside itself: the 'Dichtung' of the concept" (57). The philological and philosophical projects force an endless deferral of each other. Nietzsche is unable to complete his earliest philosophical project: a work on teleology, whose thesis he never delivers. That failed delivery or its endless deferral is itself a thesis, which, in turn, is a thesis that has to be taken up again only to be renounced again. Renunciation of *The Book of the Philosopher* leads to the abandoned sketches of Empedocles, Oedipus, and Prometheus, which are concurrent with a scientific project that includes Darwin, Zollner, and Larmarck. This series of miscarried productions or double moves brought about by the "double thesis [philology and philosophy]" repeats itself up to "what we call for convenience 'The Will to Power,' the last thesis by Nietzsche not to have taken place" (Nancy, "Nietzsche's Thesis" 61). The paralysis that overtakes Nietzsche in Turin near the end of his life is the progressive shape of those deferrals or miscarried projects.[21] Like the will to power, which always only interprets, Nietzsche's work can never speak about itself; it must speak of something other than itself, or of itself as something other.

Nancy's essay is important for two reasons. It demonstrates how Nietzsche was always visited by another to the point of paralysis, and it shows how that other is very often someone other than Nietzsche, who paradoxically turns out to be Nietzsche or whom Nietzsche becomes. For example, Nietzsche's coming and going to philosophy is for Nancy a doubling of Kant's "articulation and disarticulation of philosophical discourse" ("Nietzsche's Thesis" 59).[22] This repetition of Kant assumes its most startling form in the one figure that completes for Nietzsche the unending series of figures: the philosopher of non-finality, Zarathustra. The inscription of that name is itself a radical repetition of the name that Kant invokes in the *Opus Postumum* as the crowning figure of his own system, Zoroaster—a similarity of inscription that recalls but does not entirely duplicate the anagrammatic games Goethe played with Moritz. Just as Kant could not allow the figure of Zoroaster to be drawn since no figure could contain and render sensible the ideal of practical reason, Zarathustra is not without remainder. At the very least, in *Ecce Homo* he finds a successor in Dionysus and the Crucified.[23] A tradition or body of thinkers haunts and frustrates Nietzsche's work (Nancy eventually asserts that he reiterates even Hegel), and the stubborn reappearance of that which cannot be articulated but nonetheless is present by its ability to reveal the false ground of all appearance or of any proposition can be described only perspectivally.

The interest of this project is the Italian perspective. That which is beyond articulation approaches definition in the form of that which was censored or cut off by those who in certain ways gave rise to the tradition in which Nancy inscribes Nietzsche. As already mentioned, *Ecce Homo* is Nietzsche's attempt to reconsider or review his previous work. It ends with the provocative phrase, "Dionysus versus the Crucified." The riddle emphasizes just how irresolubly doubled the self is. Yet the apparent incompatibility of the two figures is resolved when one reconsiders the manner in which all appearance gives way to the parodist's insight. All forms of identity are offered up or sacrificed. Zarathustra's destination on the rope above the abyss would thus always be deferred; its apparent end, mere mirage. In *Ecce Homo* Nietzsche nonetheless attempts to put an end to this endless unmasking of all appearances. Not surprisingly, the effort comes in the last section of that portion of the text devoted to *Thus Spoke Zarathustra* in which Nietzsche suggests that Ariadne is the one figure substantive enough to stand over and against

CHAPTER 5

Dionysus and confirm his presence: "Nothing like this has ever been written, felt or suffered, only a God, Dionysus suffers like this. The answer to such a dithyramb of solar solitude in the light would be Ariadne. . . . Who besides me knows what Ariadne is!" (*KSA* 6:348).[24]

Even biographical notes, however, render Ariadne nothing more than a stand-in.[25] During the days of his collapse, Nietzsche sent Cosima Wagner a proclamation of love, addressing her as Ariadne and signing it Dionysus. She was one mask among many, already a stand-in for what could never present itself in any fashion other than as appearance. Only Nietzsche knows who she is, but solely by identifying himself as something other than who he is. Stand-ins generate other stand-ins, who are known only to each other and who exist by virtue of reciprocal self-projection.

This collapse of difference is evident in "Ariadne's Lament," in which the revision of the magician's song from *Zarathustra* is reflected in the changing of masculine pronouns to feminine ones. The magician and Ariadne are apparently interchangeable.[26] What distinguishes them is linguistic convention, and the author (Ariadne, Dionysus, Nietzsche?) of each is always only the same. Addressing the effects of Dionysus, Bianca Theisen frames the issue as follows: "Dionysus [instigates] confusion and erases borders; frontiers that separate god, human, and animal constantly shift. . . . Dionysus promises no transcendence, no salvation . . . and blurs gender difference" (93).[27] The final words of the poem could be said to announce both her complaint and Nietzsche's: "I am your labyrinth." What Dionysus finds in his partner is only an apparent partner, which is precisely the complaint. She is the image which confirms that the parodist is inextricably caught in a web of his own dream projections. What confronts him/her is a labyrinth, reinscribing the parodist's inability to disentangle himself/herself from the image of disentanglement. This is the trap set for Nietzsche in Italy. Goethe succeeded in losing himself in Italy. Absence thus had a stand-in. By contrast, Nietzsche cannot escape witnessing the process by which doubles are produced, stand-ins granted the appearance of the real or of a real ideal self.

Both the magician and Ariadne should be understood as figures of deception. The magician stages the torment of being forlorn to seduce Zarathustra into pitying him. Ariadne's story is likewise already one of deception, since she betrays her kin by showing Theseus how to escape the labyrinth (Theisen 87). The invitation may be to Cosima Wagner to

join Nietzsche by betraying her composer husband. Who then is the one staging abandonment to seduce—Nietzsche or Wagner? Even when the interlocutor changes, when she seems to promise an exit from the labyrinth, there is only a lure into another labyrinth.

That "mise-en-abyme" was already played out by the magician when he confessed to Zarathustra, "Everything about me is a lie, but that I am breaking—that breaking is genuine (Alles ist Lüge an mir; aber daß ich zerbreche—dies mein Zerbrechen ist ächt)" (*KSA* 4:319). The breaching of the breaking is genuine, and everything remains a lie. Genuine is nothing save a ruse of language, a breaking, at the very least, of any verifiable measure. The classical ideal depended on a similar breach. Winckelmann valorized the copy so as to dismiss it; the copy disowned itself. Goethe could be said to have done the same, depositing the specter of his being somewhere in parts south of Rome. Nietzsche's return to both Italy and Weimar introduces another order to the logic of substitution, and such logic becomes labyrinthine. As I have argued, Winckelmann imitated the ancients; Goethe imitated that imitation. In Nietzsche, the "mask . . . observes itself as mask," the "text . . . interprets itself as text" (Reinhardt 86).[28] This is another way to describe what I have just remarked about Winckelmann and Goethe respectively and what is played out by both the magician and Aridane as well as in the rewriting of the poem itself. At this order of substitution, there is no possibility of discovering a ground or object. As in the case of the magician's statement, all that remains is the principle that becomes its own object; breaching the breaking is another means to describe what I have repeatedly named cutting off. Ariadne is the figuration of the labyrinthine progression or repetition of that principle. "Unnamable! Veiled! terrible one! / You hunter behind clouds (Unnennbarer! Verhüllter! Entsetzlicher!/Du Jäger hinter Wolken)" (*KSA* 6:398). Behind the smoke and mirrors that veiled the absence of the ideal is produced, in the process of maintaining the illusion of that ideal, something that perdures: the hunter. Appearance and iteration are haunted and hunted, and they also do the hunting. Nietzsche is pursued in Italy by that which promised rejuvenation and rebirth there. And one need not only refer to his madness or to the specter of Goethe's legacy in Italy. Despite his family romance, Nietzsche can never rid himself of his maternal heritage. His collapse in Italy will finally hand him over to precisely the side of his family he sought to banish. As evidenced by Goethe, in Italy paternal genealogy can be rewritten, but as the mother one "continues to grow."

CHAPTER 5

Fixated on the male nude, Winckelmann viewed the feminine with an eye toward obliteration and absence (e.g., Niobe). For Goethe the feminine was only one figure among many in a chain of substitutions. Is Faustina any more substantive than Ariadne? For Nietzsche that which was cut off returns, and insofar as it is the feminine, its character has been shaped by the moves intended to censor the feminine.[29]

Dionysus' instructions to Ariadne at the end of the poem should be considered in this context. "You have small ears / you have my ears: / put a shrewd word into them (Da hast kleine Ohren, du hast meine Ohren: steck ein kluges Wort hinein)" (*KSA* 6:401). Putting a shrewd word into Dionysus' ears, which are both his ears and not his ears, is ceded to a figure of self-projection. He hears what the illusion of an "other" will have him hear. He is handed over to its voice. Nietzsche's fate in Italy, insofar as he identifies himself with Dionysus, suggests that the word put into the labyrinthine structure of the ear was anything but shrewd; rather it was the word of a shrew, for it is his mother and sister who will seek to have the last word regarding his texts.

The poem that most forcefully expresses Nietzsche's inability to escape the labyrinthine predicament of the parodist is the poem "Venedig." As one proceeds with the reading of the poem, it is important to remember that Venice is where Goethe recalled his father and a toy gondola; it is also the city that Heine, on his way to exile, avoided:

> An der Brücke stand
> jüngst ich in brauner Nacht.
> Fernher kam Gesang:
> goldener Tropfen quoll's
> über die zitternde Fläche weg.
> Gondeln, Lichter, Musik—
> trunken schwamm's in die Dämmrung hinaus . . .

> I stood at the bridge
> lately in the brown night.
> From afar came a song:
> as golden drops it welled
> over the quivering surface.
> Gondolas, lights, music—
> drunken it swam out into the twilight . . .

Meine Seele, ein Saitenspiel,
sang sich, unsichtbar berührt,
heimlich ein Gondellied dazu,
zitternd vor bunter Seligkeit.
—Hörte jemand ihr zu? (*KSA* 6:291)

My soul, a stringed instrument,
sang to itself, invisibly touched,
secretly a gondola song,
quivering with iridescent happiness.
—Did anyone listen to it? (W. Kaufmann 252)

The poem first appeared in 1888 untitled and part of a larger discussion about music, "Intermezzo." The discussion was incorporated into *Nietzsche contra Wagner.* Years later the poem was transferred to the seventh section of *Ecce Homo,* "Why I am so clever." What a discussion about music, particularly an intermezzo, might reveal about the cleverness of the author and thus prompt such a transfer will become clear below. It is important to note here that the experience which inspired the poem is apparently at odds with the glib, parodic, and often self-congratulatory tone of *Ecce Homo.* That experience, Nietzsche later recalled, occurred in 1885 on his last night in Venice, as he stood on the Rialto Bridge overlooking the Grand Canal and listening to the "Arsenalotti": "The final night at the Rialto Bridge brought to me a type of music that moved me to tears. It was an unbelievably old-fashioned adagio, such music as if there had never been an adagio."[30] In a book that questions the originary claims of his entire work, the poem seems to privilege the primacy of experience, save that the poem itself is a form of self-citation. The impossibility of communicating primacy (and here we should not fail to recall Goethe's primal plant) is evidenced by the words that introduce the poem: "Whenever I seek another word for music, I always find the word 'Venice'" (*KSA* 6:291). Music is a lexical term that replaces words or a word that is authored by Nietzsche or cited by him to find another word for something, music, that should need no words. Moreover, the word "Venedig" substitutes not only for music but also for the city itself. Its self-citation is already doubled, and it has "always" been that way. The primacy of experience has no original ground save for the one that the artifices of language offer and simultaneously refuse. In other words, original is the doubling of all experience, which is an-

CHAPTER 5

other way to say that experience is merely self-citation's double. That is the experience "Venedig" documents.

The eventual voiding of all sensory phenomena, or the reduction of Venice to a slow and graceful musical movement, accounts for the apparent singularity of its tone. What one discovers throughout the poem, however, is that the structure of its movements, not the tone, is descriptive of a self-overcoming similar to that found in parody. Its somber tone expresses Nietzsche's despair over being unable to replace the images of Venice with anything but an image descriptive of that overcoming. And that image is a musical one, another word for a Venice that is something always other than itself. In the opening lines Nietzsche envisions himself as he once stood on the bridge in the brown night. What presents itself to him in the following lines are projections of one's own projecting, of one looking out on himself looking out. The position of the lyrical "I" never changes throughout the poem. On the bridge the "I" maintains the position of one always crossing over—except that he never arrives anywhere. In effect, the narrator of the poem, who is both the same and not the same as the lyrical "I," is an overman, always looking over what he overcomes. According to Zarathustra, only in this position can mankind be surpassed. The poet must remain at the overpass: "What is great about man is that he is a bridge and not a goal" (*KSA* 6:16–17). If the production of an ideal self through the mechanics of reiteration produced in Goethe something he could journey away from, for Nietzsche's overman, understood here to mean the self that cannot leave the spot from which the self is projected, all movement is illusion.

The use of the past tense is consistent with the poet's attempt to retain that position. It is a conscious reconstitution of something not present and thus intentionally a projection. As something already displaced in time, the poem brings into sharper focus the moment in which such dream-like projections are surpassed, dissolved by the music they both seek and out of which they emerge. The "jüngst ich" at the beginning of the second line emphasizes that a projected self is the more enduring image of the poem. The rhythm of the line, which reverses that of the previous one, requires an elision of any apparent break between the temporal adverb and the first-person subject. The elision indicates that the presence of the self is a passing phenomenon, tied to relative positions in time. It is as vaguely present as the adverb "jüngst." The remainder of the first stanza presents a gradual but certain dissolution of the impressions that have helped situate the "I" of the second line. It is

THE RETURN OF THE REPRESSED

worth noting that in *The Birth of Tragedy* Nietzsche remarks, "The word, the image, the concept seeks an analogous expression in music and now feels itself the power of music (erleidet jetzt die Gewalt der Musik an sich)" (*KSA* 1:49). In seeking that music, the objects that would anchor the self likewise dissolve, suggesting the fate of the self. "Zittern" and "trunken schwamm" evoke the Dionysian music that the images of the stanza seek, but they also suggest an undoing of the fixed contours of objects that a view from the bridge might otherwise offer. The spatial descriptions, "fernher" and "weg . . . hinaus" so distance, even destabilize, what greets the "I" that the three nouns, "Gondeln, Lichter, Musik" effect only impressionistically, culminating in and taken up by the music at dusk. The ellipsis that concludes the stanza underscores the endlessness of this process. What the dusk or brown night has brought about continues indefinitely: the dissolution of temporal and spatial borders. Without such borders, no bridge can be crossed.

The opening four lines of the following stanza seem to confirm the poet's celebration of his complete immersion in and identification with the music of Venice. His soul sings to the music that in the first stanza was, at least in part, the result of analogous images returning to their origin, the dissolution of the city into the brown night. The deemphasis of the visual (unsichtbar), the use once again of musical imagery, and the repetition of the word "zittern" render this stanza a virtual echo of the first. The soul, however, has not found its perfect partner in Venice; rather, the dissolution of the Venice in the opening stanza is a result of the soul's reappropriation of what it initially projected of itself. The poet comes to recognize that what stood over and against him was only himself. All iteration is reiteration; the soul sings to itself what it sang in the first stanza. All evidence of an outside is erased. The soul, not the waters of Venice, trembles; the gondola is replaced by a song of the soul, and the city's lights are now taken up remotely as an adjective to describe a colorful state of bliss, which must be understood as another of the soul's projections. The dash that begins the final line of the poem signals the evacuation of the city; there is nothing there. The question that concludes the poem does not disrupt the sentiments that preceded it; the question continues and refigures them once again. It is a form of self-questioning, which by its very structure reveals that what is standing over and against the questioner is only himself. There is no response, since the question is its own form of response. It describes the process just enacted: one seeing oneself see oneself. By posing the question, the

CHAPTER 5

respondent has already been passed over. It goes without saying that the poem would end with an ellipsis. Not only does the process continue indefinitely, but there is also nothing substantial enough to withstand the dissolving force of the music—not even the word that is music. If in Italy Goethe was missing in action, Nietzsche is an ellipsis, which marks both his presence and his absence.

It is now possible to understand why Nietzsche chose to include the poem in a section entitled, "Why I am so clever." His cleverness makes everything his own. Nothing stands apart for long that is not soon returned to him. The poet is the ever-vigilant one who sees himself behind the mask of all appearance. He never arrives beyond the mask, for the mask is all there is. However, the one worn by the poet standing at the overpass is a mask of unmasking: "Yes! To look down upon myself and even my stars—that I would call my last *summit,* that has remained for me my last summit" (*KSA* 4:194).[31] The poem could just as easily have remained a part of "Intermezzo," and in a certain fashion it did. Just as Nietzsche or the lyrical "I" never leaves the bridge, there is no movement save for the one of being stranded in-between. There is no way back to an originary ground, an "Ureinen" as Nietzsche calls it in *The Birth of Tragedy*. Consequently, there is no final ground. Insofar as the case of Nietzsche is instructive, the storied return to antiquity, to Italy and the supposed roots of Western civilization, turns out to be the infinite regress of the self positing itself. In *Ecce Homo* the discussion about self-preservation and self-defense that follows "Venedig" is thus only redundant.

What I have attempted to demonstrate by these excursions into Nietzsche's philosophical and poetic works is the maddening figuration that haunts his work until his collapse in 1889. The process might just as well be described as an eternal return of the same, "eine ewige Wiederkehr des Gleichen." What returns eternally in the eternal return of the same is that which always escapes articulation but nonetheless makes itself felt by exposing the illusory or false ground of that which is articulated. And while the same that returns might defy articulation or absolute representation, it is not without body. "Gleich" is formed from the prefix "ge," which indicates a collective. "Leich" comes from the Middle High German "lich" and means appearance, figure, likeness, and in modern German, "Leiche" or corpse. Nietzsche in Italy comes to embody what Goethe could neither admit to the discourse of Weimar classicism nor truly cut off. It is the collection of ghosts that has haunted

THE RETURN OF THE REPRESSED

every traveler to Italy discussed in this book. Something always remained or lingered about to challenge any originary ground Winckelmann or Goethe might have claimed to have found. These are the demons that haunt Nietzsche, just as Goethe's request for "More light" becomes Nietzsche's refrain in his madness or "Umnachtung." His rearticulation of Faust's final words in *Zarathustra* is equally telling: "Alas, how tired I am of the inadequate that is supposed to be actual (Ach, wie bin ich all des Unzulänglichen müde, das durchaus Ereignis sein soll!)" (*KSA* 4:165). These words of Nietzsche, or rather these words of Goethe that never live up to their promise for Nietzsche, suggest that the same which forever returns to Nietzsche is linked to the unfulfillable promise or insubstantial ground of Goethe's claims. The end of that quote could be read as a just indictment of Goethe and the countless progeny that have issued since his discovery of the primal plant and the endless offspring Goethe promised to produce as a result of his find: "Alas, how tired I am of the poet! (Ach, wie bin ich der Dichter müde!)." The "ach" that marks his exasperation also serves as a placeholder for nothing. It marks the retreat of what the poet seeks in order to ground appearance, to make it adequate (zulänglich).[32] Even reiteration cannot substantiate what was only there as phantom, as interjection. Italy confirms that suspicion.

A demonic influence overtook Nietzsche's work once Elizabeth Forster-Nietzsche saw fit to become his editor. That demon seed, however, had already been replanted upon his return to Germany.[33] The Nietzsche who returns to Weimar suffers from "dementia paralytica," as Philo von Walde described it (Gilman, *Conversations* 238). Curiously, this Nietzsche now begins to resemble the man whose discarded remains in Italy he reincorporated:

> Anyone who has seen Nietzsche as a patient . . . must consider himself lucky. . . . Frankly I [Ernst Horneffer] feared this sight. But how impressed I was by his beauty. . . . This was another Nietzsche whom I saw there. . . . I stood still, awestricken with reverence. The first thing I saw was the forehead, the mighty forehead. There was something Goethean, Jupiter-like in its form. . . . Peter Gast says that Nietzsche did not make this Jupiter-like impression in his healthy days. (Gilman, *Conversations* 254–55)

CHAPTER 5

In the care of his mother and sister, Nietzsche comes like never before to resemble Goethe. This Nietzsche is a Goethe who was never meant to be returned to Weimar. It is no doubt the same Nietzsche, the same corpus prepared by Elizabeth Förster-Nietzsche that Hitler gifted to Mussolini to honor "il Duce's" sixtieth birthday in 1943 during the latter's imprisonment in La Maddelana (Mussolini 92–93).[34] Very possibly, it was also a thank-you note, aptly recognizing the "gift" from the previous year of the Bearded Dionysus.

Seeing Syphilis. Seeing Goethe

"I have made my first bow to authority," Freud writes to Wilhelm Fließ upon his promotion to professor in 1902 (*Origins*, 11 March 1902). The elation over receiving academic recognition was accompanied by another sort of recognition: repression was not solely a psychological mechanism. In 1895 Viennese liberals witnessed the fall of the city to Karl Lueger's anti-Semites. Promotions of Jews in the medical faulty became rare. In recognition of the ominous political climate, Freud joined the B'nai B'rith and took his practice to circles of Jewish citizens who neither threatened nor discouraged him (Schorske 185). Psychoanalysis became a safe refuge for the Jew, but the safety of that refuge was ambiguous at best, given that such a form of retreat became a condition of admittance to the medical faculty. In part, this dual accommodation can be attributed to the altered notion of Jewish difference that emerged alongside Freud's development of psychoanalysis and in fin-de-siècle Vienna: "What earlier differentiated the Jew from the non-Jew—as well as unified the Jews—was their religion and what evolved from their religious laws. This connection has been destroyed. The Jews no longer claim to be the 'chosen' people, no longer believe in the God of the Jews, and understand the laws of Moses to be only social and hygienic directives" (M. Marcuse 708).

With the approaching collapse of the Hapsburg Empire arrived as well an attempt to shift the origins of Jewish difference from considerations of sociopolitical boundaries, or religious practices, to indelible markers of racial inferiority. By its very nature such a shift would be impervious to the vicissitudes of war and politics. However indeterminate the differences in the Jewish way of life might have become during a century of apparent assimilation, the mythical difference indicated by race was permanent. As Adolf Hitler wrote in *Mein Kampf*, "The whole existence of the Jew is based on one single great lie, to wit, that they are

a religious community while actually they are a race—and what a race!" (232). Long before Hitler's remark, racial science had infiltrated the medical curriculum, which meant that Freud was dependent on the graces of those who had helped resituate the essence of Jewish difference in an arena in which no politics of accommodation could erase or minimize (Gilman, *Case of Sigmund Freud* 11–36). Freud's promotion in 1902, or, in effect, the acceptance of his *Interpretation of Dreams* by the medical faculty of Vienna, suggests that his own fantasies or wish fulfillments were favorably linked to this ominous shift in locating the difference of his own. He is accepted by those who disdain his Jewish character as ineradicably different, and that constitutes a fulfillment of professional aspirations. To recall his letter to Fleiß, promotion is obeisance.

Jean Laplanche has effectively argued that two competing polemical fields structure the body of Freud's work. In the context adumbrated above, which is not Laplanche's, one understands that Freud's discourse on the pleasure principle, for example, is inflected by an unconscious wish of its own, whose motives are linked to institutions with an interest in redefining repression as a biological or internal mechanism. His career path is thus formed by competing desires. The sudden appearance of the death drive in 1920 in *Beyond the Pleasure Principle* is curious for two reasons: it shifts the biological nexus of Freud's thought onto a more speculative, metaphysical sphere, and it seems to acknowledge the conflict that riddles his own project. As Laplanche explains:

> In the beginning, like all modalities of the negative, it is radically excluded from the unconscious. Then suddenly in 1920 it emerges at the center of the system, as one of two fundamental forces—and perhaps even as the only primordial force—in the heart of the psyche, of living beings, of matter itself.
>
> The soul of conflict, an elemental form of strife, which from then on is in the forefront of Freud's most theoretical formulations, death nevertheless remains most often, a silent personage in clinical practice. (5–6)

The so-called reticence or silence of death in the clinic suggests its contrary claims and interests. If psychoanalysis fostered accommodation, via a pleasure principle of its own, to a system or culture increasingly com-

CHAPTER 5

mitted to a radical displacement of the Jews, death would be more than a silent witness to the clinician's practice. It would be an operative partner as well. The political obstacles Freud overcame via psychoanalysis were at the same time evidence of a self-destructive impulse. The "fort/da" relay of *Beyond the Pleasure Principle* describes not only the double bind of its author but also the reentry of an outside—call it the political—into the refuge of Freud's science. The radical claims of Laplanche's argument are less important for this project than the manner in which Italy, as a recurrent motif in key works that describe the return of a repressed within Freud's own system of repression, functions as a reminder of Jewish difference and exclusion. For Heine, Italy gave rise to unorthodox sentiments that conflicted with its "fetishization" by a post-Goethean generation of Grecophiles. For Freud, Italy is the land of "Genitalien," whose fetishization can only obtain at great risk and for a time politically. Just as the process of erasure for Winckelmann and Goethe left a trail of its own, Freud's attempt to erase political obstacles toward advancement of his professional career leaves a trail of its own, which, not surprisingly, leads to Italy and back to Rome. In other words, the drama of "fort/da," advancement and retreat, pleasure and death, can be read or clarified with respect to Freud's Italy and particularly to what Carl Schorske has called his "Hannibal complex." Moreover, Italy as a repository for the dreams of German-speaking culture confronts Freud with an unconscious of its own.

Inserting Freud into the context of Italy as it has been developed here is also indicated by the nature of the Freudian discourse. Goethe's emphasis on sight or seeing bequeathed a troublesome legacy to Jews in the nineteenth century. Jewish difference not only accounted for the general assumption that Jews were particularly susceptible to certain diseases, syphilis in particular, but the effects of that difference were also readable on the body of the Jew. As Sander Gilman has written, "But ever more so this general claim about the hereditary risk of the Jew is linked to a diagnostic system rooted in the belief of external appearance as the source of knowledge about the pathological" (*Jew's Body* 77). And seeing, according to J. M. Charcot in his 1877 *Lectures on the Diseases of the Nervous System,* is the privileged form of diagnosis (64). Freud changes registers. The interpretation of verbal signs and the subtlety of hearing replace the crudity of seeing as the preferred diagnostic tool (Gilman, *Jew's Body* 77). Such a shift is concomitant with one that attempts to root difference in social causes rather than genetic ones; but

this way out also indicates an acceptance of Jewish difference (Gilman, *Jew's Body* 58). If for Goethe in Italy seeing and science were intricately linked, Freud's emphasis on hearing is not a complete rejection of the grounds of Goethean science. It is a response and acceptance of the notion of Jewish difference as it came to be reified through seeing. But it is also a shift that generates difference of another sort and one that is consistent with the sort of difference that Goethe's Italian journey articulates: the other is always one's own self displaced through reiteration. Nietzsche sees himself seeing himself. Freud hears himself hearing himself. He is both the "authoritative voice of the observer and the ever suspect voice of the patient," which accounts for his fondness for the "quintessentially ironic and thus Jewish poet, Heine" (Gilman, *Jew's Body* 168). The assumption here is that Freud is always the subject of his own discourse or that he is his own patient. As it comes to be understood in the nineteenth century, reiterative difference is descriptive of the Jewish difference or rather the Jewish creative force. Being the subject and object of one's discourse—one way of describing Heine's poetry—is the production of difference per se. Unlike Goethe, Heine cannot shed that difference or the self that is always different from itself. Freud's shift from the visual to the aural reinscribes and reifies difference. He shares Heine's creative force, which is both particularly Jewish and diseased or syphilitic (Gilman, *Jew's Body* 159).[35] Of course, Nietzsche might also be linked to the creative force that is syphilitic. Such a connection suggests in this instance that syphilis is the result of an inability to overcome the difference of the same or of the self. Disease announces the failure of duplicating Goethe's Italian journey. For Freud, the repetition of a discourse that stubbornly generates difference marks the impossibility of removing himself from "the category of the biological and, therefore potentially, diseased Jew" (Gilman, *Jew's Body* 162). A consideration of Italy as a trope in his works underscores how that failure is above all else a political one.

"Fort und Da": To Go or Not to Go to Rome

Much has been made of Freud's curious relationship to Rome in *The Interpretation of Dreams* or to what Schorske has called his "Rome neurosis" (189). The Rome dreams are preceded by Freud's introduction of the concept of distortion. Dreams are no longer simply wish fulfillments but rather "disguised fulfillments of a suppressed wish" (*SE* 4:134). The example Freud offers is the one discussed earlier in this chapter, that of

the uncle with the yellow beard. As we recall, in the dream Freud conflates his uncle with an acquaintance whose hopes for a professorship were compromised by the fact that he was Jewish. In the dream, the fondness Freud displays for his uncle, who was previously involved in a financial scandal, is an attempt to conceal his desire to discredit his acquaintance; there were reasons other than his being Jewish for his professional difficulties. Freud goes on to compare the mechanics of the dreamer to those of the political writer, "who has unpleasant truths to tell those in authority" (*SE* 4:142). Freud does not admit that his theory of distortion in dreams is subject to the same forms of censorship that confront the political writer, but his admission of a manifest political content to the dream points in that direction. Moreover, the person in authority who is to hear unpleasantries is just as easily the Freud who is both subject and object of his own discourse. The analysis of dreams is itself an exercise in distortion insofar as that concept is part of the fabric of Freud's own dream world. Rome, he will remark later in the text, is "the promised land seen from afar" (*SE* 4:194). The heresy of the statement underscores the political dimension of distortion. Rome, instead of Zion, becomes the promised land for one seeking admittance to a medical faculty whose science is increasingly distorted by the mythical tenets of race.

The city in which Goethe is rebaptized is the destination of Freud's own dreams, but Freud conceals from himself the significance of that distortion or the substitution of destinations. Indeed, his remarks about distortion are prefaced by one of his favorite citations from Goethe's Faust: "After all, the best of what you know may not be told to boys" (*SE* 4:142). Goethe is the father that Freud's family romance imagines in the place of his own, but what it means to pursue Goethe all the way to Rome is something even imaginary fathers cannot divulge. Psychoanalysis withholds what it promises to reveal not only because it is circuited through the forms of distortions it tracks but also because it is rooted in a psychosexual attachment of its own. Freud is said to have remarked that Goethe's "erotic descriptions of nature" were the reason he opted to study science, not law (Schorske 193). Like Winckelmann, Freud can be said to be in love with his work, but what Freud does for love is conceal from himself the consequences of his compromise with authority. Reimagining genealogy is child's play when the assumptions and laws concerning one's race are being rewritten and set in stone. Therein may lie the source of his "Rome neurosis." Succumbing to the

eroticism of Goethe's science may tempt one to dream of Rome, but as Heine's Italian journey suggested, Goethe's Rome may not be for everyone, least of all German or Austrian Jews. Here are the questions that must be posed: If Rome is the promised land when seen from afar, what is the disposition of that promise once Freud finally reaches Rome? Is there something about the Rome Freud reaches that rearticulates substitution as distortion?

Freud travels to Italy five times between 1895 and 1898. Each time he is unable to reach Rome, despite urgings from Emanuel Löwy, a professor of archaeology, who kept Freud up past three in the morning with tales of the city (*Origins*, 20 January 1899). On the anniversary of his father's death in 1899 Freud describes the situation as increasingly torturous (*Origins*, 23 October 1899). As for Goethe, the memory of the father both inspires and frustrates entry into Rome. Nonetheless, Freud devotes little time to analysis of his Rome dreams, choosing instead to disclose only the one that permits him to identify with Hannibal, who was "fated not to see Rome" (*SE* 4:196). As others have pointed out, the connection with Hannibal is via the father, who did nothing to uphold his honor in the face of an anti-Semitic insult. Catholic Rome comes to stand in for the authority that insulted his father as well as the authority that would stand in the way of his own professional ambitions. Hannibal becomes something of an incognito of its own, a prerequisite for those who would travel to Goethe's Rome. It allows Freud to experience a power and freedom through identification with a stand-in that is at best imaginary. Freud satisfies the political imperative of his identification with Hannibal through a "Revolutionary Dream" (*SE* 4:208–13). In the dream he rises to challenge Count Thun, whom he saw on a platform at the Vienna train station on the day of the dream and who, in the dream, belittled the impotency of German student militancy. As Schorske writes, "In the dream he had discharged by his defiance of the Count the commitment of his youth to anti-authoritarian political activism, which was also his unpaid debt to his father" (196). The dream occurs in 1898, the fiftieth anniversary of the 1848 uprisings and a year marked by violent anti-Semitic outbreaks in Galicia. Freud's dream allows him to do what his father could not: rise in protest against a representative of conservatism and anti-Semitism. A selective interpretation of his Rome dreams, as well as a conscious engagement with the mechanics of distortion in dreams, allows for the realization of the political ambitions of his youth, which are tied via Rome to completing the

CHAPTER 5

work of his father whom, paradoxically, he has sought to disown.

Freud finally entered Rome in 1901. Upon his return to Austria he noted in himself a growing zest for life, a diminished desire for martyrdom, and the discovery of salvation by claiming the title of professor. "One must look elsewhere for one's salvation, and the salvation I chose was the title of professor" (*Origins,* 11 March 1902). His admission to the academy required a program for overcoming his own political opposition to the empire through the tortuous pathways of dreams and their interpretations. Goethe served as guide. What for Goethe was a massive editing of his Italian manuscript (intended as a literary comeback) becomes for Freud dreamwork analysis and the editing out of other Rome dreams that might not satisfy his Hannibal complex. Like Goethe, Freud looks past contemporary Rome to partake of the eternal one. The "modern" Rome was "likable" enough, but it was the Rome of antiquity that enthralled him: "I could have worshipped the humble and mutilated remnant of the Temple of Minerva" (*Origins,* 19 September 1901). Minerva is the bisexual protectrix of the civic order, and Freud's adulation of her at a mutilated temple is symptomatic of his conversion in Rome. He has become a part of the Austrian civic order, pretending in dream to stand up to it and in reality bowing to its authority. The mutilated Italy of the present is displaced onto the past, where dreamwork analysis does not have to contend with the threat posed by political circumstances. Since Goethe, Rome had signaled an escape from "civic" responsibilities. With Freud, such an escape is also obeisance.

In the analysis of his own dreams Freud declares that his disposition to Rome was more akin to that of Hannibal than to that of Winckelmann. His romantic descriptions of the city, however, indicate a shift in that position. That shift is also announced by his emotional investment in a temple honoring one who points to an erasure or, at least, a blurring of sexual difference. Erasure of such difference has always carried a genealogical promise. Thereby Winckelmann overcame his inferior roots and Goethe came to author his father. This Italy allows Freud to supersede his father. Of course, *Totem and Taboo* is the Freudian text most concerned with the presence of fathers after they are dead; the murdered father is ingested and thereby internalized by his sons. Freud wrote the introduction to that text in Rome, but more telling are the two quotes from *Faust* that Freud incorporates into the text: "What thou has inherited from thy fathers, acquire it to make it thine." And, at the close of the text: "In the beginning was the deed" (*SE* 13:158, 161).

Freud chooses to be indebted to Goethe, who, no doubt, is one of the fathers, if not the father, Freud wishes to possess. But it is a dream and not a deed in which such an act is performed. Freud has identified substitution, in this instance of the father, as the first act. In this regard, the return of Italy toward the end of *The Interpretation of Dreams* is instructive. It forces Freud to recall his father's burial, which he carried out simply and contrary to the more elaborate designs proposed by other family members (*SE* 4:317–18). Rome also reappears as a city from which his own grieving children must be removed and brought to safety (*SE* 5:441–42). Although I do not want to overplay the association, hooking up with Goethe via Italy carries with it the recollection of one's father, which in the case of one who comes after Goethe and inherits his debt would be inseparable from a grieving for the ease with which one had hoped to dispense with ancestral guilt. And as we know from the fate of Goethe's child August in Rome, offspring are the ones most endangered by Goethe's Italy. If substitution is the primary act, burial of one's own father needs to be carried out unceremoniously, but one's offspring might follow suit. Their grief not only results from what awaits such offspring in Rome; but it also reassures Freud that he will not be interred ceremoniously.

Freud's description of the dream and his analysis of it do not render it a mere replay of Goethe's genealogical triumph. The problem for Freud is that he has more than one offspring. "A female figure brought two boys out and handed them over to their father who was not myself. The elder of the two was clearly my eldest son; I did not see the other one's face" (*SE* 4:441–42). The double bind that conditions Freud's delayed entry into Rome is replayed here. *The Interpretation of Dreams* succeeds and clears the way for Freud's entry to the eternal city precisely because it responds to Goethe's mode of experiencing Rome; as we recall, upon his entry into the city he remarked, "the dreams of my childhood have now been realized." But conscious substitution of one father for another maintains the presence of the real father, who returns to claim the offspring of the son who would be disinherited. That would be Wertheresque and would set Freud up to repeat Goethe's authorial triumph. But while the son, Freud, may necessarily no longer recognize one of his own offspring (he will go the way of Werther and August), a fear that he will be recognized also torments Freud. The two figures reflect his "un-Goethean" ambivalence. Freud remarks that the dream was "constructed on a tangle of thoughts" inspired by the play *The New*

Ghetto: "The Jewish problem, concern about the future of one's children, to whom one cannot give a country of their own, concern about educating them in such a way that they can move freely across frontiers—all of this was easily recognizable among the relevant dream-thoughts" (*SE* 4:442).

Substitution cannot escape or resolve the Jewish problem. It is redoubled here in the potential fate of each of his sons. The hard-earned crossing of frontiers from Austria to Italy and finally into Rome is less a free movement and more one that seems likely to restrict Freud's future movements and those of his offspring. To reclaim his sons is to forfeit his dreams, his family romance, and Rome. To hold onto his dreams is to subject them to the fate of the Jewish problem, which, with his entrance into Rome and a university appointment, he can no longer claim to have overcome but only to have deferred. Educating his sons in the interpretation of dreams so that they too may overcome a Hannibal complex reinscribes them in his own prison; it constructs, as the play that inspired the dream suggests, a new ghetto. This is why Freud recognizes only one of the two boys being carried from the fire as his son. It is a way of hedging his bets. It also explains why the one boy utters to one side, "Auf Geseres"—which, according to Freud, means imposed suffering or doom—then turns and recites its opposite, "Auf Ungeseres" (*SE* 4:441–42). The boy marks the impossibly "bilateral symmetry" of Freud's own double bind. That lawful symmetry no doubt occasions Freud's concluding remark that dreams are "most profound when they are most crazy" (*SE* 4:444). The law to which Freud is subjected recasts substitution as distortion. That is to say, substitution does not succeed. The distorted dreams of Rome cannot repress what they seek to conceal any more than Rome can substitute for the promised land "when [not!] seen from afar."

Goethe in Italy:
Freud's Experience of the Uncanny

Freud's name for the return of the repressed was the uncanny, "das Unheimliche." In the essay that has become a standard of literary studies, the associative chain that I have described above is played out so as to render the essay itself, at least in this context, uncanny. For its most concise formulation, Freud turned to Schelling, who described the uncanny as something that ought to remain concealed but nonetheless has come to light (*SE* 17:241). In other words, what should not return does.[36] In

the discussion above this was described as a double bind: psychoanalysis liberates Freud from his Rome neurosis, but Goethe, as the secret father of psychoanalysis, recalls the father and his authority. In this instance, that authority is the anti-Semitic one of the empire. What returns also has a historic character, anticipated by Freud's allusion to his Hannibal complex and exemplified by his love of Minerva.

Freud himself attempts to distinguish between two types of the uncanny. On the one hand, there is the return of material that has been surmounted "rather than repressed." That is to say, something occasions the return of animistic beliefs, what Freud calls belief in the omnipotence of thoughts that were previously surmounted through civilization (*SE* 17:240, 247). The apprehension of Goethe's ghosts or imagining his return from the dead could qualify as the uncanny of this sort. On the other hand, the revival of infantile complexes by some impression is a different kind of uncanny (*SE* 17:248). For the moment, let me suggest that bowing to paternal authority is in the range of such experiences. Freud further insists, most notably in his reading of Hoffmann's *The Sandman*, that the return of the castration complex often triggers the uncanny. Reiterating the family romance, it seems, could likewise occasion this type of uncanny. Castration recalls Winckelmann, or rather Winckelmann's Rome. As I argued above, in line with Schorske, that is the Rome that returns for Freud to supplant Hannibal's. The anachronism of that statement is in keeping with the boustrophedon or reading backward that structures the reading of those who follow on Goethe's trail. Uncertainty as to whether a stone figure or statue is alive also summons the uncanny. Necrophilia as it was understood in the reading of Heine's Italy in the previous chapter would therefore be a permanent experience of the uncanny, as would Winckelmann's love of statuary. If the associative chain is extended, the uncanny would include as well Goethe's Italy or the shared space Goethe and Winckelmann's Italy occupies in Freud's unconscious or the unconscious of this text. Not only does castration recall the father but, as Freud emphasizes in his discussion of *The Sandman*, fear of losing one's eyes signals a resurfacing of the castration complex as well. Losing the ability to see means losing what Goethe acquired during his Italian journey. The fear of losing Goethe is what returns as uncanny. Paradoxically, that fear recalls him and his Italy but also signals the return of something that had apparently been surmounted. The return of that material necessitates Freud's bow to authority. In these respects, the essay is an exercise in the uncanny;

CHAPTER 5

the Italian journey after Goethe is the experience par excellence of the uncanny. What has been previously described as the ensorceled roots of Goethe's Italian journey are now indistinguishable from the uncanniness of his return. "Or," as Freud observes, "it is marked by the fact that the subject identifies himself with someone else, so that he is in doubt as to which is his self. . . . In other words, there is a doubling, dividing, and interchanging of the self" (*SE* 17:234). As both the subject and the object of psychoanalytic discourse, Freud is the uncanny doubling of Goethe's own doubling of himself in Italy. It is "this factor of involuntary repetition which surrounds what would otherwise be innocent enough with an uncanny atmosphere" (*SE* 17:237). As Freud explains, that effect can just as readily be understood as the effacement of the boundary between reality and the imagination or "when a symbol takes on the full functions of the thing it symbolizes" (*SE* 17:244). From all I have argued so far, that symbol for Freud would have to be Rome. From afar it is the promised land (heimlich), but once Freud arrives in Rome, it is uncanny (unheimlich); this reiterates the very transformation of the word into its opposite that Freud traces at the beginning of the essay. Thus it is possible to understand why Freud admits that the distinction between the two types of material that resurface as uncanny—that which has been surmounted historically and that which has been repressed—is difficult to maintain and "hazy" at best (*SE* 17:244). Not only is the past that has been surmounted always upon him, but it is also the mechanism of psychoanalysis that summons that material.

Any discussion of this essay must include the key paragraph in which Freud mentions his own experience of the uncanny, since it occurs in provincial Italy and, not surprisingly, has to do with losing his way. As he wanders about, he keeps going in circles in front of the windows of "painted women" whose attentions his repeated passings cannot help but excite (*SE* 17:237). The experience suggests that his "Rome neurosis" has not been overcome.[37] His tortured return to the houses of the painted women precludes arrival in the city that for so many years he was unable to enter. What also returns is an inability to escape the provinces to the promised land. He circles about—which is to say he continues to avoid the real issue. What allowed for an overcoming of that neurosis—dancing around a direct confrontation with authority—is replayed as a movement that goes nowhere. But what of the painted women? For one whose Italian experiences are an attempt to overcome or ignore ancestral debt, the other aspect of that gesture is

THE RETURN OF THE REPRESSED

opening up the possibility of descending from unknown parentage. Any one of the painted women may be the return of one side of that unknown equation. As we will see in the following chapter, upon his return to Venice in 1790 Goethe also regarded many of the Italian women as floozies. These women suggest the persistence of that which civilization has yet to overcome; they are the distorted faces of an Italy that one seeks to look past in valorizing antiquity. Looking to the past generates a repressed content that returns with the past.

What needs to be stressed is the omnipresence of distortion. Rome as the symbol of the impossible merging of dream and reality returns in distorted guises: geographically as the provinces and genealogically as painted women. Freud's interpretation of dreams may allow him to enter the "promised land," but it also inserts him into an economy whose repressed content he inherits from a previous tradition of Germans in Italy and whose return is certain. If one thinks of psychoanalysis as partly the science of substitution and that science as a gesture of substitution itself, then psychoanalysis requires a return of the repressed content of both kinds to affirm or authorize itself. The difficulty that Freud has in maintaining a distinction between repressed material surmounted psychoanalytically and material surmounted through civilization indicates at the very least the persistence of that tradition in effecting Freud's confrontation with his Rome neurosis. Freud is not entirely unaware that he has committed himself to a tradition with potentially troubling consequences. When he describes the return of the repressed in terms of a demonic doppelgänger, he cites Heine, or specifically, Heine's "Gods in Exile" (*SE* 17:236). Heine's Italian journey eventually forced him to Paris as a writer in exile. The form of Freud's exile is yet to be determined.

Italy's Vultures

Italy is the setting for two of Freud's more conspicuous misreadings or distortions. In *Leonardo and a Memory of His Childhood* Freud attempts to construct a theory of homosexuality from Leonardo's notebooks. Because of Leonardo's thirst for knowledge, Freud describes him as an "Italian Faust" (*SE* 11:75). For Freud Leonardo's urge to fly is telling evidence of this unquenchable desire. Flying or dreams of flying are for Freud also linked in children to notions of the stork delivering babies and thus indicate a "longing to be capable of sexual performance" (*SE* 11:78). For Leonardo this longing is not confined to his childhood,

which leads Freud to develop one of his theories of homosexuality.[38] His analysis hinges on Leonardo's use of the word "nibbio" in recounting a childhood memory. As we know, Freud mistranslates "nibbio" as vulture (Geier) when it fact it means kite (*SE* 11:82). Attending to Leonardo's supposed visitation by a vulture in his crib, Freud notes the reappearance of the bird of prey in his painting "St. Anne and Two Others" (*SE* 11:111–13). The reappearance of the "nibbio" reveals for Freud the secret of the painting. Leonardo was taken from his birth mother and placed in the more well-to-do home of his father. The caresses of the vulture, of the one who brought him into the world, were thus tinged with a certain violence: that of being ripped away from the crib and placed in the home of a stepmother. The vulture of the childhood memory and of the painting suggests for Freud Leonardo's complete identification with his mother. The virginal impregnation of vultures—a notion he hopes to support through allusion to ancient Egyptian hieroglyphs—to the exclusion of the sexual functions of the male is indicative of Leonardo's wish to render his own lack of male sexual power insignificant and return to the crib of his biological mother (*SE* 11:93–97).[39] As it would be for the vulture, the powers of the male would be superfluous, and identification with the mother complete. All of this, of course, is untenable. There never was a vulture, only a kite. But when it comes to tales of Italy or tales of "Italy's Faust" misreadings are not entirely innocent. As in this instance, they express a desire to reassign filial allegiances. Winckelmann converts and serves the pope, Goethe translates and authors his father's work, Heine returns too late from Italy to attend his father's sickbed, and Nietzsche, who is already dead as his father, allows his mother and sister to take control of his body. Freud avenges his father and removes him from the picture, thereby securing relations with Goethe. The distortions that allow for such alliances, however, have a darker side. Wishes of an untoward nature may result, which both Heine and Freud associate with homosexuality, and may account for why the vultures as painted women arouse such fear.

Italy's "Faust" did not have the benefit of psychoanalysis to work through his powerlessness nor the option of adopting Goethe as a father. Italy's Faust is, of a sort, authorless, and needs a German to author him, which is what Freud would have psychoanalysis do so as to both rival and emulate Goethe. What Freud's misreading also accomplishes is to link power to identification with a presumed father. The vacuum cre-

ated by coming before Goethe forces this Faust to identify wholly with the mother. Homosexuality is the result. In this regard, Freud is strictly allied with Goethe. Time before Goethe is a vacuum, or at least a power vacuum. This father cannot be preceded, as was Johann Caspar, but instead must be followed. In exchange, the follower can preserve his belief in science (another bow to Goethe): psychoanalysis is a coming to power, an overcoming of maternal identification. Falling in love in Rome does not signal an inversion of desire, as it did for Winckelmann. It would be a mistake, however, to think that there were only kites and not vultures. The vultures are elsewhere. Luring Freud to see them where they are not opens up the possibility of their uncanny return. "Vultures" is the gathering specter of distortion.

Before working on a study of Leonardo's childhood dream, Freud offered an interpretation of W. Jensen's "Gradiva: A Pompeiian Fantasy." The study begins with Freud's summary of the novel, which deletes details that might not so readily support his psychoanalytic solution of the riddle. The story's happy ending is read and reported in such a fashion as to confirm the value of psychoanalysis.[40] In short, a German archaeologist, Norbert Hanold, is sufficiently enamored of the gait of a woman he names Gradiva, an ancient Pompeiian whose relief is reproduced as a plaster cast in Hanold's study, that he is convinced she has returned from the dead. Hanold is so infected by the spirit of Grecophilia characteristic of Winckelmann's love of statuary that the copy or plaster cast gives rise to the specter of the actual person returned from the dead. He goes to Pompeii in search of her, converses with a likeness that he is certain is she, and discovers her likeness instead to be a woman from his past whom he has not seen or acknowledged since childhood. Zoe, as she is called, effectively leads or lures Hanold through the landscape of his dreams until he overcomes his love of stone for love of Zoe, the real thing. In Freud's reading Zoe becomes the analyst and the betrothed. As he writes, "Zoe's own words . . . give us a definite right to assert to her an intention to bring about a cure" (*SE* 9:69). In effect, Freud's marriage to psychoanalysis cures him of the improper desire and necrophilia that afflicted Winckelmann and Platen, and it does so through the surrogate of Hanold. Moreover, psychoanalysis allows the surrogate to consummate a relationship that Goethe only did in poetry through the figure of Faustina. But Freud's working through a love of stone is as imaginary as Faustina. He interprets the story as the author's working out of his own incestuous desires, something Italy was said to

CHAPTER 5

have done for Goethe as well. But unlike Goethe, Jensen did not have a sister. Specifically, Freud reads the text as a working out of incestuous desires stemming from childhood (Urban and Cremerius 1–20), but the opposite is the case. Hanold's desire for a true Aryan companion, Zoe, is what is fulfilled. As Sander Gilman observes, "It is a tale of appropriate marriage within the race, or permitted, indeed encouraged endogamous marriage" (*Case of Sigmund Freud* 146). Nevertheless, in a letter exchange from 1907 Freud expresses his suspicion that the desire Jensen works through in this and other texts is a love for his sister. Jensen's reply is unambiguous, "No. I never had a sister, indeed no blood relatives at all" (Jensen 120). This does not prevent Freud from writing in the preface to the second edition of 1912 that Jensen's last novel, *Der Fremdling unter Menschen,* "contains much material from the author's own childhood [and] describes the history of a man who sees 'a sister in the woman he loved'" (*SE* 9:95). Through the production of an extra or a sister Freud substitutes one science, psychoanalysis, for another, racial science, the merits of which Jensen was certainly convinced (Gilman, *Case of Sigmund Freud* 147). That extra allows psychoanalysis to champion the merits of the dreamwork of a text that has no place for the Jew.

Indeed, one can speak of several orders of substitution in Freud's reading of Gradiva: Hanold's statue in place of Zoe, Freud reading himself through or into Hanold, and Zoe the analyst for Freud the analyst. The resolution at the end of the story, in which Zoe replaces the statue and, in Freud's reading, Jensen's sister, trumps Jensen's reading as well. In psychoanalysis, the real or true eventually replaces the surrogate, save that such a resolution is itself a misreading, which is to say that psychoanalysis is a substitute resolution. If for Goethe and Winckelmann substitution concealed the absence of the ideal, for Freud there is something to conceal. As Derrida writes in *Archive Fever:*

> Here is what it gives us to think: the inviolable secret of Gradiva, of Hanold, of Jensen, and then of Freud. . . . Beyond every possible and necessary inquiry, we will always wonder what Freud (for example), what every "careful concealer" may have wanted to keep secret. We will wonder what he may have kept of his unconditional right to secrecy, while at the same time burning with the desire to know, to make known, and to archive the very thing he concealed forever.

What was concealed? What did he conceal even beyond the intention to conceal, to lie, or to perjure? (100–101)

For Derrida the desire to archive gives rise to concealment. Once substitution acquires a history, something is concealed, even repressed, but it is destined to surface or return in another guise. As evidenced by the many orders of substitution in "Gradiva," substitution cannot contain itself; it produces something it cannot interpret away, which is what it conceals. In this instance it is the production of ineradicable difference, concealed and revealed by Gradiva's foot. Such difference is ineradicable not because of any inherent quality to distinguish it as different; rather the mechanics of how it is produced, that is, through substitution, cannot be contained. Substitution becomes a distortion of itself.

For Freud, evidence of Jensen's unhealthy desire is the latter's fixation on Gradiva's gait. Gradiva's foot is fetishized, not only by Jensen but also by Freud. Freud repeatedly describes the gait as "unusual" and "peculiar," but most critics, judging from the relief of her at the foot of Freud's couch, consider it healthy (*SE* 9:10, 12). It must be pointed out that the observation is prompted by Hanold's own suspicion that the gait was "not discoverable in reality" (*SE* 9:12). In fact, her last name, Bertgang, means bright gait, and Zoe Bertgang is a translation of Gradiva (*SE* 9:37). In his rewriting of the text, Freud's focus is on her gait, specifically the foot that articulates the gait. What he ignores or eliminates from his discussion is the emphasis Jensen places on the voluntary exposure of the foot from behind the folds of her flowing garment.[41] Freud translates "Gradiva" as the "girl who steps along" (*SE* 9:11), whereas Jensen, by assigning her the name Gradiva, translates the name as "the girl splendid in walking" (Jensen, "Gradiva" 148).

Freud's subtle shift in the source of Hanold's fascination from the act of seduction to the object of seduction is a result of the scientific climate of his time. In fin-de-siècle Vienna flat-footedness was an accepted sign of Jewish deformity and evidence of unsuitability for military service. It pointed as well to more damning difference. As Gilman explains: "The idea that the Jew's foot is unique has analogies with the hidden sign of difference attributed to the cloven-footed devil of the Middle Ages" (*Jew's Body* 39). But the peculiar foot under consideration in this instance is that of a figure set in stone, and its rehabilitation is a fiction. In other words, psychoanalysis permits Freud to read too much into the foot so as to rehabilitate a deformity that was only a result of too much

reading. (Gradiva/Zoe, who substitutes for Zoe/Freud, has an unusual and peculiar gait or foot that is charming and seductive.) Both Freud and the culture of racial science contribute to that surfeit. Psychoanalysis accommodates political ambition by rehearsing the gestures that give rise to forms of surrogate participation. It participates in the creation of markers of its own difference, and the apparent normalization or surmounting of those differences is via processes that exclude or substitute for political action. The cure that the Jewish science of psychoanalysis offers for the Jew's lack of fitness is thus not much at odds with that offered by its oppressors. Gradiva's foot substitutes for the Jew's foot just as Zoe the analyst substitutes for Freud, and Jensen's fixation is actually Freud's. Freud is both subject and object of his own reading. Such displacement from himself allows for a re-situation of Jewish difference where there is none. There is nothing wrong with Gradiva's gait; this signals the impossibility of the Jew walking in her shoes just as Freud can never walk in Zoe's. All that is left is to share Hanold's fixation and thus the credentials of another man of science. But what they really share is interest in what sets the Jew apart, the foot or gait. Since they do not share a sister, or since Jensen does not have one, the improper desire from which Freud would have psychoanalysis cure him only signals Freud's understanding of the significance of the foot but his inability to read it correctly.

When Hanold finally sees the living Gradiva on the streets of Pompeii he addresses her in Greek. When she does not respond, he tries Latin. Finally she replies "If you want to speak to me, you must do it in German" (Jensen, "Gradiva" 11). Soon thereafter she recognizes Hanold from her childhood, for the latter knew her father, a famous professor of zoology, in Germany. As her name implies, Zoe Bertgang is the incarnation of the stone figure Gradiva, a fact Hanold confirms after he commands her to walk in front of him. This is the vivification of Winckelmann's Italy. In Pompeii the coupling of Hanold and Zoe/Gradiva signals that the German archeologist has become a "Greek who has become a German who has become a Greek" (Gilman, *Case of Sigmund Freud* 146). The text thus invites psychoanalysis to demonstrate the Jew's unfitness to participate in German Grecophilia. Freud's reading canonizes the text that performs that exclusion, but it also rehabilitates—even "heterosexualizes"—the necrophilia implicit in Winckelmann's aesthetics. The Aryan family romance, successfully consummated, is psychoanalysis' subtext.[42]

THE RETURN OF THE REPRESSED

Freud's misprojection of Jewish difference onto Gradiva's gait might be dismissed as pure fiction, but what is set in stone is Freud's exclusion from the scene he has staged. In his analysis of the story, Freud notes that the one constant of analysis is the eventual love the analysand will have for the doctor—a comment that is equally descriptive of the desired result of Freud's science in the overall culture. In *Gradiva*, Zoe the analyst can accept the love directed by her to her from Hanold. Freud calls that outcome "ideal," since, in reality, the doctor was a stranger at the outset and must desire to become a stranger at the conclusion of therapy (*SE* 9:90–94). The ambiguous hopes of psychoanalysis are thus revealed: the Jewish outsider must return to the position he held at the outset.

Of the figures presented in this study, Freud is the only one who actually journeys to Greece. He thereby redraws and extends the boundaries of the Italian journey. That which was on the other side of consciousness, that which was censored or cut off from the main, begins to invade it anew. As we recall, Freud sought to distinguish between two forms of the uncanny: the psychoanalytic and the historic. Even at the time of the essay's publication, the boundary was difficult to maintain. Psychoanalysis has a historic character, and the repression of that character is only one stage or chapter in a history that traces man's apparent evolution from the primitive to the civilized. But just as the analyst desired to return at the end of therapy to his position at the outset, there is a similar return that haunts Freud's science. What Freud's science repressed was the political; he opted for Winckelmann's Rome. What returns to threaten the neat boundaries of psychoanalysis is the historically repressed. Not surprisingly, the site where these boundaries are most tellingly blurred is Rome. In the opening pages of *Civilization and Its Discontents,* Freud attempts to imagine the eternal city as the topos of the unconscious (*SE* 21:69). Archeological sites and ruins would seem to serve as an apt metaphor for the enduring and ineradicable presence of the unconscious. Freud's personal "Roman unconscious" is Hannibal's. And that unconscious can be said to return when Freud, subsequently, begins to dismiss the comparison. Referring to its historic transformations from the Etruscans, the Romans, the Goths, and beyond, he notes that the eternal character of a city, unlike the unconscious, can be wholly transformed, if not wholly erased. He ultimately concedes that the comparison is idle. The attempt demonstrates "how far psychoanalysis still has to travel." The effort requires that the "same space have two

CHAPTER 5

separate contents," a historic and a psychoanalytic or a temporal and a spatial one (*SE* 21:70–71). Rome can no longer contain the Freudian unconscious or what has resurfaced of it. In a word, it is uncanny.

By the time Freud was completing the text in 1929, he may well have been experiencing what Italy had rehearsed in various modalities for Winckelmann, Goethe, Heine, and Nietzsche: a cutting off. But what is cut off always re-appends itself elsewhere. The rehearsal of that gesture generates a content. For Freud and German Jews alike, this was the repeated excision of the Jew from the body politic. It is also interesting to note that this text, like *Beyond the Pleasure Principle,* was concerned with the death drive as the adversary of Eros: "The fateful question for the human species seems to me to be whether and to what extent their cultural development will succeed in mastering the disturbance of their communal life by the human instinct of aggression and self-destruction" (*SE* 21:145). Although the vultures gathering on the horizon would not signal the death of Freud's science, they would mark its invasion by the elements Freud hoped to have silenced and overcome with his entry into Rome at the turn of the century. The death drive that threatened his victory was a return after a series of detours and distortions of what Winckelmann initiated during his stay in Rome: an idealization of castrati and an erasure of difference. Goethe alerted one to the role of the devil in these Italian feats. Heine took off instead for Paris, but he was already infected; eventually he would contract and die of what in the next chapter will be called Leverkühn's disease, in reference to Mann's Faust. Nietzsche, diseased as well, returned to Weimar mad and recited Goethe. Freud played along while it was still pleasurable. By the time of *Civilization and Its Discontents* it was not. He recognized that another urge or instinct had invaded the topos of the unconscious and of Rome. Nevertheless, he ended the text with the assertion that the "eternal Eros" would assert himself in the struggle against civilization's adversary. Two years later he was not so certain; he appended a question: "But who can foresee with what success and with what result?" (*SE* 21:145). As Freud's English editor James Strachey explains, "The final sentence was added in 1931 when the menace of Hitler was already beginning to be apparent" (*SE* 21:145).

The promise of rebirth, which had always sent Germans and Austrians on Goethe's trail, had been eclipsed by a darker or nocturnal one. Perhaps that was the real meaning of Goethe's final entry in the *Italian Journey*. It is a fragment from one of Ovid's elegies in the *Tristia*.

THE RETURN OF THE REPRESSED

Goethe wants to recall it but cannot. What he does remember only "confuses and frustrates his own composition." The elegy is a subtext that both sponsors and threatens Goethe's text. The first four lines of the fragment offer a possible ground for Goethe's unease:

> Cum subit illus tristissima noctis imago,
> Quae mihi supremum tempus in Urbe fuit;
> Cum repeto noctem, qua tot mihi cara reliqui:
> Labitur ex oculis nunc quoque gutta meis
>
> When I remember the extreme sadness of that night
> which was my last night in Rome,
> I recall leaving behind everything that was most dear to me:
> and the tears streaming from my eyes.
> (Rome, April 1788, Report)[43]

As Goethe reminds his reader, these are the words of a poet forced to live "far away on the shores of the Black Sea." As Heine, Nietzsche, and Freud, in different fashions, remind their readers, living in exile on the edges of a black sea is also the spell of Goethe's Italy.

6
Goethe's Other Italy
The Devil's Playground

If one were to read back from Thomas Mann to Goethe, the peculiar space Italy occupies in the cultural consciousness of German writers finds in many respects its most troubling expression in Mann's *Doktor Faustus*. It is in Palestrina, after all, that Adrian Leverkühn formally seals his pact with the devil. In a town bearing the name of a sixteenth-century composer of masses or celebrations of the Eucharist, another in a line of German writers and artists fascinated by the legend of Doctor Faust can "break through the paralyzing difficulties of the time" and "strike up the march of the future" not through communion but only with the devil (Mann, *Gesammelte Werke* 4:317). Italy serves as the site of a creative rejuvenation that allows Leverkühn to "break through time itself . . . and dare to become barbaric, twice barbaric indeed, because of coming after the humane" (316). Much of the same could be said of Goethe's own Italian journey. As the renaissance of his poetic genius, to speak with Jane Brown, the journey signals Goethe's own overcoming of a creative paralysis that befell him during his time in Weimar and points the way for the future march of German classicism, which itself is a breaking through time in an attempt to restore the historically situated and remote ideal of ancient Greece.[1] And of course, Goethe's own journey strikes up a march for legions of future Germans to repeat his travels to the south. Just how compelling the rhythm of that march can be is easily verified by the *Goethe-Kalender* of 1910, in which responsible

CHAPTER 6

parents are exhorted to begin saving immediately at their son's birth for that most essential element of his education, an Italian journey (Bierbaum 79–80). A century and a half after Goethe christened Italy as the site of creative rebirth, the compelling and binding power of that journey renders Italy a suitably foreign site upon which to consort with the devil. Barbarism, the instinct to become twice barbaric indeed, can thus be said to be something Germans pick up from elsewhere.[2] Conveniently, Italy serves not only as a source but also as a repository for the deferred and often disturbed dreams of the culture, allowing Germans, if Thomas Mann is to believed, to displace and distance themselves from the barbarism necessarily infecting, perhaps even founding, the legacy of German high culture. In some fashion Mann might well have been certain of this, since he began writing his own first novel, *Buddenbrooks*, in Palestrina. And Goethe's own shameful legacy—or the one nearest, if not dearest—his son August is left behind in Italy, dead, as Eckermann races back to join Goethe, or to replace August (Ronell, *Dictations* 120–21).[3]

The concern of this chapter is to outline the persistent representation of Italy in selected works, Goethe's among them, that sharply contrasts with its traditional description as the land of cultural rebirth. Once it can be established that Italy comes to assume a demonic character as much as a quasi-"Hellenistic" one, it will then be reasonable to reconsider the construction of Italy in texts traditionally associated with portraying the land's healing or rejuvenating power with an eye for what is deceptive about those tales of restoration and rebirth. Already, the Italian experiences of Heine, Nietzsche, and Freud exposed the Italian journey to be as debilitating as it was restorative. In this chapter the emphasis shifts to a consideration of texts that recast Italy as a demonic site. As the previous two chapters demonstrate, that Italy is every much a part of Goethe's work as is the rejuvenating one.

A Disfigured Land

As Goethe's "Venetian Epigrams" had suggested years earlier, Italy is uniquely suited to unloading and leaving behind unwanted baggage; that which would otherwise compromise the purity of the homeland, or at least the dream thereof, is marked by and for Italy. "For Italy is the complementary land for each of us, what is lacking in our schools and universities, Rome and Florence will teach effortlessly and beautifully" (Bierbaum 79). If there was any doubt what character Italy assumed

in this complementary mode, Goethe's fourth epigram renders explicit:

> That is the Italy that I once left. The roadway's still dusty,
> The stranger is always swindled, do whatever he will.
> You'll seek German honesty vainly in every corner;
> Life, movement are here, but not order and discipline.
> Each cares only for self, mistrusts others, is empty and vain; . . .
>
> Lovely the land, but I'll not find Faustina again.
> It's no longer the Italy that I once left with regret. (Lind 85)[4]

Whether Goethe's disillusionment with the land of his rebirth is finding upon his return a land disfigured by the un-German desires he knew and experienced all too well in Italy is not easily determined.[5] Writing from Venice, Goethe was explicit about this change of heart: "In any case, I must confess in confidence that my love for Italy has suffered a fatal hit (tödlicher Stoß)" (*Briefe,* Bach 269). As he himself reports, this change of heart had something to do with an erotic that was left behind ("eine zurückgelassene Erotik"; *Briefe,* Bach 269).[6] The epigrams offer only shaded glimpses of what that erotic might have been. Venice, if not Italy, is often compared to a prostitute, and its female inhabitants fare no better. "Long did I seek for a wife: I found only hussies / Till I overtook you, dear hussy, and found me a wife" (Lind 154).[7] As is clear from the rhetorical structure of the epigram, opposing figures in the chiasmus begin to substitute for one another and assume a figural character. More to the point, if the Italian landscape was now disfigured by images of compromised women, Goethe's own activities necessitated a recollecting and airing of dirty laundry of another sort: "Give me not 'tail' but another word, o Priapus / For, being a German I'm evilly plagued as a poet . . . the tail's something behind, / And I never as yet have had very much fun from that quarter" (Lind 151).[8] The poet trades in substitutions, whose rhetorical shifts are inseparable from sexual ones.

The nature and necessity of these substitutions become clear when attention focuses on more of the other withheld epigrams, which, not surprisingly, render somewhat suspect Goethe's activities in Italy and communicate the reborn poet's disdain for the land responsible for such transformation. At times, these show a Goethe quite eager to hurl epithets at the Venetian women. In other instances, the epigrams point to incestuous acts, which may well have been in Goethe's mind regarding

CHAPTER 6

his sister. He chooses, however, to reserve the attendant disdain and disgust for Venetians:

> Her father commands her to stretch out her delicate thighs,
> Childishly down on the carpet the lovely part. . . .
> Ah, he who loves you first will find the blossom
> Already gone; your work took it early away. (Lind 149)[9]

If for Goethe the Italian landscape was now disfigured by images and remembrances of compromised women, his activities in seeking to preserve his purity or the purity of German classicism would necessitate a recollecting and airing of dirty laundry of another sort. These same epigrams speak of a homoeroticism that might have deemed the ancients unfit for German soil. Goethe writes, albeit in muted tones, of his own love for young boys and speaks ambiguously of how either the princess of heaven or the delight of a young man often lured him at night: "I'm fairly fond of boys, but my preference is girls; / When I have enough of a girl, she serves me still as a boy" (Lind 151).[10] If the switch from girl to boy confuses the object of Goethe's desire—and Heine was perhaps the first to detect this confusion—current research indicates how difficult it is to assess the response of Goethe's contemporaries to effusive expressions of male-male love.[11] What is clear is that such confusion writes its way into Goethe's epigrams. Elsewhere the same ease of substituting one gender for another is repeated: "To await with impatience the glance of the princess of heaven / Delight of the young man, how often you lured me at night" (Lind 127).[12] The exchange between genders or from one to the other is free and uninhibited; consistent is that girl meets man and becomes a boy.

Such delights may have been the bounty of desires Goethe knew quite well upon his first Italian journey, as his letter to Duke Karl August of 29 December 1787 makes clear. After bemoaning the spread of venereal diseases among the female prostitutes—and unlike the later epigrams the letter in no way suggests all Italian women fall into this category—he explains that men commonly love each other in Italy: "After this contribution to the statistical knowledge of the country, you will judge how tight our circumstances must be and will understand a remarkable phenomenon I have seen nowhere as strong as here, that is the love of men among themselves" (Mandelkow 2, 29 December 1787).[13] Goethe explains that this love rarely arrives at the highest degrees of sen-

suality but resides instead in the "more moderate zones of sensuality." He then praises it as something beautiful that "we have only from the Greek traditions."

The tight or suffocating conditions—economic, personal, and creative—that drove Goethe away from Weimar in the middle of the night reconfigure themselves in Italy in a fashion that darkens his view of the land when he visits it a second time. This is not to say that the disappointment Goethe felt upon revisiting Venice might not simply have been a result of having had an appointment with Anna Amalia instead of Faustina; that would undoubtedly alter the disposition of the landscape. Arguably, the reason was as deeply personal as the epigrams suggest. It is known, for example, that many of the epigrams had to be returned to sender, at Goethe's request, by Frau von Stein.[14] And upon beginning his epigrammatic project, albeit in 1782, Goethe wrote to Knebel, "soon the stones will begin to speak" (*HA* 1:587). It has also been reported that Goethe burned and "cut out with a knife" other epigrams (Hexter 529). If Goethe truly considered Frau von Stein—or Ms. of Stone—a sister, the stones that spoke of unbrotherly love or a brotherly love that dare not speak its name best be recollected and redeposited in Italy.[15] (We should recall how Heine insisted upon his ability to converse with stones in Italy.) There they could lie and call to other Germans without, the hope seems to have been, infecting the German national landscape. But the stones that he returned or had returned to Venice came to found and form a trail of their own, and it is no doubt that trail which in some fashion leads or opens up to a secret deposit left by Goethe and his followers.

That something was amiss from the start is evident from the early letters Goethe wrote to Frau von Stein shortly after his arrival in Weimar in which he could not determine what his relationship toward her was or should be. "Oh, if my sister had a brother in the same way that I have a sister in you" (Mandelkow 1, 23 February 1776). Only a month before he had written her the following: "And how I talk to you of my love, so I cannot talk to my friends of you—what I grant my sister, that is mine, in more than one sense it is mine; but—that is exactly why I would never put my seal on it (mit siegeln)" (Mandelkow 1, 12 January 1776). At issue in the second letter, which is chronologically the first, is a seal Frau von Stein gave Goethe, which he insists he must pass on to his sister. The sealing of their relationship (Goethe and his sister[s]?) allows him to use a more familiar form of address only a month later. That

in the intervening years things began to become too tight and thereby made it more difficult for him not to put his seal on a triangle that included Frau von Stein as sister and friend (mit siegeln) could well account for his flight to Italy to seek out substitutions of one kind or gender and another, only to find that in this economy of substitutions, as his letter to the duke admits, things became equally tight. If Goethe's journey to Italy is also viewed as a return to a past, an attempt to reengage a past world, there can be little doubt that he thought to find himself united with Frau von Stein. In perhaps the most important of his letters to her, the one dated 14 April 1776 and noted for the inclusion of the poem "Warum gabst du uns die tiefen Blicke (Why do you give us the penetrating glances)," Goethe enunciates the promise of the past. "Sag, wie band es [das Schicksal] uns so rein genau? / Ach, du warst in abgelebten Zeiten / Meine Schwester oder meine Frau (Tell, how [fate] bound us so utterly and precisely? / Ah, you were in times now past / My sister or my wife)" (*HA* 1:122–23, 520, and Mandelkow 1, 14 April 1776). That what in Italy stood in for the past provided "not a glimmer of idyllic days" lies perhaps in Goethe's uncertainty about sexual differences (e.g., that between sister and wife/boy and girl). Or it may have been that present-day Italy deflected or darkened those "penetrating gazes" into the past with stand-ins of its own in the rather sordid figures that populate the Venetian epigrams. Of this we will have more to say later.[16]

The Magical Transformation of the Disfigured

The magic of the Italian journey is not restricted to what Goethe deposits there for his countrymen. At the very least, the interest in that deposit is inextricably related to what Goethe brings back with him, or if we are to read along with Stefan George in his poem "Goethe's Last Night in Italy," what Goethe smuggles from Italy. George celebrates Italy as a site to be plundered, where the living ray (lebendige[r] Strahl) of the ancients can be transported to the north and serve to reveal the magical splendor of things and of the body:[17]

> Heimwärts bring ich euch einen lebendigen strahl. . . .
> Nehmt diesen strahl in euch auf— . . .
> Und ich streu euch inzwischen im buntesten wechsel
> Steine und kräuter und erze: nun alles—nun nichts . . .
> Bis sich verklebung der augen euch löst und ihr merket:

Zauber des Dings—und des Leibes—der göttlichen norm.

Homeward I bring you a living ray . . .
Receive this ray . . .
And in the meantime I throw out to you in the most colorful change
Stones and herbs and ore: now everything—now nothing . . .
Until your eyes glued to the scene before you detach you and you notice:
The magic of things—of the body—of the divine norm.
(George 1:402)

It has already been explained in part what became of those transformed or disappearing stones. What is interesting at this juncture is how Goethe, returning to Germany with the revelatory spirit of the ancients, performs, for those like George who consider his journey a theft, a virtual alchemical transformation of objects or things. In that respect his talents are not unlike Mann's Leverkühn. When the stones are turned or returned something devilish is disinterred and haunts the creative rebirth of German culture. (Heine, as the self-professed interlocutor of the stones in Italy, is an indication of what is revealed when those stones begin to speak.) Something about discarding the stones—as if, perhaps, they were mere ruins—and seeking instead to capture the spirit alone, seems to require a devilish sort of alchemy. Goethe himself was aware that there was something untoward about his riches discovered in Italy. To be sure, he returned with trunks of collectible objects. Stones to further his geological, if not his earthly pursuits, may well have been among them. But he also confessed that his greatest booty could only be described as a form of theft. Writing to Frau von Stein from Rome, he asserts: "my situation must seem like the happiest possible. And it will be, as soon as I . . . can convince myself that man should take the good that comes his way as one would take a theft and not look to the right or left, and even less should he worry about the overall fortune or misfortune of things. If one can arrive at this disposition, certainly it is in Italy, particularly in Rome" (Mandelkow 2, 25 January 1787).[18]

Of course, good and goods are clearly distinguished here. Goethe's theft does not necessarily suggest a robbery of anything vitally Italian. What he returns with to Weimar, even in the more curious terms in which George describes it, is hardly unexpected of any traveler feel-

ing him/herself rejuvenated by foreign air. Or is it? The consequences of what at least one critic portrays as the darker motive of theft underlying subsequent Italian journeys is once again better understood in terms of what is left behind.[19] This so-called darker motive is better understood if we attend to a second, less obvious reading of the excerpt above in which the "sie" in the second sentence could be identified with Frau von Stein as well as with "gluckliche[r] Lage." This would confirm what was argued above: Italy is the site in which to act out the passions whose markers would otherwise defile German soil. By regarding that which comes his way as a fortunate theft, Goethe can "take or steal" in Italy from Ms. Stein what he dare never mention, let alone perform, in Weimar. As I have demonstrated throughout this book, the import of Goethe's journey is how others, not just Goethe, read and receive and reuse it, including Goethe. What is discarded is the legacy; what remains is for reusing. Once the "living ray" is digested so as to be smuggled back to Germany and alchemically transforms the culture, how does Italy look? Remove the gold from the eyes, and how does Germany's fascination or dealing with Italy appear?

A Diabolical Consortium

A perplexing portrait of this sort was offered by Wolfgang Koeppen in his postwar novel *Death in Rome*. After two world wars in which the German alliance with Italy soured, Italy, or in this instance Rome, becomes for Koeppen once again a site for an attempt to rehabilitate the past. Judejahn, a former SS general who has subsequently secured fortune and power as an arms trader to the Arabs, is to meet in Rome his brother-in-law, a former Nazi re-ascended to power, for purposes of reinitiating Judejahn into German society. Rome, it is assumed, will allow for a reconstruction of Judejahn's German and Nazi past; the space opened up or vacated by a past in ruins will present few obstacles to Judejahn's rebirth or the need to level history. It permits a second baptism and a reuniting with his blood relatives. But the stones that Goethe left behind have also left a trail; the open and liberating spaces of Italy that for at least two centuries beckoned Germans to rediscover their classical roots are now haunted by remembrances of a German past. "In Rome one has to pay admission, if one wants to croak among the ruins" (Koeppen 616). The initial price for (re)admission to these ruins is a reenactment of the past—a literal returning, as it were, to the roots. As Judejahn falls into a delirium, the past overtakes him. He mur-

ders a Jewish woman, who had escaped the pogrom in her own German town. Staggering into the Diocletian baths, he mistakes the museum's statues for images unmistakably German.[20] "He was in a large gas chamber with naked people who were to be liquidated, but then he had to get out of there. He was not to be liquidated. He was not naked. He was the commandant" (Koeppen 619).[21] In these parts, however, Judejahn is no longer in command. He stumbles into the gardens and dies. His body is carried into a shed where plasterers are at work restoring ancient sculptures. Judejahn is laid in front of a sarcophagus depicting the triumphal procession of Roman soldiers. The pose, if we are to read along with Ritter-Santini, recalls Tischbein's famed portrait of Goethe lounging in front of a sarcophagus and surveying the Roman countryside (122–23). The completed, if in fact that is possible, restoration of an image compellingly tied to the birth of German classical culture reveals or exposes the horror beneath its apparent noble simplicity. Yet the apparent forthrightness with which Koeppen leaves his emperor, or commandant, without clothes is cloaked in a ruse of its own. The failed rehabilitation of national character is premised on an execution of affairs far enough removed from German soil so as, once again, not to allow the actual character of those events to soil the homeland. An aesthetic distance is retained.

This does not necessarily suggest that Goethe's own journey is suspect in the same fashion, but what must be understood in reconstructing the significance of Goethe's journey is the changing disposition or dispositioning of Italy as the noble site to encounter uncorrupted classical beauty. For twentieth-century writers, Italy has been transformed, demonized and haunted by Goethe's presence. The reference to Diocletian, the emperor who sought to preserve his power and maintain his homeland by cutting the empire in two, underscores why Judejahn can never make it back to German soil, why the devilish business of restoration must occur on foreign soil. German "purity" can only be maintained if its "complementary mode" is disattached and allowed to haunt the regions below. To read along with Koeppen, Goethe's absent presence accounts for this transformation. Germans in Rome are in attendance to a ghost, unavoidable perhaps due to the phantoms that haunted Goethe's own journey. What Goethe bequeaths to future travelers is not the document of his own creative rebirth, imposing as it might seem, but rather a posture of attendance to the ghosts of his own journey. Goethe's "inexhaustible metaphorical talent (metaphorische

CHAPTER 6

Unerschöpflichkeit)," Hugo von Hofmansthal reflects from Sicily, "plays with the objects in front of us; nothing is too real for him that it cannot be united with him; for a moment he transforms himself into each object, winks to us from inside the object, and then resurfaces. Suddenly, only the image is there. Before our eyes he has gone into the image and disappeared. We are alone with a painted surface. A shudder overcomes us" (Prosa 4:286).[22] And Italy, or at least some place foreign, is the necessary site for a German confrontation and consortium with demons or ghosts; only the "elsewhere" or the "not fully present" is a suitable, if not natural, habitat for phantoms.

This ghostly presence helps explain what is meant both by Goethe and George by the concept of theft. On the one hand, theft describes a violent struggle with the demonic presence of the past, in which a self is wrested from the grasp of those ghosts. The pact is broken and the spell dissolves, allowing one to remove, as George writes, the veils before the eyes. Objects can now perhaps be, no longer circumscribed by the unwanted presence of a seemingly inescapable past. The living ray with which the liberated return to the homeland is evidence of a victory, a vacating of the space once occupied by phantoms that plagued an entrapped self. On the other hand, there is a price to be paid for the breaking of any pact. The swindler has his own demons, and like the Germans who keep going back to Italy, (s)he always returns to the scene of the crime. Koeppen already reveals what Germans leave behind in Italy: the unseemly remnants of the culture's unannounced desire to rehabilitate its nationalistic soul. One cannot help but ask what it is about that remnant, about those ruins and stones that keeps calling to Goethe's followers. It is possible that they are just ruins, and that the German compulsion is a desire, as desire always is, to make something out of nothing. Therein would lie the swindle.[23]

Thomas Mann suggested as much with his *Doktor Faustus*. The prostitute who infects Leverkühn, or whom he allows to willingly infect him, is given the name "haetera esmeralda" after the noncitizen companions or concubines of ancient Greece. More than merely suggesting the questionable trade in which Germans encounter classical culture, the name also refers to the insect whose body is wholly transparent, denuded, save for a pink and violet dot that lends it the appearance of a windblown petal in flight. Seduction, whether of the prostitute or of the artistic ideal of the ancients, is at bottom deceit; what seduces appears and lures as something it is not. And it does so in flight, to and from

Weimar, toward and away from Italy. The pact Leverkühn seals with the devil begets him the creative power to lend the meaninglessness or nothingness of being the appearance of meaning. In Italy the union of prostitute and artist is sealed. That the devil serves as procurer in this transaction on the sole condition that Leverkühn renounce life and refuse to love is evidence that the creative rebirth experienced in Italy not only parodically recasts the artist as a Christ-like figure but also underscores the deception inextricably a part of the founding experiences of Weimar classicism and German national culture. Once again, the nagging question that must frame any investigation into the business German artists conduct in Italy is whether the demonization of the quest for creative rebirth is intrinsic to the nature of the quest itself. Is rebirth synonymous with attending to and consorting with the phantoms stirred by Goethe's Italian journey? Wherein lies the source of the deception, or is it in the nature of deception to have no source? If Goethe established the pattern for future forgers of the culture, does too strict attendance to his ghost behold one only to his fantastical presence, stirring up madness or enlisting one, as Judejahn surely was, in a demonology? The examples of Heine and Freud demonstrate how Goethe's ghost disabled identification. The case of Nietzsche, on the other hand, anticipates what Koeppen and Mann articulated.

The Other Italy

Numerous documents question just what "Italy" Goethe and his ilk witnessed. Already in 1801 Johann Gottfried Seume offered a portrait of Italy that sharply contrasted with the aesthetic wonderland painted by Winckelmann and Goethe. As he remarked in the presence of Italy's more impressive monuments: "I confess that I am not favorably disposed towards senseless splendor; even when it is found in monumental works (Ich bekenne, daß ich für zwecklose Pracht, wenn es auch Riesenwerke wären, keine sonderliche Stimmung habe)" (*Spaziergang* 90). His eye instead was turned to the miserable social conditions that gave rise to bands of robbers from which Seume, traveling on foot, never felt safe. "The streets are not only covered with beggars, but these beggars also die quite literally from hunger and poverty. . . . I myself have seen them collapse and die (Die Straßen sind nicht allein mit Bettlern bedeckt, sondern diese Bettler sterben wirklich dasselbst vor Hunger und Elend. . . . Ich selbst habe einige niederfallen und sterben sehen)" (*Spaziergang* 217, 219). This experience, Seume argued, was available only to the one

CHAPTER 6

who forewent the luxuries of a carriage and traveled among the people, a sentiment Heine would share. Those who maintained a perspective from above were "to some degree already removed from original humanity" (*Prosaschriften* 638). As a result of this so-called nearness to humanity, Seume does not share the same awe that Winckelmann and Goethe did in the presence of antiquity; his appraisal of artwork is always singed with political irony. "On the outskirts of Messina I came across some very well-made fountain works with pompous Latin inscriptions, in which a single fountain was justly praised as a great accomplishment. But what a shame that there wasn't any water in them" (*Spaziergang* 178).[24]

Seume's experience is colored no doubt by the political turmoil distressing Italy. Since Goethe and Winckelmann had journeyed to Italy, the French Revolution had swept across Europe. Italy's political vicissitudes (Napoleon, for example, conquered Lombardy in 1796, established sister republics in Milan and Genoa, which later collapsed and then were once again reestablished) foreground the exasperation of the people and push to the background the remnants of their rich past. In contrast to the experiences of Goethe and Winckelmann, the sight of Roman ruins does not inspire an appreciation for the unassailable character of the art of antiquity; instead they recall the "theft" and "slavery" that enabled the empire and have persisted ever since in the forms of feudalistic constitutions, corrupt governments, and religious tyranny (*Spaziergang* 213). Consequently, the Italian people are subject to the "gluttonous army" of the church and the "vermin of the state" (*Spaziergang* 217).

Gustav Nicolai shared Seueme's sentiments. In 1834 he wrote in his *Italien wie es wirklich ist* (Italy as it really is) that Italy was a "sad and desperate land." "Until now all we have seen are uninspiring, desolate fields, wastelands, cesspools, ruins and dirty caves, and now we are to make our way through this stretch of land where the plague of destruction wafts and the murderous blade of bandits flashes" (1:237).[25] Obviously, Italy was alluring for something it was not, and while the Italy of Seume and Nicolai continued to persist outside the visual field of those aspiring to find and affirm Goethe's Italy, the means for maintaining a dispossessed Italy at bay seems at first to have been offered by the country itself. Theodor Fontane, writing from Venice in 1884, described how Venice exerted its charms under moonlight, when one could only partially behold its sights. According to Fontane, without some form of

camouflage (Verschleierung) Venice was unable to please and allure in a fashion consonant with the expectations that had been maturing since Goethe (Haufe 461). The compulsion to screen out Italy's unpleasantries is not merely related to the tourist's whim; it derives from the peculiar space Italy occupied in the German imaginary. In his 1936 essay, "Platen und Italien," Bruno Arzeni asserted that the relationship between these two lands was far more profound than what history itself might suggest. It was rooted, he continued, in the "transcendental." "It is virtually a form of existence (Daseinsform). . . . Above all, Italy must be looked for in the German soul" (137). What George described as a theft has now become an inextricable element of the German soul, and the relationship is one-sided. Italy is appropriated, and by that act of appropriation the living ray is returned to Weimar with Goethe, thus completing or even granting Germany a soul. In this selection of quotes offered from diverse sources Italy undergoes a remarkable transformation from a socially backward land overrun by bandits to one sufficiently screened, censored, and plundered so as to anchor German identity. Italy is the soul of Germany, and what is behind the veil, what presences itself once the veil is lifted is not merely an impoverished Italy, already witnessed by Seume in 1801, but the darker side of this so-called German soul.

Goethe's Italian Preserves

If, as I have argued, Koeppen explored the possibility that Goethe's ghostly presence could be enlisted in the questionable rehabilitation of the German nationalist who was an SS officer, if he tested the grounds of postwar Italy for striking yet another deal with the devil, the flocks of self-styled inner emigrants who made off for Mussolini's Italy to escape Hitler's Germany suggest how the specter of Goethe's rebirth haunted political impulses in Germany's darkest hours and how these impulses proved to be, at best, fey and feckless, and, at worst, considered and complicit. Already in 1924 the anarchist writer Erich Mühsam underscored the curious terms of this alliance in his poem "Mignon: 1925." The poem appeared in the collection *Revolution* and emphasizes that there was nothing politically innocent about the persistent echoes of Goethe's attraction for Italy in present-day Germany, that the longing for Italy so eloquently articulated by Mignon could not be fully separated from a political alliance that made Italy, as Arznei argued, a fate ("Schicksal" 137) for Germany:

CHAPTER 6

> Kennst du das Land, wo die Faschisten blühn,
> im dunklen Laub die Diebslaternen glühn;
> ein Moderduft von hundert Leichen weht,
> die Freiheit still und hoch der Duce steht?
> Kennst du es wohl?
> Dahin! Dahin
> Möcht ich mit dir, mein Adolf Hitler, ziehn. (278)[26]
>
> Do you know the land where the Fascists bloom,
> In leafage dark the lanterns
> of thieves glow;
> a musty odor of a hundred corpses wafts,
> calm the freedom and
> the Duce stands high?
> Do you know it still?
> There! There!
> I would like to go with you, my Adolf Hitler.

Notwithstanding its ironic character, the poem expresses an ominous transformation in the nature of the German search for Arcadia.[27] According to Mühsam, the monuments of antiquity that lured generations of Germans south now inspire an imperial desire. The Italy that called to Goethe may have taught him to see, but it also taught him to see past the political oppression of a dispossessed land. As the willful political impotence of the inner emigrants will show, such "seeing past" is part of the legacy of Goethe's Italian travels. As Goethe himself remarks, his gaze was always transfixed by the enduring (das bestehende). One hundred fifty years later the monumental character of the Italy that sponsored his creative rebirth has perdured stubbornly enough to chart a new set of political allegiances that will soon ally National Socialist Germany with Fascist Italy. The past that is the focus of German longing is brought forward to legitimate, rejuvenate, and instantiate imperial design. And if theft was the hallmark of Goethe's making off with the classical spirit, that torch is now in the hands of Italian Fascists who will soon join hands with Goethe's countrymen. The risks of betraying that dark secret cannot be underestimated. In 1934 the author of this poem was murdered in a concentration camp. Mühsam's fate suggests the high stakes involved in maintaining silence about the secret nature of the attraction that continued to draw flocks of Germans to Italy during the

height of National Socialism. While many of those who offered portraits of Italy during those years are far less known today, their popularity during and after the war was significant. They included Werner Bergengruen (*Römisches Errinerungsbuch*), Rudolf Hagelstange (*Venezianisches Credo*), Kasimir Edschmid (*Italienische Gesänge*), Reinhold Schneider (Italian sonnets and elegies), and Rudolf Alexander Schröder (Italian elegies).[28] For most of these self-declared inner emigrants, escape from Hitler's Germany was nothing more nor less than vacationing in Mussolini's Italy.[29]

Among the most prominent writers who pursued inner emigration in Italy was Hans Carossa, who in the years between 1925 and 1941 visited Italy eight times. The visits formed the basis for his "Aufzeichnungen aus Italien" (1946), whose fragmentary character Carossa attributes to the war and its aftermath. Since he is unable to offer his readers a "round Italian book," these sketches serve instead, he suggests, as a greeting to those fortunate ones who will once again be able to travel in that happy land (1:794). Already in this opening aside, one is struck by Carossa's insistence upon Italy as a land untouched by the ravages of war and fascism. Only in the last section of these sketches does he begin to attend to the devastation of the times—that is, once he has returned to Munich and notes that Germany, unlike Italy, is incapable of absorbing the ruins of war: "But as I arrived in Munich, evidence of the war intruded upon me once again. During my short stay in Rome there was not much to notice. Sadness and need hid themselves under flowers, . . . under the sing-song and chatter of a people blessed by light. In any place where ruins are so magnificent, one can come to terms with a few more being added. Rome, the great transformable Rome, feels like everlasting growth, an everlasting present" ("Aufzeichnungen" 1:913).[30]

Carossa's Italian landscape may lack the demonic character assigned it by Thomas Mann, but surely it is implicated in a desire to dismiss the present and excuse the horrors of fascism. An Italian fever grants Carossa political immunity, whereby this German tourist is untouched by the consequences of war for Italy and, as an inner emigrant seeking solace in an imaginary Italy, an Italy impervious for him to the horrors of the time, he is absolved of any responsibility. In this Italy, eternally present and forever expanding no matter how much destruction war may wreak, there is no need to protest Hitler or Mussolini; the real present is only a blip, an imaginary deviation in the pattern of eternal growth that defines Carossa's Italy. Must not this magical inversion

of the real and the imaginary, this sighting of eternal growth and presence in the face of war and destruction, be the work of the devil? Was it not the devil as well that allowed Mann's Leverkühn to overcome the "paralyzing difficulties of the time?"

If we are to pursue this terminology to denote that which allows for the magical transformation of the present, the devil is summoned for Carossa by Goethe, who also, we might recall, was interested in finding the everlasting Rome. In the botanical gardens of Padua Carossa remarks, "Goethe has already seen them, and we remember that he had a presentiment of the primal plant as he made his way through these grounds (in seiner Phantasie . . . eine Ahnung der Urpflanze)" ("Aufzeichnungen" 1:810). Goethe's Italy offers an escape from the political exigencies of the time; his ghostly presence sponsors musings on imaginary origins (Urpflanze) cleansed of any markers of difference.

But if Carossa sought some form of political asylum in Italy, that asylum did not include a total bracketing out of the political events of the day. In the late 1930s Carossa journeys to Italy as a German cultural attaché; his visit is highlighted by an appearance at the Casa di Goethe, where he will give a talk: "And here was the simple, low lectern where Mussolini, in a German address, officially opened the Casa di Goethe (das Institut als Casa di Goethe seiner Bestimmung überantwortet hat)" ("Aufzeichnungen" 1:846). What Mussolini hands over to the new German/Italian order is not just the former residence of Germany's great poet but Germany's cultural heritage as well: "There was no text from the new or old Germanic world that was not to be found here" ("Aufzeichnungen" 1:846). This casual reference to Mussolini's presence at the institute is not so much an indication of a political naiveté as it is a suggestion of what one does or ignores to maintain appearances; true to Goethe's Germany, Carossa maintains a veil over his eyes. This peculiar manner of seeing and not seeing accounts for the particular pride he takes in seeing the Insel ship, the logo of the publishing house, as he scans the shelves of the library. "[A]nd now I was greeted by a shelf full of books that carried together that travel-happy coat of arms (fahrtfrohe Wappen)" ("Aufzeichnungen" 1:846). These rows of books, or rather "their slick and sparse appearance," not their contents, silence for Carossa the painful aftereffects of World War I (Nachwehen des Krieges; "Aufzeichnungen" 1:846). But this drug or painkiller effects its pleasures circuitously. The German cultural tradition, or all of its representative texts, gladly display a coat of arms abroad, in Italy, in an institute

where Mussolini has spoken and linked its fate to his destiny. While Carossa's response might not characterize the totality of the German attachment to Italy, it points to an uneasy aspect of the alliance. Attendance to the ghost of Goethe, at least in 1935, means sharing the dais with Mussolini. Escape from the fatherland may preserve its essence or imaginary origin (we should recall Carossa's reference to Goethe's "Urpflanze"), but the land of "il Papa" is now the land of "il Duce." The Italy that fathered the creative rebirth of the father of German classicism dispatches an ambassador, Mussolini, to haunt the preservation of that tradition. And like Leverkühn, Carossa accepts the deal. In exchange for Goethe he keeps his silence. He plays the role of the good cultural attaché as deadened to the present as Leverkühn was to love. Hannah Arendt's observation about the inner emigrants is instructive:

> We need mention here only in passing the so-called "inner emigration" in Germany—those people who frequently had held positions, even high ones, in the Third Reich and who, after the end of the war, told themselves and the world at large they had always been "inwardly opposed" to the regime. The question here is not whether or not they are telling the truth; the point is, rather, that no secret in the secret-ridden atmosphere of the Hitler regime was better kept than such "inward opposition." . . . As a rather well-known "inner emigrant" . . . once told me, they had to appear "outwardly" even more like Nazis than Nazis did, in order to keep their secret. ("Eichmann" 356)

It is perhaps worth repeating here that in the history of Germans in Italy since Winckelmann, appearance is everything, concealing the emptiness of the center and the absence of an essence.

Stated in less provocative terms, Goethe consciousness replaces political consciousness, which throughout Carossa's Italian sketches stands in for an overcoming of the present ("Gegenwärtsbewältigung"; Grimm 66–67). The German library proudly displaying the Insel logo in sleek, neat rows arouses in Carossa and his host a desire for Goethe's presence; as critics have pointed out, he is the one figure who allows Carossa to see past the present to the eternal past. In fact, Carossa follows Goethe's tracks almost obsessively, seeking at virtually every station the sites Goethe visited and described (e.g., Padua, "Aufzeichnungen"

1:800–812; Vesuvius, "Aufzeichnungen" 1:876–78) or simply the inns in which Goethe lodged (e.g., Terracina, "Aufzeichnungen" 1:867–75). However, such attention to the detail of Goethe's journey has a political purpose, which is to offer an escape route for those seeking inner exile.

Characteristic of the manner in which Goethe's presence promotes or helps justify a politics that neatly resides next to one as extreme as National Socialism is evident from Carossa's response to a question from Frau Schmid at the Casa di Goethe in which she directly asks him whether Hitler will start a war. "It did not suffice when I repeated my expressed conviction that a Volk, like the German one, would be drawn in a purely organic way, through its efficiency and its patient, supple strength, to occupy the place in the world that was due it" ("Aufzeichnungen" 1:848).[31] More than repeating some of the favorite vocabulary of the National Socialists and subscribing to the organic notions of the Volk and their destiny, Carossa's pat response has all the qualities of the double-talk reminiscent of the Nazi use of euphemism. Following Goethe's footsteps, Carossa discovers the means to turn a blind eye to the Italy and Germany of the day; instead, he focuses on the ruins and remnants of a Christian and pagan past. His visits to the Church of San Clemente and the Museo Nazionale, which structure the section "Winterliches Rom," inspire or keep alive what he considers to be the "foundational values of Western civilization" (Verrienti, "Aufzeichnungen" 1:72–73). To preserve and protect that vision Carossa recontextualizes all intrusions of Fascist Italy so that these signs of the political oppression of the present are absorbed as part of the landscape of the eternal Rome. "We feel; here is Italy, the invulnerable, that stands by all divine genius (Wir fühlen; hier ist Italien, das Unverletzliche, dem all göttliche Genien beistehen)" ("Aufzeichnungen" 1:862). Italy, as the site where one learns to see, grants Carossa a painterly perspective whereby all appearances, including those of the blackshirts, are dissolved into timeless dream images (zeitlose Traumbilder; "Aufzeichnungen" 1:836) that recall or reinforce feelings of the West's inevitable decline. "Alas, that journey to the West is today a grand departure; never again will the West show us the face that we knew so well" ("Aufzeichnungen" 1:906). Such fatalism numbs any potentially engaged response to the present, sponsoring instead a nostalgic detachment that can only heighten one's love of ruins, ancient or new.

If for Koeppen, Rome was a site to rehabilitate the depraved dreams of the culture in Goethe's shadow, the Goethe that Carossa recalls and sanctifies in Italy heightens his aesthetic sensibilities at the expense of political ones. This Italy is nothing less than a drug that relieves the inner emigrant of any responsibility to the present. If there was any doubt as to the effects of this drug, Carossa's response, upon his return to Munich, to the sight of two Jews wearing the yellow star demonstrates how sustained the drug's half-life is: "Their gait and their mien were proud and free; they carried the sign of shame and the threat of death like a war decoration. 'The German, so good and generous of nature, would never know how to mistreat anyone.' So Goethe might well have written, and certainly, it was once true" ("Aufzeichnungen" 1:927).[32]

Reconnecting with Goethe in Italy generates musings about the good German of the past. Carossa retreats to a safer world to preserve the illusion of the innate goodness of the German, which has vanished just as the Occident has now. The present is robbed of its immediacy; rather than prompting any intelligible or meaningful remonstration, it merely offers an opportunity to rehearse Goethe. "Bildung," or in this instance an Italian education, furnishes the inner emigrant with the sensibility to regard political engagement as irrelevant (the course of history is unstoppable). All that matters now is that one recite Goethe. By contrast, Fascist Italy is a necessary distraction that compels one to seek relief in the eternal Italy. To follow and echo Goethe in Italy produces a form of resistance to the present so passive that it is indistinguishable, as Hannah Arendt reminds us, from tacit complicity.

The Sexual Logic of Substitution

Of course, another possibility exists. One need not follow in Goethe's trails. What for Mann was the deceitful appearance of the object, of the nothing, might serve as an allegory of liberation or creative rebirth. That is, in discovering something or a means to present oneself as other than one is, other than nothing, one could be liberated from the prevailing rhythm that handed one otherwise over to a pack of ghosts. Italy would then become a site of a genuine other, no longer deceitfully appropriated as the living ray that reveals the divine essence of things (George), but rather embraced as the site in which being is no longer as it appears, unrecognized and liberated from the codes or pacts of a culture that

CHAPTER 6

sought to establish its essence. Goethe's stones would be remarked and reclaimed; all left luggage would be returned. Of course, therewith would die the dreams of a German national culture reborn alchemistically from the ruins of the classical world. No sustainable definition of liberation could ever include a return to the homeland.

This, in turn, points in curious fashion to Wilhelm Heinse's novel, *Ardinghello und die glückseligen Inseln* (1787), written and inspired virtually during the same years Goethe was romancing Italy, as well as to Heinse's Italian journals, inspired by an extended stay in Italy several years earlier. The sharp distinctions between the Italian experiences of the two are all the more striking given the role Goethe played in prompting Heinse to go south. In other words, before his own journey, Goethe was already practicing the art of influence, but to an effect considerably different from the one exercised after an actual visit to his so-called university.

The two met in Jena in 1774, and like Herder before him, Goethe urged Heinse to visit the land of the lemon trees (Grimm 43). Although it took another six years before Heinse heeded Goethe's advice, the Anacreontic poet's encounter during those years with the revolutionary zeal of the Storm and Stress prepared him to engage the classical world with a spirit far more vital and even feverish than the one of Goethe, who by 1786 was wearied by his years in Weimar (Zeller 23–28). Seduced by the younger generation's notion of genius, Heinse set off for Italy under the "fiery force of emotion" (Grimm 43). Despite the apparent spontaneity of Goethe's secret departure in the middle of the night, the Weimar poet's early Storm-and-Stress temperament had cooled considerably as a result of the stiff formality of his relationship with the court at Weimar and in particular with Frau von Stein. But perhaps these differences are not as telling or pronounced as one might suspect. Heinse as well sought release from a stifling existence in Germany. "I would like to glow from the highest heights that no man has yet to reach so as finally to allow this heart to breathe what otherwise would be destroyed by such a stifling existence," he writes to his friend General Gleim shortly before departing (*SW* 9:399). In fact, many of his entries from his stay in Rome seem as if they could have come from Goethe. "I have been in Rome almost a year and cannot free myself; it seizes me as if I have been bewitched" (*SW* 10:233). And Heinse's particular fondness for Italian ruins, the manner in which one could observe in those ruins nature's cycle of becoming and decay, recalls Goethe as well: "And

the spirit forever alive over you, destruction. Or rather, destruction, the young pure soul, that divinely awakens that which has long been dead to new life. The earth that we have, and everything that has breath, and grass and herbs and trees, it is an undying snake that now and then sheds its skin" (*SW* 10:191).[33]

It is perhaps here that a key difference is evidenced. As we have noted, Goethe reconstructs or draws with his mind's eye the whole structure; the cycle of decay is ultimately overlooked as he looks past the present to the persistence of antiquity. Rebirth, of antiquity or of the poet, is strictly "spiritual" (Grimm 48). Like the language of Pietism so characteristic of his descriptions of his own creative renaissance in Italy, Goethe's rebirth is a prying away of the spirit from its earthly roots; he substitutes one Italy for another. By contrast, Heinse is all about earthly pleasures (Mohr 90). "How I splash around in the river, sticking my head into it, throwing myself on my back, rolling around—oh, that I have no sweet nymphs with me! How the earth and sky around me die in rapture and then are reborn" (*SW* 7:98).[34] Striking about Heinse's narrative of potential rebirth throughout his Italian diaries is his indulgence in sensuous and physical pleasures.[35] Such rebirth can only be experienced in the subjunctive; it does not allow for a transformation of and for the spirit only. The limits and excesses of the flesh keep his spirit bound to the earth; there is no possibility of plundering the spirit of antiquity. Heinse's description of Lake Garda is a telling example of these differences with Goethe: "About a mile from Pesquiera one sees Lake Garda. . . . [T]he mountains, so magnificent and beautiful, rise little by little behind it in the fresh, magical, colorful tones of dark and brown and air. . . . Below, the lake lies still and blinking and restfully clear and bright in the lovely, sensual green of the trees and the gentle lap of the earth" (*SW* 7:220).[36]

Heinse's emphasis on the sensuous results in anthropomorphic descriptions of nature that always have a sexual character. He describes the Venetian women as "charming voluptuous creatures" (*SW* 7:97), but his hypersexual imagination is not limited to the living. Michelangelo's Eva in the Sistine Chapel is notable for her lascivious behind (*SW* 7:81), and Titian's Venus is a sensuous piglet from the hips to the hollow of her knees (*SW* 7:164). But as Heinse knows, these pleasures, everywhere a part of the Italian landscape, have no place in Germany. Italy is the land of pleasures, of a liberated sexuality; Germany, of fantasy (*SW* 7:55),

CHAPTER 6

which is to say that Heinse's Italy could never make its way back to Germany; it would have to be distilled and elegized.

In contrast to Heinse, Goethe sought to indulge in but sublate the sensuous pleasures Heinse championed. Goethe needed to leave behind those markers or scars of Italian pleasures that otherwise would encumber the classical spirit or living ray he was smuggling back to Weimar. As opposed to the anti-narrative or certainly "anti-Bildungsroman" of *Ardinghello,* Goethe's circular journey had to find a formula to negate those moments—in this case quite bodily or sensuous—that frustrated or interrupted the flight of the classical spirit back to Weimar. That, of course, led to a series of curious gestures on Goethe's part. Among these is the possible homoerotic substitution that, according to Sander Gilman, Goethe performs in Rome. To avoid the threat of contacting a sexually transmitted disease Goethe performs mutual masturbation with another male while constructing out of that act the image of Faustina. Avoidance of one horror, syphilis, or seeking to erase or avoid the physical component or complement of his creative rebirth sends Goethe quite literally into the hands of something no less easily acknowledged or sublated. And for those who could not play along, such as Heine and Nietzsche, syphilis, one is tempted to suggest, is a consequence.

That irony plays not an insignificant role in the German obsession with Italy; the business Goethe began in Italy always remains unfinished. There is a trail to follow, traces to be (re)read. Goethe himself refers to those traces. In one of the withheld epigrams he writes, "We shall drink coffee, my tourist! She meant, to shake it. / Friends, I have always detested coffee, and rightly" (Lind 149).[37] If "coffee drinking" as a euphemism for masturbation is not explicit in this epigram, it is in the next: "'Let's do something!'" said the loveliest, setting her cup / Down, and at once I felt her rummaging hand (Tun wir etwas, sagte die schönste, sie setzte die Tasse / Nieder, ich fühlte sogleich ihre geschäftige Hand)" (Lind 149).[38] Once an economy of substitutions is initiated, not only is gender subject to reversals, but the acts continue endlessly. The epigram concludes: "Thereafter they offered me a more secluded retreat / And the later hours of night for a warmer game (Darauf bezeichneten sie mir die entferntere Wohnung / Und zu dem wärmern Spiel spätere Stunden der Nacht)" (Lind 149). What initiates this economy is the lack of an original subject; after all, Italy is the land of copies and forgeries, something that Winckelmann's aesthetics qualify and canonize. To quote Heinse, Winckelmann is a "fantasist" (*SW* 8:219); his transhistorical

Italy is a hallucinatory byproduct of substituting self-discrediting copies for the real thing. And Goethe is eager to play along. The elegy or hexameter Goethe measured out on or behind Faustina's back might well have served as a document of his creative rebirth and sexual awakening, but, as I have alluded to in previous chapters, it did not provide her with a documented identity. This central figure of his Italian education was to remain missing in action. As T. J. Reed points out, the only evidence, shaky at best, to support Goethe's claim to her existence is a letter to Karl August of 16 February 1788. In rather awkward and evasive language Goethe suggests that the duke offered him advice on sexual matters and that Goethe heeded such advice to his benefit. "But this is a long way from suggesting an affair, least of all the sort of *love* affair that Goethe's *Roman Elegies* imply" (Reed xxii). In other words, the sublation is never complete; something or somebody still remains unaccounted for in Italy. To recall the lament at the end of the fourth epigram cited above ("doch ach, Faustinen find' ich nicht wieder"), Faustina has arguably multiplied (Faustinen).[39] In this economy of substitution, Faustina or her figure escapes calculation. What substitutes for sister(s) is not univocal. The reason Faustina has become plural and thus no longer identifiable is surely not unrelated to the substitution implied by her name. Faust(us) is now a diminutive, feminized noun. If we consider the *Roman Elegies* to be among the documents of Goethe's creative rebirth in Italy, then Faustina is the name we can assign the disfigurement that ensues from Goethe's Italian journey. The lack of an original subject describes not only Faustina but Goethe's own journey as well. For Goethe's journey, the one canonized as "original" was haunted by his father's trip and the tragedy that befell Winckelmann (Eisler 2:697–98; Nohl 38). Their company helped lend presence to an artistic ideal for which Winckelmann could rely only on copies of antique statuary (Potts, *Flesh and the Ideal* 60–66). The maneuvers that allowed for the flight of the classical spirit back to Weimar leave a series of tracks that extend well before and beyond Goethe. His success lay in an ability to negate those moments that would otherwise frustrate the flight of that spirit. But the sublation of those moments in this odd dialectic is never complete, something or somebody already remains unaccounted for in Italy. The success of the journey depends upon that something or somebody remaining masked, or even incognito, as Goethe, traveling under the name Möller, did for large portions of his journey.[40] (On the subject of pseudonyms, we might refer to the renaming of the prostitute in *Dok-*

tor Faustus.) Since absence, by definition, will never turn up or show itself, it is the movement of substitution itself, like the haetera esmeralda, that comes to transform and occlude the Italian landscape. These movements and substitutions eventually constitute other forms of disfigurements of Italy. Indeed, the movement of substitution as it figures and disfigures Goethe's notion of Italy appears closely allied with the tropological movements of figures and figurative language.[41] Worth repeating is that save for the terms of the wager between Mephistopheles and Faust, Goethe makes no progress on his magnum opus (*HA* 3:537). Faust, the figure of Germanic genius for Goethe as well as Thomas Mann, can only assume his titanic character once he passes through Italy, which in Goethe's case also necessitates a cross-gendering or another figurative substitution and disfigurement. In the language I have chosen to invoke by reading back from Mann, it requires an act or transformation that also requires negotiation with the devil.

The Real Italy

One might consider how Goethe's Italian journey is an attempt to enact or execute what some, such as David Wellbery, have underlined as the specular moment of his early lyrics. The failure of all specular moments is often best understood in the misprision that informs its beginning, which is fragmentary and lacks a solid ground upon which to erect its crowning structure. The Italy that Goethe canonizes or the terms under which he does lack foundation; and fashions substitutes, and these substitutions—whether of Greek statuary or sisters or sexual partners—points to an Italy that was there only in parts, fragmented and other than itself as any political map of the times confirms. That is why Heinse's hero takes to the islands. They represent the fragmentary base that remains resistant to the sweeping, if not terrorizing gesture of Goethe's specular gesture, and that resistance renders these islands truly "blissful (glückselig)." A look at the opening paragraphs of *Ardinghello* underlines the differences between Heinse's Italy and Goethe's:

> We moved past a Turkish ship, they fired their cannons; the gondola swayed in which I was standing upright; I lost my balance and fell into the sea; got tangled up in my coat, struggled in vain and went under.
> When I came to, I found myself with a young man who

had saved my life; his clothes were soaked, and his hair was dripping wet.

"We cooled ourselves off a bit," he spoke in a friendly way in order to encourage me; I squeezed his hand. (*Ardinghello* 9)[42]

The measured response of the classical Goethe, the author of the *Italienische Reise*, is nowhere to be found in these pages. If Heinse's protagonist submerges himself in an ambient overflow, Goethe, as when he witnesses the Roman carnival, withdraws to a perch safely above the fray. Heinse's hero delights in a loss of balance and measure. Goethe transforms sex or some surrogate version of it into a meantime of meter and verse. No one, however, will substitute for Ardinghello's boy; no image of Faustina emerges for the exchange of pressing hands. Moreover, if Winckelmann as well as Goethe praised the quiet grandeur of the Laokoon as evidence of the ideal in art, Heinse reverses or overturns the formula. "The Laokoon is a marvel of flesh and life" (*SW* 8:1, 562). Whereas Winckelmann described Apollo's pain as pointing to the "underlying calm of a deep sea," Ardinghello compares Apollo's expression to the "waves of a stormy sea" (*Ardinghello* 240–41). Ardinghello's "Wiederholungstrieb (urge to repeat)"—if one might so term this teacher's, painter's, poet's, and pirate's repeated need to experience an unqualified fullness at every turn—runs counter to a narrative that (re)constructs classical culture by smuggling its nonsensual essence out of Italy. Heinse's notion of creative rebirth, experienced at every moment, luxuriates in precisely what Goethe considered too unseemly to transport to German soil. Herder deemed his work "debauched spirit" (Jessen vii). Goethe rejected Heinse's work as unveiled hedonism. And Schiller saw "nothing of aesthetic worth in it"—thereby stripping German classical aesthetics of its sensual roots (*Ardinghello* introduction, 12–14). Heinse revealed what was inadmissible to Weimar. That is why his hero does not return to the homeland but takes instead to the islands. His utopian vision, which might be said to frame but not found German high culture, can only sustain itself in exile.[43] How these island fragments haunt not only the future journeys of Germans heading south but also their return to the homeland must be a primary concern of any study of Germany's obsession with Italy. These islands both withhold and preserve experiences that do not conform to a master narrative of

rebirth and creative renaissance; they persist in telling a different, even a sordid tale. We have seen in the chapter on Heine an example of how that tale came to be articulated. For Heine, at least, the result was exile and censorship of his words.

As one of Goethe's contemporaries, Heinse is an unhappy reminder of an Italy resistant to substitutions and alchemical transformations, a reminder of the unmeasured pleasures that might render one unfit for a return to Germany and certainly the court at Weimar.[44] And as we have seen throughout this chapter, refusal to enlist in a transnational, transhistorical flight from Germany to Italy and back to Germany is related to a political consciousness, which Heinse, like Seume and Heine, also voices. Ferrara, Heinse writes, must suffer from a curse, given the sadness and poverty of its people (*SW* 7:182). Disfigurement is too real to find any poetic correlative: "The beggars often break their children's legs, and then remark that they are provided for" (*SW* 7:237). Perhaps the curse of the land is not unrelated to the manner in which it is disfigured by a cutting off of the classical spirit from its actual roots. Or maybe it is more accurate to state that in the space opened up by amputation or castration the German "fantasists" could project an ideal surrogate to bracket out the squalor of desire and poverty.

The question that persists is to what extent is the political disfigurement of the land related to the tropological disfigurements of Goethe's poetics of substitution. Does succumbing to the spell of Goethe's Italy enroll one in a diabolical enterprise whereby the classical ideal or creativity itself can only be sustained through a disfigurement whose remnants, as part of the bargain with the devil, must at some time be reclaimed? To render present the absence of the ideal the present had to be rendered absent. But the specter of that (magical) act writes a history of its own from Heinse to Koeppen. It has been the fundamental wager of this book that that history is the real secret or the secret that weaves its disfiguring pattern into the veil of Goethe's truth (Schleier der Wahrheit) and that is the devil's revenge. Something, or better, a history—whether it be of the fascist political alliance of Koeppen's Italy or of the diseased pleasures of secret trysts such as those of Leverkühn and the like—comes to stand in for the absence of the ideal. From the beginning substitutions had always been the preferred stock in trade for Goethe and Winckelmann. That disfigurement as a performance of substitution should replace or displace the ideal for which substitution was undertaken is indeed a diabolical reversal. And this disfigurement lends

outline to a real Italy resistant to abstraction, substitution, and above all, theft. This Italy testifies to the political servitude and dispossession of its people. Just how neatly the "magical" Italy is sealed within Goethe's specular moment is evident years later in one of his stranger remarks to Eckermann, slightly before the latter was to make off for Italy with Goethe's son August and deposit or leave him there for dead. Once again, the unwanted or discomfiting offspring of desires is marked for Italy: "People usually come back as they have gone away. . . . Indeed, we must take care not to return with thoughts that make us unfit for the afterlife. Thus, I brought from Italy the idea of fine staircases, and have subsequently spoiled my house and made all the rooms smaller than they should have been. The important thing is to learn to rule oneself. If I allowed myself to go on unchecked, I could easily ruin myself and all those about me" (*Houben/Eckermann,* 21 March 1830).[45]

Given Goethe's characterization of his Italian experience as a rebirth, it is clear what is meant here by "after-life," namely his second life in Weimar. The reference to circumstances following his return could evoke both the apprehension of a ghostly return of August and an equally haunting recollection of the stones never delivered to Frau von Stein. Much could be made of his highlighting staircases. At the very least, it suggests a form of spiraling akin to "Bildung." It is no wonder that the rooms became too small; such movements crowd out everything that cannot be carried onto the next step. But if in every subsequent moment more stuff had to be shipped off or returned to sender, never for a moment did it stall Goethe's attempt to make off with Italy's living ray, with an Italy not disfigured by sexual substitutions and political servitude. One of the earlier of the withheld epigrams makes that clear: "Say, to whom shall I give this small book? The Duchess, my patron, / Who provides even now for me an Italy in Germany! (Sag, wem geb ich dies Büchlein? Der Fürstin, die mir's gegeben, / Die uns Italien noch jetzt in Germanien schafft!)" (Lind 140). What Goethe would will to future Italian journeyers is a land resistant to this odd dialectic of substitutions, a land no longer in ruins but ideally whole, specular and magically expunged of unseemly, unclassical desires. That this other Italy would always be left hanging below, bearing stubborn witness to the foiled theft of those who sought to catch only the spirit and not the disease, was the surest guarantee that Goethe's southerly (en)trails would have no end.

CHAPTER 6

The Sorcerer's Apprentice

The vocabulary of deformity, conjuration, and sleight-of-hand recalls the text that explicitly explores the "catastrophe" behind "the spectacle," the demonic necessary to preserve the appearance of the beautiful (Eng. 543; 8:677).[46] Conveniently, it brings us back to Thomas Mann. Mann's "Mario and the Magician," like Mühsam's "Mignon 1925," recasts Italy's spell. For Mühsam it was no longer an Italy blooming with lemon trees that summoned Germans to the south but rather the allure of an impending joint venture in fascism. For Mann it is not the persistence of an aesthetic ideal that captivates Germans in Italy but rather the conjuror's spell. The seductive power of Italy no longer lies in the enduring presence of antiquity; that ideal, as we know, had always been linked to a form of forgery. Instead, Italy's hypnotic power is inseparable from a fervent nationalism—what might be called the political forgery of the fascist state. As the real Italy begins to surface, the one that leads "from the feudal past the bourgeois into the proletarian" and "end[s] between two rows of poor fishing huts" (Eng. 538–39; 8:671),[47] the aesthetic veil is lifted, and the magician—drunk, decadent, deceitful, and deformed—assumes center stage. As a consequence, Italy is no longer the site of a sunny rejuvenation of creative capacities: "[I]t would have been silly to feel retrospective longings after a sun that had caused us so many sighs when it burned down in all its arrogant power" (Eng. 538–39; 8:671). This Italy is possessed by a demon (Ortsdämon; Eng. 538–39; 8:671), and the manner in which that demon is apparently exorcised is the final concern of this chapter.

From the outset of "Mario and the Magician" it is clear that this Italy is unpleasant yet curiously paralyzing. The narrator reports a series of events discomfiting enough that he is repeatedly drawn to excusing his family's continued stay in "the presence of a national ideal" (Eng. 535; 8:666).[48] "Shall we go away whenever life looks like turning in the slightest uncanny, or not quite normal, or even painful and mortifying?" (Eng. 537; 8:669). The staying power of Italy is uncanny; something inexplicable and equally contagious accounts for its seduction. It is, as the term "uncanny" suggests, all too familiar yet curiously transformed. And if we are to take this term seriously, it is not merely an omnipresent nationalism that accounts for its altered character but also the manner in which a persistent return to Italy has deformed or rendered the space mysterious.[49] Nationalism is but one symptom of this pathology.[50] Italy's

irresistible pull is embodied by the magician Cipolla, who, despite his grotesque appearance, seduces even the most resistant. "This man . . . was the personification of all that ["had oppressed the atmosphere of our holiday"], and, as we had not gone away in general, so to speak, it would have been inconsistent to do it in the particular case" (Eng. 556; 8:695–96).[51] His craft, the narrator repeatedly asserts, is little understood and is based "on certain powers which in human nature are higher or else lower than human reason; on intuition or 'magnetic' transmission (auf Intuition und magnetischer Übertragung)" (Eng. 552; 8:696). To the extent that it is personified by the magician who, in his "whole appearance" had "much of the historic type" (Eng. 541; 8:674), this Italy has no source to account for its attraction. Just as Goethe's Italy seduced one to see past the seediness witnessed by Seume, so does this "historic type's" sleight-of-hand lead one to ignore his deformities, and it is a feat, the narrator asserts, that is accomplished by his "blatantly, fantastically foppish air" (Eng. 541; 8:674). No longer is it the beautiful and the enduring of classical culture that seduces but rather a force conducted from organism to organism by one whose foppish air is intended to conceal the "catastrophe" behind the "spectacle" (Eng. 543; 8:678). Like the nationalism to which Cipolla so often refers in order to buttress his reputation, Italy's seductive power is transmitted like a disease, as mysteriously as the whooping cough whose "nature is unclear" and whose spread is believed by some to be acoustical (Eng. 531–32; 8:661). Mann's Italy is a diseased site—or at least a site where disease is mysteriously infectious and resistance, nonexistent.[52]

It should be repeated that Italy's diseased state is personified by the seductive power of Cipolla, whose foppish appearance and its clear allusions to a historic type is designed to conceal degeneration.[53] Degeneration, of course, recalls the overturning of genealogy so essential to Goethe's success in Italy discussed in chapter 3, but it is also in this instance specifically homosexual. The Ganymede episode at the end of the novella, of which we will have more to say in a moment, is only one such reference. It is not only Cipolla, however, who is apparently so inclined but also Mario. His slender and delicate hands, his vocation as a waiter or servant, his "pretty" scarf, and his alleged indifference to members of the fairer sex (Eng. 563–64; 8:706) all mark him as a receptive target of the magician's power. Staying in Italy, staying to the last at Cipolla's performance is something the narrator can neither excuse nor understand (Eng. 555; 8:696) because the nature of the attraction is both foreign

and familiar; it is uncanny. Like all attractions its origin is unknown, save that it is the return of the repressed, a returning of the German-Italian repressed.

If with the return of the repressed that which was repressed assumes a diseased character, it is necessary to ask more directly just what is this disease? We know that nationalism and same-sex attraction are its symptoms. While it would be tempting to name syphilis as that disease, it is hardly an Italian disease, and in the case of Leverkühn it is symptomatic of something larger as well.[54] The question is whether there exists a relationship between what I have called the logic of substitution and the ensuing disfigurement that characterized the Italian tradition as initiated by Winckelmann and Goethe and the sexual degeneration and nationalism infecting—to draw upon the jargon of Mann's text—the Italian landscape. Is there more to this relationship than textual coincidence? Throughout, the claim of this chapter has been that the literary text or tradition that arises from a rediscovery of classical roots and values in Italy has repressed political consciousness of an oppressed Italy. Although a parallel with fascism or nationalism is tempting and often indicated by the manner in which the two appear to accommodate each other, as noted in the Italian sketches of Hans Carossa, it is only in Mann's text that the pathologies of nationalism and succumbing to the spell of Goethe's Italy are linked as diseased and degenerate.[55]

One means to explore that link is to return for a moment to "Mignon's Song." Mühsam's poem equated Mignon's longing ("Do you know the land where the lemon trees bloom?") with a longing for fascism. Had the song not acquired a life outside the text, one would be tempted to explore Mühsam's equation in terms of the peculiarity of Mignon in Goethe's novel. But Goethe himself seems to foreclose that possibility. Thus the emphasis shifts from the character to the character of her longing and the manner in which that longing finds fulfillment in fascism.

As I noted in chapter 3, the elevation from "Schriftsteller" to "Dichter" had little to do with authenticity and everything to do with translation. In *Wilhelm Meister's Years of Apprenticeship* the reader is informed that Mignon's song is a reconstruction by Wilhelm from Mignon's broken German and/or Italian: "He had the verses repeated and explained, wrote them up, and translated them into German. But he could only remotely imitate their originality. The child-like innocence of the expression disappeared" (*HA* 7:146–47). Authorship, under-

stood to be a re-placement of words, is foregrounded. The original is appropriated and replaced by a reconstruction, which is the only evidence of an original. In the sequel to the novel, *Wilhelm Meister's Years of Wandering,* Wilhelm and his company cross the Alps to discover that an industry has grown up based on Mignon and her song. She has become not only a cliché, but perhaps a profitable one. A painter has depicted numerous scenes from her life, and her poem has become a favorite of those who actually live in the place she longed for. A particular favorite of Wilhelm's is one that depicts the song with some striking changes. As Eric Blackwell points out, the painting takes one back through the song, arranging the stanzas in reverse order (Blackwell 246). In this instance the boustrophedon is pictorial. It not only "summons her image, which lives in all feeling hearts before the eye" (*HA* 8:229), but also becomes the lived experience of the Italian traveler and an important station in his development or Bildung.

In the intervening years, the song that is perhaps the clearest and most poignant expression of a longing for Italy has been co-opted for what in many respects are commercial purposes. Wilhelm Meister's replacing of Mignon's words gives rise to all sorts of likenesses whereby Mignon or her surrogates now substitute for the land of her longing. What was the plaint of a displaced Italian, Mignon, and became an expression of German longing transforms the real Italy and arguably supplants it. The land of the lemon trees is now only apparently somewhere other than where one is. The distance between the two has collapsed. Longing only seems to seek something other than its own fabrication. "Mignon's Song" expresses a longing so long as one is separated from Italy. Italy is the other that is longed for. But when longing reproduces itself as that which is longed for, it authenticates itself as real. It is what it is, save that it now has the character of what Baudrillard calls the "hyperreal."[56] "Everything is metamorphosed into its inverse in order to be perpetuated in its purged form" (37). Or, we might say, everything is metamorphosed in the form of an Italy that is Wilhelm's creation.

Mignon's plaint was always less than genuine; what one heard was what Wilhelm Meister thought he heard. It legitimates itself by positing a place as the object of its longing, but that place is a reproduction of a reproduction. Longing may lend it the appearance of something real, but it is only another in a series of reproductions. Longing manufactures itself, thus acquiring a different dimension or a dimension of apparent difference. It longs for its own reproduction to be real so as to verify it-

CHAPTER 6

self as authentic. In Mann's text the appropriation of Italy also includes an appropriation of Mussolini's Italy. Carossa's sketches confirmed this. The more complicated aspect of that relationship is the manner in which the fabrication between longing and its referent leads to an implosion of that difference, which, at least in Mann's text, is coeval with fascism. As we will see, the difference that implodes is a linguistic one, between sign and signified. Language manufactures and becomes its own referent.

I am not arguing for a *causal* link between fascism and the German fascination with Italy. Instead, I am seeking to underline features of each that explain their convergence as that convergence is exposed in certain texts. Before returning to "Mario and the Magician" it is helpful to pursue this link through a renewed discussion of the hyperreal in Baudrillard. The hyperreal denies any reference to the real (appearance no longer plays at being appearance), a ploy Baudrillard links with sorcery; appearance supplants the real (12). In the history of Germans in Italy, or of those highlighted in this project, Italy as the land of an ideal that is available only through copies supplants the real Italy, just as in Mann's text language surrenders reference to anything but itself. The magician's commands are embodied. That is the sickness of nationalism and accounts for the acoustical etiology of disease in the text. Cipolla moves beyond sorcery since, as his name "onion" implies, there are only layers. His simulations are all. This form of production proceeds according to a code, to what Baudrillard calls the metaphysic of the code (103–15). That would be the law installed by Goethe's Italian journey or the code by which the magician both produces and controls his subjects. Significant about this code is how it generates "a nostalgia for a . . . referent" (Baudrillard 86) that in turn generates a binary opposition that lends the hyperreal the impression that it refers to something real.[57] But that division is threatened with implosion, since it was always only a misprision. The same will hold for the apparent distance between the narrator and Cipolla and, more importantly, the apparent difference between the political projects of Italy and Germany. The narrator's repudiation of Italian nationalism is thus mere feint.

Equally important is the relationship between nostalgia and paranoia. Paranoia allows the apparent other to acquire the power of a real other, even if that distinction is destined to implode.[58] In more general and provocative terms, this means that anti-Semitism is the fulfillment of fascist nostalgia. In terms of the story, it is signaled by the racist remarks voiced by both the narrator and Cipolla, even if the targets are dif-

ferent. It is worth recalling here how a specter of impending disaster shapes the narrative: "Looking back, we had the feeling that the horrible end of the affair had been pre-ordained and lay in the nature of things (einem, wie uns nachträglich erschien, vorgezeichneten und im Wesen der Dinge liegenden Ende)" (Eng. 529; 8:658). If Goethe could be said to have mastered the code (after all, he thematizes the process in both *Wilhelm Meister* novels[59]), all that now remains are its effects or, rather, its hypnotized subjects. In "Mario and the Magician" the code acquires an excessive character whereby illusory difference can no longer be maintained; it does indeed implode. The effects produce an unintended effect. In other words, when difference implodes, something escapes the register of the code and makes way for the intrusion of the real. As a result, the hypnotist's spell is broken, followed by an apparent awakening.

Cipolla is the key figure who, unwittingly, orchestrates this implosion. As the personification of all that is oppressive, he is repeatedly described as deformed and grotesque. His appeal to nationalism, which helps sustain his own appeal, serves to silence resistance. It is not, however, simply an appeal to nationalism that disqualifies resistance; rather, it is the illiteracy of Cipolla's first resister, the fisher lad and Mario's companion, who is unpatriotic: "'Scandalous,' said [Cipolla], in a sort of icy snarl. 'Go back to your places! In Italy everybody can write—in all her greatness there is no room for ignorance and unenlightenment'" (Eng. 546; 8:682).[60] The inability of the fisher lad to manipulate and succumb to the spell of language renders him unfit for Italy. Moreover, it is this same lad who at the story's end mocks Mario's surrender. As Eva Geulen has shown, language is the mysterious secret of the magician's power. It allows him to distract and conceal visual disfigurement; it is the medium through which the repressed travels. Cipolla, the "self-confident cripple" who is the "most powerful hypnotist" whom the narrator had ever witnessed, evinces his power through a series of verbal commands that with the crack of a whip are enacted or literalized by his subjects.

> Cipolla's art infects and affects the audience, achieving a power over bodies that far exceeds that of any direct influence. Cipolla's jokes consistently pun on language and bodies—he induces one young man to stick out his tongue and calls him a "hopeful linguist"—but the real show consists entirely in his ability to erase the distinction, literally to embody

language in the obedient bodies that dance or freeze on the order of a mere word, "for now he made them dance, yes, literally." (Geulen 26)

This explains the power of nationalist rhetoric to seduce and to obtain, but it also recalls how absence comes to be embodied, how language substitutes for something, like the classical ideal or even the "Urpflanze," that is unavailable. Moreover, such art signals the danger that ensues when language is called upon to materialize what is not there. The desire that sponsored the attraction of the ideal (e.g., in Winckelmann's or in Goethe's game of substitution) could never truly be spoken, but when the power of the ideal resides in language, the speaking of that desire is diseased. Or better, it is commanded by a degenerate. Therein lies as well the unknown origins of the hypnotist's power: he verbalizes the secret. Since the secret resides in the fact that there is no secret, that the ideal was always only a forgery or substitute, its expression must be grotesque. What comes to be verbalized are the expressions of absence or the repression of nothing save repression. As such, Cipolla's audience could never have hoped to offer resistance.

This language, however, is commanded not only by Cipolla but also by the wordsmiths of German classicism. As many critics have emphasized, the German wordsmith in this instance is the narrator or Thomas Mann as narrator. Here it is important to recall Mann's extreme adulation of Goethe and his desire to carry the Weimar poet's banner.[61] In other words, the narrator not only succumbs to a diseased attraction to Italy and to Cipolla, but is every bit Cipolla's equal as well. The two engage with matching dexterity in the same craft, discussed above through reference to Mann's hatera esmeralda—namely, lending nothing the appearance of something through language. To cite the text, both speak marvelously ("parl[ano] benissimo"; Eng. 544; 8:679), which in turn points to the narrator's tacit complicity with Cipolla's fascist train of thought (Geulen 17).[62] Among the many signs of a shared sympathy are the narrator's prominently racist remarks, which lead him to compare contemporary Italy to primitive Africa. More to the point is the pacing of the narration, its attempt to invite and seduce the reader through apostrophes as well as a calculated reconstruction of events whose end is delayed to enlist the reader's greater participation: "He made us wait. That is probably the best way to put it. He heightened the suspense by his delay in appearing" (Eng. 540; 8:674). This is precisely

what the narrator does by alluding repeatedly to a dreadful end—a certain means to heighten the suspense and keep his readers rapt.[63] It deserves remark that staged delays could just as readily describe the grand gestures of Winckelmann and Goethe. Continued stays in Italy grant a stay to the ideal, enhancing the appeal of the absent. Like all accomplished prestidigitation, the gesture or the spectacle captivates as it distracts. And Italy, at least for Goethe, is nothing if not a distraction.

In this context, the narrator's opening remarks are instructive and bear repeating: "Looking back, we had the feeling that the horrible end of the affair had been pre-ordained and lay in the nature of things" (Eng. 529; 8:658). He thereby preempts any critical response by the reader. We are passive participants, whose impulse to protest becomes as feckless as those subjects of Cipolla whose initial resistance only renders their seduction and surrender more complete: "Commanding and obeying formed together one single principle, one indissoluble unity; he who knew how to obey knew also how to command, and conversely (Befehlen und Gehorchen, sie bildeten zusammen nur ein Prinzip, eine unauflösliche Einheit; wer zu gehorchen wisse, der wisse auch zu befehlen, und ebenso umgekehrt" (Eng. 553, 8:691). The narrator and Cipolla (and the narrator and his readers) cannot be disentangled. "And I remember that involuntarily I imitated softly (leise) with my lips the sound that Cipolla's whip had made when it cut the air" (Eng. 543, trans. altered; 8:677–78). The suggestion is clear: the narrator, contrary to his will, is every much the director as is Cipolla. The unity between the two is indissoluble. If Cipolla is said to personify the entire evilness of the situation, the narrator thereby indicts himself as well. He who would mime or narrate the spectacle—and might this not recall ekphrasis in general and Winckelmann in particular?—is himself a master hypnotist seeking to conceal physical deformity. In this respect, Cipolla is inconceivable without his German narrator, and the two are every bit as hypnotized by Cipolla's language as are Cipolla's subjects.

The issue is perhaps better pursued by asking how one imitates with one's lips the sound of a cracking whip. For as I have argued, it is this involuntary gesture that serves as the metaphor to expose the narrator's complicity and deception. Additionally, the sadomasochistic character of this union, indicated by the whip, underscores the sexual character of the relation. In effect, the narrator seeks to offer through mime a linguistic counterpart for the spellbinding crack of Cipolla's whip. What his lips cannot express or articulate for others is accomplished

CHAPTER 6

through the supplement of narrative. The narrator gives voice (Stimme) to the atmosphere (Stimmung; Geulen 26). This recalls how the mothers' voices linger in the air at the beach with their cries of "'Nina' and 'Sandro' and 'Bice' and 'Maria'" (Eng. 530).[64] Linguistic bodies are everywhere, appearing and disappearing on command. This particular version of "fort" and "da" dissolves the difference between bodies. Since the resolution of language and bodies authenticates what by definition cannot be authenticated, the illusion, it repeats Winckelmann's tactics. The disease that like whooping cough is communicated acoustically is the linguistic authentication of a forgery. But if the notion of forgery and illusion recall Winckelmann's false authentication of the Ganymede and Jupiter, the Ganymede episode in Mann's story has a different twist. Mario, hypnotized by Cipolla into playing the role of Ganymede, performs the kiss that Winckelmann's Ganymede only seemed ready to perform. The kiss is the effect that breaks the code.

The question therefore arises as to what allows for the kiss. Initially, it can be argued, the narrator's quiet imitation of the sound of the whip and the sound of the whip itself are not entirely parallel. Their apparent simultaneity requires a narrative supplement to verify or seal their convergence. Writing releases the lips from the burden of speaking or making sounds. Idle, the lips can be employed by others. They can receive another's voice; they are free to be ventriloquized. Whereas Winckelmann's Ganymede could, through his lips that are pursed for a kiss, arouse the eroticism necessary to sustain the illusion of authenticity, the narrator through his supplement frees Mario's lips to do what Ganymede's never did. The narrative supplement supplements Winckelmann's text as well. The figure, Mario, assigned an identity, Ganymede, that is not properly his own, gives his lips to the cheek of the illusionist, who, with the help of the narrator, now stages the sealing of the pact ("Commanding and obeying formed together one single principle, one indissoluble unity"). The classical allusion can only be sustained through role-playing, and it is sustained by a lurid kiss between a feminized waiter and a deformed or "hunchback" conjuror (Eng. 566; 8:710).

The supplement is too much. If the kiss seals the pact, it also dissolves the spell. With the crack of the whip Mario/Ganymede descends the stage and abruptly fires two shots into the magician. The one whose lips allowed him to perform the part of Ganymede takes up or appends a "pistol-shaped tool" that in its new location, obviously his hand and arm, becomes a weapon (Eng. 567; 8:711). The cut, so essential to the

persistence of the illusion throughout this book, has been staged here as well by the crack of the whip. In the logic of substitution indicated or announced by the cut, that which is severed (and we should recall the extended arm of the Laokoon that Winckelmann praised) shows up elsewhere, just as the Tuscan cook who murdered Winckelmann now shows up as the Tyrhennian servant who murders Cipolla.

Once this surrogate Ganymede is made to actually kiss the magician, the surrogate is no longer willing to participate. The condition for maintaining the illusion had been, at least since Winckelmann, that the substitute would never be mistaken for real. As Winckelmann's final paragraph in the *History of the Art of Antiquity* describes, the art historian is like a maiden who is all the richer because she longs for that which can never return. Winckelmann's art history and the German Grecophilia that arises in response to his work require the loss of the original; the maiden can only long for the beloved if he has departed. The absence of the beloved sponsors a history that extends beyond Winckelmann to all those seduced by the illusion that issues from the surrogate. For Winckelmann the illusion was the image of the beloved projected upon a blank sail or canvas by a maiden left behind. It was of her own making, just as the Ganymede in Mann's story is of Cipolla's making. The kiss, however, calls forward the illusion, whose power resided in absence. If homoeroticism sustained the illusion and accounted for its attraction, its performance disables the conditions necessary for the preservation of the illusion. The presencing of the illusion breaks the spell; it produces an unintended effect, a real kiss. And since the illusion is the making of the magician, his end is announced the moment the illusion is shattered.

Indeed, the narrator repeatedly asserts that with the death of Cipolla the spectacle ended: "Was that the end, [the children] wanted to know . . .]? Yes, we assured them, that was the end. An end of horror, a fatal end. And yet a liberation—for I could not, and I cannot, but find it so!" (Eng. 567; 8:711).[65] In many editions, the year of the story's composition, 1929, follows the narrator's assertion of liberation. That date, of course, contests his claim, all the more so given the pronounced synonymy of the magician's spell and nationalism. The end is really no end at all, but rather a new beginning. In fact, the narrator's repeated assertion of "the end" has an incantatory effect, which he himself fears. It is an attempt to call forth an end, to instantiate an end, just as the magician's words themselves came to be embodied by his hypnotized sub-

CHAPTER 6

jects. The narrator has learned the magician's craft well, and he has succumbed hopelessly to it. He no longer merely imitates the sound of Mario's whip with his lips; he substitutes for him. The narrative may end, but like all other incantations, this end is only another of the magician-narrator's illusions.[66] As I have remarked throughout this chapter, the end of one chapter is mere occasion for another iteration. Goethe's and Winckelmann's Italy will persist in the narratives of Carossa and Koeppen. Nationalism will find a voice that is properly German, and like the haetera esmeralda, that voice will continue to seduce and to infect.

Epilogue
Birthing Italy

In the last chapter, the Italy that emerged as a byproduct of the substitutions so essential for its continuing spell converged with Mussolini's Italy. The oppression of the real or historical Italy, whether it be the one that Seume witnessed or the one that was repressed under fascism, recalled the strategies necessary to sustain the illusory Italy that granted Goethe his rebirth. In his afterlife Goethe kept showing up at all the wrong places or at all the wrong times. Carossa's Italian sketches bear witness to Goethe's untimely appearances. We need only recall Goethe's miscalculation at Vesuvius to note how Carossa's miscalculation at the Casa di Goethe in Rome rearticulates a key aspect of Goethe's journey with an unintended effect. By definition, there is also something that cannot be calculated when things are miscalculated. Heine's detour was the clearest evidence of that, and by attending to the repressive character of Goethe's journey, Heine picked up on the repression of the real or historical Italy, the one disfigured by foreign occupation and the one disfigured, at least tropologically, by Goethe's and Winckelmann's logic of substitution. Such logic ensued from a reimagining of origins; this not only allowed Goethe to supersede his father but also was coeval with Winckelmann's obliteration of the feminine. That is why Bachmann's poem, "The First-Born Land," is so important. Not because it can be read as representative of her relationship to Italy[1] but rather because it

represents perhaps the biggest miscalculation of all, namely, the mother or the voice of the mother returning unexpectedly to claim the land of Goethe's rebirth as her own firstborn. In other words, fathers are not what should have disturbed Goethe upon his arrival in the "capital of the world." The purpose of this epilogue is to engage in a renewed reading of Bachmann's poem to see if, in fact, it disrupts the logic of substitution that found its most disturbing formulations in Thomas Mann. Throughout her work Bachmann renders the connection between fathers and fascism overt. What I noted as a convergence in the last chapter is explicit in her work, which can be read as an attempt to recover a voice that is properly hers, not one that is merely ventriloquized by totalitarian figures.[2] In reading "The First-Born Land" to detect a reclamation of that voice, I am aware that the nature of that voice, its intonations and nuances, are too complex to be taken up here. I pursue something of its character in an epilogue because it restores a dimension, a feminine one, to those journeys that were disfigured by substitution. This study ends then with a consideration of what might recapture the lost promise of the Italian journey.

The first stanza immediately transfers the deed of ownership to the poet or the lyrical "I" of the poem. Equating the destination of her movement south with her firstborn land signals a reunion, even a familial one. It inserts the lyrical "I" into the family of journeyers to Italy who preceded her. Moreover, this transfer of ownership, marked by the change from the definite article of the title to the possessive pronoun of the opening phrase, is the consequence of her own movements south. She participates in the tradition whereby Italy becomes the destination of the traveler's imagination. Italy had always already structured Germany's and Austria's understanding of itself. Her transfer from the north transforms the land into a mirror of her imaginary, as evidenced by the poem's imagery, which with few exceptions does little to situate the land in the south.[3] The land's new disposition does one other thing; it eventually allows for recognition of its mother. Italy is no longer simply the land of "il Papa."

Certain is that orphaning her firstborn—to move to the land she must have been separated from it—has left the land "naked and destitute (nackt und verarmt)," disfigured by substitutions that exiled the mother. Her return seems thus to be under the sign of those who preceded her. But there is also a movement counterpoised to the one indicated by decay and poverty. The city and its fortress are submerged up

to their waists in the sea (bis zum Gürtel im Meer). The city has either begun to return to or to emerge from its womb. Recognition of the city's womb or the womb from which the firstborn arrived is the critical difference that a woman poet introduces, although how that difference will play out is yet to be seen. For in its semisubmerged state the lyrical "I's" firstborn land gives no indication of the sort of rebirth that Goethe experienced. Her rebirth has more to do with the land, with giving birth a second time to the land, than it did for Goethe. The city and castle, evidence that there is a land beneath the sea, follow from first remarking about their decayed state. The lyrical "I's" move to the south can only find its object after enunciation of that condition. The land, not the reborn self, finds itself or constructs itself in her movement south.

Images of disfigurement now begin to predominate. These are not the sorts that Seume described; they do not refer to the real political conditions of the land.[4] They refer instead to the imaginary Italy that lured previous travelers, save that the land is hardly idyllic. The lyrical "I" reports how she moved out of the dust into sleep, where she then lay in the light. The worlds seem to be reversed here. Awake, she was in a haze; asleep, she slept under the light with, as we will soon learn, her eyes open. Moving into sleep has less to do with repose than it does with beholding signs of antiquity. This is evidenced by the leaves above her that are formed by Ionian salt. These leaves form no part of a living landscape; the tree to which they belong is but the skeleton of a tree (Baumskelett). The remains of Ionia are linked to the death of the natural. What the sun of the south illuminates is an unnatural formation, which, rather than signaling rebirth, is under the sign of death. The tree that charts a genealogy from antiquity to the present (as opposed to the primal plant that seeks in its imaginary presence to overturn genealogy) is barren. The legacy that Goethe fathered and that transported the spirit of antiquity from Greece through Italy to Germany has rendered the land sterile. What is not clear is whether that skeleton hovers above her sleep or is a part of her sleep. The collapse of difference between the real and the imaginary does not summon a classical renewal. What was transplanted from under a Greek sky is not, as Winckelmann implied, an imitation of the beautiful. What remains instead is the death-like stillness inherent in "noble simplicity and quiet grandeur."

The lyrical "I"'s journey to the south reiterates previous ones in that she enters a somnambulistic state to appropriate and recall antiquity, but in this instance the Italy that she has made her own does not, as it

did for Goethe, bring to life the "dreams of [her] childhood": "There no dream descended (Da fiel kein Traum herab)." Until this point, the descriptions have had a pronounced character, both before and after the lyrical "I" drifts into sleep. The collapse of that difference leaves no room for dreams or the renewal they often inspired in the Italian journeyer. The disposition of the land that the lyrical "I" has claimed by moving south is sterile: "There blooms no rosemary, / no bird refreshes / its song in spring waters (Da blüht kein Rosmarin, / kein Vogel frischt / sein Lied in Quellen auf)." There is a distinction between the rebirth of the journeyer and the land that sponsors that rebirth. In this instance, there seems to be no possibility of rebirth so long as the land is not reborn. The shift to the present tense presents yet another collapse of difference. Past and present time are not easily distinguished; one is caught up in an eternal cycle of decay. This recasts Carossa's observation, commented upon in the last chapter, that a bombed-out landscape would somehow contribute to the inspiration emanating from Italy's ancient ruins. Instead, Italy has lost its idyllic character and become venomous or, to cite "Mario and the Magician," "diseased." A viper attacks the lyrical "I," at which point she qualifies her observations to this point as the "the horror in the light (das Grausen im Licht)."

The poison, however, has a homeopathic effect. This is her firstborn land; she shares its pathology, which is why she can break the cycle of death and decay that has overtaken the semisubmerged land by restaging its birth. This transformation is first indicated by the fragment that concludes the stanza: "and the horror in the light." Subject-object relations are disrupted. The traveler and the land are about to enter into a different arrangement. That is further announced by the sudden shift in tense and mood that follows: "Oh close, / close your eyes. / Press your mouth to the bite (O schließ / die Augen schließ! / Preß den Mund auf den Biß)." The lines recall Zarathustra's discussion in part three about the eternal return of the same. The dwarf and Zarathustra stand in front of a gate marked "Moment (Augenblick)." The gateway is where two adjacent but antithetical roads meet. Since the lane backward leads to an eternity, Zarathustra remarks, "Must everything that could have happened, already have happened, resulted and gone by? (Muss nicht, was geschehen kann von allen Dingen, schon einmal geschehn, gethan, vorübergelaufen sein?)" (*KSA* 4:200). That everything includes this "Moment," which prompts Zarathustra to conclude, "—And must we not return in that other lane out before us, that long

EPILOGUE

odd gruesome one—must we not eternally return?—" (*KSA* 4:200).[5] Afterwards, Zarathustra witnesses a young shepherd writhing and choking with a heavy black serpent hanging out of his mouth. The shepherd, Zarathustra surmises, had fallen asleep, and the serpent had crawled into his throat. At this point, Zarathustra commanded the shepherd to "Bite! Bite! Its head off! Bite! (Beiss zu! Beiss zu! Den Kopf ab! Beiss zu)" (*KSA* 4:201). The shepherd bit as commanded and spat out the head of the serpent. Thereafter, the figure, "no longer shepherd and no longer man," sprang up and laughed, "as no man on earth had ever laughed" (*KSA* 4:202). While I do not intend to pursue the meaning of "this enigma" (*KSA* 4:202), it is fair to say that Nietzsche's tale presages the emergence of the overman, while Bachmann's presages the rebirth of the land of the eternal city. If all roads lead to Rome, if one is destined to return eternally to Rome, then Bachmann returns to her firstborn land its mother as a giver of life.

As noted in the introduction, the stanza that follows the command to close her eyes and bite describes the transformation that occurs as a result of those actions. In the last chapter I argued that the "end" declared by Mann's narrator was in fact no end at all, but rather another beginning, a return of the same. In this respect, Bachmann's poem is a reflection on the southern landscape after it has been subjected to a series of substitutions by which the journeyer's repression of the real Italy eventually led to the land's desolation. The implosion of apparent difference is marked by a semi-hypnotic state in which the lyrical "I" sleeps with her eyes open. No dream came to her because the difference between dream and waking states has imploded, just as it did in the Italy of Mann's magician. With the viper's bite she too is infected, but the imperatives that follow serve to break the cycle of an endlessly relived past that has killed all natural life. The sleeping self closes her eyes and bites. Directing commands at herself, she is an entity that she is also able to consume, and her self-absorption is coeval with a quaking of her firstborn land. Like the bite, the closing of her eyes represents a rupture in the death cycle of an eternally lived past; she is thus awakened to seeing. Life now comes to her, and the land she gave birth to is alive as well. "There the stone is not dead (Da ist der Stein nicht tot)." While her merging with her partially submerged firstborn is reported in the past tense, the rebirth or coming to life of the stone is in the present. That event is the "Moment." But the significance of the moment can only be understood by attending to the motif of rebirth. The barren firstborn

land of the opening part of the poem has been reborn. The life given to the lyrical "I" who consumed herself is coeval with the rebirth of a land in which now even the stones speak. To compensate for his lack of Italian, Heine claimed to converse with stones. In this respect, Bachmann was his real interlocutor, the one who by reintroducing the feminine obliterated by Winckelmann also reintroduced the occluded and oppressed political landscape of the land. She does not merely give birth to the land of Goethe's rebirth, but she allows it as well to be reborn—or rather, it is reborn with her. Such self-generation eliminates the need for fathers. The law installed by Goethe's journey or the imperative to attend to his itinerary is annulled. In keeping with the logic of the eternal return, she has only always preceded Goethe. Her giving life and being given life is the origin that was always just beyond the reach of Winckelmann and Goethe.

If regeneration and rebirth are counterpoised to the degeneration and death of the first half of the poem, the dialectic that ensues ensures that this "new" Italy is blighted as well. That dual character is already suggested by the waters from which the castle and city are emerging or, just as likely, into which they are sinking. Birth, or rebirth, requires a retaking or reabsorption of the land to renew its life. This odd dialectic explains as well the various forms of implosion of differences noted to this point. Difference is posited only in moments. Death and rebirth are temporally indistinguishable, particularly at the origin.[6] The shifting modalities of the poem refuse the distinctions inherent in profane time. In this instance, a glance enabled by the lyrical "I"'s newly found ability to see ignites the wick, whereupon the wick stands erect (Der Docht schnellt auf, / wenn ihn ein Blick entzündet). The masculine imagery, or even its destructive potential, is summoned by the newborn lyrical "I." Are we to associate the wick with a candle that has been lit to mourn the land or the self that has just been reborn but is now threatened with a conflagration that would return that same land to the desolation and dust of the poem's first part? The candle could just as likely be a votive signaling the fulfillment of a promise. Therein would lie the notion of an auto-da-fé. Fire and an act of faith are linked; vows are broken as they are fulfilled. Bachmann's rebirth fulfills the promise of Goethe's Italian journey, but it also usurps the place of the father.[7] The "Urpflanze," which allowed for the same, was supposedly only Goethe's find. Such effrontery summons the wick to erection. "Aufschnellen," to leap up, accentuates the involuntary, almost defensive quality of the re-

EPILOGUE

action. It is what an animal would do to protect itself. As a result, the sight that signaled this indecency burns, or rather, it sets itself ablaze. Self-defensive measures are equally destructive.

Moreover, Bachmann's precession of Goethe threatens to return to the land the many fathers who plagued Goethe upon his arrival in what he called the "first city of the world." A certain promiscuity that upsets the patriarchal hierarchy inhabits the land that is forever and simultaneously reborn and destroyed. (We might recall Nietzsche's lament that "at bottom he was every name in history.") As Freud noted, fathers can always be replaced or substituted for. They are instrumentalized, as they were for Goethe—an effect of the land that burns for itself.

Now we are in a position to understand the significance of the "Moment (Augenblick)." The glance or blink of an eye that was coeval with rebirth is likewise simultaneous with its desolation or even self-immolation, just as the Italy of Winckelmann and Goethe existed alongside a dispossessed and impoverished land and just as their Italy was juxtaposed to the demonic one of Mann. Italy substitutes for itself; one Italy has always only given way to another. The road that leads to the past is eternal and perduring, not in the sense of what Goethe called "das bestehende," but rather in the endless cycle of substitutions, of which Bachmann's poetic representation must also be counted. The origin is both a beginning and an end, forever beyond the reach of the journeyer who, if nothing else, marks time. The firstborn land arrests history, and such vacating of time, to recall Winckelmann and the beginnings of this study, has always been a prerequisite for an extended, speculative vacation in Italy.

Notes

Introduction

1. Between 1954 and 1957 Bachmann lived in Rome and Naples, where she wrote the poetry she published in her collections. Her first trip to Italy was two years before, in 1952. Between 1958 and 1962 she lived alternately in Zurich and Rome. She lived in Rome for eight years before her death.
2. See the Piper collection, *Mein Erstgeborenes Land: Gedichte und Prosa aus Italien,* ed. Gloria Keetman-Maier, for a more extensive selection of works written in Italy that, according to the editor, display the unmistakably Mediterranean quality of her language (7). For the reasons for connecting the land of the poem with Italy see the same introduction (5–7). The poem appeared as part of the collection, *Anrufung des großen Bären* (*Invocation of the Great Bear*), 1956. Filkins translates the title as "The Native Land," which I reject. "Heimatsland" or "Geburtsort" would be a more likely expression of "native land."
 Here is the poem in its entirety:

 Das erstgeborene Land

 In mein erstgeborenes Land, in den Süden
 zog ich mich und fand, nackt und verarmt
 und bis zum Gürtel im Meer
 Stadt und Kastell.
 Vom Staub in den Schlaf getreten
 lag ich im Licht,

NOTES TO INTRODUCTION

und vom ionischen Salz belaubt
hing ein Baumskelett über mir.

Da fiel kein Traum herab.

Da blüht kein Rosmarin,
kein Vogel frischt
sein Lied in Quellen auf.

In meinem erstgeborenen Land, im Süden
sprang die Viper mich an
und das Grausen im Licht.

O schließ
die Augen schließ!
Preß den Mund auf den Biß!

Und als ich mich selber trank
und mein erstgeborenes Land
die Erdbeben wiegten,
war ich zum Schauen erwacht.

Da fiel mir Leben zu.

Da ist der Stein nicht tot
Der Doch schnellt auf,
wenn ihn ein Blick entzündet.

3. Goethe repeatedly emphasizes how he is learning to see throughout his Italian journey, and it is perhaps as strong or recurrent a theme as is his rebirth. For an extended discussion of how or what Goethe learns to see, refer to Bell, especially 175–80.
4. Bertha Mueller insists, and she is certainly not alone, that "Goethe coined and first used the term," yet the botanist Carl Friedrich Burdach first used the word in 1800 (9n.17).
5. Unless otherwise indicated, all references to Goethe's *Italienische Reise* are from the *Hamburger Ausgabe*, vol. 11. Dates are used instead of page numbers to facilitate use of other editions.
6. According to the *Roman Elegies*, even Faustina, the woman with whom Goethe apparently had his first sexual encounter, is now considered to be the author's invention. At the very least, there is scant evidence to support her actual being. See Reed xxii. See Swales (5–10) for an overview

NOTES TO INTRODUCTION

of how Reed's work contrasts with that of other influential biographers, not specifically with regard to the (non)existence of Faustina but rather with regard to the meaning of Italy for Goethe.

7. There is, of course, no shortage of quotes from the text to link Italy with Corinne and the feminine. As Prince Castel-Fortel remarks to Oswald, "We say to foreigners: 'Look at her, she is the image of our beautiful Italy.' We delight in gazing at her as a . . . harbinger of our future" (27). Showalter casts the novel along Bakhtinian terms to contend that "Italy argues with England, female genius with patriarchal duty" (192). In light of Bachmann's description of Italy in "The First-Born Land" as "naked and impoverished," this suggests that Italy's character results from a patriarchal oppression that descends from the north. The curious relationship between Goethe and de Staël is worth noting here. In that regard, see Behler.

8. That the spell of Goethe's Italy has never ceased enchanting subsequent generations of writers and scholars is evident from the surfeit of works in all genres and media that it continues to generate. In the past fifteen years alone, the *Goethe Jahrbuch* has devoted two volumes to the journey as well as numerous articles in other volumes. T. J. Reed recently translated into English for the first time Goethe's Italian diaries. In 2002, Norbert Miller, in a volume that exceeds 800 pages, coordinated Goethe's subsequent creative output with his experiences in Italy. Filmic references include the 1980s East German series, "Go Trabi, Go." Literary treatments include Josef Ortheil's 1988 *Faustinas Küsse* and Peter Hacks's *Ein Gespräch im Hause von Stein über den abwesenden Herrn von Goethe*. Equally significant is the 1988 reissue and translation into German of the Italian diaries of Goethe's father, Johann Caspar, by C. H. Beck.

9. It is not difficult to understand how such traces would, in turn, come to be identified with or attached to rumors of untoward dealings and behaviors. The discussion in Germany in the late 1990s of Goethe's homosexuality, prompted in part by Hugo Pruys, *Die Liebkosungen des Tigers*, is but one example.

10. "Vermittlung" or mediation is a term important to Goethe and familiar to Goethe scholars. I use instead "substitution" for two reasons. 1) The work of mediation generates its own text, which is the subject of this book. 2) Mediation suggests that there is something to be mediated. That is certainly what Goethe and Winckelmann believed, but the supersensible character of what could be mediated is, at the very least, impossible to document. Since the text that mediation generates is a textual byproduct, those who seek to discover its extratextual or extralinguistic essence will only pursue endless detours. Journeying to Italy, where one

NOTES TO INTRODUCTION

encounters Roman copies of Greek statues, is the detour Germans seeking to emulate Goethe pursue. What they encounter is thus a surrogate Goethe or his by-product. See Jaszi (121–26) for the significance of mediation in Goethe's work.

11. Since Goethe returns to Weimar to father German classicism, he could be said to be the father of the classical tradition inspired by the apparent rediscovery of the classical ideal in Italy.
12. Even the use of the singular is a form of concealment. Goethe did return to Italy, to Venice, and the salacious epigrams that were the fruits of the journey have often been purged from his works. The reasons for that are taken up in chapter 6. Since the second journey, as I argue, is a repressed subtext of the canonical one from 1786–1788, I will on occasion use the plural of "journey" to indicate this subtext.
13. The possible ontological priority of the copy over the original is uniquely worked out by Lacoue-Labarthe, *Typography*, 43–138. In this instance, Lacoue-Labarthe demonstrates how the "as such" character of the copy gives rise to Plato's forms and ideas without which the latter would not exist. Mimetic productions and facsimiles "disinstall the ideal," which, nonetheless, can only exist "as such," or as anything but ideal (79–80). The full importance of this theoretical argument for understanding Winckelmann's art history and his construction of Italy in that history is worked out in chapter 1.
14. See Aldrich 43–45.
15. In "Goethes letzte Nacht in Italien," George describes how Goethe sought to make off with the spirit of antiquity. He also describes it as a form of theft. That aspect of his journey is taken up in chapter 6.
16. In asserting the centrality of the Italian journey for Goethe, Reed finds his evidence not in the later documents but rather in the diary.
17. See the editor's discussion for the reasons for ordering the work in this manner (1:1, 751–53).
18. See the editor's discussion for the basis of presenting the works in this manner (2:2, 885–93).
19. See Nohl for a description of how Goethe's intimate circle in Rome, especially Moritz, reacted to the murders (38).
20. *HA* 11, Rome, 8 June 1787.
21. For an investigation of ghosts in the context of a German appropriation not of Italy but of England see Derrida, *Specters of Marx*. Derrida's entire project from its inception could be defined—and he himself did so—as a "hauntology" that shows the impossibility of all ontological projects to secure a meaning of being. The meaning of being, of meaning in general, is haunted. Just as Derrida shows that Marx's attempt to rid himself

of all ghosts founders, so too does Benjamin demonstrate how Goethe's attempt to overcome superstition founders ("Goethes Wahlverwandtschaften" 55–140). My argument follows Derrida's and Benjamin's hauntology into the origins of German high culture.

22. "Absent present" is a technical term used throughout this text. It specifically describes how that which is not there is present only in its effects. In other words, it lacks any essence that would link all these effects. My usage is indebted to that of Althusser. See my "Second Reads."

23. To speak of ghosts or invoke the language of ghosts to discuss the late eighteenth century is indicated by Weissberg's important study of Kant, Schiller, and Fichte, and the attempt to delimit philosophical and literary discourses. As she points out, Schiller and Kant, both of whom were important for Goethe after his return from Italy but before his publication of his *Italienische Reise,* are concerned with that which is independent of bodies or rather with the appearance of the disembodied (241). Philosophy, according to Weissberg, speaks of spirits (Geister) and literature of ghosts, "Gespenster" (240). Goethe, I argue, names those spirits so as to ghost or haunt via his absent presence Germans in Italy as well as the German cultural tradition.

24. Also see Brady 257–300.

25. Buchenwald, of course, is the concentration camp virtually located in Weimar. Goethe used to climb the Ettersberg and sit and work under a beech tree. This place was chosen by the Nazis for the concentration camp. The name was intended to obscure the relationship. In my reading, the circumstances of Nietzsche's return to Weimar return something of Goethe's legacy that finds its most grotesque expression in the choice of that site for Buchenwald.

26. The philological history of the epigrams is as complex as it is contradictory and unresolved. For example, many of the epigrams found in the Weimar edition of Goethe's works are excised quite literally with a knife from Goethe's original text. See Hexter as well as my discussion in chapter 6 of the importance of the philological debate in determining the "mythical" status of Italy in Goethe's work. Although the Italians did not fight with the Germans in World War I, they were officially still a part of the Triple Alliance until 1915. They refused to support Austria in its efforts, since the latter's efforts in the Balkans were not considered a defensive tactic by the Italians and thus not true to the letter of the Alliance. Already, by the 1880s, a tariff war with the French had weakened Italian resolve to remain a part of the Alliance. Nonetheless, at least one historian has called the official transference of Italian loyalty and military might to the Allies by 1915 a "defection." See Craig 236, 321.

27. For a discussion of how Goethe edited and redocumented his Italian journals for publication, see E. Schmidt. Schmidt describes Goethe's revisions as "nothing short of cruel" (xxiii). Also see Schulz 1–19.

Chapter 1

1. For a more recent account of Winckelmann's reception in Germany see Uhlig.
2. "Finden nur beide Bedürfnisse der Freundschaft und der Schönheit zugleich an einem Gegenstand Nahrung, so scheint das Glück und die Dankbarkeit des Menschen über alle Grenzen hinauszusteigen.... So finden wir Winckelmann oft in Verhältnis mit schönen Jünglingen, und niemals erscheint er belebter und liebenswürdiger als in solchen oft nur flüchtigen Augenblicken." For Goethe's response to Winckelmann's homosexuality see Kuzniar 10–12. For a contrasting argument that dismisses the significance of Winckelmann's homosexuality, see Sweet. See Gould for yet another take on Goethe's reception of Winckelmann's homosexuality; Gould argues that Goethe applauded Winckelmann's status as an outsider and wrote about the latter's death in a positive light.
3. "Da ferner die Menschliche Schönheit, zur Kenntniß, in einen allgemeinen Begriff zu fassen ist, so habe ich bemerket, daß diejenigen, welche nur allein auf Schönheiten des Weiblichen Geschlechts aufmerksam sind, und durch Schönheiten in unserem Geschlechte wenig, oder gar nicht, gerühret werden, die Empfindung des Schönen in der Kunst nicht leicht eingebohren, allgemein und lebhaft haben. Es wird dasselbe bey diesen in der Kunst der Griechen mangelhaft bleiben, da die größten Schönheiten derselben mehr von unserm, als von dem andern Geschlechte, sind."
4. See particularly the concluding section on painting in the *Gedancken*. "The first law directs the artists to allegory; the second to an imitation of the ancients, and the latter concerns primarily small ornamentation" (35).
5. For an examination of the repressive implications of Winckelmann's separation of the past from the present, see Parker.
6. My argument follows to some degree that of Ferris, who argues that Winckelmann posited an ideal only to render it absent so as to become an object of imitation and longing (16–52). In this regard Mayer is important insofar as he argues that Winckelmann's love of the past gave rise to a melancholic disposition in light of the Greeks' greater acceptance of male/male sexuality. The cleansing I describe would thus be, according to Mayer, a result of the inhibitions enforced upon him by

NOTES TO CHAPTER 1

eighteenth-century norms and by his own aesthetic sensibilities, thereby suggesting the impossibility of separating Winckelmann's life from his aesthetics.

7. "Living ray" comes from George's poem, "Goethes letzte Nacht in Italien." The full significance of this is discussed in chapter 6. For now it is sufficient to remark that the material remains of Goethe's journey are left behind, and he returns with only the "living ray" (1:402).

8. It is not insignificant that the language of Goethe's own Italian journey, and particularly that of the diary and his letters, echo the language of his Pietist youth, as Klaus Kiefer has shown. Something about the actual letter(s) that Italy inspires has to be redone or effaced, just as Goethe did in editing and smoothing out his account of Italy for publication in 1816.

9. One could enter into lengthy discussions of desire, the desiring of another's desire, and so on. Nonetheless, it is important to note that Goethe's inability to act on any desire for Charlotte von Stein, or perhaps his inability to arouse any desire other than a brotherly one, marks Weimar as a site that resists desire or as a station of resistance. That would help explain Lukács's assertions that Weimar frustrated the young Goethe's designs for change; they were, as he points out, stonewalled, which in turn implicates Frau von Stein, if not as a love interest than as an emblem of that stonewalling.

10. "[U]nd da die Freiheit in andern Staaten und Republiken nur ein Schatten ist gegen die in Rom, welches Dir vielleicht paradox scheint, so ist hier auch eine andere Art zu dencken. Aber Leute von der letzten Art mischen sich freilich mit Fremden, die insgeheim Rom durchlaufen."

11. Also see Potts's "Greek Sculpture and Roman Copies" for how customary it was for Winckelmann's contemporaries to view copies.

12. "[Wir haben], wie die Geliebte, gleichsam nur einen Schattenriß von dem Vorwurfe unserer Wünsche übrig; . . . und wir betrachten die Copien der Urbilder mit größerer Aufmerksamkeit, als wir in dem völligen Besitze von diesen würden gethan haben." Since the work underwent several revisions which cannot be ignored, two editions are used. Unless otherwise indicated, all references are to the first edition of 1764. The posthumous edition of 1776 is denoted by Vienna, its place of publication. In rare instances, the appropriate quotation could only be found in the collected works of 1811. Translations, unless otherwise noted, are mine. The full context of this seminal quote will be cited and discussed in greater detail below.

13. Bosshard notes how an avoidance of any limiting particulars is central to Winckelmann's notion of the ideal in art (76–81, 140–46). My argument pursues the manner in which particulars are overcome or signal

their own overcoming.
14. Obviously, the prints that Winckelmann included in the *Geschichte* are important for enabling the reader to maintain both proximity and distance to the objects discussed. See Osterkamp for a discussion of the principles, at times politically motivated, that guided Winckelmann's selection and placement of the illustrations.
15. D'Azara is a key player in the accepted history of the forgery. In the chapter "Memorie concernente la vita di Antonio Raffaello Mengs" he claims that on his deathbed Mengs confessed to him that he forged the Jupiter and Ganymede (lxxxix). Pelzel attempts to refute that claim and attributes all the forgeries to Giovani Casanova, brother of Jacopo. For a more biased account, see Justi (3:234–38, 370).
16. Winckelmann's reputation was certainly sullied by the affair, and his unwillingness to dismiss the painting as a forgery may have had something to do as well with a desire to insist upon the correctness of his judgment despite evidence to the contrary. For the damage done to his reputation as a result of the forgeries, see Hatfield 42–48.
17. Goethe weighed in as well on the controversy. In the *Italienische Reise* he remarks, "And now all contend against one another. The one maintains, it was lightly done as a joke by Mengs, the other party says that Mengs could never have done it, that it is indeed too beautiful for Mengs." He also mentions in a letter to Charlotte von Stein that he viewed the painting and has a "hypothesis" about its origins, which he never relates.
18. "Der Liebling des Jupiters ist ohne Zweifel eine der allerschönsten Figuren, die aus dem Alterthum übrig sind, und mit dem Gesichte desselben finde ich nichts zu vergleichen; es blühet so viel Wollust auf demselben, daß dessen ganzes Leben nichts als ein Kuß zu seyn scheint." Richter (*Laocoon's Body*) points out that in the letter to Baron von Stosch extolling the virtues of the painting Winckelmann uses the word "bardasse," which at the time meant catamite and thus suggested gender ambiguity. "The use of the word bardasse to designate Ganymede slices through Winckelmann's art historical discourse in such a manner as to connect it with the homoerotic underground of his time" (41). While not attempting to explain Winckelmann's aesthetics by referring to his biography, Richter points out that the Ganymede forgery marks the juncture between the two.
19. "Die reinsten Quellen der Kunst sind geöffnet. . . . Diese Quellen suchen heißt nach Athen reisen; und Dresden wird nunmehro Athen für Künstler."
20. "Da dieses [das höchste Schöne] aber gleichbedeutend ist mit der Vollkommenheit, für welche die Menschheit kein fähiges Gefäß sein kann,

NOTES TO CHAPTER 1

so bleibet unser Begriff von der allgemeinen Schönheit unbestimmt und bildet sich in uns durch einzelne Kenntnisse, die, wenn sie richtig sind, gesammelt und verbunden uns die höchste Idee Menschlicher Schönheit geben, welche wir erhöhen, je mehr wir uns über die Materie erheben können."

21. "Die Nachahmung des Schönen der Natur ist entweder auf einen einzelnen Vorwurf gerichtet, oder sie sammelt die Bemerkungen aus verschiedenen einzelnen, und bringet sie in eins. Jenes heißt eine ähnliche Copie, ein Porträt machen. . . . Dieses aber ist der Weg zum allgemeinen Schönen und zu idealischen Bildern desselben; und derselbe ist es, den die Griechen genommen haben."

22. The assertion is consistent with Winckelmann's plea in the *Gedancken*: "[The painter] should leave our mind with more than what he has shown our eye" (43). The dismal condition of contemporary painting was an inevitable result of the world the painter's eye was drawn to.

23. Justi suggests that Adam Friedrich Oeser helped supply Winckelmann with the details; see 1:474–81.

24. See the opening paragraph of the *Gedancken* (3). The significance of the sky under which the artists work is emphasized as well in the following sentence taken from the *Geschichte:* "In other parts, the sky did not allow the gentle feeling of pure beauty to come to fruition" (145).

25. See both Kunze and Fischer for the significance of symbol and allegory in Winckelmann's art theory.

26. See Benjamin, *Tragic Drama* 176.

27. "Scheinet es unbegreiflich, außer dem Haupte, in einem andern Theile des Körpers eine denkende Kraft zu zeigen, . . . es bilde mir der Rücken, welcher durch hohe Betrachtungen gekrümmt scheinet, ein Haupt, das mit einer frohen Erinnerung seiner erstaunten Thaten beschäftigt ist, und indem sich so ein Haupt voll von Majestät und Weisheit vor meinen Augen erhebet, so fangen sich an in meinen Gedancken die übrigen mangelhaften Glieder zu bilden; es sammelt sich ein Ausfluß aus dem Gegenwärtigen, und wirkt gleichsam eine plötzliche Ergänzung" (*Werke* 1:272).

28. "So wie in einer anhebenden Bewegung des Meeres die zuvor stille Fläche in einer neblichen Unruhe anwächset . . . , wo eine von der andern verschlungen, und aus derselben wiederum hervorgewältzet wird: eben so sanft ausgeschwellet und schwebend gezogen fließet hier eine Muskel in die andere" (*Werke* 1:272).

29. "Und eine dritte . . . verliert sich in jene, und unser Blick wird gleichsam mit verschlungen" (*Werke* 1:272).

30. "Eben so würksam muß sich auch der Himmel und die Luft bey den Griechen in ihrem Hervorbringen gezeiget haben, und diese Wirkung

NOTES TO CHAPTER 1

muß der vorzüglichen Lage des Landes gemäß seyn. Eine gemässigte Witterung regierte durch alle Jahreszeiten hindurch, und die kühlen Winde aus der See überstreichen die wollüstigen Inseln im ionischen Meere, und die Seegestade des festen Landes. . . . Unter einem so gemässigten, und zwischen Wärme und Kälte gleichsam abgewogenen Himmel spüret die Creatur einen gleich ausgetheilten Einfluss desselben." The quote is crucial to Szondi's argument about the aporia at the center of Winckelmann's work. See *Werke* 1:27–28.

31. "Der Einfluß des Himmels muß den Samen beleben, aus welchem die Kunst soll getrieben werden, und zu diesem Samen war Griechenland der auserwählete Boden; und das Talent zur Philosophie, welches Epicurus den Griechen allein beilegen wollen, könnte mit mehrem Rechte von der Kunst gelten." The male imagery or the reference to vivifying seeds is neutralized sentences later when Winckelmann notes how nature in ancient Greece, since it was not shrouded in fog, endowed the body with a more mature but "feminized" growth: "[I]t emerges in powerful but particularly feminine growths" (129). The significance of this de-gendering, as well as the use of "Gewächs," will be taken up below.

32. "Einer würde seiner Venus, wie ein neuerer namhafter Maler gethan, ein gewisses französisches Wesen geben; ein anderer würde ihr eine Habichtnase machen; . . . noch ein anderer würde ihr spitzige und spillenförmige Finger zeichnen. . . . [A]us jeder Figur würde man das Vaterland des Künstlers ohne Belesenheit errathen können."

33. Winckelmann's use of the word "sinnlicher" complicates any understanding of the project. It might better be said that the contemporary artist, by attending to the methods of the Greeks, renders more sensible or sensorial the fragmentation of his own era. The artistic or aesthetic transformation of one's own era is thus bringing out or to the surface the terminal decline and fragmentation of the present. It cannot be reduced to a mere imitating of the Greeks, unless, as I have suggested, fragmentation and decline become for Winckelmann the defining characteristics of the culture of the Greeks.

34. What I describe as overstatement resonates with Winckelmann's use of "Überdenkung" in the description of the Belvedere Torso and calls attention again to the manner in which his descriptions of art reflect on the performance of his own writing. In this regard see Ferris 5–6. For how Winckelmann's own descriptions are themselves overstatements and appeal to a camp sensibility, see Parker 530.

35. Also see Pfotenhauer, "Winckelmann's Gedanken."

36. Derks, in fact, points out how Winckelmann's early admirers never considered separating his life from his work (192).

37. Niobe's face, as well as those of her daughters, "[are] presented in a state

NOTES TO CHAPTER 1

of numbed and petrified feeling" (170). As Potts argues, her suffering "had reached such extremes that all traces of human feeling and inner resistance were blanked out" (*Flesh* 137).

38. It is worth remarking that until recently the Italian sketches and journals of Isolde Kurz and Fanny Lewald have received only scant attention. This suggests that Winckelmann's obliteration of the feminine extends to an attempt to silence the works of female voices or that the discourse that issues from his aesthetics cannot accommodate their perspectives. See Bäumer for a discussion of Lewald's travel writing in relationship to Goethe and the ways in which she tried to style herself as a female Goethe (137–57). Frederiksen provides a valuable examination of how women's travel writing differed from that of men and thus how it does not promote formations of a canon (147–65).

39. Richter is correct in asserting that Winckelmann's description is focused on the male body, not on the struggle with the snakes (*Laocoon's Body* 45). In the *Geschichte* Winckelmann mentions the snakebite but not the struggle with the snakes (170).

40. For a fuller and rather different account of the self-reflexive quality of the description, see Richter, *Laocoon's Body* 45.

41. "Das allgemeine vorzügliche Kennzeichen der griechischen Meisterstücke ist endlich eine edle Einfalt und eine stille Größe. . . . So wie die Tiefe des Meers allezeit ruhig bleibt, die Oberfläche mag noch so wüten, ebenso zeiget der Ausdruck in den Figuren der Griechen bey allen Leidenschaften eine grosse und gesetzte Seele.

"Diese Seele schildert sich in dem Gesichte des Laocoons, und nicht in dem Gesicht allein, bey dem heftigsten Leiden. Der Schmerz, welcher sich in allen Muskeln und Sehnen des Cörpers entdecket, und den man gantz allein, ohne das Gesicht und andere Theile zu betrachten, an dem schmertzlich eingezogenen Unter-Leib beynahe selbst zu empfinden glaubet; dieser Schmerz, sage ich, äussert sich dennoch mit keiner Wuth. . . . Der Schmerz des Cörpers und die Grösse der Seele sind durch den ganzen Bau der Figur mit gleichen Stärcke ausgetheilet, und gleichsam abgewogen. Laokoon leidet . . . , sein Elend gehet bis an die Seele, aber wir wünschten, wie dieser grosse Mann, das Elend ertragen zu können."

42. See Seeba for an important discussion of how Winckelmann's understanding of history prefigures speculative, antipositivist trends, especially in Herder.

43. "So wie eine Liebste an dem Ufer des Meeres ihrem abfahrenden Liebhaber, ohne Hoffnung, ihn wiederzusehen, und in den entfernten Segel das Bild des Geliebten zu sehen glaubet, . . . [w]ir haben, wie die Geliebte, gleichsam nur einen Schattenriß von dem Vorwurfe unserer Wünsche übrig, aber größere Sehnsucht nach dem Verlornen erweckt

derselbe, und wir betrachten die Copien der Urbilder mit größerer Aufmerksamkeit, als wir in dem völligen Besitze von diesen würden gethan haben. Es gehet uns hier vielmals, wie Leuten, die Gespenster kennen wollen, und zu sehen glauben, wo nichts ist: Der Name des Alterthums ist zum Vorurtheil geworden, aber auch dieses Vorurtheil ist nicht ohne Nutzen. Man stelle sich vor, viel zu finden, damit man viel suche. . . . [W]ir kehren jeden Stein um, und durch Schlüsse von vielen einzelnen gelangen wir wenigstens zu einer muthmaßlichen Versicherung, die lehrreicher werden kann, als die uns von den Alten hinterlassenen Nachrichten."

44. Davis characterizes the "affair" somewhat differently. Winckelmann's homoeroticism, according to Davis, accounts for a division in which the "art maiden" mourns her "lover," the "lost object" of her desire. That lost object is the ancient representation of beautiful young men. However, homoeroticism not only sponsors the division but also allows the art historian to "reconcile" and even overcome this difference (141).
45. The passage is not to be found in the first edition.
46. Potts is correct when he asserts that aside from the Niobe and the Laokoon, which "function less as examples of pure classic Greek sculpture than as vividly dramatized instances of a stylistic polarity . . . , all the other famous statues singled out by Winckelmann . . . are associated with the story of the decline of art in antiquity" (*Flesh* 61).
47. For a discussion of how Winckelmann's historiography is not as original as once thought and is dependent on those of his teachers and predecessors, see Thomas Kaufmann, "Before Winckelmann."
48. Sexual fulfillment, or a lack thereof, is something of course that cannot be documented. I merely refer to the unease Winckelmann may have felt about his homosexuality and his apparent need to project his desire onto artworks that were often copies of the real thing. See Mayer. Winckelmann's meager beginnings are obvious. What I mean by his aesthetic ambitions is, to put it simply, the impossibility of seeing the actual works or of living under a Greek sky.
49. See Grossman (221–22) and Aldrich (43–44). It is important to note, as Grossman does, that all the rumors surrounding Winckelmann's death are hard to substantiate. One can easily imagine as well how accounts by the Jesuits, for example, would negotiate Winckelmann's sexuality in ways consistent with their agenda.
50. Grossman points out that the murder weapons were purchased by Arcangeli a day before (219). Of course, such premeditation cannot be assigned to Winckelmann; it only suggests he was drawn in some fashion to one with homicidal tendencies.
51. The argument, of course, has many points of intersection with those

NOTES TO CHAPTER 1

Freud sought to develop in *Totem and Taboo*. Unlike the Freudian model, which privileges in Western cultures the internalization of the father's law within an economy of taboos, the extensive, rather than the intensive, character of Winckelmann's submission to the "father" or the law of the father is not so easily reduced to a pyschologism. In other words, Winckelmann was the victim of a father who was no longer there for ingestion. He was thereby forced to offer up himself instead. As I emphasize in the introduction, one can speculate about the relationship between his death and his aesthetics. And while it proves to be illuminating, it can only remain speculation.

52. The following argument, although it moves in a distinctly different direction, is indebted to Richter's research.
53. "Diese Aufmerksamkeit griechischer Künstler . . . blieb nicht auf die männliche und weibliche Jugend allein eingeschränkt, sondern ihre Betrachtung war auch gerichtet auf das Gewächs der Verschnittenen, zu welchen man wohlgebildete Knaben wählete. Diese zweydeutigen Schönheiten . . . wurden zuerst unter den asiatischen Völkern hervorgebracht, um dadurch den schnellen Lauf der flüchtigen Jugend, wie Petronius saget, einzuhalten; ja, unter den Griechen in Klein-Asien wurden dergleichen Knaben und Jünglinge dem Dienste der Cybele und der Diana zu Ephesus gewidmet."
54. "Das Gewächs der Verschnittenen ist in bisher unbekannten Figuren von Priestern der Sybele durch gedachte weibliche Hüften derselben angezeigt, und es ist diese Völligkeit der Hüften auch unter den Kleidern kenntlich an einer solchen Statue in der Größe eines Knabens von zwölf Jahren. . . . Die vielen Hermaphroditen in verschiedener Größe und Stellung zeigen, daß die Künstler sicher aus beiden Geschlechtern in vermischter Natur ein Bild hoher Schönheit auszudrücken gesucht haben, und dieses Bild war idealistisch."
55. In her discussion of Winckelmann's aesthetics, MacLeod notes how the "androgynous ideal of beauty is, from the outset, set apart from the natural world, above it, floating above time" (31). It thus marks the site of absence or of that which is "outside nature" (31). But by marking absence, it also transforms it.
56. It should be remarked that Winckelmann first viewed a Laokoon in very poor lighting in Dresden, perhaps only with the use of a flickering torch. Lessing's contention that the Laokoon is incapable of speaking is, in fact, the point to which Winckelmann would like to take his own argument or observations on the beautiful in art, but his own history of displacement renders that silence impossible by transferring those impossible cries onto other sites, such as the castrati or his own voice in writing about art.

NOTES TO CHAPTER 2

57. A new controversy is erupting over the Laocoon. As reported in the *New York Times,* April 18, 2005, Lynn Catterson, an art historian at Columbia University believes that the Laokoon unearthed in the sixteenth century by the Vatican is a forgery planted by Michelangelo. This again points to the concealed and troubled origins of the ideal artworks that shaped Winckelmann's aesthetics (Shattuck).

Chapter 2

1. Goethe, as we know, supposedly had his first sexual experience in Italy, with a figure known only as Faustina. As I argue in chapter 6, this passage into so-called manhood is questionable; there is no reliable evidence to support the presence of a real Faustina. An Italian journey or a Grand Tour was a ritual undertaken by noblemen, particularly in the eighteenth century, to complete their education. Since the journey could last up to eight years, it was clearly reserved for the wealthy. The trip was particularly popular among the English nobility. Part of finishing one's education evidently included losing one's virginity in Italy. It is also worth noting that Tischbein's famous portrait of Goethe is part of a particular genre. Those who returned from a Grand Tour tended to bring a similar portrait as a souvenir of their adventure. See De Seta for a comprehensive discussion of the significance of Grand Tours or Italian journeys from Montaigne to Goethe.
2. In describing the emergence of the detective novel, Nägele observes: "It is a common trait of literary fiction from the Enlightenment to Fontane's *Effie Briest* that the paternal authority enters the subject, if not literally as ghost, at least accompanied by mysterious, uncanny machineries and rituals" (14). Goethe's *Italian Journey* may not be fiction, but it charts the rituals and machineries by which the paternal ghost enters ever more conspicuously the German cultural tradition.
3. "Über das Tiroler Gebirg bin ich gleichsam weggeflogen. . . . Die Begierde, nach Rom zu kommen, war so groß, wuchs so sehr mit jedem Augenblicke, daß kein Bleiben mehr war, und ich mich nur drei Stunden in Florenz aufhielt." Translations are mine but rely as well on the Auden and Mayer translation.
4. "Denn es geht . . . ein neues Leben an, wenn man das Ganze mit Augen sieht, das man teilweise in- und auswendig kennt. . . . [E]s ist alles, wie ich mir's dachte, und alles neu. Ebenso kann ich von meinen Beobachtungen, von meinen Ideen sagen. Ich habe keinen ganz neuen Gedanken gehabt, nichts ganz fremd gefunden, aber die alten sind so bestimmt, so

lebendig, so zusammenhängend geworden, daß sie für neu gelten können."
5. "Einer der Hauptbeweggründe, die ich mir vorspiegelte, um nach Rom zu eilen, war das Fest Allerheiligen, der erste November; denn ich dachte, geschieht dem einzelnen Heiligen so viel Ehre, was wird es erst mit allen werden. Allein wie sehr betrog ich mich!"
6. "Da ich ihn aber vor dem Altare sich nur hin und her bewegen sah, . . . da regte sich die protestantische Erbsünde, und mir wollte das bekannte und gewohnte Meßopfer hier keineswegs gefallen."
7. See Brown for a discussion of Goethe's creative rebirth in Italy. See Nohl for a discussion of the huge circle of fellow Germans living in Rome.
8. See Zapperi for the manner in which Goethe's incognito allowed him to live a second or other existence.
9. Until his arrival in Rome Goethe traveled under the name of Jean Phillipe Möller, a merchant from Leipzig. This was not the first time he made use of a pseudonym, having previously traveled as the painter Weber. On the importance of preserving his incognito see Nohl 14–15. Others using pseudonyms included Giorgio Zicci instead of Georg Schütz, Federico Birr instead of Friedrich Bury, and Signor Tisben instead of Tischbein.
10. As I discuss in chapter 6, Goethe's second trip to Italy, to Venice, comes at the request of Duke Karl August. As a new father, Goethe was less than eager to revisit the land that he had once so reluctantly left. For more on his son's fate see chapter 6.
11. After sneaking off in the middle of the night for what would be a two-year stay in Italy, Goethe withheld knowledge of his whereabouts from his closest acquaintances, including Frau von Stein. See Boyle, *Goethe: The Poet* 439, for a discussion of her reaction to Goethe's secrecy.
12. Tischbein, of course, is noted for his famous painting of Goethe in Rome. See Maisak for a discussion of the friendship between the two (17–50).
13. See Hans Geller for a catalogue of the works of German artists living in Rome at that time, particularly 18–64.
14. "Am Morgen der Hinrichtung war der ganze Platz mit Zuschauern angefüllt. . . . [Der Deliquent] wurde gebracht, und sogleich in den schwarz ausgeschlagenen Torweg geführt. . . .

"Als er das Sakrament empfangen hatte, stieg er die Leiter hinauf, und sein Henker rief ihm noch einmal zu: 'credi tu in Jesu Christo?'; als er dies bejahet hatte, warf er ihn von der Leiter herunter und trat ihm dann auf die Schultern, um seinen Tod zu beschleunigen. Dann ließ er sich an dem toten Körper herunter, den . . . er umarmte und küßte, um dadurch

NOTES TO CHAPTER 2

Beweis zu geben, daß kein Haß gegen den Hingerichteten bei ihm obgewaltet habe.

"Der schöne Wuchs des Körpers wurde noch . . . von den Römern bewundert und sie riefen wiederholt aus: 'o che bel morto.'"

15. Goethe's emphasis on the execution of art is emphasized in many of his writings, and it appears frequently in his conversations with Eckermann (e.g., 14 May 1828). The use of execution in this context highlights the manner in which the violence of Winckelmann's aesthetics is echoed in the description of the public execution described by Moritz; the execution is applauded for its beauty. The term also emphasizes the need for something to be sacrificed in order to sustain the illusion of an ideal in art. As I argue later in the chapter, this is similar to how censorship produces its own object. The act or its execution is productive, the risks of which Goethe seeks to elide.

16. "Alsdann schien mir auch der Gegenstand des Selbstmordes ganz außer dem Kreise italienischer Begriffe zu liegen. Daß man andere totschlage, davon hätte ich fast Tag für Tag zu hören, daß man sich aber selbst das liebe Leben raube, oder es für möglich hielte, davon sei mir noch nichts vorgekommen."

17. "Ich bin im Land der Künste, laßt uns das Fach durcharbeiten, damit wir für unser übriges Leben Ruh' und Freude haben und an was anders gehen können."

18. "Ihr glaubt nicht, wie nützlich, aber auch wie schwer es mir war, dieses ganzes Jahr absolut unter fremden Menschen zu leben, besonders da Tischbein—dies sei unter uns gesagt—nicht so einschlug, wie ich hoffte."

19. "Nun wird es mir immer schwerer, von meinem Aufenthalte in Rom Rechenschaft zu geben: denn wie man die See immer tiefer findet, je weiter man hineingeht, so geht es auch mir in Betrachtung dieser Stadt."

20. "Wie will man sich aber, klein wie man ist und ans Kleine gewohnt, diesem Edlen, Ungeheuren, Gebildeten gleichstellen? Und wenn man es einigermaßen zurechtrücken möchte, so drängt sich abermals eine ungeheure Menge von allen Seiten zu, begegnet dir auf jedem Schritt, und jedes fordert für sich den Tribut der Aufmerksamkeit. Wie will man sich herausziehen? . . .

"Winckelmanns Kunstgeschichte, übersetzt von Fea, die neue Ausgabe, ist ein sehr brauchbares Werk, das ich gleich angeschafft habe und hier am Orte in guter, auslegender und belehrender Gesellschaft sehr nützlich finde."

21. "Was allen Fremden auffällt . . . sind die Totschläge, die gewöhnlich vorkommen. Viere sind schon in unserm Bezirk in diesen drei Wochen ermordet worden. Heute ward ein braver Künstler Schwendemann, ein

NOTES TO CHAPTER 2

Schweizer, . . . überfallen, völlig wie Winckelmann." See Pfotenhauer, "Der schöne Tod," for a rigorous reading of how a "beautiful death" shadowed Goethe in Italy (134–57). Breithaupt does not concern himself with Goethe's Italian journey, but he does demonstrate Goethe's awareness that images occluded possibilities of a different world or reality. According to this logic, learning to see in Italy would also mean awareness of something real lurking on the other side of what one sees. See especially 9–14.

22. Blättner, for example, offers a reading of Goethe's *Italian Journey* strictly in terms of "Bildung" (449–71).
23. "Wieviel tat Winckelmann nicht, und wieviel ließ er uns zu wünschen übrig! Mit Materialien, die er sich zueignete, hatte er so geschwind gebaut, um unter Dach zu kommen. Lebte er noch."
24. See Eisler 2:687–98, for a discussion of the role the father's death plays in enabling the son to travel to Italy.
25. Goethe insists that the Italian Goethe would be a better companion for Frau von Stein than the Weimar Goethe: "You will certainly rue that [Goethe], and this separation will offer you more than my presence often did" (*Goethes Briefe* 2, ed. Mandelkow, 18 September 1786). That the relationship between the two cooled upon his return is understandable, given the nature of his departure. See Boyle, *Goethe: The Poet* 471. An aspect of that cooling off, however, may have been that the more likable Italian Goethe never truly returned to Weimar. Also see Bennett, *Goethe as Woman*, for a different tack of tracking a "second" Goethe. Bennett argues that Goethe, having recognized the political cooption of literature in the classical age, set out to develop an "invisible school" of thinkers to combat that tendency. In other words, his work invites readers to seek out a second Goethe, what he refers to as Goethe as woman, in order to discourage appropriation of literature and render the writing of the "second" Goethe unreadable.
26. "Die Gunst der Musen wie die der Dämonen besucht uns nicht immer zur rechten Zeit. Heute ward ich aufgeregt, etwas auszubilden, was gar nicht an der Zeit ist. Dem Mittelpunkte des Katholizismus mich nähernd, von Katholiken umgeben . . . trat mir so lebhaft vor die Seele, daß vom ursprünglichen Christentum alle Spur verloschen ist; ja, wenn ich mir es in seiner Reinheit vergegenwärtigte, so wie wir es in der Apostelgeschichte sehen, so mußte mir schaudern, was nun auf jenen gemütlichen Anfängen ein unförmliches, ja barockes Heidentum lastet."
27. As Adorno remarks, "Goethe speaks of [the power of the mythic] as the web of guilt in which the living are entangled, as fate. Myth in this sense, a present-day, pre-historical world, is present throughout the whole of Goethe's oeuvre" (2:154). In this respect, his Italian journey may be less

liberating than assumed.
28. "Da fiel mir der ewige Jude wieder ein, der Zeuge aller dieser wundersamen Ent- und Aufwicklungen gewesen und so einen wunderlichen Zustand erlebte, daß Christus selbst, als er zurückkommt, um sich nach den Früchten seiner Lehre umzusehen, in Gefahr gerät, zum zweitenmal gekreuzigt zu werden. Jene Legende: 'Venio iterum crucifigi' sollte mir bei dieser Katastrophe zum Stoff dienen."
29. The use of terms such as the "devil" and "sorcery" in relationship to copies and doubles is not without precedent, especially since Plato. Recently, it has been worked out in Baudrillard, most notably in *Simulations*. In the first note to the text, he writes, "Counterfeit and reproduction . . . [are] like a witch's trick. . . . There is always sorcery at work in the mirror. But how much more so when this image can be detached from the mirror, transported, stocked, reproduced at will" (153). The talk here is not of mirrors, but rather of copies and substitutes that can stand in for absence. In the case of Goethe a second self, or the projection of a second self, performs the work of the mirror image.
30. In this context, Faust's apparent reciting of that phrase at the end of the second part is conveniently couched in the subjunctive: "Zum Augenblicke dürft' ich sagen: Verweile doch, du bist so schön! (To the moment should I say: Stay a while, you are so lovely!)" (*HA* 3:348). See von Molnár, 89–100, for an alternative reading of the bet.
31. "Damit es mir denn aber doch mit meinem beliebten Inkognito nicht wie dem Vogel Strauß ergehe, der sich für versteckt hält, wenn er den Kopf verbirgt, so gebe ich auf gewisse Weise nach, meine alte These immerfort behauptend."
32. The second Roman visit is organized differently from the first. A retrospective or report follows the entries for each month. The second part was also not published until 1829. Goethe destroyed the letters that formed the basis for this section as well as most of those for the parts on Sicily and Naples (*HA* 11:576–80). The dual structure of the second visit suggests an attempt to have a perspective separate from those of the journeyer. But the textual history of this part of his journal indicates that both perspectives are part of a calculation. Rüdiger offers an analysis of the second Roman visit as a melodramatic novella with respect to the Milanese woman (97–114).
33. "Vater, den ich nicht kenne! Vater, der sonst, meine ganze Seele füllte, . . . riefe mich zu dir! Schweige nicht länger! Dein Schweigen wird diese düsternde Seele nicht aufhalten—und würde ein Mensch, ein Vater, zürnen können, dem sein unvermutet rückkehrender Sohn um den Hals fiele und rufe: 'Ich bin wieder da, mein Vater!'"
34. Norbert Miller argues that Goethe's arrival in Rome was marked by a

NOTES TO CHAPTER 2

measure of disappointment since his initial impressions were at odds with expectations he had been cultivating since childhood—a disappointment heightened by the celebration commemorating All Saints Day (118).

35. See Kaplan for a discussion of how travel narratives engender identity (143–87).
36. Terminology such as "sorcery" is not intended to be provocative or flip; it is indicated by Mann's "Mario and the Magician," which I take up in chapter 6. And certainly in Mann's other works, creative accomplishment requires some form of a pact with the devil.
37. Haarhaus's three-volume work, *Auf Goethes Spuren in Italien*, is but one example of the considerable labor dedicated to tracking Goethe in Italy. Also see Brandeis's "Auf Goethes Spuren von Verona bis Rom" 38–43 and 49–54.
38. The most notable attempt to deify Goethe is Gundolf's *Goethe*, in which Goethe's works are read as symbols referring to the author's genius.
39. "Alle Tage ein neuer merkwürdiger Gegenstand, täglich frische, große, seltsame Bilder und ein Ganzes, das man sich lange denkt und träumt, nie mit der Einbildungskraft erreicht."
40. My definition of pure seeing is at odds with how Goethe's is usually understood. Typically, it has gone hand in hand with a sense of concreteness and presence. But as Lange argues, such presence is quite mediated, and pure seeing is thus only apparently so; mediation precedes the possibility of immediacy (147–58).
41. See Derrida, *Of Grammatology*, particularly those sections concerned with the supplement, 141–56 and 313–16.
42. "Der schöne Schein" or "the beautiful appearance" as an essential category of German classical aesthetics finds its most extended expression in Schiller's *Aesthetic Letters*. But the aesthetic character of the "Schein" is a product of a mode of perception, of an eye trained to perceive the aesthetic. Weissberg's analysis of Schiller's language, what she calls "Geistersprache," is even more to the point. "Delusion, transformed into semblance, is in the final analysis something positive; it is the sign of art, the goal and presupposition of the new man" (240). In this context, Goethe would be that new man, unachievable by any other.
43. The connection between science and autobiography is evident from the manner in which Goethe incorporates personal reminiscences into his scientific writings. For example, "Zur Morphologie" includes a personal reference to his Italian journey. On the inseparability of the two and the manner in which the *Italienische Reise* originates from the third part of the *Farbenlehre*, see Boyle, "Geschichtsschreibung" 162–71.
44. See Barner for Goethe's notion of entelechy with respect to Roman ruins (76–91).

NOTES TO CHAPTER 2

45. "Und wie man sagt, daß einer, dem ein Gespenst erschienen, nicht wieder froh wird, so konnte man umgekehrt von ihm sagen, daß [mein Vater] nie ganz unglücklich werden konnte, weil er sich immer wieder nach Neapal dachte."
46. "Es ist freilich unverantwortlich, daß man diesen Schatz so nahe bei Rom hat und denselben nicht öfter besucht. Doch mag die Unbequemlichkeit einer jeden Ausflucht in diesen Gegenden und die Gewalt des römischen Zauberkreises zur Entschuldigung dienen."
47. "Dergleichen Träume schweben mir vor. Denn aus Ungeduld, weiter zu kommen, schlafe ich angekleidet und weiß nichts Hübscheres, als . . . die ersten besten Phantasiebilder nach Belieben walten zu lassen."
48. Goethe's letter from Verona and Venice did not contain any mention of his whereabouts. See Trunz, *HA* 11:584, 598, 607, and 614.
49. " . . . was soll ich mir nachher wünschen? ich wüßte nichts, als daß ich mit meinem Fasenkahn glücklich zu Hause landen und meine Freunde gesund, froh und wohlwollend antreffen möge."
50. Adorno also emphasizes the importance of forgetting for Goethe. He argues that Faust wins his bet with Mephistopheles since "in extreme old age he . . . is no longer the person who signed the pact." He adds that "perhaps the wisdom of the play, which is a play in pieces, . . . lies in knowing how little the human being is identical to himself, how light and tiny this 'immortal part' of him is that is carried off as though it were nothing. The power of life . . . is equated with forgetting. It is only in being forgotten and thereby transformed that anything survives at all" (1:111–20).
51. I am obviously manipulating Deleuze's notion of difference and repetition. Most helpful is his discussion of repetition for itself in chapter 2. As he remarks, "the paradox of time [is] to constitute time while passing in the time constituted" (79). This is consistent with my reading of Böhme's analysis of Goethe's experience of time insofar as it presumes an experience of the self in two times or as two times.
52. The urgency of Bachmann's poem is in evidence here. Goethe's lyrical "I" gives birth to the feminine through self-censorship; it is something of an illusion. Instead, Bachmann would like to pronounce the priority of the feminine.
53. Just how much Goethe's timing has improved between visits to Rome is indicated by the entry of 26 May 1787 from Naples, approximately a month before his rebaptism in Rome. In contrast to his first arrival in Rome, Goethe celebrates "with devotion and joy" the feast of his favorite saint and applauds the fact that there are so many saints.
54. Culler's reading of Keats's "This Living Hand" informs my reading. Both poems are an experience of what he calls "apostrophic time" (152).

"The narrator contrasts his life with his death, proleptically predicting that when he is dead the reader will seek to overcome his death . . . by an imaginative act," thus recalling Goethe's use of a future preterit. He continues, "We fulfill this icy prediction . . . by losing our empirical lives . . . in which we can believe that the hand is really present and perpetually held toward us through the poem" (154). By reading Goethe's poem, which the hand of truth has gifted him, we confirm the presence of the absent hand. As Culler concludes, "it knows its apostrophic time and the indirectly invoked presence to be a fiction and says so but enforces it as event" (154).

Chapter 3

1. See Atkins for a discussion of the pagan and Winckelmannian roots of Goethe's Italian journey (81–96).
2. "Besonders liest sich Geschichte von hier aus ganz anders als an jedem Orte der Welt. Anderswärt liest man von außen hinein, hier glaubt man, von innen hinaus zu lessen, es lagert sich alles um uns hier und geht weiter aus von uns."
3. The difference between my argument and the psychoanalytic one, as well as with that of Harold Bloom, will become clear below.
4. "So ist denn ein ausschweifendes Fest wie ein Traum, wie ein Märchen vorüber, und es bleibt dem Teilnehmer vielleicht weniger davon in der Seele zurück als unsern Lesern, vor deren Einbildungskraft und Verstand wir das Ganze in seinem Zusammenhange gebracht haben."
5. " . . . so bemerken wir, . . . daß Freiheit und Gleichheit nur in dem Taumel des Wahnsinns genossen werden können, und daß die größte Lust nur dann am höchsten reizt, wenn sie sich ganze nahe an die Gefahr drängt und lüstern ängstlich-süße Empfindungen in ihrer Nähe genießet."
6. In his "Attempt at a German Prosody," Moritz seeks to discover "Längen" and "Kürzen" and not simply "Höhen" and "Tiefe" in the German language. He tries to shift the emphasis from emotional immediacy and meaning to rhythm and the quantitative aspects of language (3:473).
7. "[Geburt] sei der Akt wenn der gleiche Körper sich vom gleichen absondert. Den abgesonderten Körper nennen wir in dem ersten Augenblicke, da wir ihn abgesondert gewahr werden, die Geburt." The botanical notes that Goethe compiled in Italy served as the basis for his "Metamorphosen der Planzen," which was published in 1790. As Brady has pointed out, once Goethe returned to Weimar, the notion of a primal plant as an ancestral form became "something abstracted from empirical

NOTES TO CHAPTER 3

particulars" (268–69). As I show below, the metamorphosis in Goethe's own thought about the primal plant is a direct result of the apparitional form that it was in fact from the beginning.

8. In his essay on Goethe's "Über Granit," Fink argues that Goethe's science is a search for borders and transitions (16). I am interested in the manner in which those thresholds of change become petrified like granite.
9. Brydone's "Reise durch Sizilien und Malta in Briefe an William Beckford" appeared in German in 1774. The Cavaliere Gioeni warned Goethe the day before their ascent of the dangers faced by Brydone.
10. The late nineteenth century inspired volumes of speculation about their relationship. See Möbius and Ewart.
11. All critics agree that the Italian of the father's diaries, which was written with the aid of an Italian tutor, Domenico Giovanazzi, was labored and anything but idiomatic. See the Farinelli introduction to the father's diaries.
12. See Glaser for a evidence of the father's unbounded admiration for Tasso (63).
13. See Kraft for additional details about the life of the Milanese woman (75–86).
14. "'Es wäre wunderbar genug,' rief ich aus, 'wenn ein wertherähnliches Schicksal dich in Rom aufgesucht hätte, um dir so bedeutende, bisher wohlbewahrte Zustände zu verderben.'

"Ich wendete mich abermals rasch zu der inzwischen nachgelässigten, landschaftlichen Natur und suchte sie so treu als möglich nachzubilden, mehr aber gelang mir, sie besser zu sehen."
15. "[I]ch [sehe] nun die Gegenstände in der Natur . . . von denen ich den Vater so oft erzählen hörte. . . . Alle diese Dinge sehe ich freilich ein wenig späte."
16. "Ich muß nur den Dolmetscher machen, denn ich sehe, meine junge Freundin kommt nicht dazu auszusprechen, was sie so lange gewünscht, . . . wie sehr sie Ihnen verpflichtet ist für den Anteil, den Sie an ihrer Krankheit, ihrem Schicksal genommen."
17. "'Das ist alles wahr,' sagte sie, indem sie über die Freundin her mir die Hand reichte, die ich wohl mit der meinigen, aber nicht mit meinen Lippen berühren konnte."
18. "Dieses kulinarische Abenteuer gab mir Anlaß, in stillem Humor zu bedenken, daß ich selbst, von einem ganz eigenen Gifte angesteckt, in Verdacht gekommen sei, durch gleiche Unvorsichtigkeit eine ganze Gesellschaft zu vergiften."
19. I am naturally playing with Derrida's concept of the gift as poison. *Disseminations* 65–172.

20. As I argue in chapter 5, Rome is a locus of the unconscious for Freud, particularly in the *Interpretation of Dreams* and *Civilization and Its Discontents.*
21. "Da ich neuerdings nur die Sachen und nicht wie sonst bei und mit den Sachen sehe, was nicht da ist, so müssen mir so große Schauspiele kommen, wenn ich mich freuen soll."
22. "In vierzehn Tagen muß sich's entscheiden, ob ich nach Sizilien gehe. Noch nie bin ich so sonderbar in einem Entschluß hin und her gebogen worden. Heute kommt etwas, das mir die Reise anrät, morgen ein Umstand, der sie abrät. Es streiten sich zwei Geister um mich."
23. The description comes from Goethe's "Confessions of the Author" appended to the *Farbenlehre* (*HA* 14:251–52). Also see Barnouw, *Goethe* 45–82.
24. The primal plant as an emblem of cutting off is easily related to the notion of "Gewächs," as discussed in chapter 1. Of course the term can also apply to the growth or offspring of a plant.
25. Duden confirms that by the middle of the eighteenth century "bescheren" had come to be associated with the dispensation of gifts at Christmas. See Freschi for a detailed account of Goethe's representations of Cagliostro.
26. In 1792 Goethe published in the *Weimar Freitagsgesellschaft* an essay about the incident, which included the family tree (*HA* 11:650).
27. The play first appeared in 1791, although it was planned as an opera buffa in 1787. The germination of the play might thus have prompted Goethe's visit as well, although the visit does not appear to have noticeably influenced the play. Schiller's *Der Geisterseher* appeared in *Thalia* in 1787 and was apparently inspired in part by Elisa von der Reckes's *Nachricht von des berüchtigten Cagliostro Aufenthalt in Mitau* (1786). As Weissberg points out, it articulates the problem Schiller sought to solve with *The Aesthetic Letters,* namely how cultivation of an aesthetic sensibility for the beautiful could prevent one from succumbing to bald deception (156–60). As Goethe's impersonation of a confidant of Cagliostro indicates, the ability for delusion to maintain its appearance as something it is not signals Italy's transformative abilities. Like the family that is duped in this instance, one should see Goethe but also not see him. "Geisterseher" should be affirmed in their delusions.
28. "Die eigne Zierlichkeit der italienischen Sprache begüngstigte die Wahl und die edle Stellung dieser Worte, welche noch überdies von lebhaften Gebärden begleitet wurden, womit jene Nation über ihre Äußerungen einen unglaublichen Reiz zu verbreiten gewohnt ist."
29. " . . . allein als ich zu Hause meine Rechnung machte, . . . sah ich wohl, daß in einem Lande, wo durch den Mangel von Kommunikation die

Entfernung gleichsam ins Unendliche wächst, ich mich selbst in Verlegenheit setzen würde, wenn ich mir anmaßte, die Unrechtigkeit eines frechen Menschen . . . zu verbessern."
30. "Daß ich zeichne und die Kunst studiere, hilft dem Dichtungsvermögen auf, statt es zu hindern; denn schreiben muß man wenig, zeichnen viel."
31. For an extended discussion of Goethe's so-called secret encounters in Sicily, see Cometa.
32. In fact, one can note today Goethe's presence in Palermo. As Jane Brown has informed me, a plaque in both Italian and German denotes his stay there.
33. See Sprengel (158–79) for the mythical character Sicily assumes in Goethe's account of his Italian journey.
34. "Es ist ein wahres Unglück, wenn man von vielerlei Geistern verfolgt wird und versucht wird! Heute früh ging ich mit dem festen, ruhigen Vorsatz, meine dichterischen Träume fortzusetzen . . . , allein eh' ich mich's versah, erhaschte mich ein anderes Gespenst, das mir schon diese Tage nachgeschlichen. . . .

"Im Angesicht so vielerlei neuen und erneuten Gebildes fiel mir die alte Grille ein, ob ich unter dieser Schar die Urpflanze entedecken könnte.

"Ich bemühte mich zu untersuchen, worin denn die vielen abweichenden Gestalten voneinander unterschieden seien. Und ich fand sie immer mehr ähnlich als verschieden. . . . Warum sind wir Neueren doch so zerstreut, warum gereizt zu Forderungen, die wir nicht erreichen noch erfüllen können!"
35. See Sprengel (596) for a discussion of Moritz's ailment or damaged psyche and the reason for his flight to Italy. See Richter for the manner in which Goethe victimizes Moritz, *Laocoon's Body* 131–62.
36. "Mit Moritz hab' ich recht gute Stunden, und habe angefangen, ihm mein Pflanzsystem zu erklären, und jedesmal in seiner Gegenwart aufzuschreiben, wie weit wir gekommen sind. Auf diese Art konnt' ich allein etwas von meinen Gedanken zu Papier bringen."
37. Shell demonstrates in his reading of *Faust* that the "linguistic transfer of meaning" is simultaneous with "the economic transference of property." The business Goethe learned to transact in Italy is repeated in Faust, if we read with Shell. "Mephistopheles can receive the mortgaged soul of Faust no more than the people of the Empire, former believers (Gläubiger) who have become creditors, could amortize their money" (126). Likewise, Goethe's creditors may lay claim to the primal plant, but it will be as undeliverable as Faust's soul. Its "hypothecated" presence only serves to empower its author or borrower.
38. The phrase is taken from Kittler; he uses it to describe the reading and

writing network that enshrined the profession of author around 1800 (1–70).
39. Northcutt demonstrates how Goethe's negotiations with his publishers altered the author's role. I argue from the opposite perspective: how Goethe becomes the indelible effect of the emerging book trade and its discourse network.
40. The first part of the trilogy, "An Werther," speaks of this untimeliness. "Noch einmal wagst du, vielbeweinter Schatten / Hervor dich an das Tageslicht. . . . Doch erst zu früh und dann zu spät gewarnt (So once again, much lamented shadow, you venture into the light of day. . . . Warned first too soon and then too late)" (*HA* 1:381–82). The entire poem is untimely. The first part was written last; the third part, first (*HA* 1:701–3).

Chapter 4

1. As Berghahn and Hermand note, there is nothing new to be discovered under the topic of "Goethe and the Jews," so they transform that topic into "The German Jews and Goethe" (x). Nowhere, however, do they seek to understand that relationship in terms of what must be considered a German rite of passage, the Italian journey.
2. Immermann, whose defense Heine sought to aid in assuming the offensive against Platen, was quite unenthusiastic about "The Baths of Lucca" (Werner 1:187–91), as was Heine's friend Moses Moser who, as a result, broke off all relationships with Heine (*Briefe*, 1 February 1830 and 28 February 1830).
3. "[E]s zöge mich wieder nach Italien, ich hätte zuletzt wieder alle Liebeskraft vergeblich vergeudet. . . . [M]ein Herz sey jetzt leer, mein Kopf dumm und nur die Nase noch voll von Orangenduft."
4. France is evidently where Heine learned to see, a country of which Goethe, as we know, was hardly fond (Hohendahl, "Emblematic," 12–15).
5. "In Deutschland ist es unmöglich. . . . Aber in der That, wo soll ich hin?" Wieder nach Süden? Nach dem Lande, wo die Zitronen blühen und die Goldorangen? Ach! Vor jedem Zitronenbaum steht dort ein österreichische Schildwache und donnert dir ein schreckliches Werda entgegen! Wie die Zitronen so sind auch die Goldorangen jetzt sehr sauer."
6. See Geller ("Aromatics") for how Jewish identity came to be constructed around an "olfactory heuristic" that associated a stench with the Jew. "The smelly Jew was also a common figure in German literature" (223). Geller notes on Heine appropriating this stereotype. His Italian journey

is an effort to sniff out his Jewishness—why else seek a position with the University of Munich—by sniffing along Goethe's trails.
7. See Prawer 130–51.
8. Heine's polemic with Platen has been the subject of volumes of critical literature. Three of the best treatments are Mayr 151–60; Holub, "Heine's Sexual Assaults" 415–27; and Teuchert 31–41.
9. "Knoblauchfresser" or garlic guzzler was invoked by Platen to parody the offensive quality of the Jewish mouth. Platen, *Werke* 1:170–79.
10. In 1905, August Forel, professor of psychiatry at Zurich and author of the widely read *The Sexual Question,* summarized Heine's reception and the view that there was something unseemly about his work. He observed: "If we compare Heine with Maupassant, I think that we must admit that, in spite of the refinement of his art, the pornographic trait is comparably stronger in the former, because Heine continually loses the thread of the moral issue which impregnates most of the works of Maupassant" (494). Also see Gilman, *The Jew's Body* 151.
11. Since 1831 the Prussian government had deemed Heine's work "most reprehensible" (*HK* 7, 2:854). Heine's attacks against the Restoration, most notably in chapters added to *The City of Lucca* and *English Fragments,* occasioned the decree.
12. Also see Ziegler, 16. Heine was incensed that, without his approval, his publisher Campe submitted his manuscript to the commission on censorship. The text was not long enough to bring it beyond the necessary twenty signatures and thus required prefaces. Heine used the preface to attack Wolfgang Menzel, whose conservative, anti-Semitic turn added to the travails of "The Young Germany." Heine also used the preface to declare that anti-French nationalism was orchestrated to legitimate repression in Prussia. The preface was censored, although Heine published it separately and continued to insist that the work and its preface were harmless. The text thus needs to be read as an expression of Heine's conflicted desire to clear the censors but also to pursue political aims. Also see Grözinger for a discussion of the text in terms of Heine's Saint Simonistian sympathies (65–76).
13. In *Black Holes,* Miller and Asensi perform what they call a "boustrophedonic reading," in which the texts by the two authors are on opposing pages, forcing the reader to start from the left and then from the right. The effect, of course, carries over to the content. As Miller writes, "the word means turning back and forth, like an ox" (ix). The word comes from the Greek "bous," meaning ox and "strophe" meaning to turn.
14. "In diesen Marmor ist das ganze Traumreich gebannt mit allen seinen stillen Seeligkeiten, eine zärtliche Ruhe wohnt in diesen schönen Gliedern. . . . O, wie gerne möchte ich schlafen des ewigen Schlafes in

den Armen dieser Nacht."
15. See Pongs 153–63 and Sandor 101–20 for the conflict in Heine's work between a reception of antiquity and a progressive political sentiment. The most extensive and perhaps most sophisticated treatment of the topic is to be found in Holub's book-length study, *Heinrich Heine's Reception of German Grecophilia*.
16. In *Die Romantische Schule* Heine explicitly links Romanticism, ultramontanism, and oppression. This text reverses the chronology and suggests that the conversion or the return of late Romantics to Catholicism is an underdeveloped sentiment for a tradition introduced by Winckelmann.
17. "In diesem Augenblick erschien mir Bellini wie berührt von einem Zauberstäbchen, wie umgewandelt zu einer durchaus befreundeten Erscheinung, und er wurde meinem Herzen auf einmal verwandt.... [E]s war vielleicht der blühendste Moment seines Lebens"
18. "Ja, Holz, Eisen und Messing schienen dort den Geist des Menschen usurpirt zu haben ... während der entgeistete Mensch, als ein hohles Gespenst, ganz maschinenmäßig seine Gewohnheitsgeschäfte verrichtet."
19. Manfred Schneider attempts to work through this apparent ambivalence in his discussion of what he calls the sick but beautiful soul of revolution (27–86).
20. The link between castration and circumcision is also taken up by Freud in *Totem and Taboo*. In primitive societies, according to Freud, circumcision was performed at a later age and was equated with castration (*SE* 13:153).
21. Heine is baptized nearly three years before he departs for Italy. The moniker is invoked to define him as the outsider who seeks to invade the select circle of the cultural elite. August von Platen's use of the epithet, without actual knowledge of Heine's baptism, is an indication of its use in a campaign to ferret out those who might contaminate the culture (Sammons 144). For a discussion of Heine's disappointment over the failure of his baptism to open previously shut doors, see Prawer 33–37. Telling in this regard is a letter to Moses Moser, 19 December 1825: "I am sure that if the laws had allowed the stealing of silver spoons, I would not have had myself baptized." Any parody of the parvenu is thus in some measure self-parody.
22. As is well known, Heine was dependent on his Uncle Salomon for financial support. The relationship was strained—each ambivalent about the other's occupation. For a short portrait of Salomon Heine, see Lüth.
23. Heine's uncle had provided him with a letter of credit for his trip to England. The letter was intended for purposes of identification and a means of introduction. Heine presented the letter to Nathan Rothschild and

cashed it. These funds also helped finance his trip to Italy (Sammons 129–30).
24. "Ich sehe Italien, aber ich höre es nicht. Dennoch bin ich oft nicht ganz ohne Unterhalthung. Hier sprechen die Steine, und ich verstehe ihre stumme Sprache."
25. "Auch sie scheinen tief zu fühlen, was ich denke. So eine abgebrochene Säule aus der Römerzeit, so ein zerbröckelter Longobardenthurm, so ein verwittertes gothisches Pfeilerstück versteht mich recht gut. Bin ich doch selbst eine Ruine, die unter Ruinen wandelt."
26. "In Genua hat ein Schurke bey der Madonna geschworen, mich zu erstechen, die Polizey sogar sagte mir, solche Leute hielten gewissenhaft ihr Wort, und rieth mir, gleich abzureisen[.]"
27. Heine's relationship to Goethe is by no means univocal. Often the Heine of poetic sensibilities is regarded as having a desire to be Goethe (Hohendahl and Gilman 1–10). There is likewise no doubt that Heine found Goethe's work repellent and delighted in mocking him. Amusing in this regard is a letter of 25 October 1824 to Moser following a visit to Weimar: "There is also a roast goose there," by which he means Goethe. See Mende 343–54 and Nölke 82–98 for more detailed accounts of Heine's relationship to Goethe and the Goetheana.
28. "Ich aber nahm das neue Athen sehr in Schutz.... Berlin ist gar keine Stadt, sondern Berlin giebt bloß den Ort dazu her, wo sich eine Menge Menschen, und zwar darunter viele Menschen von Geist, versammeln, denen der Ort ganz gleichgültig ist; diese bilden das geistige Berlin. Der durchreisende Fremde sieht nur die langgestreckten, uniformen Häuser, die langen breiten Straßen, die . . . keine Kunde geben von der Denkweise der Menge. Nur Sonntagskinder vermögen etwas von der Privatgesinnung der Einwohner zu errathen, wenn sie die langen Häuserreihen betrachten, die sich, wie die Menschen selbst, von einander fern zu halten streben.... Hier ist es schwer, Geister zu sehen. Die Stadt enthält so wenig Alterthümlichkeit, und ist so neu; und doch ist dieses Neue schon so alt, so welk und abgestorben."
29. Examples of how the original text was reworked to be more offensive or suggestive include the following: "Dame" becomes "already deceased . . . Dame," and "loved" becomes "loved and kissed brown. I love overripe necks in which you find purple little points as if lecherous birds had picked at it" (*HK* 7:2: 595).
30. "'Es ist alles noch im Entstehen und wir sind noch nicht komplett. Nur die untersten Fächer, lieber Freund, fügte ich hinzu, sind erst besetzt, und es wird Ihnen nicht entgangen seyn, daß wir z.b. an Eulen, Sykophanten und Phyrnen keinen Mangel haben. . . . Wir haben nur einen großen Redner, aber ich bin überzeugt, daß Demosthenes über den

NOTES TO CHAPTER 4

Malzaufschlag in Attika nicht so gut donnern konnte. Wenn wir noch keinen Sokrates vergiftet haben, so war es wahrhaftig nicht das Gift, welches uns dazu fehlte.'"

31. "Freylich, um die heutige italienische Musik zu lieben . . . , muß man das Volk selbst vor Augen haben, . . . seine ganze Geschichte, von Romulus, der das heilige römische Reich gestiftet, bis auf die neueste Zeit, wo es zu Grunde ging, unter Romulus Augustulus II."

32. "Dem armen geknechteten Italien ist ja das Sprechen verboten, und es darf nur durch die Musik die Gefühle seines Herzens kund geben. All sein Groll gegen fremde Herrschaft, seine Begeisterung für die Freyheit, sein Wahnsinn über das Gefühl der Ohnmacht, seine Wehmuth bey den Erinnerungen an vergangene Herrlichkeit, . . . alles dieses verkappt sich in jene Melodien."

33. "Alles deutet dahin, daß ein glückliches, die ersten Bedürfnisse reichlich anbietendes Land auch Menschen von glücklichem Naturell erzeugt, die ohne Kümmernis erwarten können, der morgende Tag werde bringen, was der heutige gebracht, und deshalb sorgenlos dahin leben."

34. "Das ganze italienische Volk ist innerlich krank. . . .

"Der leidende Gesichtsausdruck wird bey den Italienern am sichtbarsten, wenn man mit ihnen vom Unglück ihres Vaterlandes spricht, dazu giebts in Mayland genug Gelegenheit. Das ist die schmerzlichste Wunde in der Brust der Italiener, und sie zucken zusammen, sobald man diese nur leise berührt."

35. "Schon hörte ich sie klagen—da plötzlich erscholl das dumpfsinnige Geläute einer Betglocke und das fatale Getrommel des Zapfenstreichs. Die stolzen römischen Geister verschwanden, und ich war wieder ganz in der christlich österreichischen Gegenwart."

36. Goethe's epigraph to the *Italian Journey* was "Auch ich in Arkadien." Also see Hermand 140.

37. See Brod for a description of Heine's conflicted relationship with his father (395–97).

38. Evidently Heine is referring to a passage from Eckermann in which he insists that Goethe would have created the birds just as God did, had he been given the task. "Moreover, we would have thanked Goethe as we now do God for the pleasing diversity of the species" (Eckermann 24). As we know from *The Romantic School*, Heine regarded Eckermann as a mere apologist for Goethe (*HK* 8:1, 158).

39. The comment anticipates Heine's attack on August von Platen, who thought himself to be the next Goethe and whose homosexuality, according to Heine, points to the feebleness of his lyrics. See Platen's letter of 18 February 1828 for his assessment of Goethe's reception of his work.

40. "Was ist aber diese große Aufgabe unserer Zeit?
"Es ist die Emanzipation. Nicht bloß die der Irländer, Griechen, Frankfurter, Juden, westindischen Schwarzen, . . . sondern es ist die Emanzipation der ganzen Welt. . . .
"Lächele nicht, später Leser. Jede Zeit glaubt, ihr Kampf sey vor allen der wichtigste, . . . obgleich historische Ahnung uns sagt, daß einst unsre Enkel auf diesen Kampf herabsehen werden. . . ."
41. See Reeves 21.
42. I am redeploying Gilman's term to suggest that self-hatred also serves to chart a way out of what Gilman calls Heine's double bind, a desire to conform or be baptized and a loathing for one who desires such. See Gilman, *Jewish Self-Hatred* 174–76.
43. In the French version of the text Heine substituted the name of an eighteenth-century poet who employed Greek models (Sammons 146). Platen is thus less the target than is the tradition emanating from Winckelmann and Goethe in Italy.
44. Ludwig Marcuse's landmark work of 1932 emphasizes the offensive rather than defensive or romantic aspect of Heine's work. As such, the wound his writing inflicts is as important as its target. "Heine's wit has a source other than disappointment and a goal different from relieving the tension that results from longing and its lack of fulfillment. For the most part, Heine's wit is not a salve for a wound, but a sword to inflict other wounds. Therefore, it is not a form of self-help, but a weapon" (336–37).
45. "Ach, ich will nicht wie Ham die Decke aufheben von der Schaam des Vaterlandes, aber es ist entsetzlich wie man bey uns verstanden hat, die Sklaverey sogar geschwätzig zu machen, und wie deutsche Philosophen und Historiker ihr Gehirn abmartern, um jeden Despotismus . . . als rechtsgültig zu vertheidigen."
46. "[I]ch muß beständig auf der Mensur liegen, . . . und ich erfechte keinen Sieg, der mich nicht auch etwas Herzblut kostet. Tag und Nacht bin ich in Nöthen; denn jene Feinde sind so tückisch, daß manche, die ich zu Tode getroffen, sich noch immer ein Air gaben als ob sie lebten. . . . Wie viel Schmerzen habe ich, durch solchen fatalen Spuk, schon erdulden müssen! . . . Ueberall, und wo ich es am wenigsten vermuthen sollte, entdecke ich am Boden ihre silbrigte Schleimspur."
47. See Perraudin for a discussion of Heine's relationship to the conservative tradition embodied by the Biedermeier (22–40).
48. See Peters for a discussion of Heine's reception of Goethe's text (30–46).
49. "[I]n seiner erlauchten Liebhaberey sehe ich nur etwas Unzeitgemäßes, nur die zaghaft verschämte Parodie eines antiken Uebermuths. . . . [J]ene Liebhaberey war im Alterthum nicht im Widerspruch mit den Sit-

ten, und gab sich kund mit heroischer Oeffentlichkeit.... Denn der Graf vermummt sich manchmal in fromme Gefühle, er vermeidet die genaueren Geschlechtsbezeichnungen; nur die Eingeweihten sollen klar sehen."

50. "Dieser Troubadour des Jammers, geschwächt an Leib und Seele, versuchte es, den gewaltigsten, phantasiereichsten und witzigsten Dichter der jugendlichen Griechenwelt nachzuahmen! Nichts ist wahrlich widerwärtiger als diese krampfhafte Ohnmacht, die sich wie Kühnheit aufblasen möchte."

51. The actual quote, which comes from "Ghasel XVIII," reads: "To you, I am like body to the spirit, like the spirt to the body; / To you I am like woman to man, man to woman (Ich bin wie Leib dem Geist, wie Geist dem Leibe dir; / Ich wie Weib dem Mann, wie Mann dem Weib dir)." While the edition of Heine's work used here (7, 2:1264–65) cites the ghasel in the 1828 edition of Platen's poems, the 1835 and 1895 editions of his works delete it.

52. "In der That, er ist mehr ein Mann von Stieß als ein Mann von Kopf, der Name Mann überhaupt paßt nicht für ihn, seine Liebe hat einen passiv pythagoräischen Charakter, er ist in seinen Gedichten ein Pathikos, er ist ein Weib, und zwar ein Weib, das sich an gleich Weibischem ergötzt, er ist gleichsam eine männliche Tribade."

53. Another unlikely target of Heine's is Börne in the fourth book of *Heinrich Heine on Ludwig Börne*. For Heine's motives, see Krus 32–50, as well as Holub, "Heine's Sexual Assaults," 424–28.

54. Gumpelino is based on the Hamburg parvenu Gumpel, whom Heine's Uncle Salomon thought Heine should emulate.

55. In "Jokes and the Relation to the Unconscious," Freud outlines the similarities (*SE* 14:12–13, 16–20).

56. For a study of Heine's ambivalence toward new and old forms of Judaism, see Rose 132–38.

57. In her analysis of Heine in "The Jew as Pariah: A Hidden Tradition" in *The Jew as Pariah* (69–75), Arendt describes Heine as an "exception Jew." But during the nineteenth century and so-called emancipation Jews came no longer to be seen as individual exceptions, as was Heine; rather they came to be viewed as a group or race of exceptions who were reviled for that exceptionality (60–61). For a remarkable reading of Arendt's analysis of the Jew's fate in Europe see Gottlieb 38–50. My reading differs in some respect from Arendt's insofar as I situate Heine closer to the Jews in Proust, whom Arendt describes as "utterly alien" (*Jew as Pariah* 83). In other words, I am suggesting that while Heine's Italian journey and its consequences may signal the Jew's participation in the cultural rites of Germany, it also affirms his exile from universal

humanity.
58. For a study of the Jewish body as a marker of Jewish difference see Gilman, *The Jew's Body*, particularly the section entitled "The Jewish Psyche" 60–103. It is worth noting that at least by the mid-nineteenth century the skin of the Jew was viewed as a canvas on which disease and the unmistakable markers of Jewish difference could be read (Gilman 99).
59. "Mathildes Warnung, daß ich mich an die Nase nicht stoßen solle, war hinlänglich gegründet, und wenig fehlte, so hätte er mir wirklich ein Auge damit ausgestochen. . . . [S]ind diese langen Nasen eine Art Uniform, woran der Gottkönig Jehovah seine alten Leibgardisten erkennt, selbst wenn sie desertirt sind?"
60. Heine insists that Platen's "King Oedipus" would have been far better had the son killed the mother to marry the father (*HK* 7, 1:150). Platen's failure to express desire, not his homosexuality per se, is what irks Heine.
61. "Wie soll ein Mensch ohne Censur schreiben, der immer unter Censure gelebt hat! Aller Stil wird aufhören, alle Grammatik, alle gute Sitte."

Chapter 5

1. In some respects my approach takes its cue from Ricoeur, who writes: "I think the development of Freudian theory may be looked at as the gradual reduction of the notion of a psychical apparatus . . . to a typography in which space is no longer a place in the world but a scene of action where values and masks enter into debate; this space will become a place of ciphering and deciphering" (82). I am exploring Italy as the eventual shape of that space.
2. As is well known, Nietzsche spent the decade before his collapse in Italy, with some excursions to Switzerland. The two works that occupy most of my study reflect that period in Italy. *Ecce Homo* was written in 1888, the last productive year of his life. *Thus Spoke Zarathustra* has a more complex history. Part one was written in the winter of 1883 in Rapallo; the second part, in the summer of that same year in Sils Maria; the third and fourth parts in 1884–85 in Nizza and Mentone.
3. "Das Glück meines Daseins, seine Einzigkeit vielleicht, liegt in seinem Verhängniss: ich bin, um es in Räthselform auszudrücken, als mein Vater bereits gestorben, als meine Mutter lebe ich noch und werde alt." For an interesting discussion of subjectivities in the text see Doueihi 209–25.
4. Kofman, "Fantastical Genealogy," points out that in the previously accepted version of *Ecce Homo* Nietzsche marginally maintains German origins to ennoble the paternal side of his heritage. The later version, the

one now accepted and the one his sister and mother sought to repress, seeks to cleanse him of German origins or those of the maternal side (35–54).
5. See Krell for a provocative reading of the significance of the dead father in *Ecce Homo* in relation to Derrida, Klossowski, and Gasché, 229–46. Of course, Heidegger's working out of the philological problems of *The Will to Power* as well as that text's impact on Nietzsche reception has contributed significantly to the reception of the Nietzsche text. See in particular 1:3–25.
6. For a translation of the entire letter see W. Kaufmann, *The Portable Nietzsche* 686.
7. "Den höchsten Begriff vom Lyriker hat mir *Heinrich Heine* gegeben. Ich suche umsonst in allen Reichen der Jahrtausende nach einer gleich süssen und leidenschaftlichen Musik. Er besass jene göttliche Bosheit, ohne die ich mir das Vollkommene nicht zu denken vermag."
8. Kofmann ("Fantastical Genealogy") brilliantly argues that Nietzsche wants to rewrite true kinship as typological and not physiological so as to ennoble himself despite his mother's German origins. Moreover, he wants to protect himself from his sister and mother, whom he calls "venomous vermin," because he fears an incestuous desire. She goes on to argue that the unspeakable horror of the two, which she relates to castration fear, led him to rethink and rearticulate the "eternal return," since it might have allowed for their eternal return (44–46).
9. Schur has tried to demonstrate the haunting similarities between the families, births, and deaths of the two. In this regard also see Ronell, *Dictations* 27–45.
10. McGrath argues that Freud's identification with his father, which I will take up below, is a renunciation of earlier radicalism (210). It is, insofar as his science is an attempt to remove the political edge from any conflict with the father.
11. It should be pointed out that outfitting Dionysus with a beard was common in preclassical times.
12. I am grateful to Ralf Eichberg of the Nietzsche Gesellschaft for providing a history of the work's possession. He was under the impression that the work was given to the Nietzsche archive in 1944 to commemorate Nietzsche's 100th birthday. The historical situation in 1944 would seem to make that an unlikely possibility. Thus, I accept the version offered by *Art News*.
13. The topic of Nietzsche in Italy could just as well be rephrased, as Podach in fact did in 1931, as *Nietzsches Werke des Zusammenbruchs*. The one work of his that has been translated into English, *The Madness of Nietzsche,* renders the equation of Italy and madness instructive for Nietz-

NOTES TO CHAPTER 5

sche's later works and those most under consideration here.
14. "In eine derartig aufgebaute und künstlich geschützte Welt drang nun der ekstatische Ton der Dionysusfeier, in dem das ganze Übermass der Natur in Lust und Leid und Erkenntnis zugleich sich offenbarte. Alles was bis jetzt als Grenze, als Massbestimmung galt, erwies sich hier als ein künstlerischer Schein: 'das Übermass' enthüllte sich als Wahrheit."
15. See Rella 10–21.
16. See Ronell, "Hitting the Streets," 119–40.
17. Paul de Man offers perhaps the most compelling example of how the terms in *The Birth of Tragedy* in relationship to other works soon become interchangeable ("Genesis" 79–102).
18. See Livorsi 103–11. In *Ear of the Other* Derrida concedes that Nietzsche's work cannot be said to exclude categorically the reading offered by the Nazis (29–32).
19. "Denn das war das Verhängniß jener ahnungvollen Studenten; sie fanden die Führer nicht, die sie brauchten.

"Denn ich wiederhole es, meine Freunde!—alle Bildung fängt mit dem.... Gegentheile alles dessen an, was man jetzt als akademische Freiheit preist, mit dem Gehorsam, mit der Unterordnung, mit der Zucht, mit der Dienstbarkeit."
20. See Shapiro 142–67.
21. Gasché's observation, in reference to the many remarks about diet in *Ecce Homo*, that the text is a self-constituting corpus as well as a discourse on the body (113–36) suggests that the text that is a document of self-citation is itself doubled.
22. Hamacher works through the relationship of the two by asserting that both share a recognition of the impossibility of fulfilling the hermeneutic promise, which is another way to demonstrate non-finality (10–49).
23. See Valadier for an interesting reading of the relationship of these two figures in Nietzsche's text (247–61).
24. "Dergleichen ist nie gedichtet, nie gefühlt, nie gelitten worden: so leidet ein Gott, ein Dionysus. Die Antwort auf einen solchen Dithyrambus der Sonnen-Vereinsamung im Lichte wäre Ariadne.... Wer weiß ausser mir, was Ariadne ist!"
25. Irigary links the interlocutor always beyond the limits of discourse in Nietzsche with the feminine. According to Bennett's reading of Irigary's text, his work so disallows the feminine that it prepares a space for it as well ("Bridge" 289–315).
26. See Reinhardt 186–209.
27. In this regard also see Vernant and Vidal-Naqet, 398.
28. Also see Del Caro 125–57.
29. Burgard's edited volume *Nietzsche and the Feminine* deals extensively

with this issue. Most helpful is Bennett's essay, in which he argues that the space vacated by what he calls the "untheorizable particularity" characteristic of Nietzsche's work calls forth the feminine "I" as it is spoken by a woman or by Irigaray in *Marine Lover* ("Bridge" 309–11).
30. See Grundlehner 299.
31. "Ja! Hinab auf mich selber sehn und noch auf meine Sterne: das erst hiesse nur mein *Gipfel,* das blieb mir noch zurück mein *letzter* Gipfel!—"
32. See Kittler 1–5 for a remarkable reading of how Faust's use of "ach" in his opening monologue sponsors the illusion that sustains German classicism.
33. After his collapse in Turin, Nietzsche is brought to Basel by Dr. Overbeck. In January of 1889 his mother brings him to the mental home of the Grand Duchy of Sachsen Weimar. In March of the following year he leaves the asylum; he dies in Weimar on 25 August 1900.
34. The gift was accompanied by a letter from Marshal Kesselring, which reads in part: "The Führer will consider himself happy if this great work of German literature gives you a little pleasure, Duce, and if you will consider it as an expression of the Führer's personal attachment to you" (93). The fate of the Bearded Dionysus reads as a sequel to this affair.
35. Gilman uses the case of Dora to demonstrate how the impairment of the syphilitic is linked to the hidden image of the Jew and masculine inefficiency (*Jew's Body* 85–86).
36. As Weber observes, it is the manner in which the material returns rather than the material itself that lends the experience its uncanny character (120–32). Journeying to Italy summons the experience.
37. Freud remarks that the experience occurred some twenty years before the composition of the text, which would mean that it occurred before his actual entry into Rome. But if the essay is itself an exercise in the uncanny, then recalling the experience is as well. It has neither been fully surmounted or repressed.
38. See Silverman 4–25 for a discussion of Freud's theories on the origins of homosexuality.
39. Freud writes, "At this time a thought comes to mind from such a remote quarter that it would be tempting to set it aside. In the hieroglyphics of the ancient Egyptians the mother is represented by a picture of a vulture. The Egyptians also worshipped a Mother Goddess, who was represented as having a vulture's head, or else several heads, of which at least one was a vulture's" (*SE* 11:95).
40. For a more detailed account of how Freud structures his summary to meet the needs of psychoanalysis, see Kofmann, *Freud and Fiction* 83–118.

NOTES TO CHAPTER 6

41. Jensen's description reads as follows: "Her head bent forward a little, she held slightly raised in her left hand, so that her sandaled feet became visible, her garment, which fell in exceedingly voluminous folds from her throat to her ankles. The left foot had advanced, and the right, about to follow, touched the ground only lightly with the tip of the toes, while the sole and heel were raised almost vertically" ("Gradiva" 148).
42. It was Jung who introduced Freud to the works of the conservative nationalist, Jensen (Urban and Cremerius 11–12). Jensen was the illegitimate child of the mayor of Kiel, which underscores an urgency in securing his bloodlines. In this regard, the dreams of Hanold are a wish fulfillment. It would be interesting to consider Jensen's denial of his sister in terms of his own illegitimacy. Did he have one of which he was unaware or which he simply sought to disown to disavow his own illegitimacy? If the answer were yes, it would beg a curious reevaluation of Freud's text. At the very least, Freud and Jensen would be practitioners of disavowal, which would thus certify Freud to be every bit as German as Jensen.
43. I thank Randy Cummings for his help in translating this passage.

Chapter 6

1. Brown's reconstruction of Goethe's creative rebirth in Italy is evidence of the standard by which the "canonical" Goethe's journey is understood.
2. See Barnouw ("Fascism") for the relationship of art to fascism in Mann (48–63).
3. Describing how Eckermann abandoned the ailing August in Italy, Ronell suggests that Eckermann returned to Weimar as August's double or to take the dead son's place. Her argument is strengthened by the fact that Eckermann reports that Goethe received him with open arms and never made a single mention of August nor posed a question about his dead son (Ronell, *Dictations* 120–21). Thomas Mann who, like Eckermann might be said to have hoped to become Goethe's preferred progeny, offers a less than flattering picture of August in chapters 5 and 6 of *Lotte in Weimar*.
4. "Das ist Italien, das ich verließ. Noch stäuben die Wege, / Noch ist die Fremde geprellt, stell er sich, wie er will. / Deutsche Redlichkeit suchst du in allen Winkeln vergebens; / Leben und Weben ist hier, aber nicht Ordnung und Zucht; / Jeder sorgt nur für sich, mißtrauet dem andern, ist eitel, . . . / Schön ist das Land; doch ach! Faustinen find' ich nicht wieder. / Das ist Italien nicht mehr, das ich mit Schmerzen verließ."

5. Goethe was certainly in a disagreeable mood when he arrived in Venice. Unlike his first journey, which was a welcome escape from the administrative burdens of Weimar, this journey found him alone in Venice as he waited to escort the Duchess Anna Amalia, who had been delayed, back to Weimar. Meanwhile, his mistress and newborn son were waiting for him in Weimar. I do not want to discount these factors in accounting for his different disposition toward the land of his rebirth, but my interest is in the literary legacy of his Italian journeys.

6. Although the argument moves in a vastly different direction, the most impressive study of Goethe's erotic poetry is to be found in Vaget, particularly in his treatment of Goethe's *Roman Elegies*.

7. "Lange sucht ich ein Weib mir, ich suchte, da fand ich nur Dirnen; / Endlich erhascht ich dich mir, Dirnchen, da fand ich ein Weib." The epigrams certainly question the limits of Germany's most canonical author. No one has ever truly resolved what should be included in the final text. Trunz, for example, presents only forty-three of the original 104 epigrams, and none of the hundred or so long suppressed by Goethe admirers, including the one cited here. Several reasons for the textual problems exist. Two of them are the following: Goethe was often in a different place and of a different mind when he wrote the Venetian epigrams, and he sought to excise some of the withheld epigrams (Hexter 526–55). However, Goethe's excisions were not complete enough to prevent a "full" printing of the epigrams, sanctioned and withheld, in the Weimar edition of 1914. Lind follows this edition (5:51, 53). Hexter and many others have chosen to follow Lind. At issue is what Goethe sought to erase but could not. Arguably, the philologist and I share the same concern: trying to read a text its author sought to or could not help but repress.

8. "Gib mir statt Der 'Sch . . . !' ein ander Wort, o Priapus / Denn ich Deutscher, ich bin übel als Dichter geplagt. / . . . der Sch . . . ist etwas von hinten, / Und nach hinten war mir niemals ein froher Genuß." Lind fills in the blanks of Goethe's own text, which merely offers "Sch . . ." for tail. "Schwanz," if that is what is intended here, is also a somewhat vulgar term for penis. This suggests that a new sort of confusion or substitution is embedded in the epigram, which only castration, to recall Winckelmann, would seem to resolve.

9. "Auszuspannen befiehlt der Vater die zierlichen Schenkel, / Kindisch der liebliche Teil . . . den Teppich herab. / Ach, wer einst zuerst dich liebet, er findet die Blüte / Schon verschwunden, sie nahm frühe das Handwerk hinweg."

10. "Knaben liebt ich wohl auch, doch lieber sind mir die Mädchen; / Hab' ich als Mädchen sie satt, dient sie als Knabe mir noch."

11. Such expressions may well have been countenanced in the late eighteenth century because taboos against same sex acts were sufficiently engrained to render thoughts of such acts wholly unconscious. This is counter to the explanations offered by Kuzniar who finds, for example, in the mere designation of "Winckelmann and His Age" or "The Century of Frederick the Great" at the very least a partial acceptance of homosexuality (5–12). What is certain is that a transformation of presumed tolerance to the point of indignation occurred shortly thereafter, as evidenced by the case of Johannes von Müller. See in the same edition Richter, "Winckelmann's Progeny" (40–45). Goethe's own essay, "Women's Roles on the Roman Stage, Played by Men," indicates how in Italy gender reversal fascinated and occupied Goethe. See Tobin, *Warm Brothers* 117–21. In her discussion of the essay, MacLeod argues that transvestitism opens up the possibility for Goethe to access a "third nature" (96). For me, that third nature would have something to do with the specter of his own being that is left behind in Italy. Its unrealizable character would contribute to its ideality.
12. "Ungeduldig die Blicke der Himmelsfürstin erwarten, / Wonne des Jünglings, wie oft lockest du nachts mich heraus." I am reading the young man of the second line as the one whom the poet addresses. It is also possible to read it as a description of his own feelings as he waits for the beloved to appear. In the next two lines of the epigram, she does appear, and there is no question as to the gender of the one who appears to him as the herald of the day. The gender of the one or the wished for gender of the one who appears at night, however, is just as likely masculine. The poet's disappointment in the end, "the sun rises always too soon," would thus be a result of the disillusion that results when the delightful boy turns out to be a girl. As Gustafson points out, Goethe "was into cross-dressing" (166), since it offered a means to express male-male sexual desire. In this epigram, Goethe's disappointment results from the girl failing to maintain the appearance of a boy. Transvestitism only works when the sun does not rise or when the boy is the secret behind the girl.
13. It is interesting to note how tight circumstances and male-male love are combined in the letter. For a fuller discussion of this letter see Tobin, "In and Against Nature" 94–110.
14. These are not the ones written in Venice in 1790. The letter requesting their return is dated 12 December 1794. Trunz reports that some of these were included in what Goethe published as the "Venetian Epigrams" (*HA* 1:588). What is also important is not only the personal nature of the epigrams, but also how they highlight a return viewing of supposedly previously expressed desires. That, no doubt, contributes

mightily to what Goethe sees and disdains in Venice.
15. Of course, there is little possibility of speaking "its" name since the term homosexuality had not been coined yet. The only possibility would be to name it vaguely as sodomy.
16. Important in this regard is Gilman's *Goethe's Touch*.
17. Also see Ritter-Santini 115–27.
18. "[D]aß meine Lage die glücklichste scheinen müßte. Und sie wird es sein, sobald ich . . . mich recht überzeuge: daß der Mensch das Gute, das ihm widerfährt, wie einen glücklichen Raub dahinnehmen und sich weder um Rechts noch Links, vielweniger um das Glück und Unglück eines Ganzen bekümmern soll. Wenn man zu dieser Gemütsart geleitet werden kann, so ist es gewiß in Italien, besonders in Rom."
19. See Ritter-Santini 117.
20. Much could be said about the reference to Diocletian, the Roman emperor responsible for severing the empire in half, Greek and Roman, in 286 AD in an attempt to maintain control. It is as if the German attempt to make off with the spirit, not the material remains, of the ancient world forces it now to confront the undisguised horror of its legacy of severing Italy in two halves: material and "spirit." Not surprisingly, Diocletian, like Judejahn, was given to unrestrained persecution of his religious, or in this instance, Christian rivals.
21. "Er war in einer grossen Gaskammer mit nackten Menschen, die liquidiert werden sollten, aber dann mußte er hier nun 'raus gehen. Er sollte ja nicht liquidiert werden. Er war ja nicht nackend. Er war der Kommandeur."
22. "[S]pielt vor uns mit den Objekten; keines ist ihm zu wirklich, daß er sich nicht mit ihm vereinigte; für einen Augenblick wandelt er sich in ein jedes, winkt uns aus dem Innern des Gegenstandes zu, taucht wieder auf. Mit einem Male ist nur mehr Bild da. Er ist vor unseren Augen in sein Bild hineingegangen und uns entschwunden; wir sind allein mit einer gemalten Tafel. Ein Schauder überläuft uns." In this citation Hofmannsthal plays on Goethe's fascination throughout Italy of images as if they were painted (wie gemalt). Not just the language but also the image becomes Goethe. For an alternative reading of Hofmannsthal's essay, see Ritter-Santini 120.
23. See Schmidt for a solid reading of how homosexuality subverts attempts to restore a fascist order. Such a reading extends Koeppen's critique of the German appropriation of Italian culture by linking, at least implicitly, the expression of same-sex desire with the lingering structures of National Socialism. It is in this light that Heine's stinging critique of Platen and his failure to express his desires openly should be reread. Platen had the desire but not the political will to break with the repres-

sive regimes of his time.
24. "In der langen Vorstadt von Messina traf ich einige sehr gut gearbeitete Brunnen mit pompösen lateinischen Inschriften, worin ein Brunnen mit Recht als eine große Wohltat gepriesen wurde. Nur schade, daß sie kein Wasser hatten."
25. "Bis jetzt haben wir nur reizlose, öde Felder, Wüsten, Kloaken, Ruinen und schmutzige Höhlen gesehen, und jetzt sollen wir diesen Landstrich durcheilen, in welchem der Pesthauch der Vernichtung weht und das Mordmesser des Räubers blinkt."
26. It might be recalled that in 1923 Hitler's Putsch in Munich failed. In 1925 he was released early from prison, and the NASDP was founded anew with Hitler as its "Führer." See as well Grimm 241.
27. The epigraph to Goethe's *Italienische Reise* is "I, too, am in Arcadia."
28. For other insightful accounts of the political gestures of the inner emigrants, see Hoffman 214–29 and Ziolkowski 153–72.
29. Not all who went to Italy were politically disengaged or given to what Böschenstein has called in relation to Stefan George an "Enthistorisierung (a dehistoricizing)" (317–33). A notable exception is Stefan Andres.
30. "Als ich aber nun in München eintraf, drängten sich wieder die Kriegserscheinungen vor. Während meines kurzen römischen Aufenthalts war nicht viel zu bemerken gewesen: Trauer und Not verbargen sich dort unter Blumen, . . . unter Singsang und Geplauder des lichtgesegneten Volks, und wo die alten Ruinen so herrlich sind, hätte man sich am Ende damit abgefunden, wenn ein paar neue hinzugekommen wären. Rom, das große, verwandelbare, fühlt sich als ewiges Wachstum, ewige Gegenwart."
31. "Es genügte ihr nicht, als ich mein oft geäußertes Bekenntnis wiederholte, ein Volk wie das deutsche werde auf rein organischem Wege, durch seine Tüchtigkeit und seine geduldige, geschmeidige Kraft an die Stelle rücken, die ihm in der Welt gebühre, es brauche keinen Krieg."
32. "Ihr Gang, ihre Haltung waren stolz und frei; sie trugen das Zeichen der Schmach und der Todesdrohung wie einen Orden. 'Der Deutsche, gut und großmütig von Natur, will niemand gemißhandelt wissen.' So durfte Goethe noch schreiben, und sicherlich ist es einmal wahr gewesen."
33. "Und doch Geist ewig lebendig über dir Zerstörung! Oder vielmehr Zerstörung, die selbst wieder junge reine Seele, die das alte Todte göttlich zu frischem Leben aufweckt. Die Erde mit uns, und allem was Odem hat, und Gras und Kraut und Bäumen . . . ist eine unsterbliche Schlange, die von Zeit zu Zeit die Haut ablegt."
34. "Wie ich herum plätschere darin, den Kopf hinein stecke, mich auf den Rücken werfe, mit dem Leib herumwälze—ach daß ich keine süße

Nymphe bey mir habe! Wie würde im Wonnentaumel Himmel und Erde um mich herum vergehen und wieder neu geboren werden!"

35. See Rickels for the manner in which Heinse's semiotics radically differs from that of the Enlightenment, 365–75.
36. "Etwa eine Miglie von Pesquiera erblickt man den See die Garda, . . . so prächtig und schön erheben sich nach und nach die Gebürge dahinter herum in frischen zauberischen Farbentönen von dunkel und braun und Luft. . . . Unten liegt still und blinkend und ruheklar und hell der See in lieblichem, wollüstigem, fruchtbarem Grün der Bäume und mildem Schoß der Erde."
37. "'Kaffee wollen wir trinken, mein Fremder!'—Da meint sie branlieren; / Hab ich doch, Freunde, mit Recht immer den Kaffee gehaßt."
38. Hexter as well points out that Goethe's expressed aversion to coffee has little to do with caffeine and cites the same epigrams. What Hexter does not pursue is the possible difference between coffee and coffee drinking (531).
39. The form of the noun is just as likely the accusative. Nonetheless, the given plural for a similar noun, such as "Patina," is "Patinen."
40. As I have noted in earlier chapters, Nohl offers a detailed account of how useful Goethe's preservation of an incognito was throughout his journey. Also, see Goethe's entry of 3 November 1786 for his own account of the urgency of maintaining a secret identity in Italy.
41. See Jacobs 34–56.
42. "Wir fuhren an einem türkischen Schiffe vorbei, sie brannten ihre Kanonen los; die Gondel wankte, worin ich aufgerichtet stand; ich verlor das Gleichgewicht und stürzte in die See; verwickelte mich in meinen Mantel, arbeitete vergebens und sank unter.

"Als ich wieder zu mir gekommen war, befand ich mich bei einem jungen Menschen, welcher mich gerettet hatte; seine Kleider lagen von Nässe an, und aus den Haaren troff das Wasser. 'Wir haben uns nur ein wenig abgekühlt!' sprach er freundlich mir Mut ein; ich drückte ihm die Hände."
43. Heinse describes his tale as a Renaissance novel. Goethe undertook as well to retell the life of a man from the Renaissance. Between 1796 and 1797 in the *Horen* Goethe brought out in installments a biography of Benvenuto Cellini. Baumer's description of the difference between the two figures is telling: "Cellini is not the master and revolutionary that Ardinghello is, but rather a servant; not an aristocrat who moves through his artistic phase by dint of power and life's intoxication, but rather an artist and artisan his entire life" (Heinse, *Ardinghello*; afterword 647).
44. As Mohr points out, Heinse substitutes Italy for ancient Greece or at least de-historicizes antiquity in order to bring it forward and experience

its sensuous excesses (117–20). But unlike Winckelmann and Goethe, who brought ancient Greece forward, that world is no longer one of balance and measure. The substitution overrunneth.

45. "Man kommt gewöhnlich zurück, wie man gegangen ist. . . . [J]a, man muß sich hüten, nicht mit Gedanken zurückzukommen, die später für unsere Zustände nicht passen. So brachte ich aus Italien den Begriff der schönen Treppen zurück, und ich habe dadurch offenbar mein Haus verdorben, indem dadurch die Zimmer alle kleiner ausgefallen sind als sie hätten sollen. Die Hauptsache ist, sich selbst zu beherrschen. Wollte ich mich ungehindert gehen lassen, so läge es wohl in mir, mich selbst und meine Umgebung zugrunde zu richten."

46. Unless otherwise indicated, references and citations are to the English translation by H. T. Lowe-Porter.

47. The description is of the neighborhood where the performance of Cipolla the magician takes place.

48. The German is far more expressive in this instance: "die Idee der Nation im Spiele war." Throughout this chapter I have been arguing that Germany's identity or idea of itself as a nation was linked to an Italy that not only was phantasmic but also inseparable from Italian fascism or its attempt to restore its imperial grandeur.

49. I am obviously playing with Freud's own use of the term, which, given the analysis of that text in the previous chapter and its political implications, is appropriate here as well. The narrator will use the term again to describe the performance.

50. See Lunn for a discussion of the story in terms of Italian fascism (48–63). Also see Schwarz for a discussion of how the doctor serves as an example of resistance (47–67). Geulen disputes Schwarz's claim (24).

51. "[D]ieser Mann . . . dünkte uns die Personifikation von alldem; und da wir im großen nicht abgereist waren, wäre es unlogisch gewesen, es sozusagen im kleinen zu tun."

52. In addition to its meaning as onion, Cipolla is the name of one of the characters in Boccaccio's *Decameron*. Moreover, the tales in this work are told by a group of people forced to leave the city so as to protect themselves from the ravages of a mysterious, disfiguring disease that was transmitted "even through conversation" (Boccaccio 51). Also see Schwarz (47–60) and Geulen (22–23). However, Mann objected to any such connection. See *Dichter über Dichtungen: Thomas Mann* 372.

53. For a discussion of degeneration and its sexual implication see Gilman, *Degeneration*.

54. See Geller ("Blood Sin") for how Jews were specifically linked to syphilis and how their "feminization" strengthened the connection.

55. For a discussion of same-sex desire in Mann's work see Härle.

56. In its most concise formulation the hyperreal signals the moment when the image becomes its own simulacrum (Baudrillard 11). The copy supplants the real and denies that there is anything behind it; it "dissimulates nothing" (Baudrillard 12), whereby the real is not only reproduced but always already reproduced. In my reworking of Baudrillard's definition, the real would be the real distance between the copy and its apparent ideal à la Winckelmann. The key moment occurs when the copy no longer discredits itself. The greater liberty I take with Baudrillard's text is identifying this transformation at the beginning of the twentieth century, when his examples are far more recent.
57. Baudrillard further notes, "When the real is no longer what it used to be, nostalgia assumes its full meaning. There is a proliferation of myths of origin" (12). Because the real was no longer under a Greek sky, Winckelmann posited his own myth of origin, which extended to his own origins. A myth of origin also frames fascism as the reclamation by contemporary Italy of Italy's past imperial glory, to which Cipolla frequently refers and which he uses to discredit his potential antagonists.
58. Baudrillard's own style could be seen as a performance of his thought. That he reads everything from Disney Land and Watergate to the fate of the Tasanay or even the Persian Gulf War according to the same code is evidence of what approaches, at the very least, a paranoia. His critique of Foucault's panopticon and his assertion that it is no longer valid does not signal an end to paranoia, rather it provides an understanding of the conditions that allow for the production of the panopticon (49–57). The panopticon is an effect of the code, not its key. Hence, he can speak of the "precession" of the simulacra since they precede and are essential to the production of the panopticon. Moreover, the nostalgia for the real that permeates the section is likewise a performance, endemic to the voice that cannot escape the code it has identified.
59. Bennett, in *Goethe as Woman,* argues that Goethe was keenly aware and disturbed by the prospect of literature being co-opted for political purposes. As such, he gave rise to a second Goethe, who most notably in "Literarischer Sansculotissmus" sought to work against that tendency.
60. "'Skandalös,' sagte er klar und verbissen. 'Geht an eure Plätze! Jedermann kann schreiben in Italien, dessen Größe der Unwissenheit und Finsternis keinen Raum bietet.'" Lukács argues that Mario is the working-class hero that overcomes or shatters the spell of ideology. See his "Thomas Mann. Auf der Suche nach dem Bürger" (505–34).
61. See *Lotte in Weimar* for Mann's attempt to negotiate his own seduction by Goethe, which, not surprisingly, he does in drag or through the figure of Lotte. And Lotte is the fictionalized version of the real Lotte who was fictionalized in *Werther.* However hard Mann tried to awaken from

NOTES TO EPILOGUE

Goethe's spell, he could not help but continue a chain of substitution.
62. Mann apparently wavered between assigning political or fascist motives to his text and situating it in the more general realm of the ethical. See Mann, *Dichter über ihre Dichtungen*. For comprehensive overviews of the means by which the narrator has been viewed as complicit with Cipolla in various critical studies see Mann, *Kommentar zu den sämtlichen Erzählungen* (220–50) and *Thomas Mann Handbook*, ed. Koopman (590–600). For a more extended discussion of this topic in terms of the narrator's seductive tactics see Leneaux 327–47.
63. See Freese for a comprehensive discussion of readerly expectations (659–78).
64. The German is more telling: "deren tönende Vornamen . . . in heiserer Besorgnis die Lüfte erfüllen" (659).
65. "'War das auch das Ende?' wollten sie wissen um sicher zu gehen. . . . 'Ja, das war das Ende,' bestätigten wir ihnen. Ein Ende mit Schrecken, ein höchst fatales Ende. Und ein befreiendes Ende dennoch—ich konnte und kann nicht umhin, es so zu empfinden!"
66. Geulen reads the end as a form of resistance. In a beautifully argued passage she writes, "the kiss is the one representation that cannot be annulled by that literalizing, embodying strategy. . . the kiss stands apart from what it represents, . . . liberating because that moment turns into an image, a representation of the text itself" (28). My departure from her argument is a result of inserting this narrative in the grander narrative of Germans in Italy.

Epilogue

1. See Höller for a discussion of how for Bachmann, at least in her work of the 1950s, Rome presented utopian possibilities given what Höller calls its openness and lack of isolation (82). In an interview during this time Bachmann remarked that "Rome exercises a particular power with its intricately entangled images of past times. Therein lies the tidings . . . of a utopian city. Rome exerts its power not only through that which endures; it also effects its powers through the enduring possibilities of its multi-tiered existence" ("Wir müssen wahre Sätze finden" 13).
2. The conflation of the father with fascist terror and the crimes of the holocaust is most forcefully articulated in the second section of *Malina* entitled "The Third Man," in reference to Carol Reed's spy movie of the same title. What Weigel calls the narrator's "libidinal attachment" to the father de-territorializes the conflict with the historical past and renders that terror omnipresent (221).

3. It is more accurate to say that Bachmann is conscious of both participating in the German tradition of writing about Italy and attempting to reflect on it politically. In this regard, see Morris 78–94. The lack of imagery in this poem that is unmistakably Italian is arguably a result of what Bachmann called her "double life" in Italy. In an interview from 1969, which was broadcast in Rome, Bachmann explained that the moment she entered the study in her apartment in Rome, "she was in Vienna and not Rome" ("Wir müssen wahre Sätze finden" [(65)]). The multilayered character of Rome, which for Bachmann imbued the city with a utopian possibility (see note 1), also encompassed Vienna. The significance of this blurring of boundaries will become clear below.

4. Morris argues that despite such imagery Bachmann's poetry is an attempt to come to terms with Austria's political past. Morris's reading is actually more complex than an attempt to read history into Bachmann's poetry. As she writes, "The history that I read into Bachmann's poetic texts is a history marked by allusion, elision, and absence—it is the trace of history evoked poetically and through metaphor" (9). As Morris later explains, the simultaneous presence and absence of the historical in Bachmann's poems is an attempt to represent the "gap" in historical discourse that characterized the postwar years (19).

5. "—und wiederkommen und in jener anderen Gasse laufen, hinaus, vor uns, in dieser langen schaurigen Gasse—müssen wir nicht ewig wiederkommen?—"

6. Mark Anderson, in an afterword to the English translation of *Malina* describes a similar process whereby self-obliteration and a coming to oneself are accomplished in the same moment. "The narrator gives up herself to become herself" (239), Anderson writes to describe the disappearance of the narrator from the novel or her ceding of voice to the mysterious Malina. The oft-cited line at the end of the novel, "It was murder," emphasizes how this coming-to-be of the feminine is linked to her own destruction.

7. Weidenbaum's correction of Bachmann's own account of the Nazis' arrival in her birthplace is relevant here. In an interview in the journal *Brigitte* from 24 December 1971 Bachmann described how her childhood had been been destroyed (zertrümmert) by "Hitler's invasion," when, according to Weidenbaum, Hitler's army was greeted by 10,000 jubilant Austrian members of the NASDP. Bachmann's father was evidently among them. He had been a member of the party since 1932 and willingly volunteered in 1939 for the war against Poland. The horror of her father's complicity thus necessitates a usurpation of the father (94–98).

Works Cited

Adorno, Theodor. *Notes to Literature*. Trans. Sherry Weber Nicholsen. 2 vols. New York: Columbia UP, 1991.
Aldrich, Robert. *The Seduction of the Mediterranean: Writing, Art, and Homosexual Fantasy*. New York: Routledge, 1993.
Allemann, Beda. "Nietzsche und die Dichtung." *Nietzsche: Werke und Wirkungen*. Ed. H. Steffen. Göttingen: Vanden Hoeck Ruprecht, 1974. 45–64.
Anderson, Mark, ed. *Malina*. Ingeborg Bachmann. Trans. Philip Boehm. New York: Holmes and Meier, 1990.
Arendt, Hannah. "Eichmann in Jerusalem." *The Portable Hannah Arendt*. Ed. Peter Baehr. New York: Penguin, 2000. 313–88.
———. *The Jew as Pariah: Jewish Identity and Politics in the Modern Age*. Ed. R. Feldman. New York: Grove, 1978.
Art News. "Dionysus and Mussolini." Vol. 91 (March 1992): 90.
Arzeni, Bruno. "Platen und Italien." *Platen: Gedächtnisschrift der Universitätsbibliothek Erlangen*. Ed. E. Stollreitner. Erlangen: 1936. 137–43.
Arzeni, Flavia, ed. *Il viaggio a Roma: Da Freud a Pina Bausch*. Rome: Edizioni di Storia e Letteratura, 2001.
Atkins, Stuart. "*Italienische Reise* and Goethean Classicism." *Aspekte der Goethezeit*. Ed. Stanley Corngold et al. Göttingen: Vandenhoeck and Ruprecht 1977. 81–96.
Bachmann, Ingeborg. *Mein Erstgeborenes Land*. Ed. Gloria Keetman-Maier. Munich: Piper, 1978.
———. *Songs in Flight*. Trans. Peter Filkins. New York: Marsilio, 1994.
———. *Werke*. Ed. Christine Koschel et al. 4 vols. Munich: Piper, 1978.
———. *Wir müssen wahre Sätze finden. Gespräche und Interviews*. Ed. Chris-

WORKS CITED

tine Koschel and Inge von Weidenbaum. Munich: Piper, 1983.

Barner, Wilfried. "Altertum Überlieferung: Natur und Klassizität und autobiographische Konstruktion in Goethes Italienische Reise." *Goethe Jahrbuch* 1988. Weimar: Böhlhaus Nachfolger, 1988. 76–91.

Barnouw, Dagmar. "Fascism, Modernity and the Doctrine of Art from 'Mario and the Magician' to *Doctor Faustus*." *Michigan Germanic Studies* 18.1 (Spring 1992): 48–63.

———. "Goethe and Heimholtz." *Goethe and the Sciences*. Ed. Frederick Amrine. Dordrecht. D. Reidel, 1987. 45–82.

Baudrillard, Jean. *Simulations*. Trans. Paul Foss, Paul Patton, and Philip Beichtman. N.p.: Seimotexte, 1983.

Bäumer, Konstanze. "Reisen als Moment der Erinnerung: Fanny Lewalds 'Lehr- und Wanderjahre.'" *Amsterdamer Beiträge zu Neueren Germanistik* 28 (1989): 137–57.

Behler, Ernst. "Madame de Staël and Goethe." *"The Spirit of Poesy": Essays on Jewish and German Literature and Thought in Honor of Géza von Molnár*. Ed. Richard Block and Peter Fenves. Evanston: Northwestern UP, 2000. 131–49.

Bell, Matthew. *Goethe's Naturalistic Anthropology: Man and Other Plants*. Oxford: Clarendon, 1994.

Bella, Franco. *Il silenzio and le parole. Il pensiero nel tempo della crisi*. Milan: Feltrinelli, 1984.

Benjamin, Walter. "Goethes Wahlverwandtschaften." *Schriften*. Ed. Theodor Adorno and Gretel Adorno. Frankfurt am Main: Suhrkamp, 1967. 55–140.

———. *The Origin of German Tragic Drama*. Trans. John Osborne. London: Verso, 1990.

———. *Reflections*. Trans. Edmund Jephcott. New York: Schocken, 1986.

Bennett, Benjamin. "Bridge: Against Nothing." *Nietzsche and The Feminine*. Ed. Peter Burgard. Charlottesville: U of Virginia P, 1994. 289–315.

———. *Goethe as Woman*. Detroit: Wayne State UP, 2002.

Bergengruen, Werner. *Römisches Erinnerungsbuch*. Vienna: Herder, 1959.

Berghahn, Klaus, and Jost Hermand, eds. *Goethe in German-Jewish Culture*. Rochester: Camden House, 2001.

Bierbaum, Otto Julius, and U. C. Schüddekopf, eds. *Goethe Kalender*. Leipzig: Dieterischen, 1909.

Blackwell, Eric. *Goethe and the Novel*. Ithaca: Cornell UP, 1984.

Blättner, Fritz. "Goethes Italienische Reise als Dokument seiner Bildung." *Deutsche Vierteljahrsschrift* 22 (1949): 449–71.

Block, Richard. "Second Reads: Althusser Reading Marx Reading Hegel." *Boundary 2* 22.1 (1995): 211–34.

Bloom, Harold. *The Anxiety of Influence: A Theory of Poetry*. New York:

Oxford UP, 1973.

Boccaccio, Giovanni. *The Decameron.* Trans. G. H. McWilliam. New York: Penguin, 1972.

Böhme, Hartmut. "Goethes Erde zwischen Natur und Geschichte: Erfahrung von Zeit in der 'Italienische Reise.'" *Goethe Jahrbuch.* Weimar: Böhlhaus Nachfolger, 1993. 209–22.

Böschenstein, Bernhard. "Stefan George und Italien." *Jahrbuch des Freien Deutschen Hochstifts* (1987): 317–33.

Bosshard. Walter. *Winckelmann; Aesthetik der Mitte.* Zurich: Artemis, 1960.

Bowman, Curtis, trans. *Essays on the Philosophy and History of Art. J. J. Winckelmann.* Cornwall: Thoemmes, 2001.

Boyle, Nicholas. "Geschichtsschreibung und Autobiographie bei Goethe: 1810–1817." *Goethe Jahrbuch.* Weimar: Hermann Böhlaus Nachfolger, 1993. 163–72.

———. *Goethe: The Poet and the Age.* Vol. 1. Oxford: Oxford UP, 1992.

Brady, Ronald. "Form and Cause in Goethe's Morphology." *Goethe and the Sciences: A Reappraisal.* Ed. Frederick Amrine et al. Dordrecht: D. Reidel, 1987. 257–300.

Brandeis, Arthur. "Auf Goethes Spuren von Vernoa bis Rom." *Chronik des Wiener Goethe Vereins* 16 (1902): 38–54.

Breithaupt, Fritz. *Jenseits der Bilder: Goethes Politik der Wahrnehmnung.* Freiburg: Rombach, 2000.

Brod, Max. *Heinrich Heine.* Amsterdam: Allert de Lange, 1934.

Brown, Jane. "The Renaissance of Goethe's Poetic Genius in Italy." *Goethe in Italy.* Ed. Gerhart Hoffmeister. Amsterdam: Rodopi, 1988. 77–93.

Buddensieg, Tilman. *Nietzsches Italien: Städte, Gärten und Paläste.* Berlin: Wagenbach, 2002.

Burgard, Peter, ed. *Nietzsche and the Feminine.* Charlottesville: U of Virginia P, 1994.

Butler, E. M. *Heinrich Heine: A Biography.* London: Hogarth, 1956.

———. *The Tyranny of Greece over Germany.* Boston: Beacon, 1958.

Calhoon, Kenneth. *Fatherland: Novalis, Freud, and the Discipline of Romance.* Detroit: Wayne State UP, 1992.

Carossa, Hans. "Aufzeichnungen aus Italien." *Sämtliche Werke.* Vol. 1. Frankfurt am Main: Insel, 1962. 793–936.

Casanova, Giacomo. *Storia della mia vita.* Vol. 4. Milan: Dall'Oglio, 1964.

Charcot, J. M. *Lecture on the Disease of the Nervous System Delivered at La Salpetrière.* Trans. George Siegerson. London: New Sydenham Society, 1877.

Cometa, Michele. "Goethe e i Siciliani. Gli incontri segreti del viaggio in Italia." *Goethe und Italien.* Palermo: Sellerio, 1996. 64–83.

Craig, Gordon. *Germany, 1866–1945.* Oxford: Oxford UP, 1978.

WORKS CITED

Culler, Jonathan. "Apostrophe." *The Pursuit of Signs*. Ithaca: Cornell UP, 1981. 135–54.

Davis, Whitney. "Winckelmann Divided: Mourning the Death of Art History." *Gay and Lesbian Studies in Art History*. Ed. Whitney Davis. New York: Harrington, 1994. 141–59.

De Azara, J. N. *Opere di Antonio Raffaello Mengs*. Bassano: A Spese Remondini di Venezia, 1783.

Del Caro, Adrian. "Symbolizing Philosophy: Ariadne and the Labyrinth." *Nietzsche Studien* 17 (1988): 125–57.

Deleuze, Gilles. *Difference and Repetition*. Trans. Paul Patton. New York: Columbia UP, 1994.

———. *Nietzsche and Philosophy*. Trans. Hugh Tomlinson. New York: Columbia UP, 1983.

de Man, Paul. *Blindness and Insight*. Minneapolis: U of Minnesota P, 1983.

———. "Genesis and Genealogy." *Allegories of Reading*. New Haven: Yale UP, 1979: 79–102.

Derks, Paul. *Die Schande der heiligen Päderastie. Homosexualität und Öffentlichkeit in der deutschen Literatur, 1750–1850*. Berlin: Rosa Winkel, 1990.

Derrida, Jacques. *Archive Fever: A Freudian Impression*. Trans. Eric Prenowitz. Chicago: U of Chicago P, 1996.

———. *Disseminations*. Trans. Barbara Johnson. Chicago: U of Chicago P, 1981.

———. *Ear of the Other*. Ed. and trans. Christie McDonald. New York: Schocken, 1985.

———. *Of Grammatology*. Trans. Gayatri Chakravorty Spivak. Baltimore: Johns Hopkins UP, 1976.

———. *Specters of Marx: The State of the Debt, the Work of Mourning, and the New International*. Trans. Peggy Kamuf. New York: Routledge, 1994.

De Seta, Cesare. *L'Italia del Grand Tour: da Montaigne a Goethe*. Napoli: Electa, 1992.

de Staël, Germaine. *Corinne, ou, L'Italie*. Paris: Firmin Didot, 1853.

Doueihi, Milad. "Nietzsche, Dio a Torino." *Nietzsche in Italy*. Stanford Italian Review 6.1–2 (1986): 209–25. Ed. Thomas Harrison.

Duden. Vol. 7. Ed. Günther Drosdowski. Mannheim: 1989.

Eckermann, Johann Peter. *Beyträge zur Poesie mit besonderer Hinweisung auf Goethe*. Berlin: Morawe und Scheffelt, 1911.

Edschmid, Kasimir. *Italienische Gesänge*. Darmstadt: Darmstadter Verlag, 1947.

Eisler, K. R. *Goethe: A Psychoanalytic Study*. 2 vols. Detroit: Wayne State UP, 1963.

Ewart, Felice. *Goethes Vater*. Hamburg: Leopold Voß, 1899.

WORKS CITED

Fernandez, Dominique. *Signor Giovanni*. Paris: Ballard, 1981.

Ferris, David. *Silent Urns: Romanticism, Hellenism, Modernity*. Stanford: Stanford UP, 2000.

Fink, Karl. *Goethe's History of Science*. Cambridge: Cambridge UP, 1991.

Fischer, Bernhard. "Kunstautonomie und Ende der Ikonographie: Zur historischen Problematik von 'Allegorie' und 'Symbol' in Winckelmanns, Moritz' und Goethes Kunsttheorie." *Deutsche Vierteljahrsschrift* 64.2 (1990): 247–77.

Forel, August. *The Sexual Question*. Trans. C. F. Marshall. New York: Medical Art Agency, 1922.

Frederiksen, Elke. "Der Blick in die Ferne: Zur Reiseliteratur von Frauen." *Frauen, Literatur, Geschichte: Schreibende Frauen vom Mittelalter bis zur Gegenwart*. Ed. Hiltrud Gnüg and Renate Möhrmann. Stuttgart: Metzler, 1985. 147–65.

Freese, Wolfgang. "Thomas Mann und seine Leser. Zum Verhältnis von Antifaschismus und Leseerwartung in 'Mario und der Zauberer.'" *Deutsche Vierteljahresschrift* 51 (1977): 659–75.

Freschi, Marino. "Il Cagliostro di Goethe." *Goethe und Italien*. Ed. Willi Hirdt and Birgit Tappert. Bonn: Bouvier, 2001. 92–111.

Freud, Sigmund. *Gesammelte Werke, Chronologisch geordnet*. Ed. Anna Freud. 17 vols. Frankfurt am Main: Fischer, 1940–52.

———. *The Origins of Psychoanalysis: Letters to Wilhelm Fliess. Drafts and Notes, 1887–1902*. Ed. Marie Bonaparte, Anna Freud, Ernst Kris. Trans. Eric Mosbacher and James Strachey. New York: Norton, 1954.

———. *Standard Edition of the Complete Psychological Works*. Ed. and trans. James Strachey. 24 vols. London: Hogarth, 1953–72.

Gasché, Rudolph. "Ecce Homo or the Written Body." *Looking After Nietzsche*. Ed. Laurence Rickels. Albany: SUNY P, 1990: 113–36.

Geller, Hans. *Deutsche Künstler in Rom. Von Raphael Mengs bis Hans von Márees (1741–1887). Werke und Erinnerungstätten*. Rome: Herder, 1961.

Geller, Jay. "The Aromatics of Jewish Difference; or, Benjamin's Allegory of Aura." *Jews and Other Differences*. Ed. Daniel Boyarin and Jonathan Boyarin. Minneapolis: U of Minnesota P, 1996. 203–53.

———. "Blood Sin: Syphillis and the Construction of Jewish Identity." *Faultline* 1 (1992): 21–48.

George, Stefan. *Werke*. Vol. 1. Munich: G. Bondi 1958.

Geulen, Eve. "Resistance and Representation: A Case Study of Thomas Mann's 'Mario and the Magician.'" *New German Critique* 68 (Spring–Summer 1996): 3–29.

Gilman, Sander. "Braune Nacht." *Nietzsche Studien: Internationales Jahrbuch für die Nietzsche Forschung*. Berlin: de Gruyter, 1972. 247–60.

---. *The Case of Sigmund Freud: Medicine and Identity at the Fin de Siècle.* Baltimore: Johns Hopkins UP, 1987.
---. *Goethe's Touch.* New Orleans: Tulane UP, 1988.
---. *The Jew's Body.* New York: Routledge, 1991.
---. *Jewish Self-Hatred: Anti-Semitism and the Hidden Language of the Jews.* Baltimore: Johns Hopkins UP, 1993.
---, ed. *Conversations with Nietzsche: A Life in the Words of His Contemporaries.* Trans. David Parent. Oxford: Oxford UP, 1987.
Gilman, Sander, ed. with J. Chamberlain. *Degeneration: The Dark Side of Progress.* New York: Columbia UP, 1995.
Glaser, Rudolf. *Goethes Vater.* Leipzig: Quelle und Meyer, 1929.
Goethe, Johann Caspar. *Viaggio in Italia (1740).* Ed. Arturo Farinelli. Rome: Reale Academia D'Italia, 1932.
---. *Reise durch Italien im Jahre 1740.* Trans. Albert Meier. Munich: C. H. Beck, 1988.
Goethe, Johann Wolfang von. *Briefe.* Ed. Rudolf Bach. Munich: Hanser, 1958.
---. *Briefe an Charlotte von Stein.* Ed. Jonas Fränkel. 3 vols. Berlin: Akademie Verlag, 1960–62.
---. *Goethes Briefe.* Ed. K. R. Mandelkow. 4 vols. Hamburg: C. Wegner, 1962.
---. *Hamburger Ausgabe in 14 Bänden.* Ed. Eric Trunz. Munich: C. H. Beck, 1982.
---. *Italian Journey.* Trans. W. H. Auden and Elizabeth Mayer. London: Penguin, 1962.
---. *Italienische Reise.* Ed. Peter Sprengel. Munich: Goldmann, 1974.
---. *Sämtliche Werke, Briefe, Tagebücher und Gespräche.* Ed. Dieter Borchmeyer et al. 40 vols. to date. Frankfurt am Main: Deutscher Klassiker Verlag, 1985–.
---. *Sämtliche Werke nach Epochen seines Schaffens. Münchner Ausgabe.* Ed. Karl Richter with Herbert Göpfert, Norbert Miller, and Gerhard Sauder. 24 vols. to date. Munich: Hanser, 1985–.
---. *Werke. Sophienausgabe.* 143 vols. in 4 sections. Weimar: Böhlhaus, 1887–1919.
Gottlieb, Susannah Young-ah. *Regions of Sorrow: Anxiety and Messianism in Hannah Arendt and W. H. Auden.* Stanford: Stanford UP, 2003.
Gould, Robert. "Goethes Skizzen zu einer Schilderung Winckelmanns: Biography in a Revolutionary Age." *German Life and Letters* 47.2 (1994): 152–66.
Goux, Jean-Joseph. *Oedipus, Philosopher.* Trans. Catherine Porter. Stanford: Stanford UP, 1993.
Grimm, Gunter, Ursula Breymayer, and Walter Erhart. *Ein Gefühl von freierem Leben: deutsche Dichter in Italien.* Stuttgart: Metzler, 1990.

WORKS CITED

Grossman, Lionel. "Death in Trieste." *Journal of European Studies* 22:3[87] (1992): 207–40.

Grözinger, Elvira. "Die doppelte Buchhaltung. Einige Bemerkung zu Heines Verstellungstrategien in den 'Florentinische Nächte.'" *Heine Jahrbuch*. Hamburg: Hoffman and Campe, 1979. 65–76.

Grundlehner, Philip. *The Poetry of Friedrich Nietzsche*. New York: Oxford UP, 1986.

Gundolf, Friedrich. *Goethe*. Darmstadt: Wissentschaftliche, 1963.

Gustafson, Susan. "From Werther to Amazons: Cross-Dressing and Male-Male Desire." *Unwrapping Goethe's Weimar: Essays in Cultural Studies and Local Knowledge*. Ed. B. Henke, S. Kord, and S. Richter. Rochester: Camden House, 2000. 166–90.

Haarhaus, Julius. *Auf Goethes Spuren in Italien*. 3 vols. Leipzig: C. G. Naumann, 1896–97.

Hacks, Peter. *Ein Gespräch im Hause von Stein über den abwesenden Herrn von Goethe*. Berlin: Aufbau, 1974.

Hagelstange, Rudolf. "Venezianisches Credo." *Gast der Elemente*. Köln: Kiepenhauer and Witsch, 1972. 9–28.

Hamacher, Werner. "The Promise of Interpretation: Reflections on the Hermeneutical Imperative in Kant and Nietzsche." *Looking After Nietzsche*. Ed. Laurence Rickels. Albany: SUNY P, 1990. 19–49.

Härle, Gerhard. "*Heimsuchung und süßes Gift*": *Erotik und Poetik bei Thomas Mann*. Frankfurt am Main: Fischer, 1992.

Hatfield, Henry. *Winckelmann and His German Critics, 1755–1781: A Prelude to the Classical Age*. New York: King's Crown, 1943.

Haufe, Eberhard, ed. *Deutsche Briefe aus Italien von Winckelmann bis Gregorovius*. Leipzig: Koehler and Amelang, 1987.

Heidegger, Martin. *Nietzsche*. Trans. David Ferrell Krell. 2 vols. San Francisco: HarperCollins, 1991.

Heine, Heinrich. *Briefe*. Ed. F. Hirth. Vol. 1. Munich: G. Muellen, 1914–20.

———. *Historisch-Kritische Gesamtausgabe der Werke*. Ed. Manfred Windfuhr. 16 vols. to date. Hamburg: Hoffman and Campe, 1973–.

———. *The Journey to Italy*. Trans. Charles Leland. New York: Marsilio, 1998.

———. *Säkularausgabe: Werke, Briefwechsel, Lebenszeugnisse*. Ed. Fritz Mende and Christa Stöcker. Vol. 9. Berlin: Akademie Verlag, 1994.

Heinse, Wilhelm. *Ardinghello und die glückseligen Inseln*. Kritische Studienausgabe. Ed. Max Baeumer. Stuttgart: Reklam, 1975.

———. *Sämtliche Werke*. Ed. Carl Schüddenkopf and Albert Leitzmann. 10 vols. Leipzig, 1902–25.

Hermand, Jost. *Der frühe Heine: Ein Kommentar zu den Reisebildern*. Munich: Winkler, 1976.

Hexter, Ralph. "Poetic Reclamation and Goethe's Venetian Epigrams." *Mod-

ern Language Notes 96.3 (1981): 526–55.

Hitler, Adolf. *Mein Kampf.* Trans. Ralph Mannheim. Boston: Houghton Mifflin, 1943.

Hochmeister, Gretchen. *Italy in the German Literary Imagination: Goethe's Italian Journey and Its Reception by Eichendorff, Platen and Heine.* Rochester: Camden House, 2002.

Hoffman, Charles. "Opposition und innere Emigration: Zwei Aspekte anderen Deutschlands." *Exil und innere Emigration II: Internationale Tagung in St. Louis.* Ed. Peter Hohendahl and Egon Schwarz. Frankfurt am Main: Athenäum: 1973. 119–40.

Hoffmeister, Gerhart, ed. *Goethe in Italy.* Amsterdam: Rodopi, 1988.

Hofmannsthal, Hugo von. *Gesammelte Werke in Einzelausgaben.* Frankfurt am Main: Suhrkamp 1951. Prosa 4.

Hohendahl, Peter. "The Emblematic Reader: Heine and French Painting." *Paintings on the Move: Heinrich Heine and the Visual Arts.* Ed. Susan Zantop. Lincoln: U of Nebraska P, 1989. 9–92.

Hohendahl, Peter, and Sander Gilman, eds. *Heinrich Heine and the Occident: Multiple Identities and Multiple Receptions.* Lincoln: U of Nebraska P, 1991.

Höller, Hans. "Ingeborg Bachmann's Rom-Poetik." *Il Viaggio a Roma.* Ed. Flavia Arzeni. Rome: Storia di Letteratura, 2001. 83–91.

Holub, Robert. "From the Pedestal to the Couch: Goethe, Freud and Jewish Assimilation." *Goethe in German Jewish Culture.* Ed. Klaus Berghahn and Jost Hermand. Rochester: Camden House, 2001. 104–22.

———. "Heine's Sexual Assaults: Towards a Theory of the Total Polemic." *Monatshefte* 3.4 (1991): 415–28.

———. *Heinrich Heine's Reception of German Grecophilia: The Function and Application of the Hellenic Tradition in the First Half of the Nineteenth Century.* Heidelberg: Winter, 1981.

Houben, H. H., ed. *Gespräche mit Goethe in den letzten Jahren seines Lebens. Von Johann Peter Eckermann.* Wiesbaden: F. A. Borckhaus, 1913.

Irigaray, Luce. *Marine Lover of Friedrich Nietzsche.* Trans. Gillian Gill. New York: Columbia UP, 1991.

Jacobs, Carol. *Uncontainable Romanticism: Shelly, Brönte, Kleist.* Baltimore: Johns Hopkins UP, 1989.

Jaszi, Andrew. *Entzweiung und Vereinigung. Goethes Symbol. Weltanschauung.* Heidelberg: Stiehm, 1973.

Jensen, Wilhelm. "Drei unveröffentliche Briefe: Zur Geschichte von Freuds Gradiva Analyse." *Die Psychoanalytische Bewegung* 1 (1929): 206–11.

———. "Gradiva: A Pompeiian Fantasy." Trans. Helen M. Downy. *Sigmund Freud, Delusion and Dream and Other Essays.* Ed. Philip Rieff. Boston: Beacon, 1956.

WORKS CITED

Jessen, Karl Detlev. *Heinses Stellung zur bildenden Kunst und ihrer Ästhetik.* Berlin: Mayer and Muller, 1901.

Jucker, Rolf. "Der Römische Karnival: Mit Gesetz und Ordnung gegen Gedränge." *Goethe Jahrbuch.* Weimar: Hermann Böhlhaus Nachfolger, 1994. 35–44.

Justi, Carl. *Winckelmann und seine Zeitgenossen.* 3 vols. Leipzig: Vogel, 1898.

Kaplan, Caren. *Questions of Travel: Postmodern Discourses of Displacement.* Durham: Duke UP, 1996.

Kaufmann, Thomas. "Before Winckelmann: Toward the Origins of the Historiography of Art." *Knowledge, Science and Literature in Early Modern Germany.* Ed. Stephan Schindler. Chapel Hill: U of North Carolina P, 1996. 71–89.

Kaufmann, Walter, trans. and ed. *The Portable Nietzsche.* New York: Viking, 1968.

———, trans. *On the Genealogy of Morals. Ecce Homo.* New York: Vintage, 1969.

Keller, Werner, ed. *Goethe Jahrbuch.* Weimar: Böhlhaus Nachfolger, 1988, 1993.

Kiefer, Klaus. *Wiedergeburt und neues Leben: Aspekte des Strukturwandels in Goethes "Italienische Reise."* Bonn: Bouvier, 1978.

Kittler, Friedrich. *Discourse Networks.* Trans. Michael Metteer with Chris Cullens. Stanford: Stanford UP, 1990.

Koeppen, Wolfgang. *Tauben im Gras, Das Treibhaus, Tod in Rom.* Stuttgart: Scherz und Goverts, 1969.

Kofmann, Sarah. "Fantastical Genealogy: Nietzsche's Family Romance." *Nietzsche and the Feminine.* Ed. Peter Burgard. Charlottesville: U of Virginia P, 1994. 35–52.

———. *Freud and Fiction.* Trans. Sarah Wykes. Oxford: Polity, 1990.

Koopman, Helmut, ed. *Thomas Mann Handbook.* Frankfurt am Main: Alfred Kröner, 1990.

Kraft, Werner. "Die schöne Mailänderin." *Goethe: Wiederholte Spiegelungen aus fünf Jahrzehnten.* Munich: Edition Text + Kritik, 1986. 75–86.

Krell, David Ferrell. "Consultations with the Paternal Shadow: Gasché, Derrida, and Klossowski on *Ecce Homo.*" *Nietzsche in Italy. Stanford Italian Review* 6 (1986): 229–42. Ed. Thomas Harrison.

Kruse, Joseph. "'Heinrich Heine über Ludwig Börne': Börne Bild und Heine Forschung." *"Die Kunst—eine Tochter der Zeit": Neue Studien zu Ludwig Börne.* Bielefeld: Aisthesis, 1988. 32–50.

Kunze, Max. "Affinitäten über zeitliche Grenzen: Klassizistische Kunst theorien der Antike und ihre Rezeption zu Beginn der deutschen Klassik durch J. J. Winckelmann." *Proceedings of the XIIth Congress of the International Comparative Literature Association.* Ed. Roger Bauer et al.

WORKS CITED

Munich: Ludicom, 1990. 355–63.
Kuzniar, Alice, ed. *Outing Goethe and His Age.* Stanford: Stanford UP, 1996.
Lacoue-Labarthe, Philippe. *Typography: Mimesis, Philosophy and Politics.* Ed. and trans. Christopher Fynsk. Cambridge: Harvard UP, 1989.
Lange, Victor. "Goethe's Journey in Italy: The School of Seeing." *Goethe in Italy.* Ed. Gerhart Hoffmeister. Amsterdam: Rodopi, 1988. 147–58.
Laplanche, Jean. *Life and Death in Psychoanalysis.* Trans. Jeffrey Mehlman. Baltimore: Johns Hopkins UP, 1970.
Leneaux, G. F. "'Mario und der Zauberer': The Narration of Seduction or the Seduction of Narration." *Orbis Litterarum* 40.5 (1985): 327–47.
Lind, L. R., ed. and trans. *Johann Wolfgang von Goethe's Roman Elegies and Venetian Epigrams: A Bilingual Text.* Lawrence: U of Kansas P, 1974.
Livorsi, Franco. "Ma Nietzsche non era Naziste." *Rivista Mensile di Politica e Letteratura* 48.3 (1992): 103–11.
Lukács, Gregor. *Goethe and His Time.* Trans. Robert Anchor. London: Merlin, 1968.
———. "Thomas Mann auf der Suche nach dem Bürger." *Werke.* Vol. 7. Neuwied: Luchterhand, 1964. 505–34.
Lunn, Eugene. "Tales of Liberal Disquiet: Mann's Mario and the Magician and Interpretations of Fascism." *Literature and History* 11.1 (1985): 77–100.
Lüth, Erich. *Der Bankier und der Dichter: Zur Ehrenrettung des großen Salomon Heine.* Hamburg: Tambour, 1964.
MacLeod, Catriona. *Embodying Ambiguity: Androgyny and Aesthetics from Winckelmann to Keller.* Detroit: Wayne State UP, 1998.
Maisak, Petra. "Wir passen zusammen als hätten wir zusammen gelebt. Goethe und Tischbein in Italien." *Johann Heinrich Wilhelm Tischbein. Goethes Maler und Freund.* Ed. Hermann Mildenberger. Vol. 1. Neumünster: Wachholz, 1986. 17–50.
Manger, Klaus, ed. *Italienbeziehungen des klassischen Weimar.* Tübingen: Niemeyer, 1997.
Mann, Thomas. *Dichter über ihre Dichtungen. Thomas Mann.* Ed. Hans Wysling with Marianne Fischer. Frankfurt am Main: Fischer, 1979.
———. *Gesammelte Werke in 12 Bänden.* Frankfurt am Main: Fischer, 1960.
———. *Kommentar zu sämtlichen Erzählungen.* Ed. Hans Rudolph Vaget. Munich: Winkler, 1984. 220–50.
———. *Lotte in Weimar: The Beloved Returns.* Trans. H. T. Lowe-Porter. Berkeley: U of California P, 1968.
———. *Stories of Three Decades.* Trans. H. T. Lowe-Porter. New York: Modern Library, 1936.
Marcuse, Ludwig. *Heinrich Heine: Melancholiker, Streiter in Marx, Epikureer.* Zürich: Diogenes, 1980.

WORKS CITED

Marcuse, Max. "Die christlichjüdische Mischele." *Sexual-Probleme* 7 (1912): 691–708.
Mauss, Marcel. *A General Theory of Magic*. Trans. Robert Brain. London: Routledge and Kegan Paul, 1972.
Mayer, Hans. *Outsiders: A Study in Life and Letters*. Trans. Dennis Sweet. Cambridge: MIT P, 1982.
Mayer-Kalkus, Reinhart. "Werthers Krankheit zum Tode: Pathologie und Familie in der Empfindsamkeit." *Urszenen: Literaturwissenschaft als Diskursanalyse und Diskurskritik*. Ed. Friedrich Kittler and Horst Turk. Frankfurt am Main: Suhrkamp, 1977.
Mayr, Josef. "Heinrich Heines Cholerabericht: Eine Stellungnahme des Künstlers zu seiner Zeit." *Quaderni di lingue e letterature* 1 (1976): 151–60.
McGrath, William. *Freud's Discovery of Psychoanalysis: The Politics of Hysteria*. Ithaca: Cornell UP, 1986.
Mende, Fritz. "Heinrich Heine an einen Goetheaner." *Studi Germanici* 10 (1972): 343–54.
Mieth, Günther. "Goethes Wiedergeburt in Italien und seine lyrische Leistung." *Goethe Jahrbuch*. Weimar: Hermann Böhlhaus Nachfolger, 1994. 11–21.
Miller, J. Hillis. "Ariadne's Thread: Repetition and the Narrative Line." *Critical Inquiry* 3 (1976): 57–77.
Miller, J. Hillis, and Manuel Asensi. *Black Holes: Or, Boustrophedonic Reading*. Trans. Mabel Richart. Stanford: Stanford UP, 1999.
Miller, Norbert. *Der Wanderer: Goethe in Italien*. Munich: Hanser, 2002.
Möbius, P. J. *Über das Pathologische bei Goethe*. Leipzig: J. A. Barth, 1898.
Mohr, Heinrich. *Wilhelm Heinse. Das erotisch-religiöse Weltbild und seine naturphilosophischen Grundlagen*. Munich: Fink, 1971.
Molnár, Gezá von. "The Conditions of Faust's Wager and its Resolution in the Light of Kantian Ethics." *Publications of the English Goethe Society* 51 (1981): 48–80.
Moritz, Karl Philipp. *Versuch einer deutschen Prosodie in Werke*. Vol. 3. Ed. Horst Günther. Frankfurt am Main: Insel, 1981.
Morris, Leslie. *"Ich suche ein unschuldiges Land." Reading History in the Poetry of Ingeborg Bachmann*. Tübingen: Stauffenburg, 2001.
Mühsam, Erich. "Mignon 1925," *Italien-Dichtung II*. Ed. Gunter Grimm. Frankfurt am Main: Suhrkamp, 1988. 278.
Müller, Bertha, trans. *Goethe's Botanical Writings*. Woodbridge, CT: Oxbow, 1989.
Müller-Sievers, Helmut. "Writing Off: Goethe and the Meantime of Erotic Poetry." *Modern Language Notes* 108 (1993): 427–45.
Mussolini, Benito. *Memoirs, 1942–1943*. Trans. Frances Lobb. London: George Weidenfeld and Nicolson, 1949.

WORKS CITED

Nägele, Rainer. *Reading After Freud*. New York: Columbia UP, 1987.
Nancy, Jean-Luc. "Nietzsche's Thesis on Teleology," *Looking After Nietzsche*. Ed. Laurence Rickels. Albany: SUNY P, 1990. 49–68.
———. "Dei Paralysis Progressiva." *Nietzsche in Italy. Stanford Italian Review* 6.6 (1986): 209–25. Ed. Thomas Harrison.
Nicolai, Gustav. *Italien wie es wirklich ist. Bericht über eine merkwürdige Reise in den hesperischen Gefilden, als Warnungstimme für alle, welche sich dahin sehnen*. Leipzig: Wigand: 1834.
Nietzsche, Friedrich. *Kritische Gesamtausgabe*. Ed. Giorgio Colli and Mazzino Montinari. Vol. 4/3. Berlin: de Gruyter, 1967.
———. *Kritische Studienausgabe*. Ed. Giorgio Colli and Mazzino Montinari. 15 vols. Munich: de Gruyter, 1988.
———. *Sämtliche Briefe*. Ed. Giorgio Colli and Mazzino Montinari. Munich: de Gruyter, 1987.
Nohl, Johannes. *Goethe als Maler Moeller in Rom*. Weimar: Gustav Kiepenhauer, 1955.
Nölke, Mathias. "Goethe as Kunstmittel: Heines Argumentation mit einem literarischen Muster." *Heine Jahrbuch*. Hamburg: Hoffman and Campe, 1994. 82–98.
Northcutt, Kenneth. *Goethe and His Publishers*. Chicago: U of Chicago P, 1996.
Oehlenschläger, Eckhardt. "Goethes Schrift 'Das Römische Karnival.' Ein Versuch über die Formalisierbarkeit des Tumultes," *Goethe und Italien*. Ed. Willi Hirdt and Birgit Tappert. Bonn: Bouvier, 2001. 221–34.
Ortheil, Hanns-Josef. *Faustinas Küsse*. Munich: Luchterhand, 1988.
Osterkamp, Ernst. "Zierde und Beweis: Über die Illustrationsprinzipien von J. J. Winckelmanns *Geschichte der Kunst des Althertums*." *Germanisch-Romanische Monatschrift* 39.3 (1989): 301–25.
Pabel, K. *Heines Reisebilder: Ästhetisches Bedürfnis und politisches Interesse am Ende der Kunstperiode*. Munich: Fink, 1977.
Papini, Giovanni. "A Visit to Freud," *Freud as We Knew Him*. Ed. Hendrik Ruitenback. Detroit: Wayne State UP, 1973.
Parker, Kevin. "Winckelmann, Historical Difference, and the Problem of the Boy." *Eighteenth-Century Studies* 25 (1992): 523–44.
Pelzel, Thomas. "Winckelmann, Mengs and Casanova: A Reappraisal of a Famous Eighteenth-Century Forgery." *Art Bulletin* 54 (1972): 300–15.
Perraudin, Michael. "The Young Heine as a Biedermeier Epigone," *Heine Jahrbuch*. Hamburg: Hoffman and Campe, 1984. 22–40.
Peters, George. "So glücklich, so hingehaucht, so ätherisch. Heines Beurteilung des 'West-östlichen Divan.'" *Heine Jahrbuch*. Hamburg: Hoffman und Campe: 1983. 30–46.
Pfotenhauer, Helmut. "Der schöne Tod. Über einige Schatten in Goethes Ital-

ienbild." *Jahrbuch des Freien Deutschen Hochstifts* (1987): 134–57.

———. "Winckelmanns Gedancken über die Nachahumung der griechischen Wercke in der Mahlerey und Bildhauer Kunst: Ein Kommentar." *Confronto Letterario: Quaderno del Dipartimento di Lingue e Letterature Straniere Moderne dell' Università di Pavia* 12.23 (1995): 23–40.

Platen, August. *Der Briefwechsel des Grafen August von Platen.* Ed. Ludwig von Scheffer and Paul Bornstein. 4 vols. Munich: G. Mueller, 1911–31.

———. *Werke.* Ed. G. A. Wolff and V. Schweizer. 2 vols. Leipzig: Bibliographisches Institut, 1895.

Podach, E. F. *The Madness of Nietzsche.* Trans. F. A. Voigt. London: Putnam, 1931.

Pongs. Ulrich. "Was ist Klassich? Zur Antike Rezeption Heinrich Heines." *Heine Jahrbuch.* Hamburg: Hoffman and Campe, 1991. 152–63.

Potts, Alex. *Flesh and the Ideal: Winckelmann and the Origins of Art History.* New Haven: Yale UP, 1994.

———. "Greek Sculpture and Roman Copies I: Anton Raphael Mengs and the Eighteenth Century." *Journal of the Warburg and Cortauld Institutes* 43 (1980): 150–73.

Prawer, S. S. *Heine's Jewish Comedy: A Study of His Portraits of Jews and Judaism.* Oxford: Clarendon, 1983.

Pruys, Hugo. *Die Liebkosungen des Tigers.* Berlin: Edition q, 1987.

Reed, T. J., ed. and trans. *Goethe: The Flight to Italy. Diary and Selected Letters.* Oxford: Oxford UP, 1999.

Reeves, Nigel. *Heinrich Heine: Poetry and Politics.* Oxford: Oxford UP, 1994.

Reinhardt, Karl. "Nietzsches Klage der Ariadne." *Die Antike* 11 (1935): 85–109.

Rella, Franco. *Il silenzio e la parole. Il pensiero nel tempo della crisi.* Milan: Feltrinelli, 1984.

Richter, Simon. *Laocoon's Body and the Aesthetics of Pain.* Detroit: Wayne State UP, 1992.

———. "Winckelmann's Progeny." *Outing Goethe and His Age.* Ed. Alice Kuzniar. Stanford: Stanford UP, 1996. 33–46.

Rickels, Laurence. "Wilhelm Heinse's Critique of Enlightenment Semiotics." *Papers in the History of Linguistics.* Ed. Hans Aarsleff et al. Amsterdam: Benjamins, 1987. 365–75.

Ricoeur, Paul. *Freud and Philosophy.* Trans. Dennis Savage. New Haven: Yale UP, 1970.

Ringler, Susan. "Heines 'Florentinische Nächte': The Autograph Manuscipt." *Heine Jahrbuch.* Hamburg: Hoffman and Campe, 1973. 41–70.

Ritter-Santini, Leo. "Im Garten der Geschichte." *Goethe Jahrbuch.* Weimar: Hermann Böhlhaus Nachfolger, 1988. 115–27.

Ronell, Avital. *Dictations: On Haunted Writing.* Lincoln: U of Nebraska P, 1986.

WORKS CITED

———. "Hitting the Streets: Ecce Fama." *Nietzsche in Italy. Stanford Italian Review* 6.2 (1988): 119–40.
Rose, William. *Heinrich Heine: Two Studies of His Thought and Feeling.* Oxford: Clarendon, 1956.
Rüdiger, Horst. "Zur Komposition von Goethes 'Zweitem römischem Aufenthalt'. Das melodramatische Finale und die Novelle von der schönen Mailänderin." *Aspekte der Goethezeit.* Ed. Stanley Korngold et al. Göttingen: Vandenhoeck and Ruprecht, 1977. 97–114.
Sammons, Jeffrey. *Heinrich Heine: A Modern Biography.* Princeton: Princeton UP, 1979.
Sandor, Andreas. "Auf der Suche nach der vergehenden Zeit: Heines 'Florentinische Nächte' und das Problem der Avant Garde." *Heine Jahrbuch.* Hamburg: Hoffman and Campe, 1980. 101–26.
Scheuermann, Konrad, and Ursula Bongaerts-Schomer, eds. *. . . endlich in dieser Haupstadt der Welt angelangt. Goethe in Rom.* 2 vols. Mainz: Phillip von Zabern 1997.
Schiller, Friedrich. *On the Aesthetic Education of Man in a Series of Letters.* Ed. E. Wilkinson and L. A. Willoughby. Oxford: Clarendon, 1982.
Schmidt, E., ed. "Tagebücher und Briefe Goethes aus Italien an Frau von Stein und Herder." *Schriften der Goethe Gesellschaft.* Vol 2. Weimar: Böhlhaus, 1886.
Schmidt, Gary. *The Nazi Abduction of Ganymede: Representations of Male Homosexuality in Postwar German Literature.* Oxford: Peter Lang, 2003.
Schneider, Manfred. *Die kranke schöne Seele der Revolution.* Frankfurt am Main: Syndikat, 1980.
Schneider, Reinhold. *Lyrik. Gesammelte Werke.* Vol. 5. Frankfurt am Main: Insel, 1981.
Schnell, Ralf. *Literarische Innere Emigration, 1933–45.* Stuttgart: Metzler, 1976.
Schorske, Carl. *Fin-de-Siècle Vienna: Politics and Culture.* New York: Vintage, 1981.
Schulz, Gerhard. "Goethes Italienische Reise." *Goethe in Italy.* Ed. Gerhart Hoffmeister. Amsterdam: Rodopi, 1988. 1–19.
Schur, Max. *Freud: Living and Dying.* New York: International Universities Press, 1972.
Schwarz, Egon. "Fascism and Society: Remarks on Thomas Mann's Novella *Mario and the Magician.*" *Michigan Germanic Studies* 2 (1976): 47–67.
Seeba, Hinrich. "Johann Joachim Winckelmann: Zur Wirkungsgeschichte eines 'unhistorischen' Historikers zwischen 'Ästhetik und Geschichte.'" *Deutsche Vierteljahrsschrift* 56 (September 1982): 168–201.
Serres, Michel. *Rome: Book of Foundations.* Trans. Felicia McCarren. Stanford:

WORKS CITED

Stanford UP, 1991.
Seume, Johann Gottfried. *Prosaschriften.* Ed. Werner Kraft. Köln: J. Melzer, 1962.
———. *Spaziergang nach Syrakus im Jahre 1802.* Ed. Albert Meier. Munich: dtv, 1985.
Shapiro, Gary. *Nietzschean Narratives.* Bloomington: Indiana UP, 1989.
Shattuck, Kathryn. "An Ancient Masterpiece of a Master's Forgery." *New York Times.* 18 April 2005. E5.
Shell, Marc. *Money, Language and Thought.* Baltimore: Johns Hopkins UP, 1993.
Showalter, Elaine. "Corinne as an Autonomous Heroine." *Germaine de Staël: Crossing the Borders.* Ed. M. Outwirth et al. New Brunswick: Rutgers UP, 1991. 180–95.
Sichtermann, Helmut. "Der Wiederhergestellte Laokoon." *Gymnasium* 70.3 (1963): 193–211.
Silverman, Kaja. *Male Subjectivity at the Margins.* New York: Routledge, 1992.
Sprengel, Peter. "Sizilien als Mythos. Das Sizilienbild in Goethes 'Italienischer Reise.'" *Un paese indicibilmente bello: il "Viaggio in Italia" di Goethe e il mito della Sicilia.* Ed. Albert Meier. Palermo: Sellerio, 1987. 158–79.
Stone, Jennifer. "Italian Freud: Gramsci, Giula Schucht, and Wild Analysis." *October* 28 (Spring 1984): 105–24.
Swales, Martin, and Erika Swales. *Reading Goethe: A Critical Introduction to the Literary Work.* Suffolk: Camden House, 2002.
Sweet, Dennis. M. "The Personal, the Political, and the Aesthetic: Johann Joachim Winckelmann's German Enlightenment Life." *The Pursuit of Sodomy: Male Homosexuality in Renaissance and Enlightenment Europe.* Ed. Kent Gerard and Gert Hekma. New York: Harrington, 1989. 147–62.
Szondi, Peter. *Poetik und Geschichtsphilosophie.* Frankfurt am Main: Suhrkamp, 1991.
Teuchert, Hans Joachim. *August Graf von Platen in Deutschland: Zur Rezeption eines umstrittenen Autors.* Bonn: Bouvier, 1980.
Theisen, Bianca. "Rhythms of Oblivion." *Nietzsche and the Feminine.* Ed. Peter Burgard. Charlottesville: U of Virginia P, 1994. 82–103.
Tobin, Robert. "In and Against Nature." *Outing Goethe and His Age.* Ed. Alice Kuzniar. Stanford: Stanford UP: 1996. 94–110.
———. *Warm Brothers: Queer Theory and the Age of Goethe.* Philadelphia: U of Pennsylvania P, 2000.
Uhlig, Ludwig. *Griechenland als Ideal: Winckelmann und seine Rezeption in Deutschland.* Tübingen: Narr, 1988.
Urban, Bernd, et al, eds. *Der Wahn und die Träume in W. Jensens "Gradiva" mit dem Text der Erzählung von W. Jensen.* Frankfurt am Main: Fischer,

WORKS CITED

1989.
Vaget, H. R. *Erotic Poems*. New York: Oxford UP, 1994.
Valadier, Paul. "Dionysus versus the Crucified." *The New Nietzsche*. Ed. David Allison. Cambridge: MIT P, 1990. 247–61.
Vernant, Jean Pierre, and Pierre Vidal-Naquet. *Myth and Tragedy in Ancient Greece*. Trans. Janet Lloyd. New York: Zone, 1988.
Verrienti, Virginia. "Roma, luogo della 'Innere Emigration', tappa d'esilio." *Il Viaggio a Roma da Freud a Pina Bausch*. Ed. Flavia Arzeni. Rome: Edizioni di Storia e Letteratura, 2001. 63–82.
Volger, O. "Goethes Vater." *Müncher Allgemeine Zeitung*. Beilage. 25 May 1882. 145.
Weber, Sam. *Legend of Freud*. Minneapolis: U of Minnesota P, 1982. 120–32.
Weidenbaum, Inge von. "Ingeborg Bachman: sie lebte gefährlich, wie man es aus Liebe tut." *Il Viaggio a Roma*. Ed. Flavia Arzeni. Rome: Edizioni di Storia e Letterature, 2001: 93–100.
Weigel, Sigrid. "Malina." *Interpretationen: Werke von Ingeborg Bachmann*. Stuttgart: Reclam, 2002. 220–46.
Weissberg, Liliane. *Geistersprache: Philosophischer und literarischer Diskurs im späten achtzehnten Jahrhundert*. Würzburg: Königshausen und Neumann, 1990.
Wellbery, David. *The Specular Moment: Goethe's Early Lyric and the Beginnings of Romanticism*. Stanford: Stanford UP, 1996.
Werner, Michael, ed. *Begegnungen mit Heine in Fortführung von H. H. Houbens' Gespräche mit Heine*. Hamburg: Hoffman and Campe, 1973.
Wilkinson, Elizabeth. "Torquato Tasso: The Tragedy of the Poet." *Goethe: Poet and Thinker*. Ed. with E. M. Willoughby. London: Arnold, 1962. 75–95.
Winckelmann, Johann Joachim. *Briefe*. Ed. Walter Rehm. Berlin: de Gruyter, 1952–57.
———. *Gedanken über die Nachahmung der Griechischen Wercke in der Mahlerey und Bildhauer Kunst*. Dresden: In der Walterischen Buchhandlung, 1756.
———. *Geschichte der Kunst des Altherthums*. Dresden: In der Walterischen Buchhandlung 1764. Also, Vienna: 1776.
———. *Kleine Schriften, Vorreden, Entwürfe*. Ed. Walter Rehm. Berlin: de Gruyter, 1968
———. *Versuch einer Allegorie besonders für die Kunst*. Leipzig: Dressel, 1866.
———. *Werke*. Ed. C. L. Fernow with Heinrich Meyer and Johann Schulze. 11 vols. Dresden: In der Walterischen Buchhandlung, 1808–25.
Windfuhr, Manfred. "Zensur und Selbstzensur nach dem Bundestagsbeschuß. Heines 'Florentinische Nächte.'" *Das Junge Deutschland*. Ed. J. A. Kruse and B. Kortländer. Hamburg: Hoffman and Campe, 1985. 218–37.

WORKS CITED

Zapperi, Roberto. *Una vita inkognito: Goethe a Roma*. Torino: Bollati Boringhieri, 2000.

Zeller, Hans. "Wilhelm Heinses Italienreise." *Deutsche Vierteljahrsschrift* 42 (1968): 23–54.

Ziegler, Edda, ed. *Literarische Zensur in Deutschland 1819–48: Materialien, Kommentare*. Munich: Hanser, 1983.

Ziolkowski, Theodore. "Form als Protest. Das Sonett in der Literatur des Exils und der Inneren Emigration." *Exil und Innere Emigration*. Ed. Reinhold Grimm and Jost Hermand. Frankfurt: Athenäum, 1972. 153–72.

Index

Adorno, Theodor, 121, 250n.50
Albani, Cardinal, 42, 60, 62, 135
Alleman, Beda, 152, 154
Amalia, Anna, 53, 189
Arcangeli, Angelo, 42, 48, 242n.50.
 See also Winckelmann, Johann
 Joachim, death/murder of
Arendt, Hannah, 201, 203, 261n.57;
 Jew as Pariah, 138, 139
Arzeni, Bruno, "Platen und Italien,"
 197
August, Karl, 188, 190, 207
Austria, 1, 142

Bachmann, Ingeborg, 250n.52,
 275n.3; "Das erstgeborene
 Land," 1–2, 16, 223–24, 233n.7
Balsamo, Joseph, family of. *See*
 Cagliostro family
Baudrillard, Jean, 215, 216, 248n.29,
 273nn.56, 57
Bearded Dionysius, sculpture of,
 147–48, 164
Bell, Matthew, 67–68, 69
Belli, Giovanni, 45
Benjamin, Walter, 64, 234n.21;
 "Naples," 22, 40; *Tragic Drama,*
 27

Berendis, Dietrich, 21
Bergengruen, Werner, *Römisches*
 Errinerungsbuch, 199
Blackwell, Eric, 215
Böhme, Harmut, 69, 70, 71, 74
Bologna, 88
Bowman, Curtis, 28
Boyle, Nicholas, 20
Brandes, Georg, 151
Braunschweig, Duke of, 132
Brown, Jane, 185, 245n.7, 254n.32,
 266n.1
Buchenwald, 235n.25
Butler, E. M., 17–18, 122; *Tyranny,*
 23

Cagliostro family, 98–100, 102, 103,
 107, 142
Calhoon, Kenneth, *Fatherland,* 143,
 144, 145, 146
Caravaggio, 55
Carossa, Hans, "Aufzeichnungen aus
 Italien," 199–203, 223
Casa di Goethe, 200–201, 202,
 223
Casanova, Giovanni, 24, 31
Charcot, J. M., 166

INDEX

Deleuze, Gilles, 150, 250n.51
De Man, Paul, *Blindness*, 31
Derrida, Jacques, 234n.21; *Archive Fever*, 178–79
De Staël, Madame, *Corinne, ou, L' Italie*, 4, 129

Eckermann, Johann Peter, 53, 105, 132, 211
Edschmid, Kasimir, *Italienische Gesänge*, 199
Eisler, K. R., 90, 91
Emigration, inner, 15, 199, 203

Faustina. *See under* Goethe, Johann Wolfgang von
Fernandez, Dominique, 42
Fließ, Wilhelm, 164, 165
Fontane, Theodor, 196–97
Förster-Nietzsche, Elizabeth, 13, 148, 158, 163, 164, 175, 263n.8
French Revolution, 196
Freud, Sigmund: and antiquity, 170; and anti-Semitism, 145, 164, 169, 173; and art, 144; and Austria, 172; and authority, 145, 146, 164, 168, 169, 170, 173, 174; and Bachmann, 229; and biology, 165, 167; and B'nai B'rith, 164; and body, 147; career of, 164, 165, 168, 170, 172; and castration, 13, 173, 257n.20; and Catholicism, 13, 169; and censorship, 146, 168, 181; and childhood, 174, 175; and Christian wish-fulfillment, 145, 146, 147; and concealment, 178; and conservatism, 169; and cutting, 13, 14–15, 146, 181; and death drive, 165–66, 182; and debt, 145; and degeneracy, 14; and demon, 174; and desire, 165, 177; and distortion, 146, 167, 168, 169, 172, 174, 175, 176, 177, 179, 182; and doppelgänger, 174; and dream of Thun, 169; and dream of uncle, 168; and dreams, 144, 167–68, 170, 171–72, 174–75; and erasure, 170, 181; and Eros, 182; and exile, 174, 183; family romance in, 143, 145, 146, 168, 172, 180; and fantasy, 165; and father, 13, 50, 143, 144, 145, 146, 168, 169, 170, 171, 173, 242n.51; and Faust, 174, 177; and female figure, 171; and fetish, 166, 179; and Fließ, 164, 165; and fort-da game, 146, 166; frontiers in, 172; and genealogy, 145, 168, 170, 175; and Goethe, 3, 142–43, 144–45, 146, 166, 167, 168, 169, 170–71, 173, 174, 175, 177, 178, 182, 195; and Greece, 181; and guides, 170; and Hannibal, 13, 166, 169, 170, 172, 173, 181; and hearing *vs.* sight, 166, 167; and Heine, 13, 145, 147, 166, 167, 169, 174, 175, 182; and history, 173, 174, 181, 182; and Hoffmann, 173; and homosexuality, 174–75, 177; and ideal, 181; and identification, 174, 175; and incest, 177–78; and incognitos, 169; and ingestion of father, 50, 144, 145, 170; and Italy, 14–15, 145, 146, 169, 171, 172, 174, 181; and Italy as Genitalien, 6, 147, 166; on Jensen, 14, 177–81, 266n.42; and Jews, 13, 14, 15, 145, 146, 147, 164, 166, 167, 168, 169, 172, 179, 180, 181, 182; and law, 172; and law of father, 50, 242n.51; and Leonardo, 174–75; and love in analysis, 181; maternity in, 143; and metaphysics, 165; and Minerva, 173; misreading by, 14, 174, 175, 178; and mother, 175, 177; and necrophilia, 177, 180; and Nietzsche, 143, 182; off-

spring of, 171, 172; and omnipotence of thoughts, 173; and origins, 144; as own subject, 167, 178; as own subject and object, 168, 174, 180; and past, 174; and paternal authority, 145–46; and pleasure principle, 165; and politics, 13, 14, 15, 146, 164, 166, 167, 168, 169, 170, 173, 180; and power, 176, 177; and promised land, 174, 175; and prostitutes, 174–75; and psychoanalysis, 14, 144, 145, 146, 165–66, 168, 173, 174, 175, 177, 178, 179, 180, 181, 182; and race, 165, 168, 178, 180; and reappending, 182; and rebaptism as Roman citizen, 145; and reiteration, 167; and repetition, 174; and repression, 13, 14, 164, 165, 166, 173, 174, 181; and return of repressed, 13, 166, 172–73; and Rome, 13, 14, 145, 166, 168, 169–70, 171, 172, 173, 174, 175, 177, 182; and science, 144, 145, 146, 166, 167, 169, 177, 178, 180, 181, 182; and sexuality, 170, 174–75, 177, 179; and sight, 173; and substitution, 146, 168, 171, 172, 174, 178, 179; surmounting of material in, 173; and surrogates, 177, 178; and symbol, 174; and Temple of Minerva, 170; and uncanny, 13, 14, 172–73, 177, 181, 182; and unconscious, 14, 165, 166, 181, 182; and Vienna, 13, 179; and vultures, 176, 177, 182; and Winckelmann, 142–43, 166, 168, 170, 173, 175, 177, 178, 180, 182; and wish fulfillment, 165, 167; WORKS: *Beyond the Pleasure Principle*, 165, 166, 182; *Civilization and Its Discontents*, 14, 181; *The Interpretation of Dreams*, 13, 146, 147, 165, 167, 171; *Leonardo and a Memory of His Childhood*, 174–75; *The Origins of Psychoanalysis*, 169, 170; *The Psychopathology of Everyday Life*, 145; *Totem and Taboo*, 50, 144, 170

George, Stefan, 56, 67, 142, 194, 197, 203; "Goethes letzte Nacht in Italien," 190, 237n.7
Germans: and Arcadia, 198; and Carossa, 201; and creativity, 195; and demons, 195; and imperialism, 198; innate goodness of, 203; in Italy, 149; Italy as soul of, 197; and national soul, 194, 195
Germany: demonic disposition in, 142; and Greece, 43; and Heinse, 204–5; and Italy, 1, 10, 13, 15, 192, 206; in Koeppen, 193; rebirth of, 204; Restoration, 11, 113, 118, 125, 139; and Winckelmann, 20
Geulen, Eva, 217–18
Gilman, Sander, 206; *The Case of Sigmund Freud*, 165, 178, 180; *The Jew's Body*, 166–67, 179
Goethe, August, 53, 67, 95–96, 105, 171, 186, 211
Goethe, Johann Caspar, 49; and Bologna, 88; death of, 60, 112, 141; diaries of, 87, 91–92; and education, 8; and Italy, 9; journal of, 84; journey of, 50; and Milanese woman, 91–92, 93, 94; and origins, 4; and past, 89; and Tasso, 90; and Venice, 87. *See also* Goethe, Johann Wolfgang von, and father
Goethe, Johann Wolfgang von: absence in, 4, 5, 8, 15, 49, 50, 53, 59, 60, 62, 63, 65, 66, 67, 68, 70, 73, 74, 75, 76, 79, 82, 88, 89, 91, 96, 105, 107, 108,

INDEX

Goethe (*continued*)
113, 114, 127, 128, 139, 140, 156, 178, 210; and absent present, 9, 59, 63, 89, 107, 235n.22; and after-life, 211; and alchemy, 191, 192; and All Saints Day, 51, 52, 66, 67, 73, 74; and All Souls Day, 52; and Amalia, 53, 189; and anagrams, 84, 106, 155; and antiquity, 61, 63, 65, 70, 74, 88, 116, 124, 128, 129, 205; and appearance, 63, 64, 98, 113; and Arcadia, 129; and art, 8, 53, 56, 65, 70, 86, 100, 102, 123, 126, 127, 209; and artifact, 108; and artists, 8, 53, 54–55, 56; and artists' models, 68; and Ash Wednesday, 81; and authorship, 2–3, 4, 9, 81, 95, 96, 99, 102, 105, 107, 108, 175; and avoidance, 95, 96; and Bachmann, 2, 3, 4, 224, 225, 226, 228, 229, 250n.52; baptism of, 9, 62–63, 73, 80, 121–22, 168; and baroque art, 61; and beauty, 25, 106; and being, 56–57; and beloved, 65; Benjamin on, 64, 234n.21; and bet motif, 64; and Bildung, 203, 206, 211, 215; and body, 85, 122, 190, 206; and Brenner Pass, 95; and Buchenwald, 235n.25; and Cagliostro family, 98–100, 103, 107, 142; and calculation, 82, 83–84, 85, 89, 96, 100, 107, 207; career change by, 54; and Karl August, 207; and Carossa, 201–2, 203; and castration, 8, 67; and Catholicism, 19, 52, 61; and censorship, 9, 10, 57, 58, 62, 64, 67, 68, 89, 115, 122, 250n.52; and chain of being, 87, 88; and chaos, 81; and Charlotte von Stein, 7, 21, 189–90, 191, 192, 204, 211, 237n.9, 247n.25; childhood of, 8, 51, 52, 61, 66, 75, 80, 91, 142, 171; and Christmas, 98; chronology of works by, 7–8; and class, 87; and classical ideal, 88, 89, 91; and collection, 191; and concealment, 5, 80, 85; and conjuration, 89; and conservatism, 121; and copies, 8, 60, 62, 71, 105; and Corpus Christi, 63, 121–22; and covering, 52, 113; and creativity, 2, 7, 56, 65, 80, 112, 185, 186, 193, 206, 207, 210; and crickets, 104; and culture, 192; and cutting/cutting off, 6, 10, 15, 60, 61, 62, 68, 74, 82, 83, 85, 97, 98, 108, 121, 132, 140, 162, 182; and death, 54, 55, 56, 63, 106, 129; and debt, 58, 64, 65, 67, 72, 95, 96, 100, 105, 106, 107, 108; and deception, 99, 195; and demons, 15, 73, 90, 91, 132, 186, 194; and departure, 101; and de-realization, 83; and desire, 188; and deterioration, 70; and devil, 63–64, 68, 182, 191, 210; and disease, 6; and disfigurement, 16, 207, 208, 210–11, 214; and disguise, 98; and displacement, 49, 96; and division/splitting, 109; and doubles, 8, 76, 96, 102, 105, 106; and drawing, 56, 59, 60, 93; and dream, 52, 89; and Easter, 63; and Eckermann, 53, 105, 132, 211; education of, 4, 7, 8, 50, 58, 59, 60, 62, 63, 66, 68–69, 73, 74, 87, 105, 203, 207; and ekphrasis, 70, 105; and emptiness, 52, 113; and empty center, 7; and equality, 82, 87; erasure in, 9, 61, 62, 63, 67, 74, 83, 88, 91, 97, 113, 121, 142, 166; and eroticism, 168, 187, 188; and escape, 104; and escape from self, 71; and essence, 84; and ethnic difference, 111; and exe-

INDEX

cutions, 55–56, 58, 60, 61, 106, 246n.15; and exile, 103; and experience, 83; and extraction of alternate essence/identity, 91; and father, 2–3, 4, 8, 9, 10, 44, 49–50, 51, 52, 53, 54, 59, 60, 61, 62, 63, 65, 66, 67, 69, 70, 71–72, 73, 76, 81, 84, 85–87, 90, 91, 92, 93, 94, 95, 96, 97, 98, 103, 105, 108, 121, 124, 128, 129, 143, 144, 151, 169, 170, 171, 175, 223; and fatherland, 52; and fatherless child, 98; and father's business, 91, 106; and father's death, 112, 141; and father's diaries, 87, 91–92; and father's ghosts, 52, 66; and Faust, 207, 208; and Faustina, 67, 68, 76, 80, 90, 101, 122, 158, 177, 189, 207, 232n.6, 244n.1; and feast of Peter and Paul, 96; and females, 94; and feminine, 3, 4, 158, 250n.52; feminine figure of truth in, 76; and feminine presence, 74, 75, 77; and Festival of Santa Rosalia, 102–3; and festivals, 96; and Florence, 51, 54; followers of, 9, 10, 15, 68; and forfeit, 99; and forgery, 99, 195, 238n.17; and forgetting, 74, 84, 94, 250n.50; and formalism, 10; and Frascati, 106; and fraud, 98; and Frau von Stein, 60; and freedom, 73, 82, 90; and French Revolution, 81, 82, 98, 131; and Freud, 3, 142–43, 144–45, 146, 166, 167, 168, 169, 170–71, 173, 174, 175, 177, 178, 182, 195; and game of chance, 92; and gender, 75, 87, 97, 188, 206, 208; and genealogy, 2, 3, 9, 97, 98, 213; and geography, 96; and geology, 85; and German classicism, 15, 70, 88, 141, 145, 151, 185, 188, 201; and Germany, 58, 60; as

ghost, 52, 53–54, 105; and ghosts, 9, 52, 69, 71–72, 73, 75, 76, 82, 86, 91, 104, 162–63, 173, 193, 194, 211, 235n.23; and ghostwriting, 104, 105, 106, 107; and Greece, 23; and Greeks, 189; and guilt, 52, 105; and hand of writing, 92, 94, 101, 106; as haunted, 54, 71–72; and Heine, 3, 10, 11, 12, 111, 112, 113, 114, 115, 116, 117, 121–23, 124, 125, 126, 128, 130, 131, 132, 133, 135, 139, 140, 188, 195, 206, 258n.27; and Heinse, 204–5, 206, 208–10; and historical memory, 69; and history, 68, 80, 81; Hofmannsthal on, 193–94; and homesickness, 66; and homoeroticism, 188, 206; and homosexuality, 188–89; and human nature, 84; and human time, 69; and ideal, 7, 10, 15, 53, 60, 61, 62, 63, 65, 66, 67, 68–69, 70, 76, 79, 82, 88, 89, 91, 105, 122, 123, 127, 128, 131, 142, 178, 209, 210, 218; and identity, 52–53, 60, 62, 65, 68, 91, 98, 99, 103; and illusion, 7, 10, 15, 223; and imitation, 60, 61, 104; and imitation of imitation, 79, 80, 157; and immediacy, 82, 83, 89, 90, 92, 93, 94, 102, 105, 107; and imperfection, 131; and impermanence, 56–57; and incest, 187–88; and incognitos, 9, 54, 60, 65, 98, 100, 207, 245n.9; and ineffability, 108; and Italian journeys, 68, 76, 77, 80, 95, 97, 108; Italians in, 127–28, 129; and Italy, 7, 9, 10, 49–50, 51, 53, 54, 56, 57, 60, 61, 62, 63, 65, 66, 69, 82, 91, 92, 95, 99, 152, 156, 162, 185, 186, 187, 188, 195, 211, 223; and Jenkins, 94–95; journeys of, 51,

INDEX

Goethe (*continued*)
149; and junk, 72, 73; and Karl August, 188, 190; and Knebel, 189; and Kneip's drawings, 86, 101; and Koeppen, 193, 197, 203; and language, 99, 208, 237n.8; and language games, 83–84; on Laocoon, 33, 209; and law, 3, 60, 83, 114; and lawlessness, 57; and law of father, 49–50, 51; leaving of Italy by, 56; as leaving something behind, 7, 15, 66, 67, 90, 91, 111, 132, 142, 152, 157, 192; legacy of, 11–12, 52, 54, 141, 142–43, 193, 233n.8; and living ray, 20, 21, 190, 191, 192, 194, 197, 203, 206, 211, 237n.7; as locked up with priest, 61, 62; and loss, 10, 52; and loss of self in object, 86; and loss of senses, 62; and love, 76, 77, 92–95; and magic, 72, 73, 102, 142, 190, 191; manhood of, 76, 101; and Mann, 208, 213, 214, 216, 218, 219; and masses, 127, 128, 131; and masturbation, 206; and material world, 56; and mediation, 233n.10; and memory, 74; as merchant, 54, 245n.9; and Messina, 102, 103; and Michelangelo, 123; and Milan, 91, 128; and Milanese woman, 91–92, 93, 94, 95, 96; and mirror, 97; and miscalculation/missed calculation, 85, 89, 96, 100, 103, 107; and misdirection, 68, 69; and misprision, 4, 208; as missing, 162; as Möller, 53, 54, 65, 207, 245n.9; and Monete, 55–56, 65; and monuments, 128, 129; and Moritz, 54, 55, 83–84, 105–6, 155; and mother, 3, 97; and Mount Etna, 84, 86; and movement backward, 88; and movement forward and backward, 89; and Mühsam, 214; and murder, 54, 55, 59, 80, 95; and muses, 77; and Naples, 2, 9, 71–72, 85, 86, 88, 96, 97, 103, 104; and natural time, 69, 70; and nature, 56–57, 60, 70, 88, 93, 123, 130, 133, 168, 204; and necessity, 98, 107; and new life, 71; and Nietzsche, 3, 12, 142–43, 144, 149, 153, 156, 157, 162, 163, 182, 206; and noble perfection, 123; and nothingness, 8, 77, 80, 128; and objectivity, 69, 70; and observation, 58; and Oedipal repression, 80; and Oedipus myth, 95; and opera, 126; and original ground, 142, 163; and originality, 93; and originals, 8, 60, 62, 76; and original subject, 207; and originary act, 80; and origins, 4, 10, 85, 104, 105, 141, 142; and Ottaino, 85; and Paestum, 96–97, 104; and painterly, 57, 98; and painting, 54, 57, 102, 105; and Palermo, 98, 102; and Palladio, 123; and Pallagonia, 104; and past, 51, 71, 113, 194; and perdurance, 70, 81, 129; and perfection, 123, 128; and perspective, 56, 69, 93; and petrification, 84, 85, 93, 117; and Pietism, 21, 61, 205, 237n.8; and plague, 103; and Platen, 133, 135, 136; and poetry, 6, 8–9, 56, 66, 75, 76, 80, 83, 88, 89, 99, 101, 102, 104, 105, 108, 177, 214; and poison, 95; and politics, 10, 127, 170, 200, 210, 211; and pope, 52, 53, 61; and presence, 4, 53, 54; and present, 71, 107, 128; and preservation, 128; and Prince of Liechtenstein, 65; and Prince Pallogonia's estate, 97; and productivity, 70; and prostitutes, 175, 187, 188;

INDEX

and Protestantism, 52, 61; and psychoanalysis, 90, 91, 145; and purity, 188, 192; and Raphael, 123; as reader, 79, 80, 82; readers of, 81, 82, 89, 95, 105, 107, 108, 109; and reason, 95; and rebirth, 2, 7, 8, 9, 50, 56, 58, 59, 60, 62, 63, 68, 70, 71, 74, 80, 85, 113, 144, 146, 182–83, 187, 193, 195, 205, 206, 207, 211, 223, 225; and recollection, 85, 93; and reiteration, 73, 75, 76, 77, 80, 82, 93, 101, 105, 142, 160, 167; and rejuvenation, 186, 192; repayment by, 67; and repression, 10, 58, 80; and restoration, 69, 113; and resurrection, 62, 63, 71; and retrospection, 107; and role-reversal, 102; and Roman carnival, 81–82, 83, 87, 89, 123, 127, 209; as Roman citizen, 9, 63, 73, 80; and Rome, 8–9, 17, 50, 51–53, 54, 55, 57, 58, 59, 60, 61, 62, 64, 66, 67, 71, 72, 73, 74, 77, 80, 81, 83, 85, 92, 96, 100, 101, 103, 104, 121–22, 123, 125, 128, 129, 142, 170, 171, 200, 248n.32; and ruins, 15, 70, 73, 91, 124; and sacrifice, 9, 52, 60, 61, 67, 92, 99, 102; and Schein, 70, 71, 249n.42; and Schriftsteller *vs.* Dichter, 99, 214; and science, 70, 83, 95, 98, 123, 146, 167, 169; and second crucifixion, 62, 63, 73; and second self, 71, 74, 75, 248n.29; and secrecy, 66, 139; and self, 194; and self-consciousness, 85; and self-description, 101; and self-discrediting art, 8; and self-displacement, 103; and self-division, 98; and self-doubling, 73, 102; self-enshrinement of, 8–9; and self-erasure, 9, 58, 61, 62, 63, 67, 74, 83, 88, 91; and self-execu-

tions, 61; and self-observation, 58; and self-presencing, 91; and self-preservation, 85; and self-projection, 10; and self-reflection, 97; and self-reflexivity, 85; and self-reproduction, 71; and self-sacrifice, 60, 61, 67; and self-severing, 85; and self-splitting, 69; and self-surrender, 105; and senses, 81; and sensuality, 206, 209; and sensuousness, 56; and Seume, 196, 213; and sexuality, 10, 19, 20, 76, 80, 83, 187–89, 190, 207, 209, 211, 232n.6, 244n.1; and shadows, 98; and Sicily, 2, 9, 86, 87, 88, 90, 96, 97, 99, 103–4, 109; sight in, 2, 68–69, 112, 113, 117, 127, 166, 167, 173, 249n.40; and simile of simile, 82; and sister, 188, 190; as smuggler, 190; son of, 67, 95–96, 105, 171, 186, 211; and sorcery, 68, 80, 101; and specular moment, 208, 211; and staging, 55–56, 60, 74, 80, 81, 82, 106, 108, 219; and stand-ins, 9, 52, 60, 63, 65, 68, 74, 76, 91, 102, 105, 156; and stones, 83, 84, 85, 93, 123, 191, 204; and subjectivity, 70; and sublation, 207; and substitution, 9, 15, 60, 67, 68, 72–73, 74, 76, 77, 79, 80, 82, 90, 95, 103, 104, 105, 142, 158, 178, 187, 207, 208, 210, 214, 218, 233n.10; and substitution of substitution, 105; and suffering, 108; and suicide, 56; as superstitious, 64; and surrender to object, 57, 102, 105; and surrogates, 9, 49, 68, 91, 122, 177; and syphilis, 188, 206; and Tasso, 90; and theft, 191, 192, 194; and thimblerigging, 73, 142; and time, 69, 70, 71, 74, 101, 127; and timing, 73, 77; and Tischbein, 53, 56–57,

301

INDEX

Goethe (*continued*)
60, 69–70, 83, 193; and *Torquato Tasso*, 90, 107–8; and totality, 68–69, 82; and transcendence, 126; and transformation, 187; and translation, 89, 94, 95, 96, 107, 175; and transubstantiation, 63; and travel, 142; and truth, 74, 75, 76, 98, 107, 210; as two, 73–74; and unconscious, 95; and unutterability, 108; Urpflanze/primal plant in, 2–3, 9–10, 20, 50, 56–57, 68, 87, 88, 89, 97, 98, 103, 104, 105, 107, 113, 140, 141, 142, 159, 163, 200, 228; and veil, 74, 75, 76, 77, 80, 88, 102, 107, 140, 210; and Venice, 128, 129, 158, 187, 189; and Verona, 128; and Vesuvius, 63, 82–83, 84–85, 91, 93, 96, 223; and Villa Borghese, 64; and violence, 84, 85; and vision, 76; and visual art, 101; and voluptuousness, 81, 82; and Wandering Jew, 62, 73; and Weimar, 12, 61, 62, 66, 68, 74, 88, 106, 112, 148, 189, 191, 204, 206, 210, 211; and Weimar circle, 7, 73, 90, 99; and Weimar classicism, 7, 12, 15, 162; and Werther, 10, 65–67, 69, 89–90, 91, 92, 93, 94, 96, 107, 171; and wholeness, 71, 98, 205; and Winckelmann, 7, 8, 9, 10, 18–19, 20, 21, 37, 49, 53, 56, 58–60, 61, 63, 65, 66, 67, 68, 71, 74, 76, 79, 80, 82, 84, 91; and witches, 64, 73; witness to, 60; and word-play, 64; youth of, 90; and youth restoring potion, 73; WORKS, 129–30; "Amor as Landscape Painter," 101–2, 105, 108; "An Werther," 90; *Dichtung und Wahrheit*, 51, 108; *Faust*, 63–64, 73, 76, 145, 163, 170–71; *Geheimnisse*, 74; *Gespräche mit Eckermann*, 108; *Der Groß Cophta*, 81, 98; *Iphigenia*, 106; *Italienische Reise*, 7, 8, 15, 68, 69, 73, 74, 89, 90, 96, 105, 108, 135, 182–83, 209; letters of, 7, 60, 107; "Mignon," 129–30; "Moritz als Etymolog," 84; "On Granite," 83; "Roman Carnival," 7, 81–82, 131; *Roman Elegies*, 67, 83, 207; *Tagebuch*, 7; "Triologie der Leidenschaft," 108; "Über Laocöon," 25, 33; "Venetian Epigrams," 15, 186–88, 189, 190, 235n.26; *Werther*, 56, 65–67, 95; *West-Östlicher Divan*, 134; *Wilhelmeister's Years of Apprenticeship*, 129–30, 214–15, 217; *Wilhelmeister's Years of Wandering*, 215, 217; "Wilhelm Tischbeins Idyllen," 57, 69–70, 71; "Winckelmann und sein Jahrhundert," 7; "Zueignung," 74–76
Gottlieb, Susannah Young-ah, 261n.57
Goux, Jean-Joseph, 95, 96

Hagelstange, Rudolf, *Venezianisches Credo*, 199
Heine, Heinrich: and absence, 114, 139–40; anecdotes in, 123–24; and antiquity, 116, 123, 125, 128–29, 130; and anti-Semitism, 121; and appearance, 114; and art, 115–16, 116, 117, 126, 127; and artist, 115; and Athens, 124, 125; and Bachmann, 228; and backward reading, 116–17; baptism of, 122, 134, 257n.21; as baptized Jew, 11, 12; and Berlin, 124; and birth, 118; and body, 11, 139; and boustrophedon, 114, 116, 120; burial alive in, 118, 119; and castration, 118; and Catholicism, 116, 135,

INDEX

149; and censorship, 10–11, 113, 114–15, 116, 117, 118, 119, 120, 121, 130, 131, 139, 140, 141, 210, 256n.12; as circumcised, 11, 121; and classical illusion, 122; and concealment of sources, 119; and conservatism, 121, 131; and copies, 116, 122; and corpse, 118; and Cotta, 132; and covering up, 113; and creativity, 112; and culture, 135, 136; and cutting, 11, 114, 118, 119, 121, 131, 136, 138, 139, 140, 141, 182; and dance, 118; and death, 115, 117, 118, 119, 120; and demons, 132; and de Staël, 129; and destiny, 118; and disease, 182; and Duke of Braunschweig, 132; education of, 127; enemies of, 132; and equivocity, 121; and erasure, 13, 113; and ethnic difference, 111–12; everyday in, 123; exile of, 111, 113, 141, 183, 210; and father, 135, 138; and fatherland, 133; and fatherly patrons, 122; and father's death, 112, 121, 129, 141, 175; and feminized male, 135, 136; and foreign domination, 126, 127; and formalism, 11; and France, 121; and freedom, 126; and Freud, 13, 145, 147, 166, 167, 169, 174, 175, 182; and gender, 116; and genealogy, 129; and Germany, 11, 121, 133, 141, 143; and Gewächs, 11, 113, 131; and ghosts, 119, 124, 133; and Goethe, 3, 10, 11, 12, 111, 112, 113, 114, 115, 116, 117, 121–23, 124, 125, 126, 128, 130, 131, 132, 133, 135, 139, 140, 188, 195, 206, 258n.27; and Greeks, 115, 116, 124, 125, 135; health of, 132, 142; and history, 130–31; homosexuality of, 134; and ideal, 114, 122; identity of, 138; and illusion, 123, 142; and immediacy, 123, 125; and Immerman, 133, 134; as interlocutor, 122; irony in, 126; irreal in, 118; Italian journey of, 111, 113, 125, 141; Italians in, 127–28, 130, 138; Italian sketches of, 122; and Italy, 123, 131, 166, 223; itinerary of, 123; as Jew, 11, 12, 114, 121, 122, 131, 133, 137, 138, 142, 167, 169; and Jews, 136, 137, 139; and kiss, 115; and language, 122, 137–38; and law, 114, 116, 117; and liberation, 130–31; and Lucca, 112; and magic, 117; and masses, 127; and material remains, 122; and Menzel, 121; and Milan, 130; and mimesis, 122, 137–38; mimicry in, 126; and missed calculation, 112; and Morgan, 129; moribund imagination of, 117; and Munich, 124–25, 135; and Napoleon, 119, 120; and nature, 130, 133; and necrophilia, 115, 116, 117, 118, 138, 173; and Nietzsche, 144, 149, 153; and "noble simplicity and quiet grandeur," 127; and obliteration of expression, 117; and opera, 117, 126, 130; and oranges, 112, 113; and origins, 142, 143; and outsider, 138; as own enemy, 133; as own subject, 167; and Paganini, 117; and Paris, 11, 114, 174, 182; and parody, 118, 126, 136; and past, 122, 129, 133; and pederasty, 135; and petrification, 117; and Platen, 11, 112, 131, 132, 133–36, 269n.23; poetic restoration of, 113; and poison pen, 114, 132; and politics, 11, 113, 114, 115, 118, 120, 121, 126, 127, 128, 129, 130, 223;

INDEX

Heine (*continued*)
and pornography, 142; and present, 113, 124, 125, 126, 129; and progeny, 119; readers of, 115, 125; and reading, 116–17; and rebirth, 132; and religion, 114; and repression, 142; and Restoration, 113, 118, 125, 139; and ribaldry, 114; and Romantics, 116; and Rome, 113, 121, 125, 129; and ruins, 115, 122; and Salomon, 112, 122, 134; and Schein, 114; self-citation by, 125–26; self-critique in, 131; self-hatred of, 131, 136; and sensuality, 11; and Seume, 196; and sexuality, 134, 135; shifting perspective of, 125; and smell, 112, 113; and speculation, 122; and stand-ins, 113; and statues, 115, 116, 117, 118; and stones, 11, 83, 117, 122, 140, 189, 191; and storytelling, 115, 116; and substitution, 111, 136; as surrogate, 122–23; and syphilis, 167; and time, 116; and time as arrested, 118; and timing, 112; and transcendence, 126; and translation, 122; truth in, 117; and University of Munich, 11, 112, 132; and univocity, 121; and veil, 133; and Venice, 158; and ventriloquism, 119, 140; and Verona, 128; and Weimar, 114; and Wellington, 120; and Winckelmann, 11, 113, 114, 116, 117, 119, 121, 122, 131, 136, 139, 140; youth of, 123; WORKS: *The Baths of Lucca*, 11, 112, 122, 131, 134, 136–38, 139; *Briefe*, 122; *The City of Lucca*, 131, 132–33, 139; *Florentine Nights*, 111, 114–21, 134, 136, 137; *The Journey from Munich to Genoa*, 122, 123, 135, 140; *Nordsee*, 134; *Politische Annalen*, 132

Heine, Salomon, 112, 122, 134
Heinse, Wilhelm, *Ardinghello und die glückseligen Inseln*, 204–7, 208–10
Herder, Johann Gottfried von, 204
Hermand, Jost, 11, 123
Hitler, Adolf, 164, 182, 197, 202; *Mein Kampf*, 164–65
Hochmeister, Gretchen, 5
Hoffmann, E. T. A., *The Sandman*, 173
Hofmannsthal, Hugo von, 193–94; "A Conversation about Goethe's *Tasso*," 108
Holub, Robert, 134; "Heine's Sexual Assault," 11

Immerman, Karl, 133, 134
Italy: absence of, 4; and Bachmann, 223–27; as backward, 129; Carossa on, 199–200; and cutting, 6, 10; and demonic, 4, 16; and devil, 3; differing accounts of, 195–97; as diseased, 127–28, 213; and disfigurement, 16; as empty space, 37; fascist, 198–99, 202, 203, 210, 212, 214, 216, 218, 223; and fathers, 8; and feminine, 3, 4; Germans in, 149; and Germany, 1, 10, 13, 15, 192, 197, 206; and Grand Tour, 244n.1; and Greek antiquity, 5; and Heinse, 204–5; and ideal, 6; and illusion, 15; illusion in, 123; journeys to, 40; political servitude of, 11, 130; and politics, 196, 198, 211, 214; and rebirth, 2; as rebirth, 68; and sexuality, 6; violence in, 79–80; and Winckelmann, 55. *See also under* Freud, Sigmund; Goethe, Johann Wolfgang von; Heine, Heinrich; Mann, Thomas; Winckelmann, Johann Joachim

Jenkins (Englishman), 94–95

INDEX

Jensen, W., 266n.42; *Der Fremdling unter Menschen*, 178; "Gradiva: A Pompeiian Fantasy," 14, 177–81
Jew(s), 164–65; and deformity, 14, 179–80; and Freud, 13, 14, 15, 145, 146, 147, 164, 166, 167, 168, 169, 172, 180, 181, 182; and Goethe, 62, 73; and Heine, 136, 137, 139; Heine as, 11, 12, 114, 121, 122, 131, 133, 137, 138, 142, 167, 169; and syphilis, 166
Justi, Carl, 18

Kant, Immanuel, *Opus Postumum*, 155
Kiefer, Klaus, 82
Knebel, Karl Ludwig von, 189
Kneip, Christoph Heinrich, 86
Koeppen, Wolfgang, *Death in Rome*, 192–93, 194, 195, 197, 203

Laplanche, Jean, 165, 166
Leonardo da Vinci, 174–75; "St. Anne and Two Others," 175
Lessing, Gotthold Ephraim, 17, 243n.56
Liechtenstein, Prince of, 65
Löwy, Emanuel, 169
Lukács, Georg, 21

Mann, Thomas: and absence, 203–4; and anti-Semitism, 216; and appearance of meaning, 195; and artist, 195; and Bachmann, 224, 227; barbarism in, 185; and creativity, 64, 195; cut in, 219, 220–21; and deceit, 194, 203; and demonic, 16; and demons, 199, 200, 212; and devil, 3, 64, 185, 191, 195; disease in, 213, 214, 216, 218; fascism in, 216; and Ganymede, 213, 220–21; and Goethe, 208, 213, 214, 216, 218, 219; and Greece, 194; and homoeroticism, 221; and hyperreal, 216, 273n.56; and illusion, 16, 217, 218, 219, 221; Italy in, 212–14; and language, 217–18, 219, 220; magician in, 212, 213, 216; and nationalism, 212, 214, 217, 218; and politics, 214; and prostitute in, 203–4; and racism, 218; and sexuality, 213, 219, 221; and substitution, 221; and surrogate, 221; uncanny in, 212, 214; and Winckelmann, 220; WORKS: *Buddenbrooks*, 186; *Doktor Faustus*, 64, 182, 185, 191, 194–95, 201, 203, 207–8; "Mario and the Magician," 16, 212–14, 216–22, 226
Marcuse, M., 164
Mauss, Marcel, 102, 105
Mayer-Kalkus, Reinhart, 65
Menzel, Wolfgang, 121
Monete, Abbate, *Aristodemo*, 56, 65
Morgan, Lady, *Italy*, 129
Moritz, Karl Philipp, 54, 55, 60, 83–84, 105–6, 155, 246n.15
Mühsam, Erich Mühsam, "Mignon: 1925," 197–99, 212, 214
Müller-Sievers, Helmut, 83, 89
Mussolini, Benito, 13, 147, 164, 199, 200, 201

Nancy, Jean-Luc, 153; "Nietzsche's Thesis," 12, 154–55
Napoleon I, 119, 120, 196
National Socialism, 13, 150, 151, 192, 197, 198–99
Nicolai, Gustav, *Italien wie es wirklich ist*, 196
Nietzsche, Friedrich: and absence, 148, 154, 157, 162; and Apollonian, 152; and appearance, 152, 153, 155, 156, 157, 162; Ariadne in, 155–56, 157, 158; and authorship, 156; and Bachmann, 226–27, 229; and being, 152, 154; and body, 162, 175;

305

INDEX

Nietzsche (*continued*)
and Brandes, 151; and bridge, 160, 161, 162; and Buchenwald, 235n.25; and censorship, 155, 158; and classical ideal, 157; collapse of, 143, 154, 156, 157, 162; and completeness, 144; and the Crucified, 155; and cutting, 12, 13, 151, 155, 157, 182; and deception, 153, 156; and demons, 150, 163; and difference, 150, 156; Dionysian in, 149, 152, 153; Dionysus in, 155, 156, 158, 161; and disease, 182; and distinctions, 152; and doubling, 12, 150, 151, 152, 154, 155, 156, 159–60; and dream, 156, 160; and dualism, 152; and education, 150; and elision, 160; and ellipsis, 162; and erasure, 13, 150; eternal return in, 162; and exile, 183; and experience, 159; and false ground, 162; family of, 148; and family romance, 157; and fate, 152; and father, 12, 143, 144, 157; and fatherland, 143, 144; and father's death, 175; and feminine, 148, 158; and final ground, 162; and forgery, 154; and Freud, 143, 182; and genealogy, 152, 157; and ghosts, 153, 154, 162–63; and God, 151; and Goethe, 3, 12, 142–43, 144, 149, 153, 156, 157, 162, 163, 182, 206; and ground, 157, 162; and guides, 150, 151; haunting of, 151; and Heine, 144, 149, 153; and ideal, 149, 153, 154, 156, 157; and identity, 155, 156; and illusion, 152, 153–54, 158, 162; and image, 152–53; and incognito, 152; and Italy, 150, 151, 153, 155, 157; and iteration, 157, 161; and Kant, 155; and labyrinth, 156; and language, 159; and legacy of Winckelmann and Goethe, 142–43; and madness, 3, 12, 150; and magic, 156, 157; and male authority, 148; and man as rope across abyss, 153, 155; and mankind, 160; and Mann, 195; and masks, 153, 154, 155, 156, 157, 162; and mother, 12, 13, 143–44, 148, 157, 158, 164, 175, 263n.8; and music, 158, 160, 161, 162; and name(s), 144, 151, 155; nature in, 149; and Nazis, 13, 150, 151; and object, 157; and originals, 154, 159–60; and originary ground, 162; and origins, 143, 153; and other, 152, 154, 156, 158; and outside, 161; and overman, 153, 160; and paralysis, 154, 155, 163; and parody, 152–53, 155, 156, 158; and past tense, 160; and philology, 154; and philosophy, 154, 155; and poetry, 162; and presence, 162; and present, 160; and primacy, 159; and projection, 156, 158, 161; and rebirth, 144, 157; and reiteration, 152, 154, 161, 167; and repetition, 155; and representation, 162; and sacrifice, 155; and science, 154; and self, 151, 152, 153, 154, 155, 156, 161; and self-overcoming, 160; and self-positioning, 162; and self-projection, 154, 158, 160, 161; and self-questioning, 161; and semblance, 153; and sensory phenomena, 160; and sister, 13, 148, 158, 163, 164, 175, 263n.8; and soul, 161; and staging, 156, 157; and stand-ins, 156; submission by, 148; and substitution, 148, 149, 157; and syphilis, 167; and teleology, 154; and text, 157; and ultimate ground, 154; and unmasking,

INDEX

154; and Venice, 158–59; and violence, 149, 151; and visual, 161; and Wagner, 156–57; and Weimar, 143, 147–48, 148, 157, 163; and will, 152; and will to power, 154; and Winckelmann, 12, 149, 157, 163; and Zarathustra, 155, 156, 157, 226–27; WORKS: "Ariadne's Lament," 156; "The Birth of the Tragic Thought," 149; *The Birth of Tragedy,* 12, 152, 161, 162; "Dei Paralysis," 151; *Dionysian Dithyrambs,* 144; *Ecce Homo,* 12, 143, 150, 152, 155, 159; "Intermezzo," 159; "Magician's Song," 144; *Nietzsche contra Wagner,* 159; "On the Future of Our Educational Institutions," 150; *Thus Spoke Zarathustra,* 144, 153, 155–56, 156, 163; "Venedig," 152, 158–60; *The Will to Power,* 12, 143–44

Ovid, *Tristia,* 182–83

Pabel, K., 124
Paganini, Niccolò, 117
Palestrina, 185, 186
Papini, Giovanni, 144
Pelzel, Thomas, 24
Platen, August von, 11, 112, 131, 132, 133–36, 139, 177, 269n.23; *Der romantische Oedipus,* 133
Podach, E. F., 148
Potts, Alex, *Flesh and the Ideal,* 5, 22, 26, 32, 35, 37, 39, 40, 207

Reed, T. J., 207
Richter, Simon: *Laocoon's Body,* 5, 32, 33, 45, 47; "Winckelmann's Progeny," 44–45
Riedesel, Baron, 42
Romantics, 116
Rome: and absent father, 60; and Bachmann, 227; and Carossa, 199, 202; and staging of executions, 55; violence in, 79–80. *See also under* Freud, Sigmund; Goethe, Johann Wolfgang von; Heine, Heinrich; Winckelmann, Johann Joachim
Ronell, Avital, *Dictations,* 144

Sammons, Jeffrey, 121, 136
Schelling, F. W. J., 172–73
Schiller, Friedrich von, 209, 249n.42, 253n.27
Schneider, Reinhold, 199
Schorske, Carl, 166, 167, 169, 173
Schröder, Rudolf Alexander, 199
Serres, Michel, *Rome,* 79–80, 81, 85, 114
Seume, Johann Gottfried, 195–96, 210, 213, 225
Shapiro, Gary, 150
Stein, Charlotte von, 7, 21, 60, 189–90, 191, 192, 204, 211, 237n.9, 247n.25
Stosch, Baron von, 35
Strachey, James, 182
Szondi, Peter, 29

Tasso, Torquato, 90, 107
Theisen, Bianca, 156
Tischbein, Johann Heinrich Wilhelm, 53, 56–57, 58, 60, 83, 193
Trunz, Eric, 57

Venanzio, 45
Vienna, 164, 179
Volger, O., 87

Wagner, Cosima, 156–57
Walde, Philo von, 163
Weimar. *See under* Goethe, Johann Wolfgang von; Heine, Heinrich; Nietzsche, Friedrich
Wellington, Lord, 120
Winckelmann, Johann Joachim: and absence, 28, 29, 31, 36, 38, 39,

307

INDEX

Winckelmann (*continued*)
40, 41, 43, 44, 47, 59, 70, 114, 139, 178; and absolute, 47; and aesthetics, 29; and Albani, 42, 60, 62, 135; and allegory, 19–20, 30, 31, 44; and ancients, 157; on Apollo, 35, 209; on Apollo Belvedere, 22, 36, 37, 45, 122; and appearance, 35, 36, 201; and appreciation of object, 20; and appreciation of works removed from view, 18; and art, 5, 6, 8, 55, 70, 209, 237n.13; and art as lacking, 5; and Athens, 25; and Austria, 41; and authenticity, 22, 23, 24–25, 34; and Bachmann, 225, 228, 229; and baroque art, 61; and beauty, 19, 25, 26, 27, 32, 35, 36, 37, 39, 40, 45–46, 47, 55; and Belli, 45; on Belvedere Torso of Hercules, 27–28, 39; and Berendis, 21; biography of, 43; and body, 32, 33–34, 48; and castrati, 5, 6, 45, 46, 47, 116, 118, 121, 122, 134–35, 140, 182; and castration, 45, 50, 67, 173; and Catholicism, 19–20, 22, 44; and center, 32; circle of, 54; and completeness, 28, 35; conjuring by, 37; and conservatism, 121; and contemporary art, 29; and copies, 5, 6, 22–23, 24, 25, 31, 35, 36, 37, 39, 40, 44, 47, 55, 60, 62, 71, 105, 141, 157, 206, 207; and corpse, 118; and cover-up, 31; and criminals, 55; and cutting/cutting off, 10, 43, 44, 47, 48, 61, 62, 79, 121, 135, 139, 140, 182; and death, 6, 32, 55, 118; death/murder of, 18, 23, 41–42, 43, 44, 48, 55, 60; and debauchery, 43; and decline, 36, 37; and de-gendering, 46, 141, 148; and desire, 5, 21, 22, 23, 24–25, 34, 35, 37, 38, 39, 41, 136, 177; and difference, 47; disciples of, 7, 59; and disfigurement, 6, 44, 45, 214; and dismemberment, 28; and displacement, 20, 21, 39, 41, 42, 43, 47, 48; dizziness of, 42; and Dresden, 25, 26, 31, 34, 42, 45; and effacement, 41; effacement of object by, 20; ekphrasis of, 5, 20, 36, 46, 70, 134–35; and empress of Austria, 42, 44; and emptiness, 91; and empty center, 31, 60; and empty space, 21; and erasure, 5, 30, 32, 34, 43, 45, 47, 58, 62, 63, 67, 83, 113, 121, 136, 148, 149, 166, 170, 182; and eroticism, 6, 35, 36, 41, 48, 220; and ethnic difference, 111; and excess, 36; and executions, 246n.15; exile of, 139; and father, 8, 9, 44, 47, 49, 50, 59, 60, 67, 141, 175, 242n.51; and fatherland, 29–30, 44, 45; and female, 34, 38; and female body, 32; and female figure, 41; and feminine, 3–4, 148, 158, 223, 241n.38; and feminine gaze, 38, 46; and feminization, 32, 38, 44; and flowering and waning of art, 39; and forgeries, 23–26, 26, 28, 31, 55, 206, 238nn.16, 18; and fragmented present, 30; and fragments, 40; and freedom, 21–22, 23, 39, 43, 44; and Freud, 142–43, 166, 168, 170, 173, 175, 177, 178, 180, 182; and fullness, 35; and future, 30; and gaze, 38, 46; and gender, 38, 46, 141, 148; and genealogy, 148; and Germany, 6, 20, 41, 42, 43, 45; and gesture, 34; and Gewächs, 6, 11, 45, 46, 47, 48; and ghosts, 37, 38; and Goethe, 7, 8, 9, 10, 20, 21, 37, 49, 53, 56, 58–60, 61, 63, 65, 66, 67, 68, 71, 74, 76, 79, 80,

308

INDEX

82, 84, 91; and good taste, 28; and Grecophilia, 34; and Greece, 6, 23, 31, 34, 38, 40, 42; and Greeks, 25, 26, 27, 28, 29, 31, 35, 36, 38, 39, 40, 47, 127; and Greek sky, 26, 27, 28, 29, 31, 34, 127, 239n.24; and Heine, 11, 113, 114, 116, 117, 119, 122, 131, 136, 139, 140; and Heinse, 206–7; and Herculaneum paintings, 23–24; and hermaphrodites, 46; and history, 34, 36, 40, 44, 48; and homoeroticism, 6, 21, 24, 38, 46, 242n.44; and ideal, 5, 6, 20, 22, 23, 25, 28, 30, 31, 32, 34, 35, 36, 37, 38, 39, 40, 41, 42, 43, 44, 45, 46, 47, 48, 60, 65, 70, 131, 140, 141, 142, 149, 178, 209, 218, 237n.13; and illusion, 48; and imitation, 26, 27, 31, 34, 36, 39, 40, 43–44, 60, 79, 157; and imperfection, 131; and inexpressible beyond frame, 149; and infamy, 43; influence of, 17–18; and intermediaries, 44; and internalized absence, 43; and invisible, 40; and Italy, 5, 6, 20, 31, 35, 37, 43, 44, 55, 195; and Jupiter embracing Ganymede, 23–24, 31, 220, 238n.17; on Laocoon, 5–6, 32–33, 34, 45, 46, 47, 55, 60, 117, 122, 209, 243n.56; and law of father, 9, 44, 49, 50, 67, 242n.51; as leaving something behind, 20, 21; legacy of, 6, 7, 8, 43, 49, 141, 142–43; letters of, 23, 24, 59; and libido, 41; and loss, 37, 46; and love, 35, 38; and male, 43; and male body, 32, 33, 34, 38; and male nude, 5, 46, 141, 148, 158; and Mann, 220; and material world, 36, 40; and model, 55; and moderns, 40; and mythology, 35; and narrativization of life, 79; and nature, 25, 26; and necrophilia, 177, 180; and Nietzsche, 12, 142–43, 149, 157, 163; on Niobe and her children, 5, 32, 33, 41, 158; "noble simplicity and quiet grandeur" in, 22, 31–32, 116; and nostalgia, 39; and nothingness, 44; and nudes, 35, 38; and obliteration, 33; and obliteration of female, 38, 241n.38; and obliteration of self, 34; and observation, 32; and original ground, 163; and originals, 5, 8, 23, 26, 27, 28, 30, 35, 37, 39, 40, 43, 60, 62; and origins, 4, 142; and other, 34; and overthinking, 28; and overturning, 38, 40; and pain, 5, 32, 33, 34, 46; and Paris, 139; and past, 30, 34, 41; and pathos, 33; periodization of, 36–37; and Platen, 134–35, 136; and pope, 44, 47, 61, 141, 175; and prejudice, 37; and present, 22, 23, 26, 28, 30, 31, 34, 37, 41; pseudonyms of, 22, 44; and quiet grandeur, 40, 46, 61, 127; and reading backward, 36; and real thing, 38; and reappending, 47, 48; and rebirth, 80; and remnant of loss, 37; and remoteness, 39, 41, 42; removal of object from sight by, 20; and replacement, 37; and repose, 149; and representation, 40; and return to Germany, 41, 42, 43; revisions of, 35–36; and Riedesel, 42; and Rome, 17, 40, 43, 44; and sacrifice, 60; and scars, 47; and sculpture, 35; and secrecy, 139; and self-discrediting art, 5, 6, 8; and self-erasure, 62, 63, 67, 74, 83; and self-expression, 33, 34; and self-obliteration, 32, 34; and self-presentation, 20; self-reflexivity in, 33, 34; and self-representation, 34;

INDEX

Winckelmann (*continued*)
and self-sacrifice, 43; and sensuality, 30, 240n.33; and Seume, 196; and sexuality, 6, 18–19, 20, 22, 31, 34, 45, 46, 47, 48, 142; sight in, 117; as Signor Giovanni, 18; and simplicity, 27; and source, 25; space demarcated and voided by, 22; and space of absence, 40; and spatial displacement, 47; and staged delay, 219; and staging death, 55; and stand-ins, 6; and statues, 5, 116; and stillness, 32, 33; and stones, 117; and Stosch, 35; and sublime, 27; and substitution, 22–23, 60, 105, 135, 136, 178, 210, 214, 218; and suffering, 46; and time, 41, 42, 43, 45, 48, 116; and totality, 27, 28; and tranquility, 32; and transportation of objects home, 20; and Trieste, 41; and Unbezeichnung, 47; and unfinished work, 59, 60, 62; and Urbild, 26, 27, 28, 37; and vacated space, 21–22, 34; and vacated subjectivity, 20; and Venanzio, 45; on Venus de Medici, 22, 36; and violence, 149; and voiding of present, 20; and wholeness, 29, 30; and wounds, 47, 48; and youth, 47; WORKS: *Briefe*, 24; "Essay on the Capacity for the Beautiful in Art," 19; *Gedancken über die Nachahmung der griechischen Wercke in der Mahlerei und Bildhauer Kunst*, 22, 25, 47; *Die Geschichte der Kunst des Alterthums*, 5, 7, 22, 23, 24, 25, 29, 31, 32, 34–35, 36, 39, 43, 45, 46, 54, 58, 142, 221; *Kleine Schriften*, 29, 30; *Versuch einer Allegorie*, 27; *Werke*, 28

Zoroaster, 155